MAKING HOME
Belonging,
Memory, and
Utopia in
the 21st Century

Ed
Cu
Ch
Michelle Joan Wilkinson

Smithsonian Design Triennial

MEMORY

UTOPIA

MAKING

MAKING HOME

BELONGING

MEMORY

UTOPIA

INDEX & CREDITS

HOME

RESUME
Kevin Young

Where the train once rained
 through town
like a river, where the water

rose in early summer
 & froze come winter—
where the moon

of the outhouse shone
 its crescent welcome,
where the heavens opened

& the sun wouldn't quit—
 past the gully or gulch
or holler or ditch

I was born.
 Or, torn—
Dragged myself

atop this mountain
 fueled by flour, butter-
milk, grease fires.

Where I'm from
 women speak
in burnt tongues

& someone's daddy dug
 a latrine so deep
up from the dark

dank bottom springs a tree.

KEVIN YOUNG is the Andrew W. Mellon
Director of the Smithsonian's National
Museum of African American History and
Culture. He previously served as the direc-
tor of the Schomburg Center for Research
in Black Culture. Young is the author of fif-
teen books of poetry and prose, including
Stones, a finalist for the T. S. Eliot Prize,
from which this poem is taken.

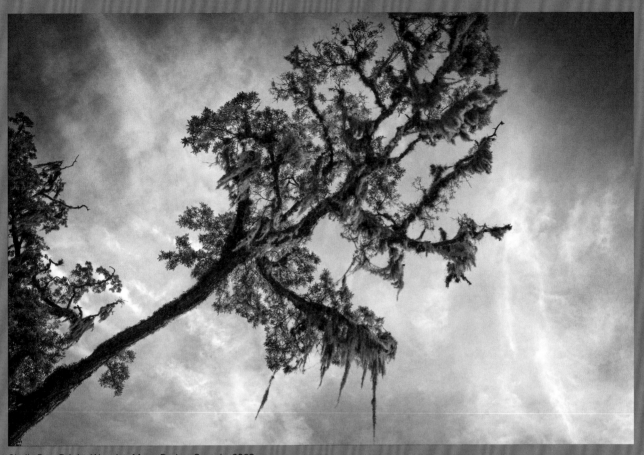

Sheila Pree Bright, Weeping Moss, Darien, Georgia, 2023

RESUME

FOREWORD
Maria Nicanor, Director, Cooper Hewitt, Smithsonian Design Museum

Consider your home—wherever, whatever, or whoever it may be for you—and the memories, aspirations, or strong visceral reactions that conjuring this idea might evoke. Thinking about the idea of our own homes is a deeply personal exercise; yet the forces that shape the way we live are a product of a centuries-long construction of the idea of belonging. The emotional and physical aspects of what makes us feel at home have been shaped by powerful and multilayered political, economic, and social factors, which have, in turn, materialized into the design of spaces, ideas, urban systems, legal structures, institutional narratives, and ultimately frameworks of behavior that guide our relationships. In the end, what type of home, nation, and world do we want to build for ourselves?

When it comes to building the systems by which societies function, design plays a crucial role. As the national museum of design, Cooper Hewitt, Smithsonian Design Museum (CHSDM) has a mission to tell the stories of how design shapes the public and private stages on which our daily lives unfold. It must do so always with the understanding that as a non-neutral agent, design will always be a double-edged tool: both a mechanism that can help us achieve inclusion, acceptance, loyalty, or kinship, and a widely used tactic for exclusion, detachment, and division.

This book—the companion publication to *Making Home, Smithsonian Design Triennial*—and its contributors address this dualism and the interwoven nature of the ideas of belonging, memory, and utopia; the role that design plays in them; and what they mean for the twenty-first-century United States, US Territories, and Tribal Nations in a particularly vulnerable moment in the nation's history as it approaches the 250th anniversary of its experimental creation. We thank them all, with admiration for the quality and rigor of their scholarship, which has been channeled through the thoughtful design eye of Sunny Park of Park-Langer.

Since their inception in 2000, Smithsonian Design Triennials have operated as moments of pause to critically tackle topics of importance to the nation and the world through a design lens. They have shed light on questions that shape the experience of the world around us. The exhibition component of the Triennial features twenty-five installations within the home of the nation's design museum, the Andrew and Louise Carnegie Mansion, where CHSDM has been housed since 1976.

Making Home is the seventh iteration in the Triennial series and the first conceived in collaboration with another Smithsonian museum, in this case the National Museum of African American History and Culture (NMAAHC). Our institutions have previously collaborated on oral histories, live public programs, a publication, and a digital effort to spotlight Black and Latinx designers in our collections. For the Triennial, we were invigorated by the prospect of our shared interest in preserving and interpreting design. I am indebted to my fellow director, Kevin Young, and his team for this rewarding alliance and their support in bringing the project to life.

A heartfelt thank-you to the steadfast curatorial team with representation from both CHSDM and NMAAHC. I wish to thank the tireless curatorial trio of Alexandra Cunningham Cameron, curator of Contemporary Design and Hintz Secretarial Scholar; Christina L. De León, associate curator of Latino Design and acting deputy director of Curatorial from CHSDM; and Michelle Joan Wilkinson, curator of Architecture and Design, NMAAHC, along with curatorial assistants Sophia Gebara and Julie Pastor, CHSDM, and Isabel Strauss, NMAAHC, who together and with unprecedented ambition stewarded the project to the end and have given a voice to many others along the way.

To date, this Triennial is the first to span all four floors of the museum's spaces in a complete mansion takeover, as well as the most expansive ever in the composition and diversity of its exhibition participants and book contributors. Institutionally pushing the needle in this direction is our irrefutable future. *Making Home* benefits from the curators'

FOREWORD

intentional porosity in their definition of design and its interplay with adjacent disciplines. With generosity, the curators have openly shared the Smithsonian platform with a multiplicity of creators across fields, utilizing the Triennial as an engine for the commissioning and creation of new work for a whole generation of designers, artists, and cultural producers of our time, something of which I am immensely proud.

Having this conversation at Cooper Hewitt's own home, also the residence of Andrew and Louise Carnegie more than a century ago, holds poignance. Devoid of the preconditions provided by the white cube or the sprawling museum gallery, the home setting of the Carnegie Mansion predetermines the encounter in meaningful ways. Built between 1897 and 1902 in New York's Gilded Age, the mansion is a symbol of the ideological and infrastructural foundations of the American experiment. Embedded in the metaphorical walls of the Carnegie Mansion are some of the seeds of the very stories confronted, embraced, and explored in the essays in this volume and the mansion installations. The curatorial vision for engaging this space has been masterfully shaped and intelligently developed throughout by architects Johnston Marklee and graphic designers Office of Ben Ganz.

There are many people to thank in a project of this scale and complexity over the many years of its planning. None of it would have come to be without the cross-departmental efforts of extraordinary colleagues at Cooper Hewitt. I extend here my immense gratitude, and that of the board of trustees, to every single person involved, for creating a Triennial that is imbued with both critical thinking and a sense of hope.

The Triennial would not have been possible without unprecedented one-Smithsonian support for this project, led by Secretary Lonnie Bunch's call for Smithsonian units to collaborate and unite; the generous support from the Smithsonian American Women's History Initiative Pool, administered by the Smithsonian American Women's History Museum; the Latino Initiatives Pool, administered by the National Museum of the American Latino; the Asian Pacific American Initiatives

Pool, administered by the Smithsonian Asian Pacific American Center; and the Smithsonian's National Museum of African American History and Culture. I am deeply thankful for the generous support provided by the Henry Luce Foundation and by the Terra Foundation for American Art. My heartfelt gratitude also goes to the Lily Auchincloss Foundation; Edward and Helen Hintz; re:arc institute; the Keith Haring Foundation; the Lemberg Foundation; Maharam; and the Graham Foundation for Advanced Studies in the Fine Arts. Without the committed support of all these individuals and organizations, *Making Home—Smithsonian Design Triennial* would have remained a distant dream.

At a crossroads moment for the country, this volume explores different facets of the history of making home in this nation and seeks to make space to voice the collective realities of how we live. At Cooper Hewitt, we wanted to open the doors to our home to have others make it their own—an exercise of great vulnerability in a search for radical change. The result is *Making Home* in all of its manifestations.

MARIA NICANOR is the director of Cooper Hewitt, Smithsonian Design Museum in New York. An architecture and design curator and historian, Nicanor had previously been an architecture curator at the Guggenheim Museum in New York and a curator in the Design, Architecture, and Digital Department of the Victoria & Albert Museum in London. Following her museum roles, she was the inaugural director of the Norman Foster Foundation in Madrid and executive director of Rice Design Alliance at the Rice University School of Architecture in Houston, Texas.

FOREWORD

BELONGING

MEMORY

UTOPIA

INDEX & CREDITS

INTRODUCTION
Alexandra Cunningham Cameron
Christina L. De León
Michelle Joan Wilkinson

Plans for *Making Home—Smithsonian Design Triennial* were begun at the close of 2019 with the idea that the subject of home could be a relatable framework for exploring the synergies and divergences in how people across the United States, US Territories, and Tribal Nations experience design today. Rather than identifying existing projects that represent a pervasive contemporary ethos, we set out to support the development of new work and works in progress. With this Triennial, we focus on perspectives that made visible personal and professional design processes and embrace design not just as a tool, but also as a means of connection. This approach has been shaped by a desire to foster a greater understanding of our cultural, economic, geographic, and political landscape as ideological divides reverberate across the nation.

We could not have predicted the impending 2020 global lockdown that brought intense scrutiny to the meaning of home in our lives. As we persevered with research for the Triennial, conducting virtual meetings with designers, architects, activists, and experts in the field—often zooming from living room to bedroom, closet to garden—the intimacy of those exchanges meant they moved beyond a professional dialogue. People shared their memories, gave us tours of their homes; we met family members and partners, spoke about vulnerability, exclusion, and dreams for the future. These encounters defined the exhibition, which presents twenty-five site-specific and newly commissioned installations illustrating home in the United States as an individual and a collective phenomenon. The shared experience also identified a direction for this book, *Making Home: Belonging, Memory, and Utopia in the 21st Century*. Collected here are Triennial exhibition participants and a roster of additional contributors telling the stories of how they have made home, and what for them defines home in the first quarter of this century.

We often grappled with the word "home" and the ambiguity it can hold. Home can conjure comfort and a longing to feel secure and at ease. It can evoke both fond and turbulent memories. It can feel disconnected and out of reach. Associations with home are intensely subjective and are circumscribed by the sociopolitical sphere. Home's near-universal resonance makes it both meaningful to explore and impossible to pinpoint. After having many discussions about the definition of home, we chose not to define it. Instead, we invited nearly eighty designers, artists, academics, writers, and advocates to examine how home has been created, destroyed, reimagined, and transformed today. *Making Home* considers how design has shaped our society and, by extension, our homes, which refer not only to the physical spaces in which we reside but also to our land, our neighborhoods, our environment, our institutions, our imaginations, our bonds, and our country. Although the most recent iterations of the Triennial have been international in scope, the decision to focus *Making Home* on the United States, US Territories, and Tribal Nations posed an opportunity to explore the geographical, cultural, and ecological breadth of the country's expansive terrain. As the national design museum, Cooper

Hewitt was faced with these questions: What does it mean to explore the concept of home within the elastic borders of this nation? How are people most affected by design? How do the housing and climate crises influence the nation and its future? Addressing these questions means looking back as much as looking around in efforts to tackle the colonial narratives and historic prejudices that have influenced our understanding of the people, lands, and systems that fall under US sovereignty and influence.

Contemplating historical circumstances inevitably leads to the contemplation of design as a reflection of humanity. And although a linear progression of technological advancement is relevant to tracking the evolution of design over time, there is more to learn by considering material culture as, to interpret art historian George Kubler, part of a continuum of invention that is coming into being to serve similar problems and desires across geography, time, and experience.[1] This necessary dialogue across the past, present, and future is central to Black and Native American ancestral wisdom, but on the margins of the technocratic and theocratic optimism that has dominated the development of the United States. The rhetoric behind Manifest Destiny, which has shaped US policy and perceptions for nearly two hundred years, overlooks continued systemic racial and economic oppression for the sake of relentless growth.

To great humanitarian and environmental destruction, the United States designed and implemented systems of enslavement and exclusion that privileged economic advancement for settler colonists, their descendants, and the white majority. Through scholarly inquiry, personal reflection, conversation, and photography, *Making Home* examines how such sustained inequities in the United States reveal an ongoing crisis of unequal access, economic precarity, incarceration, racial and gender discrimination, ecological threat, and housing insecurity. At the same time, these contributions unravel this imperial narrative, documenting creative work across the country to reckon with this history and to honor, if not concede, our differences.

Our multiplicity is fundamental to the national context. As of July 2023, the US's "resident population" was estimated at 334,914,895[2]—a number that accounts only for individuals within the fifty states and the District of Columbia. Puerto Rico, American Samoa, Guam, the United States Virgin Islands, and the Northern Mariana Islands—Territories that are defined as subnational administrative divisions overseen by the US government—are not accounted for in the "resident population"; nor are the US Armed Forces stationed abroad.[3] Although English is the dominant language in the US, the country has no one official language. People communicate in more than 350 languages, of which 169 are Indigenous.[4] In addition, the US has 574 federally recognized Tribal Nations, along with an estimated four hundred non–federally recognized Native groups.[5] The lands that make up the United States encompass places taken forcibly or with coercion by the federal government. Imperialism is deeply embedded in the formation of the United States and its growth over

[1] George Kubler, *The Shape of Time: Remarks on the History of Things* (New Haven: Yale University Press, 1962).
[2] US Census Bureau, "Annual Estimates of the Resident Population for the United States, Regions, States, District of Columbia, and Puerto Rico: April 1, 2020 to July 1, 2023," 2023, https://www.census.gov/newsroom/facts-for-features/2024/fourth-of-july.html.
[3] The 2020 census reported the following resident populations: Puerto Rico, 3,285,874; American Samoa, 49,710; Guam, 153,836; United States Virgin Islands, 87,146; and the Northern Mariana Islands, 47,329. 228,390 of US military personnel are stationed abroad. Puerto Rico Profile (census.gov) (2020 number); Census Bureau Releases 2020 Census DHC Summary File for American Samoa; 2020 Census DHC Summary File for Guam.
[4] US Census Bureau, "Native North American Languages Spoken at Home in the United States and Puerto Rico: 2006–2010," 2011, www2.census.gov/library/publications/2011/acs/acsbr10-10.pdf.
[5] US Government Accountability Office, "Indian Issues: Federal Funding for Non–Federally Recognized Tribes," 2012, www.gao.gov/products/gao-12-348.

time, which has included more Territories, Commonwealth islands, military occupations, and space colonization. The contemporary concepts of home and homeland in the United States are inextricably linked to questions of land ownership, Indigeneity, national security, and historic precedent. Addressing the complexity of the nation means letting go of a singular notion of "America" or "American" and leaning into the multiplicity that exists within a vast and diverse region.

As curators at the Smithsonian Institution—a federal organization predating the Civil War and established "for the increase and diffusion of knowledge among men"—we work in museums and with collections that have a history of being utilized to establish a "national" heritage.[6] This work has reinforced the justification for the US's existence and its democracy-building mission in concert with a history of violence, enslavement, exclusion, and bias that has caused ongoing harm to communities both within the geographical US and outside of it. The question of how an institution like the Smithsonian can be a place for underscoring a national narrative while openly challenging it has been central to this project. The anthropologist Benedict Anderson defines the nation as "an imagined political community—and imagined as both inherently limited and sovereign."[7] For Anderson, the nation is a socially constructed community, created by individuals who will never meet each member of the group yet are united by a profound sense of solidarity and national identity.[8] A shared language of creative production, of art and innovation, contributes to this sense of common values and has become an essential lever of empathy, disobedience, and progress during countless periods of historic division and stagnancy.

Cooper Hewitt's own home story illustrates the role of museums in mediating this dialogue between lived and metaphoric experience. The architect Hans Hollein and founding museum director Lisa Taylor's inaugural 1976 exhibition and catalog *MAN transFORMS: Aspects of Design* brought together nine architects to present experiential installations throughout the former Andrew and Louise Carnegie Mansion. The show addressed a shift in the role of the museum as a site for the construction of cultural identity to a site of personal interpretation and theoretical expression. It also marked a shift in curatorial practice by allowing designers themselves to present the cause and effects of their work through spatial immersion while employing spectacle as a strategy for institutional engagement with the public. *Making Home* inherits this vital approach to exhibition making across the mansion as a platform for designers and artists to express their theories, labor, and expertise in response to contemporary concerns.

This book, like the *MAN transFORMS* publication, gives voice to designers, artists, and agents of culture. It enables them to articulate the foundations of their practices and examine what home can be, where home can exist, and how concepts of home intersect with our understanding of design—whether architecture and product design or the design of cities, systems, services, and laws. The approach is decidedly expansive, and at times imprecise because attempts to identify a definition of design (like a definition of home) inevitably end up frustrated. The nature of the exercise and the reach of the enterprise are vast.

Before author and theorist bell hooks took up residence at Berea College, where the program privileges the spiritual advantages of handcraft, she described

[6] Smithsonian Institution, "History" (n.d.), www.si.edu/about/history.
[7] Benedict Anderson, *Imagined Communities: Reflections on the Origin and Spread of Nationalism* (Verso, 1983), 6.
[8] Ibid., 6–7.

design as our agency to shape considered and interconnected lives: "All my life I have been obsessed by the pleasure of design. There is no human being in the world who is not born into a happening life—who is not born with the will to endlessly design."[9] In that hooks considers design as a longing to build worlds of "interbeing"—an idea of relationality originally proposed by activist Thich Nhat Hanh—she suggests a psychological foundation for design.[10] For many living in the US, home is defined by a sense of belonging. In immigrant and migrant communities, this sentiment manifests in housing design styles and decorative choices that echo the transnational identities of their inhabitants. For others who may be nomadic or without permanent physical housing, home is less a tangible structure than a mental and emotional space. If we see home as a wide-ranging term that can change in scale and meaning based on a variety of experiences, then making home is a universal design practice, one we build with our own intimate tools.

Embracing design's subjective qualities led to our positioning "belonging," "memory," and "utopia" as organizing principles for the essays, conversations, home stories, and images that populate this book. Each notion is inseparable from personal context and hovers among the past, present, and future. Each implies its inverse, creating a tension between the imagined ideal and the reality of practice.

Belonging is active, taking place in the present tense while referring to connections across a continuum of time and space that can reinforce or undermine our relationships with one another. *Memory* evokes the influential force of times past as well as the active work to retain recollections in the present. *Utopia* invents an ideal that upends the status quo. More than a

[9] bell hooks, "Design: A Happening Life," Lion's Roar, July 1, 1998, www.lionsroar.com/design-a-happening-life/.
[10] Ibid.

theoretical framework, utopia is an aspirational operator that influences behavior on a variety of scales, from the popular to the individual.

The process of developing *Making Home* often felt like a leap of faith—one that frequently pushed us out of our comfort zones. In considering what the scope of this exhibition and publication might encompass, we had to confront our own biases about home and what stories illuminate the topic. We worked to find consensus on how to create institutional space for the expansive experiences of others while considering the comprehension of audiences who may or may not share those realities. This publication was conceived to provide further insight into those interwoven perspectives and how people see through this rotating kaleidoscope of a nation.

You may find that you resonate deeply with the stories and images shared in this book, or that they differ significantly from your own. In either case, we hope you will take them as an invitation to dialogue.

ALEXANDRA CUNNINGHAM CAMERON is the curator of contemporary design and the Hintz Secretarial Scholar at Cooper Hewitt, Smithsonian Design Museum.

CHRISTINA L. DE LEÓN is the acting deputy director of curatorial and associate curator of Latino design at Cooper Hewitt, Smithsonian Design Museum.

MICHELLE JOAN WILKINSON is the curator of architecture and design at the Smithsonian's National Museum of African American History and Culture.

INTRODUCTION

MAKING HOME

BELONGING

MEMORY

UTOPIA

INDEX & CREDITS

BELONGING

BELONGING
Christina L. De León

"The most important good we distribute to each
other in society is membership."
JOHN A. POWELL AND STEPHEN MENENDIAN,
"The Problem of Othering: Towards Inclusiveness and Belonging"[1]

From the moment we emerge from the womb, we begin seeking where and with whom we belong. This pursuit is never-ending and continues, to varying degrees, until we depart this existence. How we navigate that process shapes our identities, influences our relationships, and defines the sense of purpose we carry through life.

In 1995, the psychologists Roy F. Baumeister and Mark R. Leary published a paper that identified belonging as an inherent human need rather than a desire.[2] The drive to create "interpersonal bonds" is so paramount to our livelihood that the lack of such social connections can result in a decline in mental and physical health.[3] Biobehavioral synchrony reinforces how the human body is biologically programmed for belonging. Because a fetus's heartbeat coincides with that of the mother, a baby's brain activity and hormones reflect those of their caregiver upon birth.[4] This attachment, present in the nascent stage of a person's development, lays the groundwork for empathy.[5]

The amount of empathy we feel is dependent on how much we believe we belong within our social groups.[6] If belonging is an important marker that stimulates emotional satisfaction in our relationships and provides us with the chance to express ourselves freely,

Brian Adams, 4th of July, Naknek, Alaska, July 2019

then *othering* is a process that pushes us into the realms of discontent and exclusion. john a. powell and Stephen Menendian from the Othering and Belonging Institute define othering "as a set of dynamics, processes, and structures that engender marginality and persistent inequality across any of the full range of human difference based on group identities."[7]

Whereas belonging makes us feel like valued members in society, othering leads us to the conclusion that our voice is insignificant. We continuously seek out and create moments of belonging in our lives; yet we design communities, cultural frameworks, and governance systems that perpetuate discrimination

[1] john a. powell and Stephen Menendian, "The Problem of Othering: Towards Inclusiveness and Belonging," *Othering & Belonging: Expanding the Circle of Human Concern* 1, no. 1 (2016): 14–39, https://www.otheringandbelonging.org/the-problem-of-othering/.

[2] "The Need to Belong: Desire for Interpersonal Attachments as a Fundamental Human Motivation," *Psychological Bulletin* 117, no. 3 (1995): 497–529.

[3] Kelly-Ann Allen et al., "The Need to Belong: A Deep Dive into the Origins, Implications, and Future of a Foundational Construct," *Educational Psychology Review* 34, no. 2 (2022): 1138.

[4] Over Zero and the American Immigration Council, *The Belonging Barometer: The State of Belonging in America*, rev. ed. (2024), 36, https://www.projectoverzero.org/media-and-publications/belongingbarometer.

[5] Ibid., 2–3.

[6] powell and Menendian, "The Problem of Othering," 24.

[7] Ibid., 17.

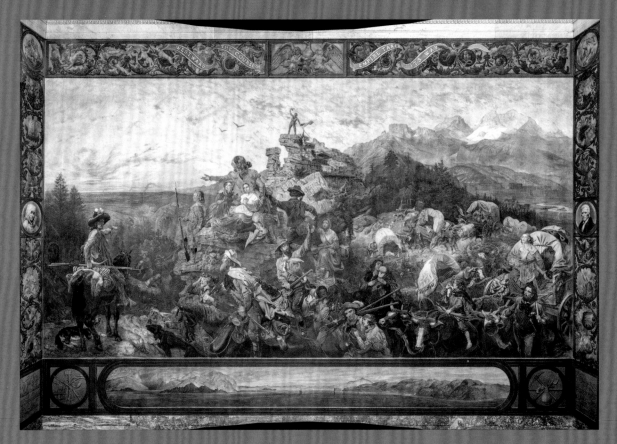

Emanuel Leutze's mural Westward the Course of Empire Takes Its Way (1861–62) was designed as a visual anchor within the US Capitol Building to underscore the tenets of Manifest Destiny and unify the country after the Civil War.

and limit opportunities for belonging. This duality is experienced every day by people living under US sovereignty. The following essays, conversations, and personal accounts examine the multifaceted aspects of belonging in the twenty-first century.

Since the arrival of the first European colonists to this vast territory now known as the United States, the concept of belonging has remained a difficult and fraught issue for the many people who reside within its borders. Although belonging can be defined as a connection to a place or environment, it can also be used to identify a possession. The longing to feel settled in a place or social group and the desire to acquire land, wealth, or power have long been at the root of the US experience. Notions concerning the nature of belonging in this country have often centered on the binary dynamic of "us" versus

"them," engendering social and political ideologies that have dictated perceptions about who belongs and who does not. The consequences of this thinking—stoked by fear, racism, and xenophobia—have unfolded throughout US history via violent acts of land displacement and enslavement.

In the twenty-first century, countless laws in the US have targeted a person's race and ethnicity, sexual orientation, body, religion, and immigration status. In a recent study published in *The Belonging Barometer*, researchers asserted that across partisan lines many people in the US are often unaware of their similar viewpoints on national issues and are concerned that the country "will not hold a place for them, their family, or their way of life in the future."[8] In fact, the same study found that "non-belonging"—a term that applies to individuals who experience ambiguity and

[8] Over Zero and the American Immigration Council, *The Belonging Barometer*, 36.

Landsat satellite images, like this 2009 capture of northwestern Minnesota, reveal the ongoing influence of settler colonial concepts of land distribution and use.

global empire. Beginning with the Louisiana Purchase (1803) coupled with foreign policies such as the Monroe Doctrine (1823) that resisted European colonization in the Americas, this century laid the foundation for US hegemony.[10] Armed conflicts such as the Mexican–American War (1846–1848) transformed the country's territorial expanse,[11] and the Spanish–American War (1898) and the forced annexation of Hawai'i (1898) secured the US government's power and influence beyond its continental borders.[12] At first glance, these events and policies may appear disconnected from the issues we grapple with today. However, the contributions that follow illuminate the enduring consequences of these contested actions in our contemporary world, demonstrating how they persist through our institutions, international relations, military strategies, and penal systems.

Simultaneously, the elusive promise of the "American Dream" continues to serve as an animating national ethos. The American Dream—rooted in the conviction that the US offers people the freedom and opportunity to attain a better life through individual talent and fortitude—has existed in one way or another since the inception of this country, but it was popularized in the twentieth century by the writer James Truslow Adams. Adams described the American Dream not just as "material plenty" but also as the opportunity "to grow to fullest development as man and woman, unhampered by the barriers which had slowly been erected in older civilizations, unrepressed by social orders which had developed for the benefit of classes rather than for the simple human being of any and every class."[13] However flawed his thinking, Adams believed deeply that the US offered

exclusion—is prevalent across various aspects of life, with a significant majority of people reporting feelings of non-belonging in their workplaces (65 percent), in the nation (67 percent), and in their local communities (74 percent).[9]

In the US, belonging has come at the cost of others' well-being. For centuries, legal frameworks were designed to ensure the prosperity of selective groups while systematically subjugating many others. This is evident in the enslavement of Africans and Black Americans, which was driven by economic interests that led to the establishment of a social and racial hierarchy the country continues to reckon with today. Manifest Destiny framed US westward expansionism as a divine mandate to spread democracy and conquer unattributed lands at the expense of Indigenous peoples that has resulted in their continued oppression.

The close of the nineteenth century saw the US transform from a former British colony into a

[9] Ibid., 26.
[10] The Monroe Doctrine declared the Western Hemisphere was off-limits to further European colonization or interference. It also emphasized that any attempt by European governments to control or intervene in the Americas would be viewed as an act against the United States.
[11] The Treaty of Guadalupe Hidalgo signed in 1848 after the Mexican–American War ceded present-day California, New Mexico, Utah, Nevada, as well as most of Arizona and Colorado and parts of Oklahoma, Kansas, and Wyoming.
[12] The Treaty of Paris, signed on December 10, 1898, formally ended the Spanish–American War, and under its terms, Spain relinquished control of Cuba, ceded Puerto Rico and Guam to the US, and transferred control of the Philippines to the US for $20 million. This event, coupled with the annexation of the Hawaiian Islands in the same year, marked the advent of US colonial authority in the Pacific and the Caribbean.

DE LEÓN

the chance for personal growth, social mobility, and financial stability.[14]

The home has always been at the epicenter of the American Dream, whether it refers to homeownership or simply stable housing. It can be argued that the process of making a home leads to finding a sense of personal and communal belonging; yet in the twenty-first century, many believe this goal to be aspirational at best, if not completely out of reach for many. Although in 2023 at least 60 percent of individuals living in the US reported feeling a sense of belonging among their families and friends, 40 percent expressed feelings of non-belonging.[15] The Belonging section of this book features essays that explore the host of housing challenges those residing in the US currently face. Interspersed among them are personal narratives that highlight the social, cultural, and political systems influencing our capacity to create and maintain both the physical and the emotional aspects of home.

Despite the numerous challenges, humans remain dedicated to the pursuit of belonging, and our desire to forge new connections does not cease after birth. We find these bonds through online interactions, in formal groups or associations, and via everyday exchanges. Many of the contributions here speak to how moments of belonging can be discovered in unexpected places and how this search can be an ongoing journey. Achieving a sense of belonging requires that we expand our scope of empathy by confronting and rejecting the marginalization and stereotyping of others—it's an idea powell and Menendian identify as "widening the circle of human concern."[16] Ultimately, this section casts light on the experiences that contribute to an individual's overall sense of societal membership, of feeling like they belong despite the incessant obstacles to inclusion they may face in their daily life.

[13] James Truslow Adams, *The Epic America* (Boston: Little, Brown and Company, 1931), 405.
[14] Ibid.
[15] Over Zero and the American Immigration Council, *The Belonging Barometer*, 26.
[16] powell and Menendian, "The Problem of Othering," 32.

HOME(BE)COMING
Context and Conditions in Contemporary American Housing

FOUNDATIONS

Nisiquiera un cafecito les puedo ofrecer.
"I can't even offer you a cup of coffee."
EVERARDO MARTÍN, my father

CARLOS MARTÍN is the director of the Remodeling Futures Program at Harvard University's Joint Center for Housing Studies and Vice President for Research and Policy Engagement at Resources for the Future. He has over 25 years of experience researching the physical quality of homes and their social disparities. He serves on several National Academy of Science committees and served on advisory boards for HUD, EPA, and FEMA. He received his BSAD from MIT and his MEng and PhD from Stanford.

We sold my family home this year. The home my parents bought when I was born has passed to others. A suburban California lot on Ohlone land stolen by the Spanish.[1] Appropriated from Mexicans after statehood, parcels passed to European settlers who created a speakeasy town during Prohibition.[2] One of those settlers' farms, with its basement wine barrel stands, landed in the hands of my Mexican immigrant parents. It was the wood for the whittling of their aspiration.

That building was our lives and livelihoods made manifest. My earliest memories are of my father's constructions—breaking through walls, adding new rooms, modifying pillar and post of that home to transform it into something altogether different, completely ours. The home was a mirror of who we were becoming as much as it was a product of those who had come before. The memories spurred my desire to be an architect, an engineer, any vocation that contemplated how social aspirations become physical places. Long after moving away, I could still distinguish the slightest of creaks from the staircase—a signal my father was walking up to announce that meals were ready. I could fly down the stairs blindfolded, intuitively knowing their number and tread. I can still hear my mother singing in her *taller*, the bedroom she converted to a sewing room so she could build something of her own.

But I can't prove my memory correct anymore. My mother's passing forced us to grapple with the disposition of both the home and its one remaining occupant, my father. His wish to be away from the rooms that reminded him of her conflicted with

[1] See Lee Panich, *Narratives of Persistence: Indigenous Negotiations of Colonialism in Alta and Baja California* (Tucson: University of Arizona Press, 2020).
[2] See Christopher M. Sterba, "Taming the Wild West in the Late 1940s: Suburban Progressives in the San Francisco Bay Area," *California History* 92, no. 1 (2015): 27–52; and Rick Radin, "El Cerrito Era of Gambling, Vice and Racketeers Recounted in Talk," *East Bay Times*, March 16, 2017.

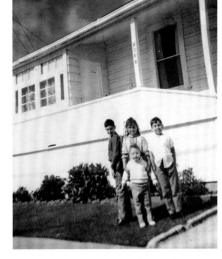

Martín family photo in front of the author's original family home, 1971

the potential loss of the only physical evidence of his lifelong work. He moved to assisted "living," a nursing "home," euphemistic places with fewer reminders of his memories. There, he laments what his surroundings represent more than the comforts they provide; he tells us, "I can't even offer you a cup of coffee." The home, for him, shapes the most basic of social customs. But a house built to withstand California's earthquakes could not endure my family's generations.

Americans are taught that our homes are exceptional extensions of our families and, collectively, that they are unique structures on the planet. The immigrant's aspirational American Dream is as much a part of our national folklore as the Barbie Dreamhouse is part of our children's fantasies.[3] Changes in American households are in dialogue with the physical form of American housing and all its accompanying economic, design, sociological, and psychological baggage.[4] American housing consequently reflects the social norms of our country's regions as it reveals our material capacity: New York tenement, New England three-decker, Gulf Coast shotgun, Sears kit, California ranch, and all the Levittowns in between.[5]

Whether shelter, asset, showcase, or prison, home is central to our shared self-conception.[6] We center housing so squarely in our familial finances and our collective history that protecting the status quo has today become a national pastime, from NIMBYism to "stand your ground."[7] Despite the importance we place on the home, we do a middling job of housing everyone in the United States.

We are a nation of diverse family compositions, sizes, and resources. Today's accumulated housing stock is inadequately matched to the contemporary American household. Affordability, class and racial integration, and environmental justice all remain elusive goals in the American housing project. My former home is one of the

[3] See Matthew Wills, "James Truslow Adams: Dreaming up the American Dream," *JSTOR Daily*, May 18, 2015, https://daily.jstor.org/james-truslow-adams-dreaming-american-dream/; Gregory Schmidt, "Homeownership Remains the American Dream, Despite Challenges," *New York Times*, June 2, 2022, https://www.nytimes.com/2022/06/02/realestate/homeownership-affordability-survey.html; and Anna Kodé, "Barbie, Her House and the American Dream," *New York Times*, June 23, 2023, https://www.nytimes.com/interactive/2023/06/23/realestate/barbie-dreamhouse.html.
[4] See Gwendolyn Wright, *Building the Dream: A Social History of Housing in America* (Cambridge: MIT Press, 1983); Gwendolyn Wright, "Design and Affordable American Housing," *Cityscape* 16, no. 2 (2014): 69–86; and Harvard Joint Center for Housing Studies, "The State of Housing Design 2023," 2023.
[5] See Dolores Hayden, *The Grand Domestic Revolution: A History of Feminist Designs for American Homes, Neighborhoods, and Cities* (Cambridge: MIT Press, 1981); Ted Cavanagh, "Balloon Houses: The Original Aspects of Conventional Wood-Frame Construction Revisited," *Journal of Architectural Education* 51, no. 1 (1997): 5–15; and Barbara M. Kelly, *Expanding the American Dream: Building and Rebuilding Levittown* (Albany: SUNY Press, 1993).
[6] See Kenneth T. Jackson, *Crabgrass Frontier: The Suburbanization of the United States* (Oxford, UK: Oxford University Press, 1987).
[7] See Michael Dear, "Understanding and Overcoming the NIMBY Syndrome," *Journal of the American Planning Association* 58, no. 3 (1992): 288–300; Erin McElroy and Andrew Szeto, "The Racial Contours of YIMBY/NIMBY Bay Area Gentrification," *Berkeley Planning Journal* 29, no. 1 (2017); Chandler McClellan and Erdal Tekin, "Stand Your Ground Laws, Homicides, and Injuries," *Journal of Human Resources* 52, no. 3 (2017): 621–53; and Adeel Hassan, "What Are 'Stand Your Ground' Laws, and When Do They Apply?," *New York Times*, April 19, 2023, https://www.nytimes.com/2023/04/19/us/stand-your-ground-laws-states.html.

HOME(BE)COMING

[8] US Census, American Housing Survey, 2021, https://www.census.gov/programs-surveys/ahs.html.

[9] Harvard Joint Center for Housing Studies, "Improving America's Homes 2023," 2023, https://www.jchs.harvard.edu/sites/default/files/reports/files/JCHS-Improving-Americas-Housing-2023-Report.pdf.

[10] Political activist Jimmy McMillan created the "Rent Is Too Damn High" political party in the late 2000s, leading up to a gubernatorial campaign in New York State by 2010. Bill Chappell, "One Man, One Message: The Rent (It's Too High)" NPR, October 19, 2010, https://www.npr.org/sections/thetwo-way/2010/10/19/130680249/one-man-one-message-the-rent-it-s-too-high.

[11] National Association of Home Builders, "Housing's Contribution to Gross Domestic Product," https://www.nahb.org/news-and-economics/housing-economics/housings-economic-impact/housings-contribution-to-gross-domestic-product.

[12] US Department of Housing and Urban Development, "Evolution of the U.S. Housing Finance System," 2006, https://www.huduser.gov/publications/pdf/us_evolution.pdf.

[13] See Dennis J. Ventry, "The Accidental Deduction: A History and Critique of the Tax Subsidy for Mortgage Interest," *Law and Contemporary Problems* 73, no. 1 (2010): 233–84; and Daniel J. Hemel and Kyle Rozema, "Inequality and the Mortgage Interest Deduction," *Tax Law Review* 70 (2016): 667.

almost 130,000,000 residential units in the United States.[8] Though the number grows each passing year, new home construction does not keep pace with the needs of our growing population and is typically built for the needs of wealthier Americans. Like our population, our homes are aging. At an unprecedented median age of forty-one years, US homes are now entering human middle age.[9] A midlife crisis is at hand.

LAYOUT

"The rent is too damn high."
JIMMY MCMILLAN[10]

Aside from the symbolism of the home and its role as American centerpiece, housing is also an economic system. When speaking about a region's housing stock, policymakers and scholars refer to the local housing "market." Those fortunate enough to have owned a home have relied on it as a primary source for personal wealth. In turn, the aggregate contribution from building, financing, and maintaining homes to the US gross domestic product is staggering, at over $4.4 trillion in 2023 alone.[11] We have remarkably nimble and opportunistic design and building industries in the United States. These industries have also pushed to incubate innovations in housing finance and financial policy: thirty-year mortgages, mortgage securitization, home equity lines of credit, reverse mortgages, and, yes, predatory lending, have all blossomed here.[12] We reward property possession in our tax codes.[13] In promoting homeownership for everyone, we have forgotten that there must be enough homes available, affordable, and of appropriate physical quality to realize that American Dream.

Exclusionary zoning, increasing land and construction costs, and our persistent commitment to the sprawling form of communities we have already built have colluded to ensure there is an insufficient supply of housing—a condition that prices millions out of homeownership and also elevates rents. Consequently, one of the largest wrenches thrown into the machinery of the contemporary American Dream is the housing affordability crisis. Elevated home prices and rents leave millions struggling with high or even severe housing cost burdens, such as the record 20.3 million households that devote over 50 percent of their income to pay either their mortgage or rent and related

costs.[14] Individuals must have an annual household income of at least $100,000 to afford a median-priced home in nearly half of all metro areas in the United States.[15] To rent a modest two-bedroom home today, a person would need to make $28.58 per hour, working forty hours per week—over three times the federal minimum wage.[16]

The market challenges have been known for decades, but the acuteness of today's affordability crisis has resulted in new examination.[17] Municipal ordinances over decades have produced the housing restrictions and household exclusions we see today. State and local governments are experimenting with a range of land, design and construction, regulatory, and financing techniques such as inclusionary zoning and infill housing to increase housing supply in the hope that housing costs will come down while accommodating new residents and retaining existing ones.[18] Public policy is a mix of mortgage securitization, mortgage interest deductions, mortgage insurance, and the occasional assistance for mortgage down payment for a majority of owners, as well as public housing, rental vouchers, and tax-credit subsidized units for a minority of low-income renters. The initiatives for renters are all severely underfunded.[19]

For many, the American Dream is more of a nightmare; the inability to afford housing contributes to the persistence of people experiencing homelessness, a reality for over a half-million individuals on any given night in the United States. Cost-burdened households live under threat of eviction, being one family emergency away from financial spiral.[20] The voices of advocates calling for universal tenant protections in response to the unprecedented affordability crisis are deafening in the contemporary housing discourse.[21] Rental housing is recognized today for the critical asset it has always been.[22] Yet, housing options are increasingly limited to all but a few households.

[14] Thyria A. Alvarez and Barry L. Steffen, "Worst Case Housing Needs: 2023 Report to Congress," US Department of Housing and Urban Development, 2023.

[15] Harvard Joint Center for Housing Studies, "The State of the Nation's Housing 2024," 2024, https://www.jchs.harvard.edu/state-nations-housing-2024.

[16] National Low Income Housing Coalition, "Out of Reach: The High Cost of Housing," 2023, https://nlihc.org/oor.

[17] See Advisory Commission on Regulatory Barriers to Affordable Housing, "Not in My Backyard: Removing Barriers to Affordable Housing," US Department of Housing and Urban Development, http://www.huduser.gov/portal/publications/RBCPUBS/NotInMyBackyward.html; and Yonah Freemark, Lydia Lo, and Sara C. Bronin, "Bringing Zoning into Focus: A Fine-Grained Analysis of Zoning's Relationships to Housing Affordability, Income Distributions, and Segregation in Connecticut," Urban Institute, June 2023, https://www.urban.org/research/publication/bringing-zoning-focus.

[18] See Bill Fulton, David Garcia, Ben Metcalf, Carolina Reid, and Truman Braslaw, "New Pathways to Encourage Housing Production: A Review of California's Recent Housing Legislation," Terner Center for Housing Innovation Brief, 2023, https://ternercenter.berkeley.edu/wp-content/uploads/2023/04/New-Pathways-to-Encourage-Housing-Production-Evaluating-Californias-Recent-Housing-Legislation-April-2023-Final-1.pdf; and "A Summary of Supply Skepticism Revisited: A Review of the Latest Research on the Relationship Between Housing Supply and Affordability," New York University Furman Center Brief, August 2023, https://furmancenter.org/files/Supply_Skepticism_-_Working_Brief_1.pdf.

[19] Will Fischer, "Housing Investments in Build Back Better Would Address Pressing Unmet Needs," Center for Budget Policy and Priorities, February 10, 2022, https://www.cbpp.org/research/housing/housing-investments-in-build-back-better-would-address-pressing-unmet-needs.

[20] Abt Associates, "The 2022 Annual Homelessness Assessment Report (AHAR) to Congress—Part 1: Point-In-Time Estimates of Homelessness," US Department of Housing and Urban Development, December 2022, https://www.huduser.gov/portal/datasets/ahar/2022-ahar-part-1-pit-estimates-of-homelessness-in-the-us.html; Princeton Eviction Lab, https://evictionlab.org/; Kathryn Edin and Luke H. Shaefer, *$2.00 a Day: Living on Almost Nothing in America* (Boston: Houghton Mifflin Harcourt, 2015).

[21] See Josephine Nesbit, "What Is the White House's Renters Bill of Rights?," *US News and World Report*, March 16, 2023, https://realestate.usnews.com/real-estate/articles/what-is-the-white-houses-renters-bill-of-rights.

[22] Harvard Joint Center for Housing Studies, "America's Rental Housing 2022," 2022, https://www.jchs.harvard.edu/americas-rental-housing-2022.

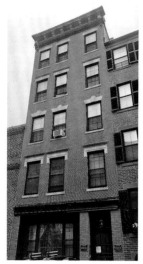

81 Joy Street, the site of David Walker's home at the time of his death. The plaque inscription reads: "8 Belknap Street. David Walker c 1976–1830. In 1829 published 'Appeal to the Colored Citizens of the World' decrying American slavery, racial hatred, and summoning his fellow African Americans to resist. Possession of the Appeal was a crime in the South. A bounty was placed on him by Georgia slave owners. —The Heritage Guild, Inc."

BELONGING

Without consistent financial resources and clear value statements in policymaking, we are reverting to housing markets that amplify exclusions of the past.[23]

The United States has a unique history of inscribing class and wealth into its housing. This includes our homes' design. Where other nations, particularly in the developing world over the last century, equated modernist design with status and wealth, the American postwar aesthetic gazed toward ersatz historicity and spaciousness—distinct from urban density and modernist residential forms associated with social housing or, more accurately, its occupants.[24] Ironically, that same aesthetic is now interpreted as a signal of gentrification as the urbane, upper-income *Dwell* magazine crowd moves in.[25]

WALLS

"Can a man of colour buy a piece of land and keep it peaceably? … and will they drive us from our property and homes, which we have earned with our *blood*?"
DAVID WALKER, *Walker's Appeal*, 1829[26]

Housing choices have never been offered to everyone equally in this country. The preeminence of property ownership that figures into contemporary housing is the direct descendant of strictures that kept wealthy white landholding men in power at this nation's start.[27] The same authority weakened alternative forms of stewardship, including the communal ones of many Native nations and that some settlers brought themselves.[28] Native property rights are this country's unfinished business.[29]

Current property in the United States is built on the foundations of past institutions and strictures, a portion of which treated enslaved people as property themselves. After Emancipation, the same institutions ensured that the posterity of enslaved Africans and others could not partake in the purchase of prop-

[23] C. J. Dawkins, *Just Housing: The Moral Foundations of American Housing Policy* (MIT Press, 2021).

[24] Geon Woo Lee, "Debunking the Myth: Utopian Public Housing in Mid-20th Century America," *Medium*, June 30, 2021, https://gwlee1.medium.com/debunking-the-myth-utopian-public-housing-in-mid-20th-century-america-f4e523289934.

[25] Jerusalem Demsas, "In Defense of the 'Gentrification Building': The New Multifamily Buildings in Your Neighborhood Actually Slow Displacement," *Vox*, September 10, 2021, https://www.vox.com/22650806/gentrification-affordable-housing-low-income-housing; and Molly Jane Quinn, *It's Lonely in the Modern World: The Essential Guide to Form, Function, and Ennui from the Creators of Unhappy Hipsters* (New York: Chronicle Books, 2011).

[26] David Walker, *Walker's Appeal, in Four Articles: Together with a Preamble, to the Coloured Citizens of the World, but in Particular, and Very Expressly, to Those of the United States of America—Reprinted from the 1829 Original Text* (1829; New York: Macmillan, 1922).

[27] Matthew Desmond, "In Order to Understand the Brutality of American Capitalism, You Have to Start on the Plantation," 1619 Project, *New York Times*, August 14, 2019, https://www.nytimes.com/interactive/2019/08/14/magazine/slavery-capitalism.html.

[28] Allan Greer, "Commons and Enclosure in the Colonization of North America," *The American Historical Review* 117, no. 2 (2012): 365–86.

[29] Naomi Schaefer Riley, "One Way to Help Native Americans: Property Rights," *Atlantic*, July 30, 2016, https://www.theatlantic.com/politics/archive/2016/07/native-americans-property-rights/492941/.

erty or would devalue their property when they could.[30] The institution's strategies have been exhausting: redlining and other housing covenants and rules,[31] the relegation of underserved communities to places that were either environmentally unfit or less amenable for settlement,[32] financial and legal barriers to homeownership,[33] and the tacit behaviors of decision-makers. Indeed, professionals and workers in all housing fields are implicated: designers, builders, real estate agents, appraisers, lenders, investors, and insurers.[34] Public infrastructure, private utilities, and other entry points into homes have also contributed to the viability of certain homes for certain folks in certain places.[35] We see this today in headlines from residential neighborhoods in Flint, Michigan; Jackson, Mississippi; and Conroe, Texas, as well as the persistently underreported infrastructure on tribal lands.

Racism left the nail holes of segregation and discrimination in the framework of housing today.[36] Despite efforts to include more people of color in housing-related professions,[37] to shed light on racism's forms,[38] and to enforce fair housing laws,[39] the demography of property remains dismal. Low homeownership rates persist: 46 percent of Black households and 49 percent of Latino households are homeowners, compared to 75 percent of white households.[40] Tellingly, my parents bought our family home from Doña Aurora, the other Mexican in town.

People of all racial and ethnic backgrounds aspire to the benefits and significance of homeownership, but the historically erected barriers to that achievement are matched by the challenges of sustaining the home afterward.[41] Differences in property tax assessments and other public excises as well as disparities in the enforcement of blight, civil incivility, and "broken window" laws within the broad range of policing tactics have devalued homes owned

[30] See Andre M. Perry, *Know Your Price: Valuing Black Lives and Property in America's Black Cities* (Washington, DC: Brookings Institution Press, 2020).

[31] "Mapping Inequality: Redlining in New Deal America," University of Richmond, https://shelterforce.org/2023/08/25/holding-redlinings-perpetrators-accountable/; Richard Rothstein, *The Color of Law: A Forgotten History of How Our Government Segregated America* (New York: Liveright Publishing, 2017).

[32] Robert D. Bullard, *Dumping in Dixie: Race, Class and Environmental Quality* (Boulder, CO: Westview Press, 2000).

[33] Keeanga-Yamahtta Taylor, *Race for Profit: How Banks and the Real Estate Industry Undermined Black Homeownership* (Chapel Hill, NC: UNC Press, 2019).

[34] For designers' complicity, see Whitney Young's 1968 speech to the American Institute of Architects Convention: https://content.aia.org/sites/default/files/2018-04/WhitneyYoungJr_1968AIAContention_FulLSpeech.pdf. Current disparities by other professionals can be found respectively in Colette Coleman, "Excuse After Excuse: Black and Latino Developers Face Barriers to Success," *New York Times*, March 3, 2023, https://www.nytimes.com/2023/03/03/realestate/real-estate-developers-black-latino.html; Ann Choi, Keith Herbert, and Olivia Winslow, "Long Island Divided," *Newsday*, November 17, 2019; Gene Slater, *Freedom to Discriminate: How Realtors Conspired to Segregate Housing and Divide America* (Berkeley, CA: Heyday Books, 2021); Colette Coleman, "Selling Houses While Black," *New York Times*, June 20, 2023, https://www.nytimes.com/2023/01/12/realestate/black-real-estate-agents-discrimination.html; Debra Kamin, "Black Homeowners Face Discrimination in Appraisals," *New York Times*, January 26, 2023, https://www.nytimes.com/2020/08/25/realestate/blacks-minorities-appraisals-discrimination.html; Margery Austin Turner and Felicity Skidmore, eds., "Mortgage Lending Discrimination: A Review of Existing Evidence," Urban Institute (1999); Elora Lee Raymond et al., "From Foreclosure to Eviction: Housing Insecurity in Corporate-Owned Single-Family Rentals," *Cityscape* 20, no. 3 (2018): 159–88; Ronen Avraham, "Discrimination and Insurance," in *The Routledge Handbook of the Ethics of Discrimination*, ed. Kasper Lipper-Rasmussen (London: Routledge, 2018): 335–47; G. Galster, "Do Home Insurance Base Premium-Setting Policies Create Disparate Racial Impacts?: The Case of Large Insurance Companies in Ohio," *Journal of Insurance Regulation* 24, no. 4 (2006); and Laureen Regan, "Unfair Discrimination and Homeowners Insurance Availability: An Empirical Analysis," *Risk Management and Insurance Review* 10, no. 1 (2007): 13–31.

[35] See Carlos Martín, "Fairness and Equity in Infrastructure Policy," Testimony to US House Select Committee on Economic Disparity and Fairness in Growth, February 15, 2022, https://www.brookings.edu/articles/fairness-and-equity-in-infrastructure-policy/; and Robert Walton, "The Energy System Is 'Inherently Racist,' Advocates Say. How are Utilities Responding to Calls for Greater Equity?," *Utility Dive*, October 26, 2022, https://www.utilitydive.com/news/energy-system-inherently-racist-utilities-responding-equity-ej-justice40/634203/.

[36] See Mona Hanna-Attisha, *What the Eyes Don't See: A Story of Crisis, Resistance, and Hope in an American City* (London: Oneworld, 2017); Robert Samuels and Emmanuel Martinez, "The Problems in the Pipes," *Washington Post*, February 18, 2023, https://www.washington post.com/nation/interactive/2023/jackson-mississippi-water-crisis/; Jose R. Gonzalez, "Conroe Boy's Death Following February's Arctic Blast Confirmed as Carbon Monoxide Poisoning," *Courier of Montgomery County*, May 13, 2021, https://www.yourconroenews.com/neighborhood/moco/news/article/Conroe-boy-s-death-confirmed-as-carbon-monoxide-16172711.php; and Nancy Pindus et al., "Housing Needs of American Indians and Alaska Natives in Tribal Areas," US Department of Housing and Urban Development, https://www.huduser.gov/portal/publications/HNAIHousingNeeds.html.

[37] Sharon Egretta Sutton, *When Ivory Towers Were Black: A Story about Race in America's Cities and Universities* (New York: Fordham University Press, 2017).

[38] Irene Cheng, Charles L. Davis, and Mabel O. Wilson, eds., *Race and Modern Architecture: A Critical History from the Enlightenment to the Present* (Pittsburgh: University of Pittsburgh Press, 2020).

[39] Katherine M. O'Regan and Ken Zimmerman, "HUD's Affirmatively Furthering Fair Housing Rule: A Contribution and Challenge to Equity Planning for Mixed Income Communities," in Mark Joseph and Amy T. Khare, eds., *What Works to Promote Inclusive, Equitable Mixed-Income Communities* (Cleveland: National Institute for Mixed Income, 2020).

[40] See Rachael W. Bostic and Brian J. Surette, "Have the Doors Opened Wider? Trends in Homeownership Rates by Race and Income, *Journal of Real Estate Finance and Economics* 23 (2001): 411–34; and US Census Bureau, "Quarterly Residential Vacancies and Home-ownership, Second Quarter 2023," Census Release Number: CB23-114, August 2, 2023, https://www.census.gov/housing/hvs/files/currenthvspress.pdf.

[41] Dan Immergluck, *Red Hot City: Housing, Race, and Exclusion in Twenty-First Century Atlanta* (Oakland: University of California Press, 2022).

[42] See Carlos F. Avenancio-León and Troup Howard, "The Assessment Gap: Racial Inequalities in Property Taxation," *Quarterly Journal of Economics* 137, no. 3 (2022): 1383–1434; K. Babe Howell, "The Costs of Broken Windows Policing: Twenty Years and Counting," *Cardozo Law Review* 37 (2015): 1059; and Stephen K. Rice and Michael D. White, eds., *Race, Ethnicity, and Policing: New and Essential Readings* (New York: NYU Press, 2010).

[43] Leah Rothstein and Richard Rothstein, *Just Action: How to Challenge Segregation Enacted Under the Color of Law* (New York: Liveright Publishing, 2023).

[44] See June L. Gin and Dorceta E. Taylor, "Movements, Neighborhood Change, and the Media: Newspaper Coverage of Anti-Gentrification Activity in the San Francisco Bay Area: 1995–2005," in *Environment and Social Justice: An International Perspective* (Leeds, UK: Emerald Group Publishing Limited, 2010), 75–114; and Ingrid Gould Ellen and Gerard Torrats-Espinosa, "Gentrification and Fair Housing: Does Gentrification Further Integration?," *Housing Policy Debate* 29, no. 5 (2019): 835–51.

by households of color and the neighborhoods in which they reside.[42] Today's anti-gentrification efforts counter the civil rights era's vision of integration by arguing for the continuity of extant social networks and form in situ.[43] But households of color stand to lose their homes in both processes. David Walker articulated the precariousness of Black and brown housing two centuries ago.[44]

Despite the expanded ability to realize and sustain property today compared to in Walker's time, homeownership is still—and possibly increasingly—untenable. Its value as a viable wealth-building tool is in question.[45] Bootstrap-ism and the financial security of homeownership have created an urgency among people of color to retain the scraps of wood and handfuls of nails onto which some of us have been able to or someday wish to hold. We might never dismantle the master's house with his tools, but we can certainly take some of the wood.[46]

DOORS

Era una vida en que dominaba la propiedad particular corta...porque constantemente se dividía por ventas o procesos de herencia que daban igual derecho a todos los hijos.
"It was a life dominated by short-term landholding...because (land) was constantly divided through sales or through inheritance norms that gave all offspring equal rights."
JOSÉ ANTONIO GUTIÉRREZ GUTIÉRREZ, my great granduncle, in *The Gutiérrez of Media Hanega in Jalostotitlán*, 1998[47]

During the Mexican Revolution, my maternal grandfather was offered a chance to come to the United States by visiting Jesuits. He declined, noting that he would probably learn "bad foreign ideas" here. But change

is always afoot in our ideas—including our idea of home. Media Hanega, our ancestral compound in the eastern part of Jalisco, where my grandfather grew up, was built with Spanish colonial wealth on Tecuexe soil with means and methods from both traditions.[48] My grandfather told me this story well after four of his children—along with almost half of the grandchildren from the children who remained—had made the trek

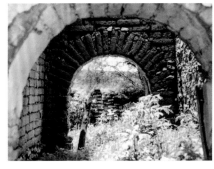

Media Hanega, ca. 2000

to the United States over the next century. To his dismay, my mother was among them, marrying a man who had left their town to work the fields of the American Southwest as part of the Bracero Program.[49]

The cliché that the United States is a nation of immigrants has much truth to it. International immigration and domestic migration have been dominant chapters in US history in many forms and to many ends: African enslavement, Native displacement, the Great Migration, and the movement of political refugees, victims of persecution, and fortune seekers from around the world. Immigrants, whether forced, coerced, compelled, or willing, are also visibly inscribed in our buildings, from the most historic to the mundane.[50] Migrants have factored into US housing in two very critical ways.

First, migration has shaped the demographic growth in household formation and in the consequent demand for homes across various regions over the last century.[51] This is particularly true for international immigration, with the movement of populations altering housing markets and transforming housing industries.[52] Migration patterns inform the evolution of local businesses, development patterns, and political organizing—factors that in turn influence housing supply. In the new immigrant gateways of the suburban South, for example, immigrants have had qualitatively different experiences than in the traditional immigrant magnets of central

[45] Christopher E. Herbert, Daniel T. McCue, and Rocio Sanchez-Moyano, "Is Homeownership Still an Effective Means of Building Wealth for Low-Income and Minority Households? (Was it Ever?)," Harvard Joint Center for Housing Studies, September 2013, https://www.jchs.harvard.edu/sites/default/files/hbtl-06.pdf.

[46] Audre Lorde, *The Master's Tools Will Never Dismantle the Master's House* (Penguin UK, 2018).

[47] J. A. Gutiérrez Gutiérrez, *Los Gutiérrez de la Media Hanega de Xalostotitlán* (Altos de Jalisco: Amigos de la Historia de los Altos de Jalisco, A.C., 1998).

[48] Carolyn Baus Reed Czitrom, *Tecuexes y cocas: dos grupos de la región Jalisco en el siglo XVI*, vol. 112 (Mexico City: Instituto Nacional de Antropología e Historia, Departamento de Investigaciones Históricas, 1982).

[49] Ernest Galarza, *Merchants of Labor: The Mexican Bracero Story: An Account of the Managed Migration of Mexican Farm Workers in California 1942–1960* (San Jose: Rosicrucian Press, 1964).

[50] See Mabel O. Wilson, *Thomas Jefferson, Architect: Palladian Models, Democratic Principles, and the Conflict of Ideals* (New Haven: Yale University Press, 2019); and Carlos Martín, "The Most Common of Buildings: The Design and Construction of US Homes and the Households That Occupy Them," *Cityscape* 16, no. 2 (2014): 3–10, https://www.huduser.gov/portal/periodicals/cityscpe/vol16num2/guest.pdf.

[51] See Riordan Frost, "Local Population Growth Dependent on Migration and Immigration in 2022," Harvard Joint Center for Housing Studies Blog, September 1, 2023, https://www.jchs.harvard.edu/blog/local-population-growth-dependent-migration-and-immigration-2022-0; and Dowell Myers and John R. Pitkin, "Immigrant Contributions to Housing Demand in the United States: A Comparison of Recent Decades and Projections to 2020 for the States and Nation," *Research Institute for Housing America Research Paper* 13, no. 1, March 26, 2013.

[52] See Rocio Sanchez-Moyano, "Geography and Hispanic Homeownership: A Review of the Literature," *Journal of Housing and the Built Environment* 36 (2021): 215–40; and Sharon Cornelissen and Livesey Pack, "Immigrants' Access to Homeownership in the United States: A Review of Barriers, Discrimination, and Opportunities," Harvard Joint Center for Housing Studies Report, July 25, 2023, https://www.jchs.harvard.edu/research-areas/working-papers/immigrants-access-homeownership-united-states-review-barriers.

HOME(BE)COMING

[53] See Audrey Singer et al., *Twenty-First Century Gateways: Immigrant Incorporation in Suburban America* (Washington, DC: Brookings Institution Press, 2008).

[54] John Arroyo, "Facades of Fear," *Cityscape* 23, no. 2 (2021): 181–206.

[55] See Gordon H. Chang and Shelley Fisher Fishkin, eds., *The Chinese and the Iron Road: Building the Transcontinental Railroad* (Redwood City, CA: Stanford University Press, 2019); David Weitzman, *Skywalkers: Mohawk Ironworkers Build the City* (Sardinia, OH: Flashpoint Publications, 2014); Carlos Martín. "Building America: The Immigrant Construction Workforce," Urban Institute Blog, November 14, 2016, https://www.urban.org/urban-wire/building-america-immigrant-construction-workforce-0; and Jacqueline Hagan, Ruben Hernández-León, and Jean-Luc Demonsant, *Skills of the Unskilled: Work and Mobility among Mexican Migrants* (Oakland: University of California Press, 2015).

[56] James T. Rojas, "Los Angeles: The Enacted Environment of East Los Angeles," *Places* 8, no. 3 (1993).

[57] Carlos Martín, "Global Constructions, or Why Guadalajara Wants a Home Depot While Los Angeles Wants Construction Workers," in *The Green Braid: Towards an Architecture of Ecology, Economy and Equity*, ed. Kim Tanzer and Rafael Longoria (New York: Routledge, 2007), 359–68.

[58] Riordan Frost, "Did More People Move During the Pandemic?," Harvard Joint Center for Housing Studies Research Brief, March 14, 2023, https://www.jchs.harvard.edu/sites/default/files/research/files/harvard_jchs_pandemic_mobility_frost_2023.pdf.

urban areas of major US metropolises.[53] There, they have settled in homes and built businesses in buildings indistinct from their neighboring subdivisions and strip malls. But housing involves a set of controls that have also been used in these places to restrict access to newcomers during years of backlash against their presence.[54]

A second profound transformation that migration and mobility have on housing is formal—that is, the qualitative but significant ways migrants have shaped the housing cultures, aesthetics, and use of the places that receive them. This includes actually shaping places. Migrants have built the United States, from Chinese rail workers and the Mohawk "skywalkers" to the undocumented Latino workers who work on home construction sites across the country today.[55] These same groups shape their material surroundings. The architecture and construction of their native lands have informed alternative norms about the functions and form of homes, from front yard vending to kitchens as the central hearth.[56] This process also means that the places of origin change; when possible, immigrants have exported American construction techniques and home planning principles to their homelands.[57] We, figuratively, have been taking wood from one place to another.

Migration and mobility patterns, however, have changed dramatically from those of the nineteenth and twentieth centuries. Global immigration flows to the United States have become trickles in the Donald Trump era and domestic migration is playing a more noticeable role in local housing. The COVID-19 pandemic lockdowns did not produce a predicted movement of white-collar workers seeking the promise of teleworking from secluded forests. Rather, the lack of available and affordable housing has forced all but a few to stay put, continuing a decades-long pattern of immobility.[58] Historically, domestic migration blurred regional design, with the New England family looking for a Southwestern colonial, the empty nesters looking for a postmodern pied-à-terre. But demographic trends could make these lines more rigid again. Reducing population growth and mobility may shape the geography of housing and housing design in

unprecedented ways by encouraging new vernaculars and enforcing local solutions to housing needs. This stasis may just be the quiet before the storm.

WINDOWS

En algún lugar de un gran país
Olvidaron construir
Un hogar donde no queme el sol
Y al nacer no hay que morir.
"Somewhere in a great country
they forgot to build
a home where the sun may not burn
and when you are born, you do not have to die."
DUNCAN DHU, "En algún lugar," 1987

<div style="float: right; writing-mode: vertical-rl;">BELONGING</div>

Our homes shape and are shaped by environmental elements: soil and land, water, natural resources, flora and fauna. US housing development alone has bulldozed land at a recent rate of one million acres a year, particularly through low-density sprawl.[59] Housing has endangered plants and animals. It consumes tons of water and releases tons of wastewater annually, not to mention the mass extraction of minerals, lumber, metals, and fossil-fuel- based plastics used to build homes over the last several centuries. By one estimate, eight thousand pounds of construction waste are produced when constructing the average home.[60]

One element may be contemporary US housing's greatest Frankenstein: climate. Homes produce 15 percent of our country's greenhouse gas emissions.[61] Our nation's housing alone emits more than the total emissions from all sectors for all but four other countries.[62] Numerous efforts are underfoot to electrify homes and make them more energy efficient, a daunting task that requires changes in housing policies, practices, and behaviors.[63] But, the current so-called culture wars have already hit homes where it hurts: the kitchen. The mere suggestion in 2023 of exploring the health implications from combusting natural gas for cooking became fodder among unwitting Patrick Henrys for our nation's appliances.[64]

[59] Edward L. Glaeser and Matthew E. Kahn, "Sprawl and Urban Growth," in *Handbook of Regional and Urban Economics*, vol. 4 (New York: Elsevier, 2004).

[60] Peter Yost and Eric Lund, "Residential Construction Waste Management: A Builder's Field Guide," NAHB Research Center (1997), https://p2infohouse.org/ref/11/10171.pdf.

[61] H. Estiri, "Household Energy Consumption and Housing Choice in the U.S. Residential Sector," *Housing Policy Debate* 26, no. 1 (2016): 231–50.

[62] US Environmental Protection Agency, "Inventory of U.S. Greenhouse Gas Emissions and Sinks: 1990–2021," 2023, https://www.epa.gov/ghgemissions/inventory-us-greenhouse-gas-emissions-andsinks-1990-2021.

[63] See American Council for an Energy Efficient Economy, "Residential Retrofits for Energy Equity," 2023, https://www.aceee.org/r2e2-resources; Ines Lima Azevedo et al., "Reducing U.S. Residential Energy Use and CO2 Emissions: How Much, How Soon, and at What Cost?," *Environmental Science & Technology* 47, no. 6 (2013): 2502–11; and Carlos Martín, "Exploring Climate Change in US Housing Policy," *Housing Policy Debate* 32, no. 1 (2022): 1–13.

[64] Bess Levin, "GOP Rep. Ronny Jackson Throws Ridiculous Shit Fit Over the Prospect of Losing Gas Stove," *Vanity Fair*, January 10, 2023, https://www.vanityfair.com/news/2023/01/ronny-jackson-gas-stoves; Nik Popli, "How Gas Stoves Became the Latest Right-Wing Cause in the Culture Wars," *Time*, January 14, 2023, https://time.com/6247293/gas-stoves-right-wing-memes/; and Tanya Lewis, "The Health Risks of Gas Stoves Explained," *Scientific American*, January 19, 2023, https://www.scientificamerican.com/article/the-health-risks-of-gas-stoves-explained/.

[65] Mary C. Comerio, *Disaster Hits Home: New Policy for Urban Housing Recovery* (Berkeley: University of California Press, 1998).

[66] Carlos Martín, C. "Understanding U.S. Housing Data in Relation to the 2017 Disasters," *Natural Hazards Review* 20, no. 3 (2019).

[67] Shannon Van Zandt et al., "Mapping Social Vulnerability to Enhance Housing and Neighborhood Resilience," *Housing Policy Debate* 22, no. 1 (2012): 29–55.

[68] Elizabeth Fussell, Narayan Sastry, and Mark VanLandingham, "Race, Socioeconomic Status, and Return Migration to New Orleans after Hurricane Katrina," *Population and Environment* 31, nos. 1–3 (2010): 20–42.

[69] See Susan Julius et al., "Built Environment, Urban Systems, and Cities," in D. R. Reidmiller et al., eds., *Impacts, Risks, and Adaptation in the United States: Fourth National Climate Assessment vol. 2,* (Washington, DC: US Global Change Research Program, 2018), 438–78.; Carolyn Kousky et. al., "Flood Risk and the U.S. Housing Market," *Journal of Housing Research* 29 (2020); American Planning Association, "Hazard Mitigation Policy Guide," 2020, https://planning-org-uploaded-media.s3.amazonaws.com/publication/download_pdf/hazard-mitigation-policy-guide.pdf; Insurance Institute for Business and Home Safety, "Home Disaster Guides" (2023), https://ibhs.org/guidance/homedisasterguides/; Gail Cooper, *Air Conditioning America: Engineers and the Control of the Environment* (Baltimore, MD: Johns Hopkins University Press, 1998).

[70] Caroline M. Kraan et al., "Promoting Equity in Retreat through Voluntary Property Buyout Programs," *Journal of Environmental Studies and Sciences* 11, no. 3 (2021): 481–92; and Lynée Turek-Hankins, Miyuki Hino, and Katharine J. Mach, "Risk Screening Methods for Extreme Heat: Implications for Equity-Oriented Adaptation," *PLOS ONE* 15, no. 11 (2020).

Our homes are also a target of climate change.[65] Horrifying evidence surfaces in the aftermath of hurricanes, tornadoes, and wildfires. Disasters force people to evacuate and seek temporary—and in some cases ongoing—shelter. Owners look to repair home damages soon after, while communities look to replace losses in local housing affordability in the long term.[66] Similar but slower-moving changes to our home environments are also occurring. Heatwaves, "sunny day" flooding often associated with sea-level rise, and droughts cast new doubts on our homes' primary function as shelter, a protection from the elements, which, in this case, are of our own creation. Well before the milestone events of Hurricane Katrina and well after Hurricane Maria, these disasters have reduced housing options for already disadvantaged households, further dividing the housing haves from the housing have-nots.[67]

These conditions have induced mass displacement in the past.[68] But they have also elicited a distinctly American response: the technological fix. We have mitigated hazards—partially—through numerous strategies. Protective infrastructure and geoengineered development have secured whole regions. Home hazard insurance and advanced building techniques have secured individual homes, including home elevations, "fireproofing," tornado rooms, and that most blessed of American inventions, air conditioning.[69] Innovations can defer chaos, buying time for rational and equitable transitions for households, their properties, and even whole communities and their cultures.[70] A new but prolonged and widespread dust bowl is upon us. But, this time, the clock continues to tick and there is no place to run. Displacement in all its forms will happen, internally and across borders and oceans. The abandoned home in one place leads to the need for a home in another, the elevated and reinforced home buying time. If we are all stewards of the commons, whither my house?

ROOFS

Tengo miedo del encuentro con el pasado que vuelve
A enfrentarse con mi vida.
Tengo miedo de las noches que pobladas de recuerdos
Encadenen mi soñar.
Pero el viajero que huye
Tarde o temprano detiene su andar.
"I fear encountering the past that comes back
To confront my life.
I fear the nights filled with memories that
Chain my dreams.
But the traveler who flees
Sooner or later halts his journey."
CARLOS GARDEL AND ALFREDO LE PERA, "Volver," 1934

I just spent months searching for a new home for my family—in my case, my husband, our rescue dog, and me. We are moving into that home as I write this, after decades of having occupied the same building. I know this move is less traumatic than most, less memory laden than my father's last move, and less life altering than my parents' move over sixty years ago. The search was exhausting, nonetheless. My weariness has come less from physically moving my stuff from one place to another, to paraphrase the comedian George Carlin, but from acknowledging the tensions that exist in how we conceive of our homes in the United States.

Homes are meant to be our shelter. They protect us, our families, and our possessions. Homes conjure images of security, belonging, and stability. But they are also manifestations of change. We are not, on the whole, a country of homes occupied by multiple generations. We emphasize moving out and moving up in our popular culture. Our homes mirror our wealth and social aspirations.

Leaving one home for another reminds us that we are always searching in the United States, even when that search is for an imagined home. I now understand. I am still searching for home. And I am still coming home.

BELONGING

BRIAN ADAMS

HOME

BRIAN ADAMS is an editorial and commercial photographer based in Anchorage, Alaska, specializing in environmental portraiture. His work has been featured in both national and international publications, and his work documenting Alaskan Native villages has been showcased in galleries across the United States and Europe. He is the author of the photography books *I Am Alaskan* (2013) and *I Am Inuit* (2017). In 2018, he received a National Artist Fellowship from the Native Arts and Cultures Foundation, and he was awarded a Project Award from the Rasmuson Foundation in 2023 to continue his work on documenting Inuit life in Alaska and the circumpolar region.

I make a lot of pictures at home—of my kids playing outside, the kettle on the stove, and the bunny graveyard on the side of our house. I have a poor short-term memory and am a visual thinker, so I make photographs of these scenes as often as possible. It's okay if the pictures are not perfect, because our memories are also not perfect. My kids appreciate it; they have inherited a penchant for nostalgia from both their mother and myself.

Alaska, in the bigger sense, is my home, and I try to bring a similar sensitivity and work ethic to my fieldwork by valuing what is in front of me as the work of documenting

for the sake of the historical record and collective memory. Whether I am at the top of the world in Utqiagvik, Alaska, documenting the butchering of a whale, or bird-watching on the Aleutian Islands (which extend off mainland Alaska, separating the Bering Sea and the Pacific Ocean), I feel at home. I want to preserve these moments in time in some way. Home, to me, is not about ownership, but about stewardship and continuing the work of the generations before me who respected the land they lived on. I'm contributing to the collective photo album of a place I love and want to remember.

Below: Polar bear fur drying outside a home, Point Hope, Alaska, 2013

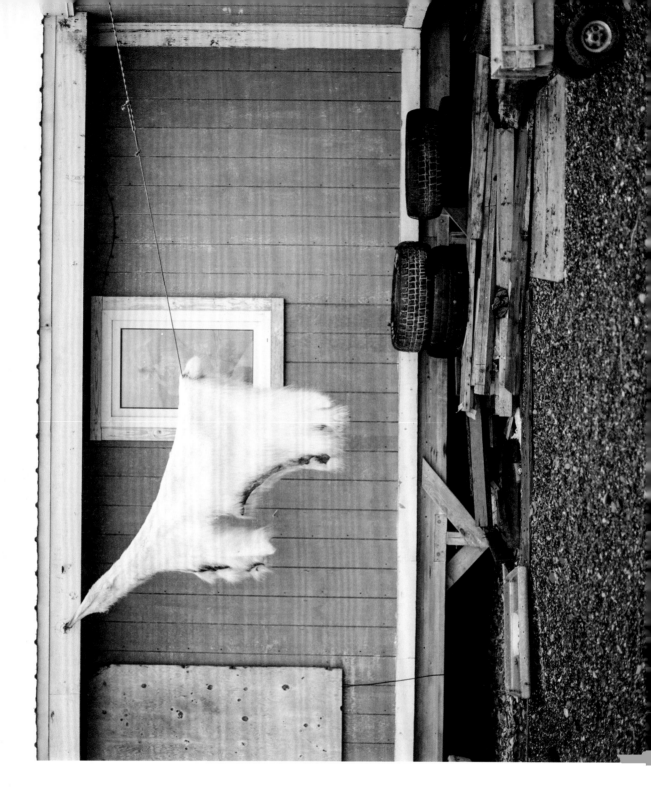

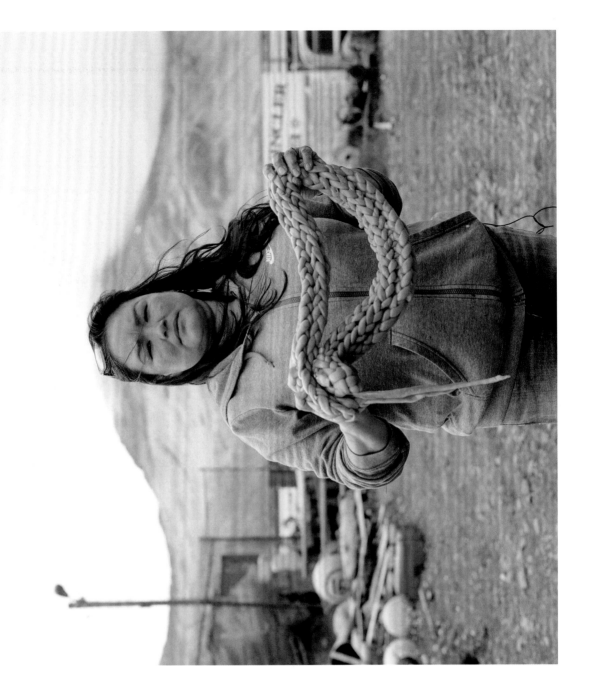

Josephine Shangin with a braided seal intestine, Akutan, Alaska, June 2022

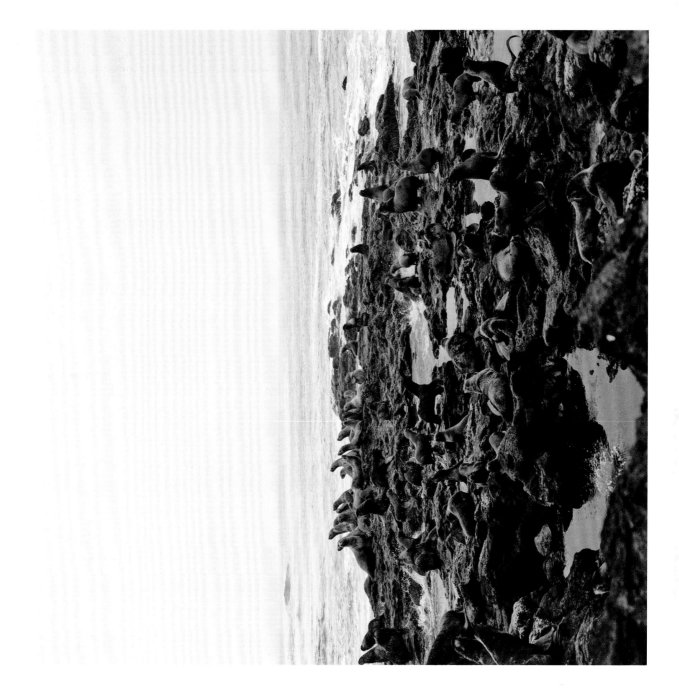

Northern fur seals on the coast, St. Paul, Alaska, 2023

Above: Moth on the front-door window, Anchorage, Alaska, 2023. Below: Home, Anchorage, Alaska, 2019

4th of July, Naknek, Alaska, July 2019

42

4th of July, Naknek, Alaska, July 2019

4th of July, Naknek, Alaska, July 2019

4th of July, Naknek, Alaska, July 2019

4th of July, Naknek, Alaska, July 2019

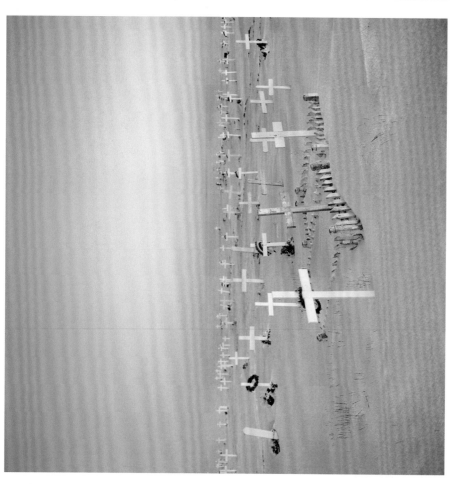

Left: Cemetery, Utqiaġvik, Alaska, 2019. Right: Children watching others play baseball in the street, Kivalina, Alaska, March 2021

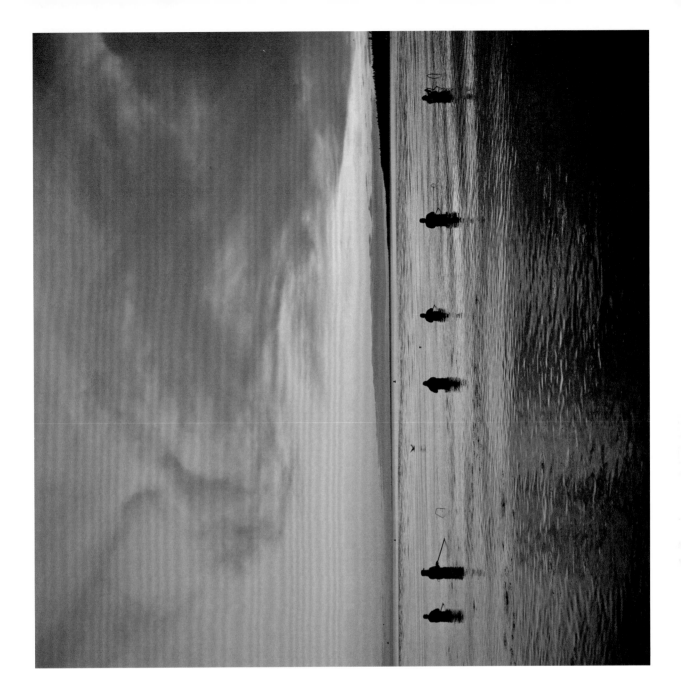

Dipnetters fishing for salmon at the mouth of the Kasilof River, Alaska, 2023

Bruce standing outside of a houseboat he built with a friend, Anchorage, Alaska, October 2023

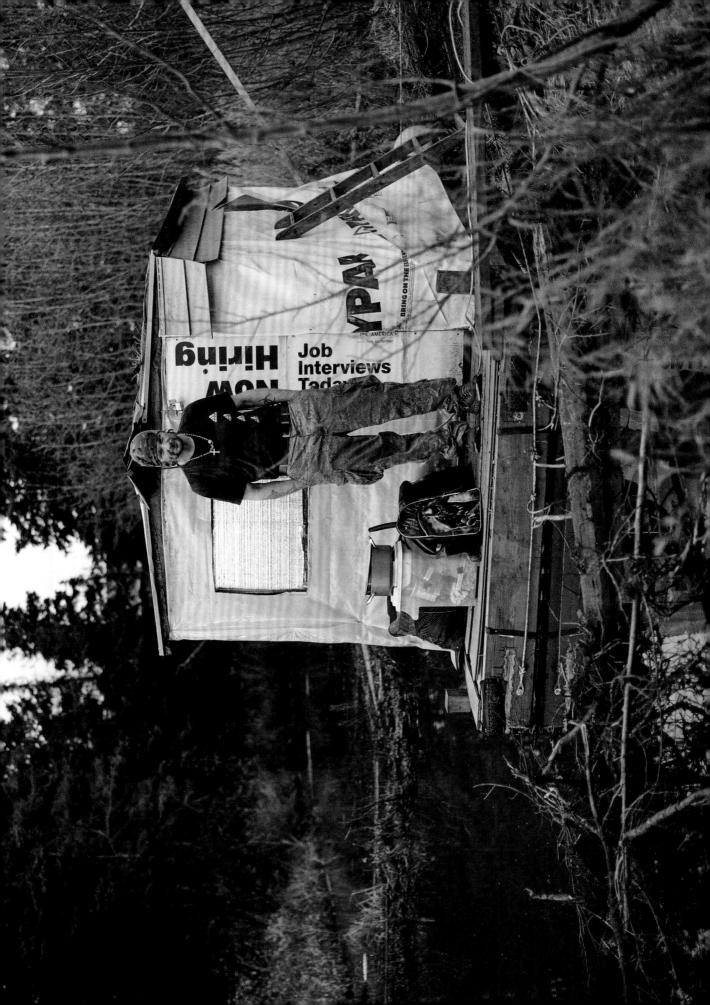

\mathscr{A} ROOM TO SIMPLY, BE

BELONGING

Prior to buying my house years ago, I used to have a recurring dream that would begin with me walking alone through an old house that was in a state of disrepair. In the dream it is clear I have just purchased the house and, after I am handed the keys, I stroll through, assessing the space I am about to make home. Occasionally I stop to make mental notes of the things I will need to fix or change—a cracked windowpane; peeling paint; stained, outdated wallpaper; a missing doorknob.

RENÉE STOUT grew up in Pittsburgh, Pennsylvania, and received her BFA from Carnegie Mellon, where she majored in painting. Upon moving to Washington, DC, in 1985, she began to focus on mixed-media sculpture, and eventually became the first American artist to exhibit in the Smithsonian's National Museum of African Art.

I take in the space while I simultaneously move about it, observing myself, as if hovering outside my body. The most satisfying thing about the dream is the look of contentment on my face as I think to myself, "It's not perfect, and there's so much work to be done, but it's *mine*."

As the dream continues, I get so excited about the prospect of transforming the space and making it my own that I take a few more rounds. Suddenly, I come upon a closed door that I have not noticed before. I stand in front of it, feeling a combination of anxiety and exhilaration as I reach out and turn the knob. I open the door to discover three or four more large rooms that I did not know existed.

This is always the point when I would wake up.

I purchased my house in 1999 as a fixer-upper nobody wanted in a neglected neighborhood. My parents came from Pittsburgh to attend the closing. I held the keys in my hand as we walked through the house together. It was not perfect; plaster had fallen from the ceilings, some floors and windows were slanted, and the rooms were too small (the largest, 16 by 14 feet, would have to work as my "studio"), but it was *mine*. The contentment on my father's face mirrored mine as

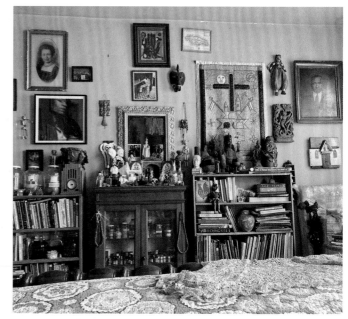

In her creative process, Stout created an alter ego named Fatima Mayfield—a seer, herbalist, and spiritual advisor—who has become an ongoing protagonist in her work. There is a room in her house and studio that features dried herbs in jars, fragrant oils, sequined Voodoo flags, Kongo power figures, hand-painted Russian icons, and other spiritual objects. The room serves as an environment for Fatima to research herbs, compose remedies, or simply sit as the spirits of Ancestors whisper to her.

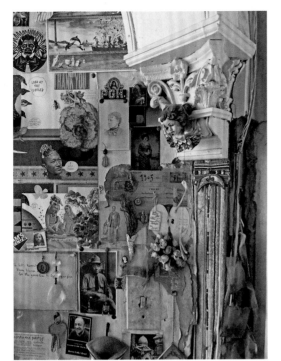

Near the front door, Stout created a wall collage that she has built over the years. The collage features favorite gallery announcements from various artists' shows, antique tintype and sepia-toned photographs, and an assortment of talismans, such as *milagros* and a collection of dried wishbones.

he said to me, "You need this house, and it needs you."

I recall the general feeling of economic optimism of the time that enabled me to imagine I would eventually sell enough artwork to restore this now 118-year-old Victorian row house to its former stateliness. It seemed that everything was possible. I envisioned removing a couple of walls and opening the space up so I could work. I could just see it! But, in the meantime, I would work with what I had to make a space of comfort, solace, and creativity, a place to entertain family and friends, a cocoon for an introverted homebody to recharge.

Over the years, I could still hear my father saying "it needs you," and the house became more than just bricks and mortar, concrete, plaster, and wood; it was an entity that enveloped me and kept me safe and warm. It became an extension of me, and I felt a responsibility to bring it out of disrepair. I assumed this would be my forever home.

But, times change, political administrations change, a pandemic ensues, economies fluctuate, neighbors move, and we change.

Back in 1999, no one could have told me that it was possible for time to move backward, or that everyday hard-working people who had "pulled themselves up by their bootstraps" would become downwardly mobile—by design. Or that each time we succeeded in making the playing field just a little bit more level, someone would be there to move the goal posts. All systems seem to be breaking down, and the optimism I once felt has all but disappeared. What country are we in again? I do not recognize this place.

Two and a half decades later, the walls of the house are still where they have always been, there are no expansive spaces to spread out in, and no extra rooms have magically appeared. Gentrification has made me feel less safe, because the new neighbors are not as warm or caring. The energy in this row of houses has shifted. Suddenly, I feel claustrophobic, like a hermit crab in need of a new shell. I feel as if I am in a state of limbo as I search for a space that will fit with how I have grown, creatively and spiritually.

But I struggle with the question: should I stay or go? I love my house. I have had so many experiences here; the walls remember

all who have passed through. All the signs are telling me it is time to move on, but I feel like I am betraying a loyal friend. This house once needed me, but now it needs someone else who has the resources to restore it. She deserves to be grand again.

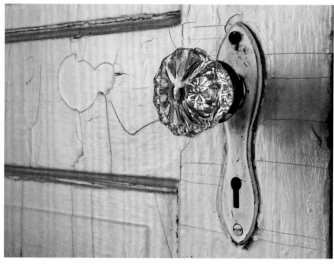

A few doors around the interior of Stout's house have knobs that look like huge diamonds. The elegance of the knobs is a stark contrast to the layers of paint, now brittle and cracked, that have been applied by previous inhabitants over the decades. Sometimes Stout ponders those surfaces and imagines the people before her who made this space a home.

The uncertainty feels all-consuming, and it overwhelms me at times. But in wistful moments of quiet reflection, I am reminded that I am privileged to already have a home to leverage for the next one—even if the next one, to be "move-in ready" and less precarious, will require huge compromises and downsizing. Finding such a home is not an easy task in one of the worst housing markets in decades. The American Dream is a carrot on a stick.

My thoughts drift to the hundreds of perpetually homeless people I see in tents as I move about Washington, DC. I cannot make sense of this situation, of these conditions existing in one of the wealthiest countries on this planet. I hear the stories of couples and young people who cannot afford to buy first homes, and of young women who find that ownership of a home and control of their very own bodies are increasingly denied.

As a coping mechanism, I escape to my parallel universe, a space in my imagination where we all crave beauty and believe everyone should be surrounded by it. In this rich interior world, the word "exclusive" and the concept it represents have been stricken from language and human consciousness, because caviar does not taste sublime just because someone else cannot have it. In my universe, opulence abounds, and every human being has a space to call their own where they can shut out the chaos and madness of lesser-evolved worlds to simply and peacefully *be*.

THE ARCHITECTURE OF REENTRY

For those in the United States systematically targeted by mass incarceration, the idea of home can prove not only to be elusive, but also in most cases, extremely challenging to achieve. The US's prison system is, by design, driven not by the desire for public safety, but as a for-profit system targeting people of color and those living under or below the poverty line. For every $100 an American pays in taxes, $32.50 goes toward paying for incarceration. By comparison, only $14.12 is allotted to much-needed healthcare services.[1] The US not only incarcerates its citizens at a rate far higher than that of any other country in the world, but it also claims some of the highest recidivism rates in the world. Within their first year of release, 43 percent of formerly incarcerated individuals return to prison; 70 percent return to prison within five years.[2]

Designing Justice + Designing Spaces believes that ending mass incarceration is the defining public safety, health, and civil rights issue of our time—a deep-seated challenge created by centuries of harmful policies and infrastructure. We believe that when communities are resourced with infrastructure that creates access to healthcare, healthy food, safe housing, education, and jobs, they can begin to interrupt cycles of systemic harm. We want to radically imagine how architecture and design can be used as a new tool in the abolition of prisons, jails, juvenile detention centers, and other spaces of confinement. One of the first questions that comes up when beginning to think about undoing centuries of racism through the built environment is, What do we build instead?

We are on a journey to build spaces rooted in care and dignity. Communities should have access to spaces that care for the body, lift the spirit, and support individuals' emotional well-being. This design ethos is the foundation of Designing Justice + Designing Spaces. Housing is the first critical step to reentry and a key factor to ending mass incarceration. It also proves to be one of the most complex. Reentry housing that provides

DESIGNING JUSTICE + DESIGNING SPACES is a design firm with the vision of building a world without prisons and jails. Its mission is to build infrastructure rooted in dignity and care to replace the architecture of the criminal legal system, particularly for BIPOC communities most impacted by mass incarceration.

BELONGING

[1] "At What Cost? Examining Police, Sheriff, and Jail Budgets across the US," National Equity Atlas, https://nationalequityatlas.org/us-carceral-spending/dashboard.
[2] Lucius Couloute, "Nowhere to Go: Homelessness among Formerly Incarcerated People," Prison Policy Initiative, August 2018, accessed August 23, 2024, https://www.prisonpolicy.org/reports/housing.html.

access to job training, education, mental health support, and a place to rest—all in one location—is challenging to build.

Designing Justice + Designing Spaces presents the Mobile Refuge Room, a project born out of the need for rehabilitative housing with increased safety, dignity, and privacy. Paired with the ideal service provider, the Mobile Refuge Room represents a unique opportunity to provide trauma-informed care and temporary living spaces.

In 2019, as part of our community engagement process, Designing Justice + Designing Spaces forged a partnership with the following organizations in Oakland, California, to design and fabricate the Mobile Refuge Room prototype: Restoring Oakland Communities (ROC) at Laney College, an academic support program run by and for formerly incarcerated students; FAB City, a global sustainability initiative; and Elevator Works, a local co-working space.

The process of developing the design concept involved a one-day workshop that engaged formerly incarcerated ROC students, all of whom were positioned as the experts to build full-scale cardboard mock-ups of the Mobile Refuge Room. Designing Justice + Designing Spaces selected, trained, and hired two ROC students to help fabricate two Mobile Refuge Room prototypes. The students managed all necessary manual and digital machinery for fabrication, including 3D modeling software, CNC routing programmed laser cutting, and assembly.

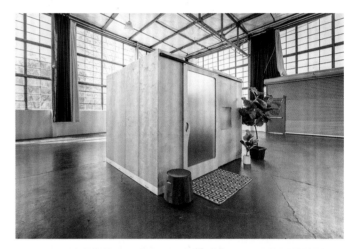

The Mobile Refuge Rooms are designed for ease of transport, optimizing durability and universality to accommodate multiple users while ensuring privacy and dignity. To support opportunities for socialization, a cluster of multiple Mobile Refuge Room units can be arranged in a variety of spatial configurations. Each room includes essential furniture components and can be

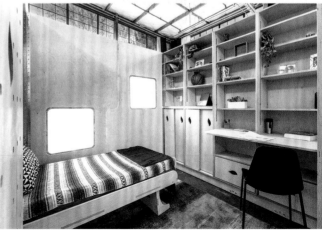

Top: Exterior of a Mobile Refuge Room, 2024. Bottom: Shelves, desk, and a Murphy bed in the interior of a Mobile Refuge Room, 2024

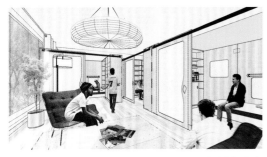

Rendering of a lounge space within a cluster of Mobile Refuge Rooms, 2018

personalized to reflect an individual's experience, age, and gender expression. The rooms offer a level of agency that is generally unavailable to incarcerated individuals and is crucial for emotional well-being.

Treetop, a workshop participant and student fabricator, said of the Mobile Refuge Room: "This by far is the most humane place; I could imagine walking into [this] place and being a part of society. It shows that someone spent some money on me and invested in me. I would want to stay there and follow the rules because wherever else I would go wouldn't be as nice."

The rooms are designed for interior use in both existing and new buildings. These spaces ideally feature wide-span truss structures and minimal columns with ample natural light from new or existing windows and skylights. Using basic tools, a minimum of two people can efficiently assemble the Mobile Refuge Room's modular components to create a private "room within a room." With careful planning, the rooms could also fit into smaller spaces as long as safe and sufficient circulation is ensured.

A large space and mission-aligned service providers are crucial to the success of the Mobile Refuge Room as a sustainable, restorative alternative to support returning citizens. Local governments are particularly well positioned to invest in restorative justice infrastructure that could lower recidivism rates, increase revenue from employment, and lower costs associated with healthcare, homelessness, and incarceration.

The fabrication of the Mobile Refuge Rooms also presents opportunities to navigate workforce development as social enterprises. Formerly incarcerated individuals can obtain living-wage jobs in manufacturing the Mobile Refuge Rooms by learning full-scale fabrication, distribution, and on-site installation while continuing to inform the design of the unit. Working within a community-driven model that is trauma informed and flexible to the needs of its members, we can create new iterations and modifications that can be implemented for improved versions to go to market quickly. Ultimately, a worker-owned cooperative model could offer a pathway to long-term agency and ownership.

Designing Justice + Designing Spaces is proposing a radical and concrete way to change the built environment as a catalyst for social justice. Community feedback is needed to develop these Mobile Refuge Room units in collaboration with mission-aligned program partners to replace prisons with spaces of care.

KILLING BIRDSONG

BELONGING

If you had wandered around the Iraqi city of Fallujah in the winter of 2004, you would have seen what happens when a city is ravaged by bombs. You would have seen the miles of rubble made from the 70 percent of the city's homes that were damaged or destroyed. The wreckage would also contain the remnants of at least one-hundred mosques, six-thousand businesses, and nine government offices.[1] These buildings were destroyed by US-made and US-driven tanks and bombs.

Fallujah has not recovered, and neither have its residents. Twenty years is not enough time to rebuild and repair devastation on this scale. Meanwhile, outside Iraq, the US leaders who claimed these acts were justified by the existence of weapons of mass destruction (which turned out not to exist) have continued on with their careers. Outside Iraq, there are no consequences for this destruction.

After October 2023, I began working with the team at SITU Research to find homes that had been destroyed in Gaza—a search that quickly expanded to Pakistan, Yemen, Iraq, Libya, Afghanistan, and other countries where US weapons have contributed to the destruction of housing. I was learning about domicide. To understand more about the meaning of this word, and about what accountability looks like, Brad Samuels from SITU Research and I spoke with the UN special rapporteur on the right to housing, Balakrishnan Rajagopal. —MONA CHALABI

MONA CHALABI is an award-winning writer and illustrator. Using words, color, and sound, she rehumanizes data to help us understand our world and the way we live in it. Her work has earned her a Pulitzer Prize, a fellowship at the British Science Association, an Emmy nomination, and recognition from the Royal Statistical Society.

BALAKRISHNAN RAJAGOPAL is associate professor of Law and Development at the Department of Urban Studies and Planning and the UN special rapporteur on the right to adequate housing. He founded both the Program on Human Rights and Justice at the Massachusetts Institute of Technology and the Displacement Research and Action Network.

BRAD SAMUELS is a founding partner at SITU Research, a visual investigations practice focused on merging data and design to create new pathways for justice and accountability. Samuels has overseen SITU's work with legal and advocacy organizations including the International Criminal Court, Human Rights Watch, Amnesty International, the United Nations, and many others.

MONA CHALABI What led you to housing as an area of focus?

BALAKRISHNAN RAJAGOPAL I am from India. One of the major issues when I was a young student was India's large-scale infrastructure projects, like dams which ended up displacing hundreds of thousands of people, resulting in the destruction and submergence of their homes. They would often end up as displaced people wandering the country and then later as the urban poor in many of the emerging cities. As a student in India, I became very engaged with issues like this.

I began to ask, Why isn't mass destruction of housing treated as a bigger wrong globally? By talking to people who lost their homes, it began to dawn on me that the emotional, psychological, and cultural connections they have, not just with the land but with the landscape of the territory

that they are living on, is much more than simply four walls, or a roof, or even a neighborhood. It's something that connects them with the area where they live. And they deeply, deeply miss it. Since then, I've been researching the loss of homes and the displacement of communities, either due to major development projects or because of conflict and violence, such as the wars in Gaza. And thirdly, because of increasing risks due to climate change. These three factors are driving mass displacement and loss of housing around the world.

CHALABI You're describing those early experiences of witnessing the destruction of housing. Was "domicide" part of your vocabulary back then?

RAJAGOPAL No, it was not. This was in the 1990s. One of the first publications using the term "domicide" was actually by two Canadian scholars who were studying people massively affected by dam projects.[2] I've been familiar with the term for many years. But armed conflict is not a context in which domicide has been put forward so far. No one with an international law background has called for its recognition as a crime under international law. I was the first one to do it.

CHALABI Why do you think no legal professionals have come forward with that language?

RAJAGOPAL I think it shows many of the biases that exist among the legal elite about what they think matters. Part of the problem is that a lot of legal professionals come from elite backgrounds, where the idea of having a home is not a big deal. It's like having air to breathe—it just exists. For example, I don't face the risk of eviction;

my home won't get destroyed, either by a bulldozer showing up or because of a bomb or a drone from the sky. We are living in privileged circumstances. And I think that's probably a bias of the privileged, that having a home is not something you think about as a human right.

CHALABI Perhaps this thinking also comes from those who do not necessarily have their identity tied to the land that their home sits on.

RAJAGOPAL Exactly. There has long been a criticism that the international law we have right now is largely the result of colonialism and imperialism. There is a Western bias in international law. This was a major theme for newly independent countries from the Global South, that the international law they were being told to adhere to was not something of their own creation but came because of rules and regulations set up by the Western countries in their own interest. So part of the bias in international law has to do with its Western origins and its class-based origins of privileged elites using international law to defend their own interests.

CHALABI Language has been really key to that. What is the definition of domicide that you're principally working with here?

RAJAGOPAL Language *is* critical. Domicide, basically, is the mass destruction of housing, in its factual elements. But whether domicide can turn out to be a particular crime under international law depends on many other factors. For example, how widespread or systematic is it? Who is committing the destruction? And what is their intention when they commit the destruction?

The concept of domicide is not about individual home demolitions. Those

happen all around the world; they happen not only in war zones or conflict zones but everywhere, even in peacetimes, in fact, as part of city planning and development.

I wanted to be able to capture the variety of different forms of loss of housing by using the term "domicide" to indicate mass destruction of a neighborhood during a war, as, for example, in Afghanistan, or Iraq, or Gaza now; it could very well be a war crime, when there is no justification for use of force. But it could also be genocide, as what we are witnessing in Gaza, when the destruction is of such a magnitude that it renders a territory uninhabitable for the people and erases the ability for these people to exist as a group. Then it is covered under Article II of the Genocide Convention. All this is happening around the world, and we need to be able to speak about the loss of housing, community, and land. But not a single court has found mass destruction of housing to amount to genocide so far, starting from World War II jurisprudence after the Nuremberg tribunals. It will be a new thing.

BRAD SAMUELS In terms of mass versus individual homes, does that feel like an essential characteristic of what you're arguing for?

RAJAGOPAL Just to clarify, whether it's a mass destruction of housing or an individual home that is destroyed, they're both violations of international law. The individual home destruction is a human rights violation. But we do have an odd situation, particularly in the context of a conflict like Gaza, when it comes to individual homes. They, in theory, enjoy a certain minimum level of protection under the Geneva Conventions, in that if you're a military commander making a decision about launching a drone or dropping a bomb, then you have to choose the exact GPS location of where you're going to do it.

Suppose you've done that proportionality analysis. And you're convinced that the target is worth causing all those losses of lives and the destruction of the house; then you drop a bomb. If you're dropping a 2,000-pound bomb, it's not going to affect only a single house but will also wipe out an entire neighborhood. And if the only justification for that is that there is one Hamas commander who is hiding under one house, but you don't know exactly which one, that, to me, is domicide, and it is not acceptable. Increasingly, unfortunately, we have armies using disastrous weapons—explosives that basically explode a few hundred feet above the surface and drop bomblets all around the neighborhood. Many go off, but many do not. The whole area becomes unsuitable, and this was used a whole lot in Iraq.

SAMUELS Could it be that the term "indiscriminate" creates a potential loophole, allowing military actions that destroy homes to be seen as intentional and targeted, rather than indiscriminate, once they pass the threshold of proportionality?

RAJAGOPAL To be lawful, you know, a use of force that results in destruction of housing, or destruction of lives for that matter, doesn't have to be discriminate or indiscriminate. It depends on proportionality and necessity. Proportionality is about whether the harm that you're causing is proportional to the military advantage that you expect to gain. And necessity is about whether that particular use of force is necessary to achieve your objective. So, the first one is about collateral damage, and the second one is about whether the target or the particular use of force is necessary to achieve the military goal that you expect to achieve by eliminating the target.

For example, if you destroy a whole bunch of water wells or a desalination plant, or you engage in destruction of agricultural fields, is it necessary for you to do that to achieve your objective? If it is indiscriminate in that way, then it's already illegal under international law.

CHALABI Is it about trying to capture disproportionality that you use the word "destruction" rather than "damage"?

Not widespread damage to homes, but destruction?

RAJAGOPAL Exactly. Although widespread damage can also render homes unusable. But the evidence shows that in many areas where homes are destroyed or damaged, people's first instinct, if they have a chance, is to return to the places where bombs were dropped, to actually return to their homes to check how they're doing. Damage can lead to different behavioral responses by individuals. Destruction nobody can quarrel about—destruction is destruction. It's unusable.

CHALABI What does that accountability look like? What are the kinds of repercussions that individuals and governments should face?

RAJAGOPAL At the international level, there is no electoral accountability. Nobody is running for elections globally. On the other hand, there is a reputational accountability under international law once you are named as a suspect in an international

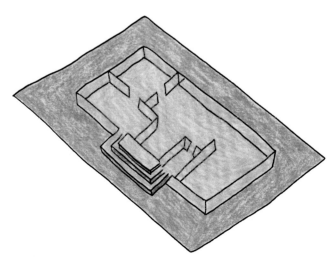

tribunal in a case where you're accused of war crimes or genocide or crimes against humanity. Basically, you're a marked individual; you become radioactive even if you are not arrested yet. In international law, accountability has to do with your legitimacy as a state or as an individual. Secondly, there is accountability in terms of criminal accountability, where you might well be arrested.

CHALABI It's interesting for us to be having this conversation now given that the UN passed a resolution regarding action in Gaza. Do you believe that might lead to some kind of accountability for the Israeli state in the ways that you describe—either criminal charges being brought against individuals or reputational damage to the State of Israel itself?

RAJAGOPAL I think there's no question that the reputational damage to the State of Israel has already happened. But the resolution solidifies in a clearer way that what Israel is doing is indefensible, even according to its own allies, including the United States, which couldn't bring itself to veto the resolution. But legal or criminal accountability is always a taller order in international law. I want to increase the legitimacy costs of domicide. If you're going to do it, you're going to be seen as a bad actor.

CHALABI It is a very worthwhile pursuit. And what I'm hearing you talk about is taking a longer view of history.

RAJAGOPAL During the struggle against South African apartheid, it took almost a whole century of loss of lives, destruction, and enslavement for the people of South Africa to finally realize their goal of freedom. Not all individuals were held accountable in a criminal law sense, but there

was reputational damage and the constant delegitimation of the apartheid government. I do see some possibilities of such changes even in Israel, because there are enough Israelis who think very differently and want an alternative regime. It will happen, but it's a longer struggle.

CHALABI Part of what you're doing is decoupling this notion of the destruction of homes with inevitability. Homes can be spared, civilians can be spared, and therefore it's not just the cost of business. What do you think the public doesn't understand about domicide?

RAJAGOPAL They don't recognize the loss of a home as being morally objectionable in the same way the killing of a human being might be. Killing is always valorized as the biggest loss. If a bomb is dropped on my house and my mom or dad dies, it's a profound loss. The only attention I get from the rest of the world is due to the death of my mom or dad, and there is no recognition that the same bomb destroyed my house, which means my sisters and my elderly grandparent who all barely survived now do not have a safe house to live in. And a house that I used to call my own for fifteen years is now suddenly gone. People don't recognize that as enough of a loss. So there is a moral blindness about what losing a house means.

And the second thing is that the categorization of something as a crime is often made by people in privileged positions. There is a class bias in international law. We don't think of losing a home as important. A house is not just a commodity. It's a human right. When we acknowledge housing is a human right, we then have more space to talk about the emotional and moral connections and psychological impacts of losing a home.

CHALABI It's making me realize how much all of this is rooted in capitalism. For some, a home's value is not a string of zeros. It has a value that cannot be quantified or commodified. Laws are still failing to capture that.

RAJAGOPAL We see this particularly with Indigenous people when they're told that their land is going to be flooded by a dam but that they will be resettled elsewhere and given new homes.

CHALABI If every single one of your ancestors lived in one area, your identity is tied to the land. In some cases, people's family name is connected to the land. That is an enormous loss.

RAJAGOPAL And for Indigenous people, their ancestors are often buried in these places, and you cannot replace that with any compensation. The main framing should be reparation and not just financial aid. Everybody who has worked on reparation knows that it's about atonement, it's about acknowledgement. So, for example,

if there is a loss of access to your ancestors' graves, much more can be done if those responsible show sincere regret and apologize.

CHALABI Acknowledgment before any kind of apology!

RAJAGOPAL What happens, unfortunately, is that when the noneconomic losses are not seen as important, none of this is taken seriously.

I just completed an official UN mission to the Netherlands in December. I visited this social housing complex mainly occupied by elderly people. They've been living there for more than two decades in most cases, and now it's been slated for demolition because the city wants to "redevelop" it. Behind the building there is this vast open space with a lot of trees, including this giant tree which is probably at least sixty or seventy years old. A resident told me that every day his routine is to get up in the morning, go to the back garden, and listen to the birds. He said he's seen some of the models of what their new homes will

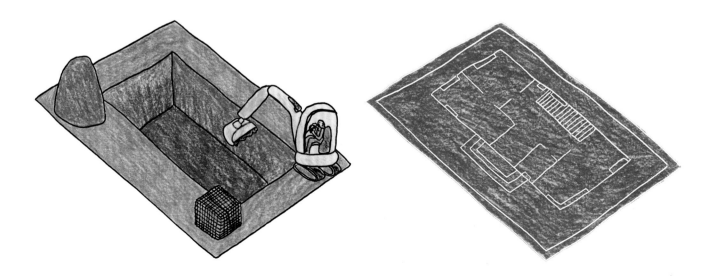

look like, but there is no space for any such trees. And it's going to take twenty years for those trees to grow to a point where there will be any birds on them, and he'll be dead by that time. And he's asking me, "How will I hear my birds again?" That is his main worry about losing his home.

CHALABI That's very powerful. A home is about looking out as well as looking in.

RAJAGOPAL Exactly.

[1] Dahr Jamail, "Seven years after sieges, Fallu-jah struggles," *Al Jazeera English*, January 2012.
[2] J. Douglas Porteous and Sandra E. Smith, *Domicide: The Global Destruction of Home* (Mon-treal: McGill-Queens University Press, 2001).

BELONGING

CHALABI, SITU RESEARCH

𝒲HERE BARBED WIRE FENCES HAVE NO PLACE

The southern part of Guam is an undeniably beautiful place. As a child, my family and I often drove to the southern village of Humåtak to visit relatives on weekends. The fond memories from these drives—sun shining through the tinted car windows and views of the rolling hilltops—evoke a nostalgia like no other. Yet there was something along this drive that stuck out like a thorn: Naval Base Guam, with its sprawling barbed wire fence surrounding the sentry-guarded entrance. As a child, I asked my parents about these fences. They would simply respond, "That's the base." I would shrug it off and move on. Little did I know that these barbed wire fences and the systems they represent play a large role in crafting what "home" means to the people of Guam.

KENNETH GOFIGAN KUPER is an associate professor in the Political Science and Micronesian Studies program at the University of Guam's Micronesian Area Research Center. He is also director of the Guam-based think tank Pacific Center for Island Security, which aims to provide an island perspective to geopolitics in the Pacific Islands.

BELONGING

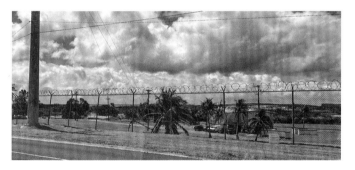

The barbed wire fence surrounding Naval Base Guam, located on the southern half of the island

Part of the Mariana Islands archipelago, the island of Guam lies in Micronesia in the western Pacific Ocean. It is home to the Indigenous CHamoru people and to competing nomenclatures and narratives. Guam is known as "Guåhan" in the CHamoru language. Translating to "we have," these two syllables encapsulate the CHamoru view of Guam as an island of abundance. Throughout their history, CHamorus sustained themselves through an interdependence with the land, the ocean, and one another. They felt secure at home. They felt provided for. This interdependence necessitated a respect for the environment and stewardship of it for future generations. Yet "Guåhan" is not the island's only name. There are competing ideologies whose accompanying material and physical consequences complicate Guam as a place of "we have" and disrupt the very notion of "home."

In opposition to "we have" is the phrase "where America's day begins," which refers to the island's location west of the International Date Line. Guam is

[1] Bartholomew H. Sparrow, *The Insular Cases and the Emergence of American Empire* (Lawrence: University Press of Kansas, 2006).
[2] Marine Corps Base Camp Blaz, "Reactivation and Naming," https://www.mcbblaz.marines.mil/Reactivation

currently an unincorporated territory of the United States. This means that it has only a non-voting representative in the House of Representatives, no representation whatsoever in the Senate, and no Electoral College votes. Furthermore, unincorporated territories such as Guam are under the plenary power of the US Congress. Perhaps most illustrative of Guam's relationship with the United States is the Supreme Court ruling (via the controversial Insular Cases) that unincorporated territories belong to but are not an integral part of the US.[1]

The result is a vibrantly clear democratic deficiency. The island's residents often express the feeling of being "second-class" US citizens. Without a true voice in the government of their administering power, this is a legitimate grievance and leaves many islanders wondering about the status of their home. Are we the US? Are we lesser than? Neither a country of its own or a state of the union, Guam lives in political purgatory not of its own making. Turning Guåhan on its head, "we (do not) have" full rights as American citizens and "we (do not) have" US government support for the exercise of self-determination of the island's colonized people. America's day begins in the abyss of its democratic ideals.

Related to its territorial status, a more sinister subgenre of nicknames refers to Guam's importance to the US military. The island has been called the "tip of the spear" or the "forward edge of the Indo-Pacific." Twenty-seven percent of the island's 212 square miles is occupied by US military installations such as Andersen Air Force Base, Naval Base Guam, and Marine Corps Base Camp Blaz, the most recent US Marine Corps base to be activated since 1952.[2] The island is strategically located, occupying the center of the "second island chain." This means the island is important for providing logistical support in the case of any conflict in the "first island chain," such as in Taiwan. This places the people of Guam in the midst of perpetual geopolitical tension.

The reality of this is not abstract. The ramifications are of the everyday variety. The bases make their presence known while the barbed wire fences that surround them are a reminder to stay out. Remembering again those trips with my family down south, I recall that I wanted to know what was beyond the fence. I was told that things were cheaper inside. I felt shut out.

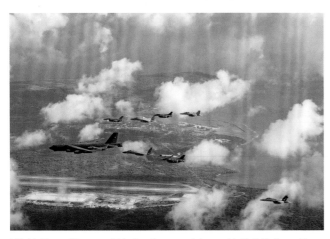

US Air Force, Navy, and Marine Corps and Japan Air Self-Defense Force aircrafts during Cope North 24, a three-week multinational aviation training exercise, alongside joint, partner, and allied forces in Guam and the Northern Mariana Islands from February 2 to 23, 2024.

View of sunset in Guam

My parents did not have a military ID, so I could not partake in these "gifts of liberation." Base access (with its cheaper gas and cheaper goods at the commissary) is something that is commonly desired. There is even a sad joke that people will marry anyone with a military ID so they can access the benefits: "ID? I do."

The end result of this is that Guåhan as "we have" becomes less and less true. There is a consistent erosion of autonomy here. It is hard to say "we have" when the military occupies so much of your land. It is hard to say "we have" when much of your economy is centered around military projects. It is hard to say "we have" when young people believe their primary road to success and financial stability is joining the US armed forces.

Instead, Guam as a provider is being turned into a "has-been." For many today, Guam's military role in the world is viewed as the primary way for us to survive in our homeland. Many believe Guam will be invaded by China if we renegotiate US military presence on the island or that we would go from "riches" to rags if we stopped being a US Territory. In making the military the lifeblood of the island, the US has also eroded people's beliefs in their own and their island's capacities. Home, for many, can only be a comfortable place to live based on what we are doing for the United States. Some people say home means nothing without family. The local spin in Guam seems to be that home means nothing without the US military.

In holding on to Guam as a territory, the US gains greatly. The meaning behind Guåhan's sacred name has been slowly shifting into the hands of the military. The military now gets to say "we have" control of an island only three to four hours away from our potential enemies in Asia. "We have" US soil here, from which we can project power. "We have" a place to experiment with missile defense.[3]

At the end of the day, we have to ask what the stakes are of these competing narratives. Is home large enough for these various nomenclatures? To put it differently, do "the tip of the spear" and "the forward edge of the Pacific" serve as barbed wire obstacles to making Guåhan deserving of the moniker "we have" on its own? This is the place Guam finds itself in today. A footnote in the American imagination and political system, the island is a territory that secures the United States'

[3] Zach Abdi, "Missile Defense Agency Provides New Details on Defense of Guam," *Naval News*, October 1, 2023, https://www.navalnews.com/naval-news/2023/10/missile-defense-agency-provides-new-details-on-defense-of-guam/.
[4] Bryan Metzger, "Trump Declared That Guam Isn't America," *Business Insider*, September 21, 2023, https://www.businessinsider.com/donald-trump-john-kelly-guam-isnt-america-north-korea-2023-9.

WHERE BARBED WIRE FENCES HAVE NO PLACE

geopolitical interests in the Asia-Pacific. This is happening in a place that really is not America. President Donald Trump, at the height of North Korean tensions during his presidency, was not concerned with threats to Guam, saying, "Guam isn't America."[4]

Yet, like anything, it was crafted to be this way. The islanders who have always called Guam home have seen their island transformed into the spear's tip. This was by design, as these decisions were made thousands of miles away in Washington, DC. The CHamoru people, from Spanish colonialism to American imperialism to Japanese brutality during World War II, have had to live with the nightmare of not being able to decide their futures. They have had to live with the horror of not paving the path forward for themselves.

Looking over the horizon at the political destiny of my island, I believe barbed wire fences have no place. The competing narratives over what Guam means in the world inevitably affect the daily lives of those who call the island home. This is why the colonized people of Guam deserve a chance to determine their political destiny. We deserve a chance to transform Guam into Guåhan yet again: a place of abundance. The stakes are high. The stake is "home."

I dream of the day I can drive my children down south, where they can take in the beauty of their island with a view that is clear. Barbed wire fences should not obstruct one from seeing the true beauty of home.

GENÍZARO HOMELAND

Loss and separation make up the contemporary fabric of the small village of Conejos, Colorado, one of the earliest permanent settlements in the San Luis Valley west of the Rio Grande River. Throughout the Southwest, Native children who were separated from their family and home in this community were referred to as *criados*, a Spanish word that describes a captive Indigenous child who is raised in a family as a servant.[1] Another term to describe this group of Hispanicized and detribalized Native Americans who were raised in Spanish-speaking households is *Genízaro*, a word used in the Spanish caste system that came to apply to this group as well.

RONALD RAEL is the Eva Li Memorial Chair of Architecture and chair of the Department of Art Practice at the University of California, Berkeley. His creative practice is connected to multigenerational land-based customs. Rael combines Indigenous and traditional materials and processes with contemporary technologies to address the contrasts, contradictions, and complexities of othered subjects that include people, materials, and places in contemporary society.

As child captives were released upon reaching adulthood and allowed to marry, they integrated into communities with diverse cultural identities. Abiquiú, New Mexico, serves as an illustration of a Genízaro settlement, and many forebears of Conejos settlers previously resided in Abiquiú, indicating their connection to and perpetuation of the *encomienda* system—a system of forced labor imposed on Indigenous workers by Spanish colonists. Given that Conejos was established by individuals predominantly from Genízaro communities, it is plausible that the continued practice of Indigenous enslavement in Conejos County stemmed from cultural loss, Hispanicization, and the enduring legacy of such practices among those whose ancestors were themselves victims of this system. Arguably, Conejos could be viewed as a Genízaro settlement, emerging as a consequence of a new wave of colonization by the United States that perpetuated the traumas inherited from earlier Spanish colonial legacies.

The original settlers to La Plaza de Los Conejos arrived in 1854, establishing themselves in the village of Guadalupe, Colorado, approximately one mile north of present-day Conejos, to claim the Conejos Land Grant: 2.5 million acres extending from northern New Mexico into the San Luis Valley, which was approved in 1833 by the Mexican government. Early attempts at claiming this Mexican grant were unsuccessful, as Native Americans resisted the occupation of their traditional hunting grounds, which were primarily inhabited seasonally by the Capote, Mouache, and

[1] Ramón A. Gutiérrez, "The Genízaro Origins of the Hermanos Penitentes," in *Nacion Genízara*, ed. Moises Gonzales (University of New Mexico Press: 2021), 90.

Tabeguache bands of the Ute tribe, as well as by the Pueblo, Comanche, Kiowa, Arapaho, Cheyenne, and Diné.

However, after the Mexican–American War (1846–1848), when the United States claimed the lands defined by the Conejos Grant, the presence of the US Army in the San Luis Valley and the violence that accompanied this occupation

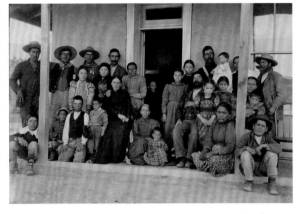

Genizaro Families, Abiquiu, New Mexico, photographed by Sumner Matteson, 1905; From the collection of the Milwaukee Public Museum

persuaded the Mouache and Capote Utes to sign the Treaty of Abiquiú. The treaty gave the US government a presence in the San Luis Valley, northern New Mexico, and other territories previously controlled by Indigenous peoples, which the US claimed following the conclusion of the Mexican–American War in 1848.

Lafayette Head (1825–1897), a young former US soldier who fought in the Mexican–American War in Santa Fe, attempted to claim the Conejos Grant. His journey to Conejos was marked with the violence of war and the loss of love. He had grown up at Head's Fort in Howard County, Missouri, a military fort named after his grandfather, Captain William Head (1752–1824), a Revolutionary War veteran and a pioneer settler of central Missouri during the Indian Wars. At age seventeen, Lafayette ran away from home, rebelling against his family, who forbade him to marry as they considered him too young. He ultimately served as a major in the US Army, riding into Santa Fe in 1846 during the Mexican–American War alongside United States General Sterling Price, who led the 2nd Missouri Infantry Regiment. Following the war, he settled first in Santa Fe, then Abiquiú, where he married "a wealthy Spanish widow with one child" and became a merchant and US marshal for the northern district of New Mexico Territory and sheriff of Rio Arriba County.[2]

Seeing an opportunity, Head and fifty families, most of them from Abiquiú, San Juan de los Caballeros, and Santa Cruz, attempted to settle the Conejos Grant, and in 1854 arrived in present-day Guadalupe just north of the Conejos River. The susceptibility to flooding in the Plaza de Guadalupe forced them to relocate to higher ground, and in 1855, the settlers established a new plaza a mile south—La Plaza de Los Conejos. Occupation and development of the plaza quickly ensued. By 1855, construction began on Head's massive adobe compound as well as on a mill ditch, one of the first adjudicated ditches in Colorado, which served to

[2] State Historical and Natural History Society of Colorado, State Museum (1945). *Colorado magazine* vol. 22–23, 194.

power the first grist mill in the state. The subsequent year, construction began on Nuestra Señora de Guadalupe, which today

[3] Virginia McConnell Simmons, *The Ute Indians of Utah, Colorado, and New Mexico* (University Press of Colorado, 2000), 112.

is the longest continuously operating Catholic parish in Colorado. By 1863, the plaza of Conejos became a town of adobe houses with a population of approximately 300 "Mexicans," 500 soldiers, some Jewish merchant traders, four Anglos (Head and his sister, nephew, and niece), and approximately 5,000 Ute living in or near the plaza.[3] Among the Ute were Ouray (1833–1880), appointed "chief" by US forces, and his wife, Chipeta (ca. 1843–1924), who was of Kiowa-Apache descent.

Ouray was born in 1833 near the Taos Pueblo in the Mexican State of Santa Fe de Nuevo Mejico, now New Mexico, where Utes made their winter encampments. When Ouray was a child, his father gave him and his brother to a Spanish family to serve as laborers in a large hacienda, now believed to have been the Hacienda de los Martinez in Taos. The practice of displacing children from their home was common, having evolved from the legacy of the *encomienda* system. In Taos, young Ouray learned Spanish and English, and as a young man he would return to Conejos to rejoin his family in their summer encampments. There he met Head and eventually helped negotiate several treaties for the Ute, which took him far from home on journeys that twice included visits to Washington, DC, to meet with President Abraham Lincoln. It was in Conejos that Ouray would also meet his wife, Chipeta, whose own history, beginning from childhood, is an account of displacement from her home.

Chipeta (likely "Chepita," a nickname for Josefina), also known as White Singing Bird, was born around 1843 into the Ute community in what is now Conejos. Of Kiowa-Apache descent, she was taken captive as an infant, possibly at El Cerrito de los Kiowas, located twelve miles east of Conejos, where a fierce battle unfolded between the Utes and Kiowas. At the age of sixteen, in 1859, Chipeta married Ouray, and together they emerged as influential advocates for Indigenous rights. They played pivotal roles in crafting the initial Treaty of Conejos in 1863, which conferred upon the United States the rights to all land in Colorado's Rocky Mountains east of the Continental Divide. Subsequently, the Ute Treaty of 1868 was enacted, establishing a vast reservation for the Utes on Colorado's Western Slope. This unfortunate agreement involved the Utes ceding the Central Rockies to the United States, leading to the

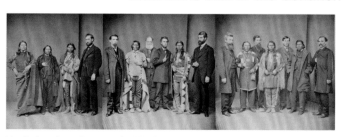

Ute Delegation, photographed by Mathew Brady Studio, 1868; National Portrait Gallery, Smithsonian Institution

GENÍZARO HOMELAND

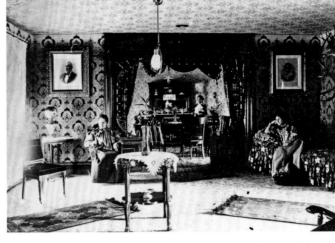

Interior of Lafayette Head home and Ute Indian Agency, Conejos, Colorado, 19th century; Luther Bean Museum

relocation of Chipeta and most of Colorado's Ute bands. Later, because of the Ute Removal Act of 1880, Chipeta was again forcibly relocated by the US Army to the Uintah and Ouray Indian Reservation in Utah. Chipeta was displaced from her home several times during her lifetime, yet her experiences and leadership led her to meet with several presidents—Lincoln, Lyndon B. Johnson, Ulysses S. Grant, and Howard Taft—to advocate for the rights of her people. Chipeta died in 1924 in Bitter Creek in Utah, blind and impoverished, far from her people's stolen home, which she had bravely fought to save.

As Conejos expanded, its early development by the land grant settlers—including the construction of a church, *acequias* (irrigation waterways), the first grist mill in Colorado, and the adobes used for homes and businesses in the plaza—may have been significantly influenced by the cultural practice of Indigenous slavery and child separation. This practice, prevalent for centuries in New Mexico and across the Southwest, persisted into the late nineteenth century. Construction, domestic, and agricultural labor in Conejos and neighboring counties was, in part, supplied by Native children who were separated from their families and subjected to bondage and servitude within numerous families in Conejos. Lafayette Head, appointed as Indian Agent in 1861, utilized his compound as the location for the Conejos Indian Agency. After the Civil War, President Andrew Jackson tasked Indian Agents, including Head, with documenting all enslaved captives in their regions. Head's census of the Indigenous population held in servitude in Conejos County and the surrounding area included tribal affiliation, age, location of purchase, baptized name, and other statistics, such as if they desired to return to their tribe. The outcome was a list comprising 149 individuals, predominantly children, who had been taken from their Native communities and placed into servitude. Notably absent from these lists were Head's own child servants.

Today only a small portion of Head's opulent home, which served as the Ute Indian Agency and lieutenant governor's mansion, exists. Most of the compound was destroyed by 1970, leaving only the easternmost portion and a small part of the flat-roof adobe that local oral history has suggested was a "slave

quarters." However, Conejos remains the home of the descendants of those whose names appear in the lists Head produced in 1868, from both the column that accounts for the owner and the column that accounts for the captive. In the distinctive multi-language dialect persistently spoken in the Plaza de Conejos in Southern Colorado today, 176 years after the Mexican–American War, echoes of a history marked by child separation and the *encomienda* system endure. The terminology reflects a lingering cultural imprint, where young individuals are commonly denoted as *los plebes*—a term synonymous with plebians, representing the lowest class of workers. Young laborers are also often labeled *peones*, signifying individuals subjected to exploitation. Furthermore, adults in the community may refer to misbehaving children as *malcriados*, evoking the historical context of the term, which translates to "bad slaves."

GENÍZARO HOMELAND

FRANK BLAZQUEZ

IN SEARCH OF MY HOME

FRANK BLAZQUEZ is a visual artist working in portraiture, documentary film, and mixed media. He is also a writer with multiple essays published in the *Guardian*. Blazquez focuses on counter-narratives across the American Southwest and tropes related to Latinx culture along the US-Mexico border, demonstrating his experiences connected to urgency and rehabilitation.

New Mexico is an adobe home built crookedly on a slope. I discovered this when I spilled water on my kitchen floor and the streams traveled to the nearest tile grout lines. New Mexico is a forgotten 1994 Oldsmobile Cutlass Ciera roasting in the August sun. I can smell the interior's vinyl and carpet, which reminds me of window shopping for items I would never own while running errands at a department store. New Mexico is the land of small casinos in remote locations, where everyone recognizes a familiar face. The hopelessness of gambling away your child's Christmas gift money is alleviated by neighbors and coworkers sharing a similar misery at slot machines nearby.

New Mexico is a dark parking lot on Montgomery Boulevard NE at midnight, where three teenagers stripped off my clothes, pressed pistols against my skull, and told me they would kill me if I did not cooperate. New Mexico is where I touched an oxycodone pill for the first time. I developed a relationship with a chemical companion, a friend who was always there when I needed her. New Mexico is where I entered rehab and met a sober coach named Nate. Nate thought my name was Vince, the name

of the other brown man in the program. I experienced withdrawal there on sweat-drenched bedsheets, having fever dreams of Pulte Homes–style Potemkin villages draped in Berber carpet.

New Mexico is where friends have died by gunfire. Diego Garcia-Urban was like my little brother. He was murdered in broad daylight at a Love's Travel Stop in February 2023. New Mexico in two words is "hard pain." Yet this is why I capture portraits across Albuquerque, Santa Fe, Las Cruces, Roswell, Chaparral, Artesia, and Grants. New Mexicans are resilient and inspiring survivors constantly in the throes of tragedy. When I achieved sobriety, I made a promise to narrate my story about the complex mechanisms of life and death in New Mexico.

I selected these photographs to reflect the personalities and iconographies of New Mexico that loop repetitively in my mind. My photographs are not ideological. Instead, these images detail my idea of the relationship between recuperation, which offers the hope needed to remain faithful to my craft, and home, a structure underpinned by compassion, patience, and warmth.

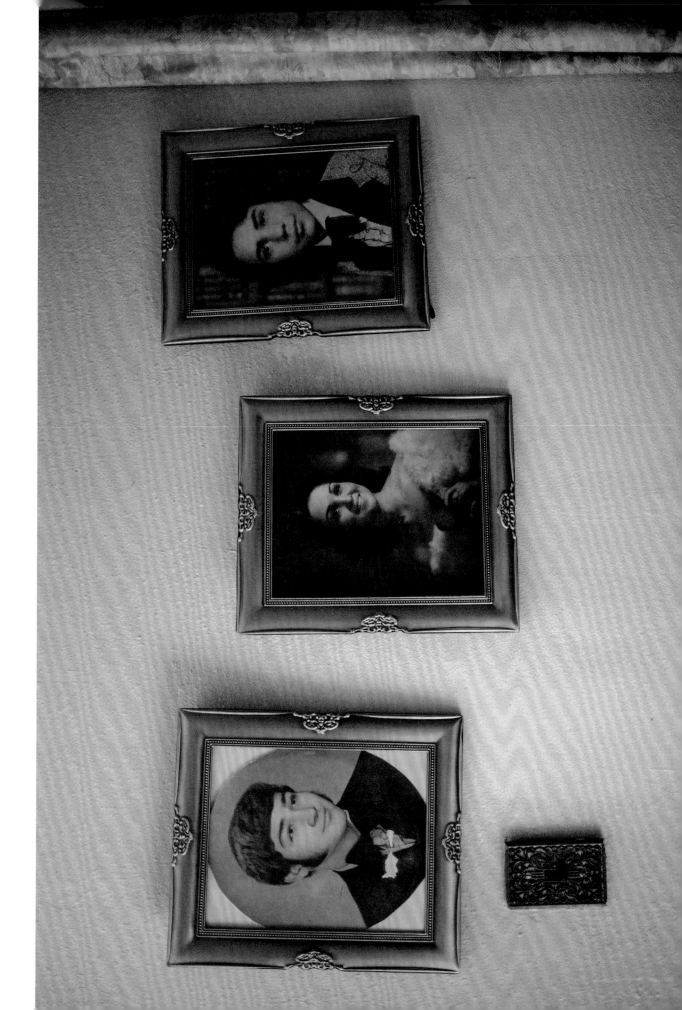

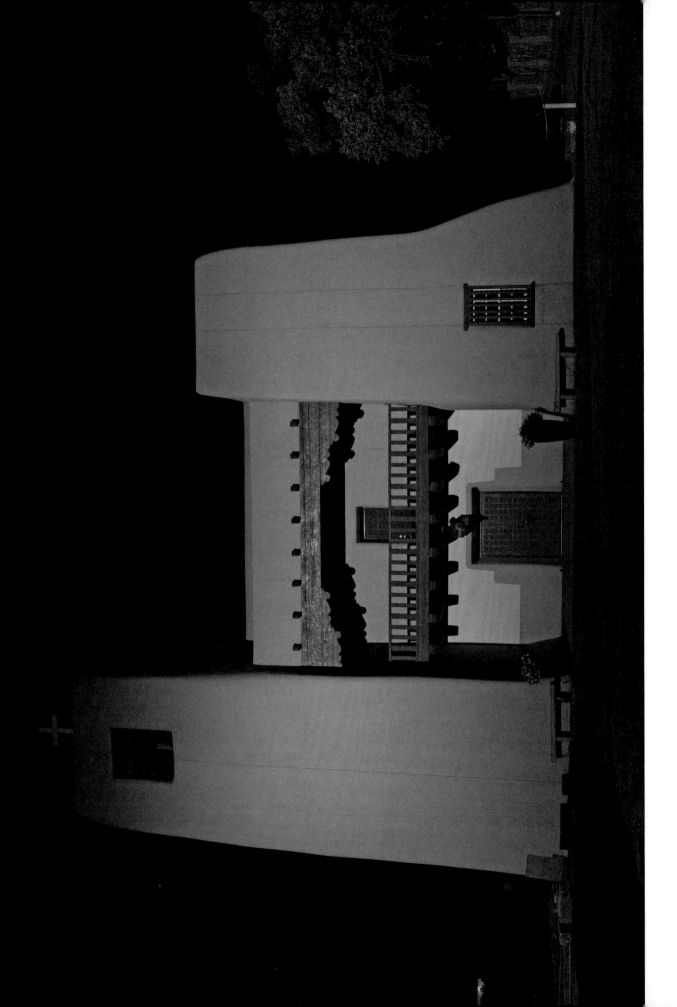

Santa Fe, 2019

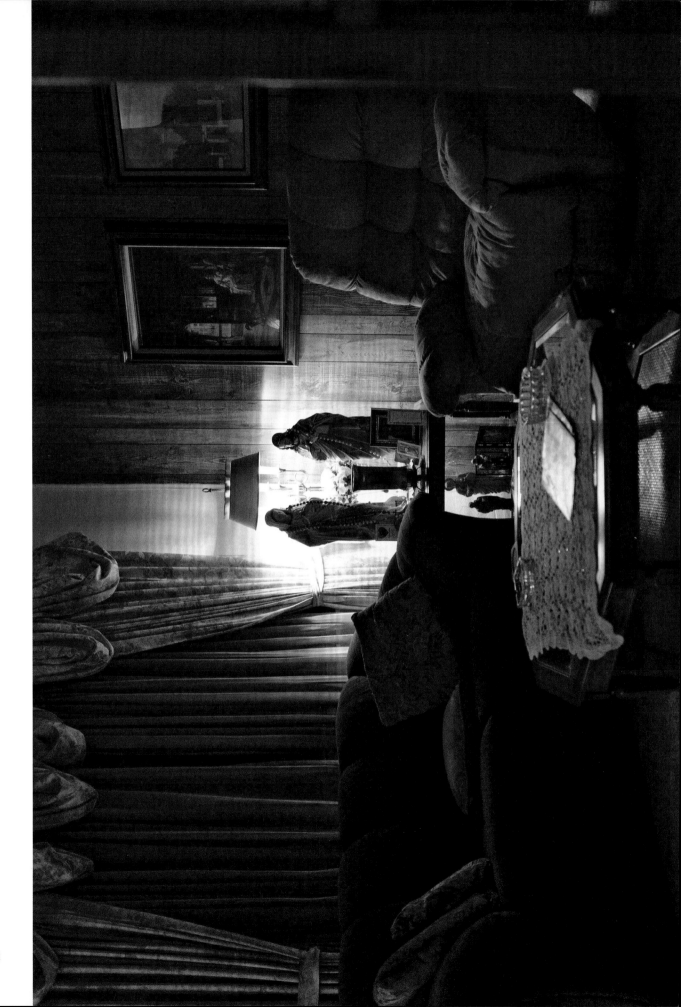

The Gutierrez-Padilla Living Room, 2018

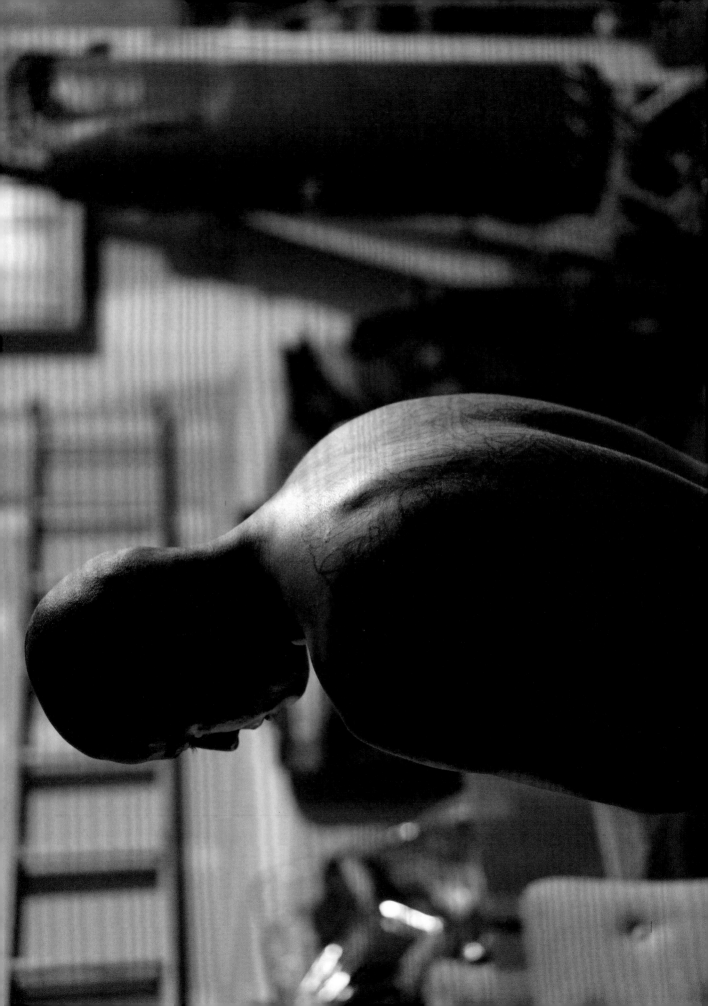

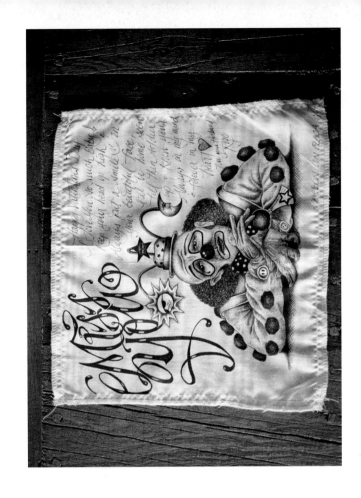

Above: Forgiveness, 2020. Below: Prison Paño for Flaca, 2021

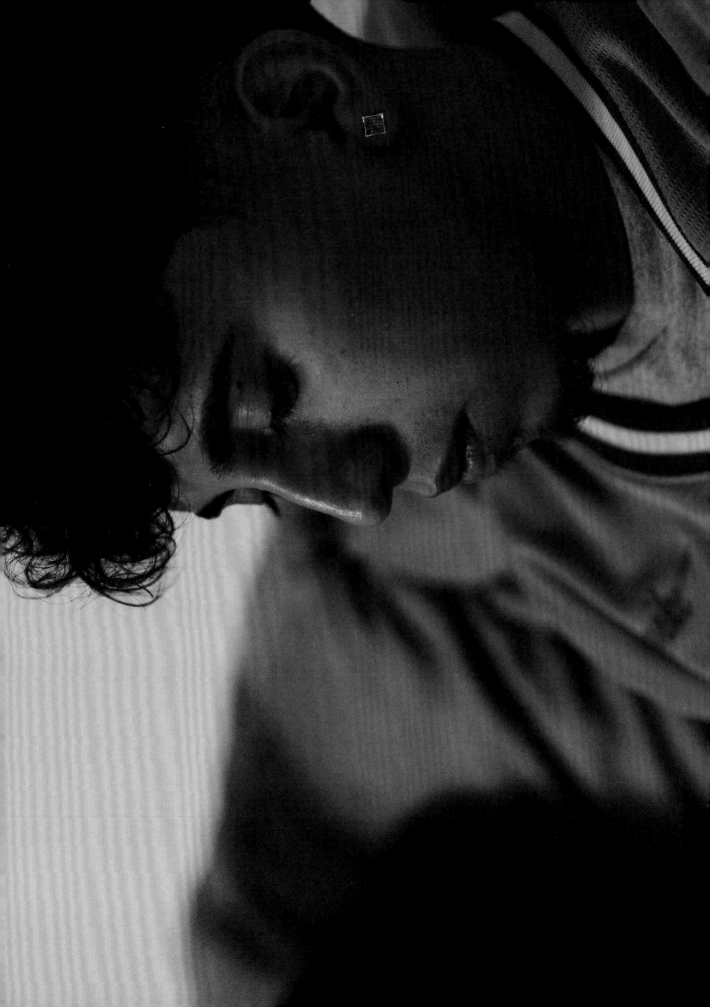

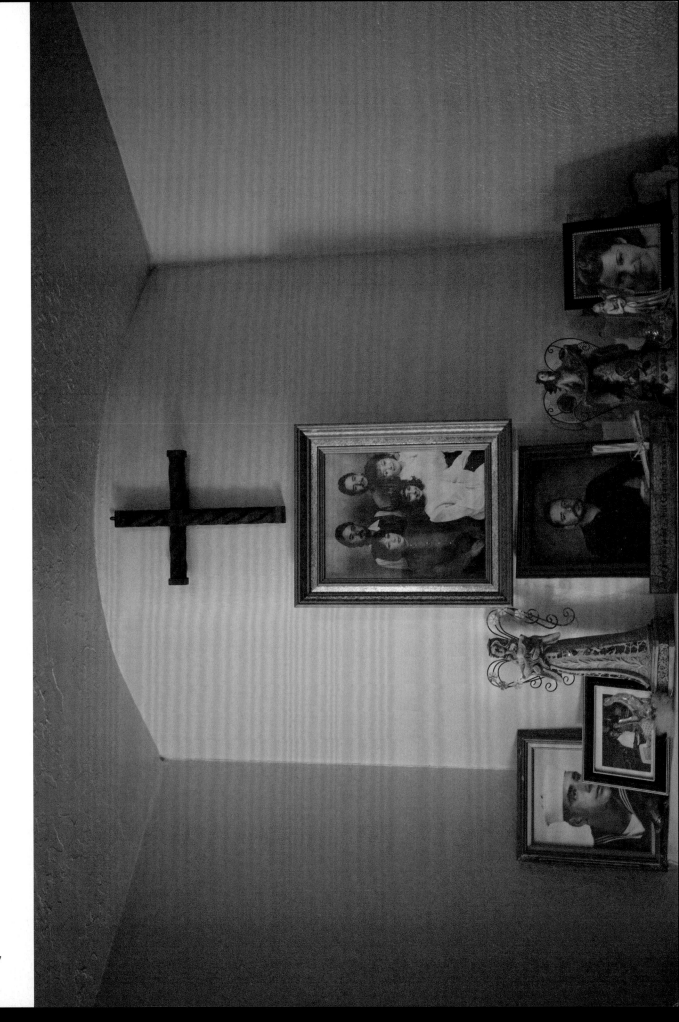

Above: Diego, 2022. Below: Santa Fe Relatives, 2020

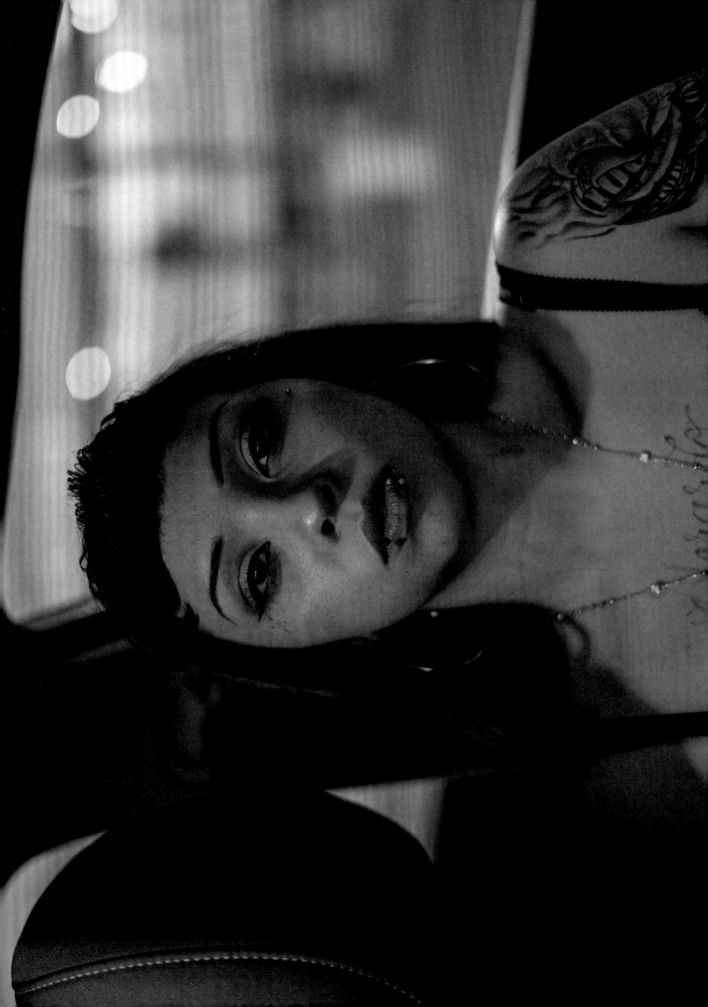

Above: Lorena, 2020. Below: Northern New Mexico Clown Doll, 2020

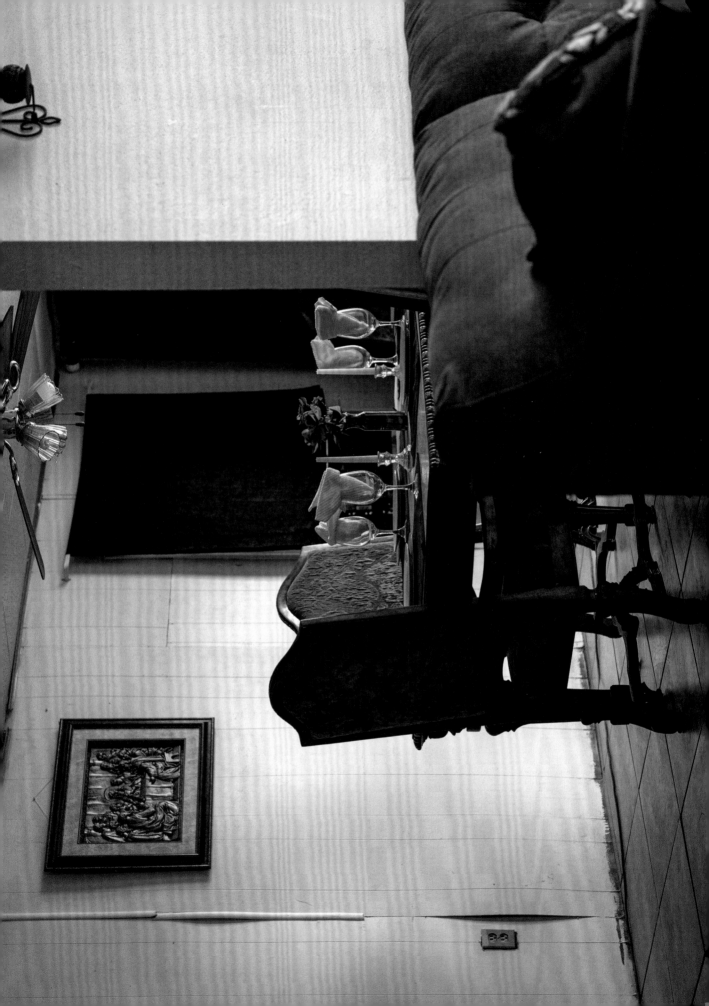

NOCHE LATINA
United by the Pursuit of Home

Nestled among the reflecting lakes and cresting mountains of Northern Michigan lies the small town of East Jordan, where young people have mobilized to create moments of human connection and mutual understanding among their neighbors.

SOPHIA GEBARA is the curatorial assistant of Latino Design at Cooper Hewitt, Smithsonian Design Museum. With a master's in art history from Columbia University, her work explores colonialism, pre-Columbian art, and material culture. She also focuses on contemporary artists and designers who challenge and redefine perceptions of Indigeneity in the twenty-first century.

In recent years, East Jordan—a predominantly homogenous white town with approximately 2,239 residents—has seen a subtle rise in immigration, particularly among individuals from Latin America.[1] Over recent decades, the seasonal agricultural industry has attracted a small but growing group of Spanish speakers from Mexico, Nicaragua, and the southern United States to the region, many of whom have settled in East Jordan to raise families. This caught the attention of students at the local public East Jordan Middle/High School, who endeavored to find ways to engage with their community's newest members. Their motivation stemmed from a desire to connect with their classmates and to foster a stronger sense of belonging in East Jordan.

The conversation began in the classroom of Angela Barrera, a Spanish teacher and director of Title VI and EL/Migrant Services. Here the students came together and established one guiding question distilled from a multitude of provocations, ideas, and perspectives—evidenced by a wall of mosaicked neon sticky notes. Trying to find a unified approach, the students determined that their most crucial question was: *Como podemos conectar con las familias hispanohablantes para que se sientan mas bienvenidas en nuestra comunidad y como podemos ayudarnos mutamente con nuestras metas linguisticas respectivas?* (How can we connect with Spanish-speaking families so that they feel more welcomed in our community, and how can we mutually help each other with our respective language goals?)

From the inception of this inquiry emerged the concept of *Noche Latina* (Latino Night), an event aimed at gathering

Aerial view of Northern Michigan, 2024

[1] US Census Bureau. "East Jordan city, Charlevoix County, Michigan," accessed September 25, 2024, https://www.census.gov/search-results.html?searchType=web&cssp=SERP&q=East%20Jordan%20city,%20Charlevoix%20County,%20Michigan.
[2] Mayra Y Bámaca-Colbert et al., "Cultural Orientation Gaps within a Family Systems Perspective," *Journal of Family Theory & Review* 11, no. 4 (2019): 524–43. doi:10.1111/jftr.12353.

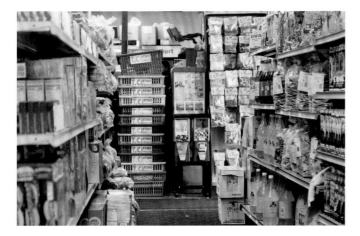

TC Latino Grocery Store, East Jordan, Michigan, 2024

people socially to provide new paths for cross-cultural understanding. Recognizing food as a powerful source of connection, the teens designed Noche Latina to be an evening event for not only the student population but also their families, the school's faculty, and the broader community. Guided by Latino parents, students learned how to prepare a variety of recipes, which produced meaningful moments of bilingual communication. Upon completing their dishes, the students embraced the challenge of presenting their meals in their nonnative language, whether Spanish or English. The event culminated with attendees gathering around tables, where all could indulge in the various foods they had collectively made.

After Noche Latina concluded, the students reflected on the experience in their classroom. They discussed how food served as a remarkable medium for bringing people together, recognizing it as a universal language that surpassed cultural boundaries. For many Latino families, the event evoked the cherished flavors and aromas of childhood meals, bringing back the sensations and memories of home, even though they were far from their native countries. The students contemplated what home meant to them, and with unanimous agreement, they described it as a place of safety, warmth, and understanding.

The desire to belong is especially felt by young people. Many individuals first begin to grasp their sense of belonging among their peers, often stemming from experiences in the classroom. It is during a child's formative years that the groundwork is laid for their adult identity, shaping not just who they are, but also how they fit into their surroundings and society.

Students in East Jordan's Latino community who are first-generation US citizens or recent immigrants can face a more complex struggle to find their place. The acculturation process can be particularly challenging for immigrant adolescents who must navigate between two cultures. Managing this duality can lead to feelings of detachment and identity volatility, which often pose a challenge to finding personal stability and a sense of belonging.[2] Weighing the pull of one's homeland with the challenges of adjusting to a new environment is an ever-evolving process. Conforming to conventional societal norms while preserving one's cultural identity is a difficult balance to strike.

The motivations behind the students' desire to find commonalities with their neighbors served as a platform to cultivate a stronger sense of connection within their town. Projected as a one-time event, Noche Latina transcended its initial concept and became linked to a broader movement. Word spread through East Jordan and its surrounding towns, leading to a growing number of people wanting to participate and share their stories. The evenings provide a welcoming space for a multigenerational, multicultural, and multiracial community to connect freely and encourage

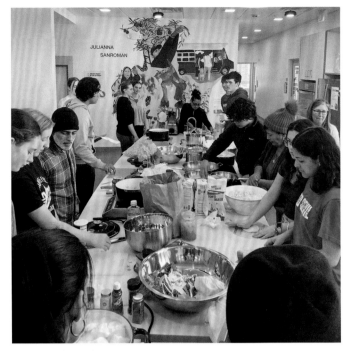

Students and community members prepare a meal together, East Jordan, Michigan, 2024

empathy within East Jordan. Noche Latina serves as an opportunity for reflection not just for teens, but for community members of all ages, encouraging contemplation on how the concept of home has evolved for them over time.

The residents of East Jordan are actively pursuing connections that help build a stronger foundation for both individual and collective belonging. Driven by one idea and one guiding question, a group of young people in rural Michigan have embraced the challenges and advantages that are intrinsic to multilingual, cross-cultural collaboration to make an impact in their town.

Home is not an inherent condition but an ongoing pursuit that both retains memories of heritage and influences future understandings of self.

*H*OMEWARD
At Home Becoming Alien

"Is there a direction home that
doesn't point backward?"
PAUL CHAN[2]

ALLAN PUNZALAN ISAAC is professor of American Studies and English at Rutgers University-New Brunswick, New Jersey. He is the author of *American Tropics: Articulating Filipino America* and *Filipino Time: Affective Worlds and Contracted Labor*. His research areas include studies of Asian American culture, race, migration, coloniality, gender and sexuality, and the Philippines and its diaspora.

The creatures go about their crossings and connections unnoticed at the airport, checking for departure gates, buying over-priced fast food, and whiling away time at the duty-free. "Uuwi ka ba?" (Are you headed home?) the Filipina sales worker at Detroit Duty-Free asks me during one of my layovers on the way to Manila. Having caught my eye, she nods in recognition. She refers to a "home," the Philippines, a colony of Spain and then of the United States before it was granted independence in 1946, a place neither of us inhabits. The sales worker's query has been asked more widely across the planet since the 1970s, when the Philippines began exporting professional and service labor as part of a domestic political safety valve and later as its comparative advantage in the global marketplace.[2]

The woman never actually referred to home as such. In Tagalog or Filipino, "uwi" refers not to home (*tahanan*) or house (*bahay/balay*) but rather to the direction toward home: homeward. "Ka" refers to me, the addressee, and "ba" is the interrogative. The repetition of the first syllable in "uuwi" denotes eventuality, and the root, "uwi," is not so much an endpoint but a direction we both understand is toward home. Thus, the word connotes not necessarily a physical topos or telos, but a shared orientation, an embodied anticipatory movement in time, space, and imagination. In the context of migration and histories of colonization, to go homeward for many Filipinos is perhaps not an act of return, but is about anticipation, communality, and the fact that we together are here and no longer *there*. With the friendly query, the saleswoman marked not only our shared displacement from Philippine soil but also our alien origins. After all, she sees her fellow creatures daily passing through her workplace, a way station for transients. These aliens hide in plain sight, holding blue and other passports like appendages at these border crossings, more aliens of Manila and other points in the archipelago.

[1] Paul Chan, quoted in Monica Youn, *From From* (Minneapolis: Graywolf Press, 2023).
[2] The inhabitants of the Philippine archipelago have been arriving in the Americas since the sixteenth century as compelled and forced labor with the Manila-Acapulco galleon trade under Spain and Mexico, and as laborers and students to the US, as colonial subjects, since the early twentieth century. See Kale Bantigue Fajardo, *Filipino Crosscurrents: Oceanographies of Seafaring, Masculinities, and Globalization* (Minneapolis: University of Minnesota Press, 2011).

Aliens of Manila (2014–present) is a photography series by Philippine-based queer artist Leeroy New that features the mundane lives of Filipinos. The photographs document aliens as both migrants and otherworldly creatures, organic-inorganic humanoids, partaking in workaday activities like shopping, commuting, even passing through airports. Inspired by the Humans of New York series (2010) but

Leeroy New, Aliens Grocery, from Aliens of Manila series, 2014–present

departing from the inspiration that sought to humanize and tell stories of millions of urban dwellers,[3] Aliens of Manila centers the nonhuman elements of urban dwellers and their global migration. Staged in different cities around the world, Aliens of Manila depicts the inhumane conditions of living in one of the densest cities in the world, in a country where a chunk of its population is born and destined to be transported to other sites overseas as immigrants and Overseas Filipino Workers.

In 2022, almost two million Filipinos left the Philippines to work abroad.[4] More than four million now live in the US, and many others find themselves working in Saudi Arabia, Canada, Australia, and Japan.[5] Siphoned off by capital-rich nations, many work in healthcare, teaching, domestic service, and care professions, embarking on life precarities and possibilities elsewhere. Cash sent home by overseas Filipinos through banks hit US$33 billion in 2023.[6] As with the duty-free shop or the TSA at US airports, many hotels, hospitals, schools, and care homes are where Filipinos earn their livelihoods by nourishing, transforming, educating, and caring for others. Speculating on their own futures abroad and loved ones at home, they contribute personal remittances accounting for almost 9 percent of the national GDP in a constant tension of care and loss, presence and absence, as they make new homes elsewhere.[7] Initiated by the US-backed Marcos regime in 1974, the out-migration of skilled workers was a way to quell domestic unrest and unemployment as well as a response to debt restructuring. Subsequent administrations have taken up what was then considered a temporary solution to consolidate the brokerage state.[8] From training and governmental bureaucracies and financial and commercial outreach targeted to potential emigrants, the Philippine state and corporations optimize the conditions by which exporting labor becomes the national comparative advantage

[3] Interview with Leeroy New, Quezon City, Philippines, July 2023. See also Humans of New York: https://www.humansofnewyork.com/.
[4] "Survey on Overseas Filipinos," Philippine Statistics Authority, Republic of the Philippines, September 13, 2024, https://psa.gov.ph/statistics/survey/laborand-employment/survey-overseas-filipinos.
[5] Jeanne Batalova and Luis Hassan Gallardo, "Filipino Immigrants in the United States," Migration Policy Institute, July 15, 2020, https://www.migrationpolicy.org/article/filipino-immigrants-united-states2020.
[6] Christy Balita, "Overseas Filipino Workers (OFW) Cash Remittances 2012–2023," Statista.com, April 19, 2024, https://www.statista.com/statistics/1242750/remittance-overseas-filipino-workers-tophilippines/.
[7] "Indicators," World Bank Group, https://data.worldbank.org/indicator.
[8] See Robyn Rodriguez, Migrants for Export: How the Philippine State Brokers Labor to the World (University of Minnesota Press, 2010).

enabling the state to compete in the global marketplace. For a host country like the United States, Filipinos arrive as commodified sources of surplus labor whereby lifetimes of acquired knowledge are translated into usable labor and profit. In the last half-century, three generations of Filipino migrants have taken up roots elsewhere, including New's mother, who lives and works in New York.

The fantastical worlds New invites us into do not depict other planetary spaces but rather our own neighborhoods. Aliens of Manila: New York Colony (2019), exhibited on Manhattan's Lower East Side, uses brightly colored plastic household cleaning items—sponges, feather dusters, flyswatters, colanders—to produce luminescent environments. These mundane housekeeping items employed for domestic labor are often pushed out of sight, like the people who use them. Here, the items radiate an extraterrestrial glow. Whereas the forms seem alien, this environment is home-grown from the vestiges of domestic labor, built from the very material and effort that transform houses into homes. Once out of sight and out of mind, with New's expert touch and imagination, labor's traces come to surface as this ethereal yet strangely familiar world.

New has been known to create fantastical hybrid creatures thriving undaunted in cities across the globe. For New York Colony, as with others, he designed breathing apparatuses and exoskeletons made of plastic and other castoff material that performers wear in a public movement piece around the site-specific installations. Donning the plastic headgear and suits made of discarded water bottles and jugs, the creatures' extended limbs and adorned heads move through the Lower East Side streets alongside spectators. The appendages are not additions: they are adaptive capacities that help the aliens grow into a place that may make no place for them. These appendages are the outward manifestations of how they have transformed physiologically to adapt to harsh conditions of the equally alien environment. They reshape themselves as much as they transform these alien worlds into homes. New York Colony is but one of the many colonies Filipino workers inhabit in their quest to make home by fusing past and future worlds, dead and living material, stasis and movement, disposability and permanence—all mutually constitutive in making manifest new life-worlds in the here and now. It is not the case that the alien migrants do not belong here or cannot navigate the hostile worlds. They navigate them all too well. They were always here and are now reshaping our homes as they build theirs; we just don't notice.

Indeed, the sales worker in her uniform and I in my sweats ready for the long-haul flight somehow saw each other past our

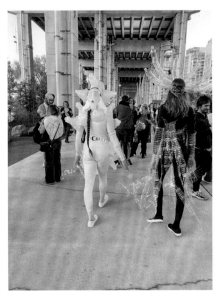

Allan Punzalan Isaac, *Aliens at Balete Bulate Bituka* (Banyan Worm Viscera) under the Bentway Expressway, Toronto, 2023

disguises, as creatures always anticipating that journey homeward, away from familiar notions of belonging to one or any national community. We blend and circulate, imperceptible not only to others but also perhaps to ourselves, until we hear that whisper of recognition and reminder to go homeward: *Uuwi ka ba*?

The author thanks Lucy San Pablo Burns, Ethel Brooks, Martin Manalansan, Donette Francis, and Mark Berkowitz for providing insights and clarifying ideas toward this direction home.

ℛECOLLECTION

Once, in the middle of the night, my grandmother Prudencia heard a loud thud from an impact on the corrugated tin roof of the small wooden house she lived in with her children and her husband. She heard footsteps and other strange noises above her as

JOIRI MINAYA is a New York-based, Dominican-United Statesian multidisciplinary visual artist. She attended the ENAV (Santo Domingo), the Altos de Chavón School, and Parsons / The New School. Her work has been exhibited, awarded, and collected internationally, mostly across the US, the Dominican Republic, and the Caribbean.

BELONGING

she lay in bed. She tried to persuade her husband to go check, but he refused. The next morning, she found a large, strangely shaped clump of what looked like organs or skin outside her house, and a faint trail of blood dotting the bedsheets of her children's bed. My mother, who was a newborn baby, had a tiny wound on her navel.

Not bearing any scars on her belly other than the stretch marks from her own subsequent pregnancies, my mother has said jokingly that imagination flourished in the countryside back when people could look out the window into the pitch-black night. She believes it waned once electricity finally arrived to the then-remote and neglected region of the Dominican Republic's south, bringing clarity to the previously obscured contours of the nighttime view. But my grandmother swears my mother was *chupada por una bruja*—sucked by a witch. She also says she knows who the witch was—a neighbor, the midwife whose herbs and knowledge had helped to bring my mother into this world just a few weeks earlier.

Prudencia converted to the Pentecostal faith in the 1960s at the church erected in front of the plot where she rebuilt her house in Barahona with the materials from the one she tore down in Caletón following her separation from a cheating husband. The supernatural stories she shares—her dreams, encounters, and premonitions—are revelations that led to her faith and continue to confirm it.

Unlike the overwhelming Catholicism that has defined the Dominican Republic's religious identity since the days of Spanish colonization, the denominations of Protestantism, fast spreading in the last decades, are much less porous to the syncretism and creolization that allowed Afrodiasporic deities to survive in the Americas under the guise of Catholic saints. Protestantism was introduced to the

Joiri Minaya, Cotton Bolls #1, 2024

island at various points in time—by smugglers through the north coast near the end of the sixteenth century, by free Black people relocating from the United States and Anglophone colonies in the Caribbean in the 1820s, by white US and Puerto Rican missionaries in the context of the first US occupation between 1916 and 1924. The religion discourages devotion to saints, the Virgin Mary, or much protagonism of any figure outside the Holy Trinity, demanding a total abstinence from anything that can be seen as "idolization" of images. This shapes an austere, almost nonexistent visual culture and sparse rituals beyond Sunday service, apart from baptism by immersion in water.

And yet, I don't think there's that much difference between the Holy Ghost that moved among the worshipers in the working-class church I attended as a kid. People would euphorically shake, faint, and ecstatically speak in tongues (a phenomenon I no longer witnessed once we moved to an upper-class church in my teen years, where the Holy Spirit apparently didn't manifest much). The Spirits of the African Diaspora moved through similar rituals and trances that shaped the various manifestations of Santería and Dominican vudú. Perhaps it is a recent camouflage strategy: the Spirits flow like water, marooning in yet another iteration of their unfixed state, abstracting from image into energy.

The Gullah Geechee, descendants of Africans who were enslaved centuries ago on the rice, indigo, and Sea Island cotton[1] plantations in the Lowcountry region of the Atlantic Coast—including South Carolina, North Carolina, Georgia, and Florida within the coastal plain, and the Sea Islands—preserve a unique culture due to their former geographic isolation. They share a similar mix of folklore and beliefs from their African heritage, which survived despite a strongly rooted Protestant religion. One of these beliefs describes trusted neighbors in disguise during daytime who turn into energy-sucking spirits at night by shedding their skin, roaming around town searching for victims, then returning to their skin before sunrise. To protect their homes from these entities—or "haints"—the Gullah Geechee paint their doors, windows, and porch ceilings with a variety of shades of blue, ranging from sky-blue to turquoise, teal, and grayish light-blue hues. They believe that "haint blue" confuses harmful spirits, making them think the painted surface is the sky or water, which they cannot cross, forcing them to turn around and leave. The formulation for haint blue is said to have been originally based on the indigo grown in the region in the eighteenth century, a result of the British textile industry's demand for blue dye.[2]

Between 1815 and 1821, a group of over seven hundred immigrants, formerly

[1] The cotton grown in this region is a tropical species called Sea Island cotton (*Gossypium barbadense*), which originated in South America, but has also been grown in the Caribbean since the fifteenth century, before the arrival of Europeans.

[2] For information on the formulation of haint blue paint, see Hollis Koons McCullough, ed., *Telfair Museum of Art: Collection Highlights* (University of Georgia Press, 2005), 45.

enslaved African Americans from this re-
gion, settled in Trinidad. They had gained
their freedom, plus sixteen acres of land
each, by fighting against the United States
in the War of 1812, as part of the Corps of
Colonial Marines in the British naval ser-
vice. These settlers eventually became
known as the Merikins, an abbreviated ver-
sion of the word "Americans."

Althea McNish, Golden Harvest textile, designed
late 1950s, printed early 1960s; Cooper Hewitt,
Smithsonian Design Museum; Museum pur-
chase from General Acquisitions Endowment
Fund, 2021-1-1

Althea McNish, a Trinidadian of Merikin
descent, migrated to England in 1951.
Credited with bringing vibrant color and
tropical themes to postwar England through
her pattern designs for the textile indus-
try, McNish became a successful British
designer, working for the likes of Liberty and Dior.[3] "In Trinidad
I used to walk through sugar plantations and now I was walking
through a wheat field. It was a glorious experience," McNish said
about one of her most famous pattern designs, Golden Harvest.[4]
By finding the Caribbean in the Global North, seeing the familiar
in the unfamiliar, I can relate to McNish's work and life. But I see in
her gestural marks an abstraction and elusiveness that keeps me
from locking her practice in any fixed description. In my eyes, her
designs tend toward the fugitive rather than the overdetermined
tropicality that others focus on and that she herself embraced, not
as the main feature of her work, but as one of its many facets.

I may be biased against tropical motifs in decorative arts af-
ter studying the link between botanical illustrations, colonization,
and imperialism. I've observed how this aesthetic continues to
serve as a vehicle for the Global North's voracious consumption
of the Caribbean and other tropical regions, perpetuating mis-
representation and imbalance. Yet I can appreciate the subver-
siveness in how, at a time when British Member of Parliament
Enoch Powell was spewing racist, anti-immigrant rhetoric in his
1968 "Rivers of Blood" speech, McNish had a booming career
decorating British homes with her own "tropical eye." I would
like to think that it was intentional; as a founding member of the
Caribbean Artist Movement, she was concerned with advocat-
ing for British society's acknowledgment of the contributions of
Caribbean artists like herself.

McNish's successful career was ironically a result of the
same British textile industry that once exploited her ancestors
and is interwoven with the global textile industry that employed
my grandmother's siblings in New York's
Garment District when they first migrated

[3] Victoria and Albert Museum, "Althea McNish:
An Introduction," last modified August 15, 2024,
https://www.vam.ac.uk/articles/althea-mcnish-
an-introduction.
[4] Rachael Espinet, "Iconic Designer Althea
McNish Dies in London," Newsday, April 21,
2020, https://newsday.co.tt/2020/04/21/iconic-
designer-althea-mcnish-dies-in-london/.

RECOLLECTION

from the Dominican Republic. Years later, my mother would purchase wholesale merchandise in the Garment District—sometimes manufactured in Dominican free-trade zones—that she would then sell at the retail store Unika Boutique she started in the Dominican Republic, the business that sustained me and my sisters through our upbringing.

In the always incandescent city of New York, where my grandmother migrated at age fifty-five and where I now live, I am sometimes reminded of her *bruja* stories. In my tiny renovated, overpriced apartment in gentrified Bedford-Stuyvesant, a historically African American and Caribbean neighborhood, there is a small, narrow skylight. Sometimes my cat will stare at it for long moments, so I look up to see if there may be a haint there (I imagine we can exchange herbal recipes and become friends). Other times, I lie down on the floor underneath it, watching the clouds pass by, reflecting on all the threads and currents that (in)formed what is home for me these days.

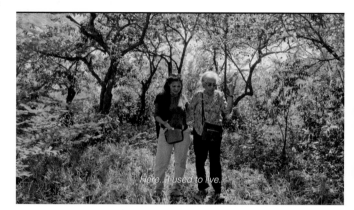

Still of Minaya's mother and grandmother, from her film *The Promise of Progress*, 2023

SOFÍA GALLISÁ MURIENTE
NATALIA LASSALLE-MORILLO
CARLOS J. SOTO

THE AFTERLIFE OF OBJECTS

In this conversation, designer Carlos J. Soto discusses with artists Sofía Gallisá Muriente and Natalia Lassalle-Morillo their participation in the Smithsonian Artist Research Fellowship and the exhibition *Making Home—Smithsonian Design Triennial* at Cooper Hewitt. During the summer of 2022, Gallisá Muriente worked with objects in the Teodoro Vidal Collection of Puerto Rican History at the National Museum of American History, while Lassalle-Morillo studied Indigenous objects collected by Jesse Walter Fewkes in Puerto Rico housed at the National Museum of Natural History. Together, Gallisá Muriente and Lassalle-Morillo share how these experiences shaped their understanding of repatriation, memory, and the Smithsonian as a home for Puerto Rican cultural heritage.

SOFÍA GALLISÁ MURIENTE employs text, image, and archive as medium and subject, proposing mechanisms for remembering and reimagining. Her work has been exhibited in documenta, Kassel; the Museum of Modern Art, New York; the Whitney Museum of American Art, New York; and the Museo de Arte Contemporáneo de Puerto Rico, San Juan. She was a Latinx Artist Fellow at US Latinx Art Forum in 2023 and a recipient of the United States Artist Fellowship in 2024.

NATALIA LASSALLE-MORILLO's research-based practice reconstructs memory and history through a transdisciplinary and participatory approach. Her films, installations, and theater works have been presented at the Museo de Arte Contemporáneo de Puerto Rico, San Juan; Amant, New York; Videobrasil Biennial, São Paulo; and Redcat, Los Angeles. In 2023 she was the Mellon Foundation Bridging the Divides Fellow. She lives in Puerto Rico.

CARLOS J. SOTO is a New York City-based designer and creative director working in opera, theater, dance, film, live music, and installation. Soto studied art history and literature before embarking on a lifetime of practice-based exploration of form and dramaturgy, focusing on an economy of line and gesture.

CARLOS J. SOTO What struck me most about the research the two of you have been working on is that it contends with "afterlife." I have had conversations with you both about reverse colonization and the idea of the Puerto Rican diaspora. I grew up in Puerto Rico, but I haven't been back in a long time. Learning how to reconnect or how to repatriate myself has been a perpetual journey, especially to an island where the word *"patria"* is so loaded. In many ways, your work is multivalent and has some degree of institutional critique. At the same time, there's also a poetics happening, or even wordplay with "home" and "housing"—the way objects are stored, conserved, and cared for—or not.

NATALIA LASSALLE-MORILLO I'm drawn to your mention of afterlife. I hadn't quite thought of it that way, but this idea has made me reconnect with my initial impetus when I began the Smithsonian Artist Research Fellowship at the National Museum of Natural History (NMNH).

When I first proposed to do research as a fellow, I wanted to think about what happened to Indigenous ritual objects from the Caribbean in the absence of their rightful owner. Spending time in NMNH's collection storage, it was bizarre to see all these belongings in *gavetas*, in these drawers, without the warmth of a human being's presence. What does it mean to preserve something forever and for it to

be cold and unused for a hundred years or more, apart from the people, the descendants who are meant to steward its history and be its custodians? When I held these objects, I felt I was connecting with a living being. I thought about the people who had carved them and the people who had believed in them. Where did these stones come from? What meaning did they have for their maker? That information lives in each one of these objects.

SOFÍA GALLISÁ MURIENTE This also reminds me of our conversation with the Puerto Rican archaeologist Reniel Rodríguez Ramos. We were discussing the problem of storage in Puerto Rico for cultural patrimony and of the lack of a national archaeology repository. There are vast logistical problems with Puerto Rico claiming or requesting repatriation. He said something that I thought was very beautiful.

LASSALLE-MORILLO Yes. He said, "*Esos objetos son una diáspora que no tiene a dónde regresar*," which translates to, "These objects are a diaspora that have nowhere to return to." They don't have a home.

SOTO There's an anecdote you've shared about how people were storing objects in their homes since there was no space in museums.

GALLISÁ MURIENTE Yes, currently in Puerto Rico the official directive is for licensed archaeologists to hold in their homes whatever objects they excavate, since there is no space left in any of the government repositories. They're supposed to keep inventory of those objects, but unfortunately, it's a chaotic, decentralized system. It is very hard to know what the future holds for those objects or when the funding and political will might exist to develop the

infrastructure that's missing. Nevertheless, I think part of the point that Reniel was making is that his greatest concern within archaeology is the study of people and not objects.

It's something for us to keep in mind when we talk about repair, return, or restitution. How can we think more broadly through poetry, through images, through other means about how to be custodians of this knowledge? How do we think of our relationship to the people who made and used these objects—the ways they relate to our land and materialities? How can we develop a sense of this history that implicates us in its continuity?

SOTO The sheer number of objects at the NMNH and the National Museum of American History (NMAH) is, in a way, a kind of reverse colonization, because these objects take up so much space.

GALLISÁ MURIENTE It's interesting to think about how the Teodoro Vidal Collection came to NMAH and the controversial response it incited. When it was donated to the Smithsonian in the 1990s, a lot of people felt it should have stayed in Puerto Rico. There are many different stories and debates about it to this day. Some mention Vidal's frustrations with government officials, because he was unable to get the historical building he lobbied for in order to establish a museum in Puerto Rico. Others criticize the move of over three thousand objects from Puerto Rico to the Smithsonian and see it as part of a history of colonial plunder, while still others argue that had they remained in Vidal's house they would have been eaten by pests and damaged by humidity. Then, there's the joke that these objects reverse-colonized the Smithsonian, like you say, because of all the storage space that they take up.

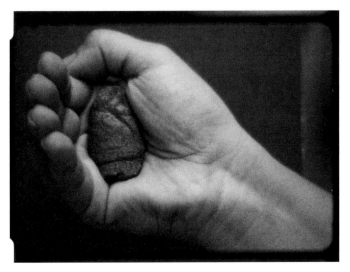

Sofía Gallisá Muriente and Natalia Lassalle-Morillo, Sofía cradling an Indigenous stone object, 2024

SOTO Some of the collection objects you encountered at both NMAH and NMNH have some "opaque" histories. How do you create relationships or connections among these objects in the absence of information?

LASSALLE-MORILLO We've been considering connections and contrasts between the collecting methods of the anthropologist and archeologist Jesse Walter Fewkes (1850–1930) and of Teodoro Vidal (1923–2016), a Puerto Rican government administrator and a passionate collector who researched and published extensively. Although these collections are from very different periods and are housed at different Smithsonian museums, most of their makers remain unnamed, and some of the information attributed to these objects is incorrect and hasn't been updated since they were acquired by the Smithsonian, due to lack of research and use.

In the case of the Indigenous objects, Fewkes was sent by the Smithsonian's Bureau of American Ethnology to gather this collection after the Spanish–American War (1898) when the United States invaded Puerto Rico. A couple of decades later, Vidal amassed a collection of Puerto Rican material culture spanning from the sixteenth to the twentieth centuries. These collections are named after the men who collected them. We want to examine the intentions of these collectors and the desire to possess, but we also want to connect these objects to their origin, in Puerto Rico, and to the people who are giving continuity to these cultural legacies that have been ruptured by colonial extraction. Our project has expanded from our initial idea, and now is to create a series of short films, to include collaborations with thinkers and artists who are reclaiming these histories and knowledge through their practices.

GALLISÁ MURIENTE My initial proposal for the fellowship was partly to consider what story can be told exclusively from the Puerto Rican collections within the Smithsonian. There are environmental and political conditions in Puerto Rico that constantly compromise the evidence of history within formal and informal archives and I thought, naively, that the Smithsonian was in a better position to survive the climate crisis and political upheaval. If, in the future, Puerto Rico sinks into the Caribbean or everything is taken over by the elements, then what remains of our material history will be stored in distant museums, I proposed. What are the stories that can be told with those fragments, so often decontextualized? I came to understand that the stories I care most about telling have less to do with the objects themselves and more with the political and historical entanglements that led them to these institutions, like how the Smithsonian holdings reflect the United States' interests in Puerto Rico.

Even though Fewkes and Vidal were so different in many ways, the truth is that the information available at the Smithsonian about the objects in both collections is similarly scarce. One way in which we countered this absence of information was by

THE AFTERLIFE OF OBJECTS

doing further research in Puerto Rico, for example going through Vidal's books and papers at the Fundación Luis Muñoz Marín and speaking to archaeologists like Reniel and Soraya Serra-Collazo, who have studied the Smithsonian collections and other related materials housed in the archipelago. At the same time, our work focuses on making the decontextualization visible and problematizing rather than solving it.

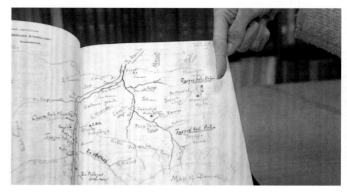

Sofía Gallisá Muriente and Natalia Lassalle-Morillo, Jesse Walter Fewkes's 1903 map of rivers, *bateyes,* and sites he excavated in Utuado and present-day Jayuya, Puerto Rico, 2024

LASSALLE-MORILLO I spent a good amount of time toward the end of my fellowship reading Fewkes's journals from his time in Puerto Rico, because they were one of the few records that speak to where these objects were taken from. I was entranced by these journals and felt conflicted about it, because Fewkes came to Puerto Rico with a very specific agenda: to collect not only for the Smithsonian and the Bureau of American Ethnology, but also for George Heye and his Museum of the American Indian, which is now the Smithsonian's National Museum of the American Indian. Despite his imperialist agenda, reading these journals was like gazing into a postwar period in Puerto Rico that felt opaque to me. I found a strange sense of familiarity in the way Fewkes described places that I know and that are close to us, and this drew me into the journals, which are also evidence of a violent act. In one of his entries, he describes excavating an Indigenous burial mound in Mameyes Arriba in Jayuya, near a friend's farm and ecological project, Camp Tabonuco. The ceramic objects he excavated from this burial mound now live in NMNH's collection. Despite the repulsion I felt when reading his account, I understand this is also a valuable document that provides evidence that this happened, and that it should be shared with others. This also led Sofía and me in our search for the *batey* (ceremonial ball court) he excavated, which we visited with friends who now care for this land.

SOTO Diving into these archives was so much about your own investigating, your own digging and following of trails that maybe you weren't expecting. And finding yourself experiencing these very visceral reactions in these moments of research.

LASSALLE-MORILLO From the get-go, we were both thinking of ways we could evoke the visceral sensation we felt during our research process into a series of video works. How do we share the experience of encountering and touching these objects, of navigating the corridors of this massive, football-field-size storage space where objects are "preserved forever"? How do we share the privileged access we got from this fellowship with others who don't have the opportunity of visiting these materials in person?

We came to the Smithsonian as artists invested in studying these objects, but we are also the descendants of the people who made and believed in these objects and the descendants of the people these objects were taken from in the aftermath of the Spanish–American War and the United States' occupation of Puerto Rico. That visceral and physical encounter also forced us to contend with the question of our standing as Puerto Ricans who claim a right to

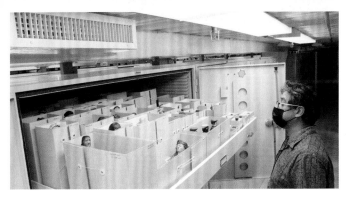

Sofía Gallisá Muriente and Natalia Lassalle-Morillo, NMAH curator Steve Velázquez opening a drawer full of *santos* in their housing at the Museum Support Center, Suitland, Maryland, 2024

this history, to know and learn from these objects. Through our project, we are asking questions about the ethics of collecting and the ideology of preservation, but we are also thinking of how our work as artists can propose methods of restitution and repair for these objects and for the people they rightfully belong to.

GALLISÁ MURIENTE One thing we've observed is that imagery is a medium essential to the process of preservation and the circulation of these objects and histories. Objects are turned into images as a way of making them more accessible. So, when we talk about access and about the importance of people having a similar experience to ours, it's about making the objects and their institutional context more visible to people through the research and filming we are doing in these museums. We want to ground all this analysis, conversation, and questioning in lived experience.

SOTO There's a fascination you find, which I share, in the way these objects are cared for and protected and stored. The housing of these objects has a certain aesthetic that I think is visually so vague.

GALLISÁ MURIENTE It's a huge part of the experience, the wonder and the magic—or the shock—of visiting the storage facilities and being able to see the objects as they are

housed and the different design strategies for these delicate structures that hold and protect them. I often feel they look cradled, like they are asleep, although the sterile environment also suggests a morgue. One example I love is that each saint from the Teodoro Vidal Collection has tailor-made housing after an earthquake knocked some of them over. To me there's a real beauty to those boxes, both aesthetically and also because they trace an often invisible labor of care. They prove that the storage pods are not sealed off from the world or impervious to tectonic movements; that life goes on even inside this place meant to contain time. I also love the little boxes to catch insects within the drawers and all the details that hint at another kind of life and threat that's there, potentially undermining the prowess of this enormous effort to possess and protect material culture.

SOTO There's so much poetry. It's beautiful.

\mathscr{G}AME ROOM

Liam Lee and Tommy Mishima discuss their distinct strategies on the question of functionality in art and design for their installation for Cooper Hewitt's *Making Home—Smithsonian Design Triennial*. Lee's furniture examines the utility in everyday objects through the introduction of biomorphic shapes that encourage viewers to reorient their relationship to domestic space. Similarly, Mishima's board game, despite also having a known practical appearance, is not meant to be played, but rather acts as one element of a larger installation that explores the power and influence of Andrew Carnegie's philanthropic efforts. Although divergent in execution and objective, these two approaches converge on ideas related to home.

LIAM LEE is an American artist and designer based in New York whose work is concerned with the dissolution of the boundary between interior and exterior space, between manmade object and what constitutes the "natural" environment. Liam received his BA in English literature from the University of Chicago in 2015.

TOMMY MISHIMA was born in Lima, Peru. He received his MFA from Rhode Island School of Design and his BFA from Parsons School of Design. He has exhibited in galleries across the United States and Europe, including Stuart & Co., Nancy Margolis, Turbine Space, the Lamar Dodd School of Art, and Clemente Soto Vélez.

LIAM LEE Tommy, what constitutes a home, and what is its relationship to your interest in Andrew Carnegie's philanthropic efforts?

TOMMY MISHIMA Home to me has an inextricable connection with family. My notion of home is a rather basic and conservative one, and in this respect it connects with Carnegie's own sensibilities of home, where one could detect his strict Protestant ideals and values, which mirror some of my own Catholic upbringing. Carnegie's Fifth Avenue mansion was built with as much consideration for the needs of his wife and daughter as it was for his own business necessities. What are some of the interests that have informed your work?

LEE For some time I've been interested in the relationship between the built environment and the human body, which has extended to object design. One thing that has informed my work is the notion that the domestic interior is imprinted with traces of its inhabitant—that our interiority is mapped onto the accumulated objects and detritus within our homes. This idea was generative, particularly during the pandemic, when both our homes and bodies became focal points of safety and anxiety, protecting us from the outside world, yet porous and vulnerable to external forces, susceptible to disease and violence. It became increasingly apparent that we are less apart from and more a part of those around us, and are consequently obligated to care for and be receptive to others.

What initially drew you to research Andrew Carnegie?

MISHIMA Much of my work from the last ten years began with an interest in power dynamics, which gradually expanded to a curiosity in networks and the nature of information itself. I'm interested specifically

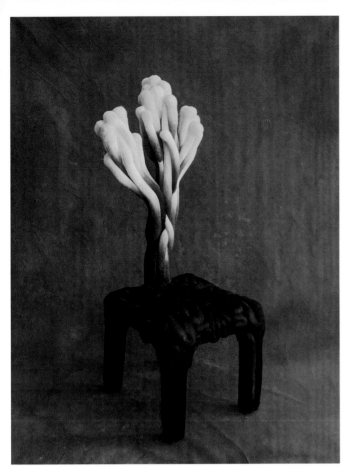

Liam Lee, Chair 17, 2024, featured in the installation Game Room in *Making Home*

game, Philanthropy, the objective is similar: to fund and name the most research institutions, with the hope that fellow players will declare bankruptcy, leaving you the last player standing. In reality, however, massive charitable donations don't result in the undoing of other donors and are instead intended to generate art, opportunity, technology, knowledge, et cetera. I'm wondering why the final objective of the game isn't to give away all your money, or why it has to be a zero-sum game. What do you hope players will take away from playing the game you've designed?

MISHIMA Philanthropic efforts, mainly those undertaken by the major foundations, have very little to do with altruism or even charity. Chief among the reasons foundations were created was the propagation of a particular ideology regarding society espoused by their eponymous founders. What these magnates were after was the power to formulate and redesign society based on their own visions of what society should look like. The avatars of Philanthropy and Monopoly are ultimately one and the same.

My work, at first glance, be it a crossword puzzle or a board game, has an inviting quality that asks for the viewer's participation. I have thought about creating work that can be mass-produced, but I also have this romantic idea of maintaining a distance or aura between observer and work of art. Your chairs, for instance, also possess that inviting quality evoked by their innate utility. What is the role of functionality in the creation of your work?

in how narratives are born or created in the individual and how information is synthesized. This in turn led me to explore the role of games, primarily that of crossword puzzles, in forming public opinion.

For the Triennial, I've been developing a board game I've titled Philanthropy that is inspired by Monopoly. Philanthropy has a connection with both the concept of home and the history of Carnegie's mansion. Board games are generally linked with family time, while Philanthropy has an inextricable link with the type of elite capitalism that inspired the game of Monopoly and made the erection of lavish mansions possible.

LEE I didn't grow up in a board game family and have played Monopoly a handful of times, but I understand the objective is to accumulate as much wealth as possible at the expense of the other players. In your

LEE On one hand, I'm creating functional works that support the weight of a human body and have structural elements that render them legible as pieces of furniture. On the other hand, I aim to imbue

these domestic objects with a level of the uncanny by introducing abstracted natural forms that aren't usually associated with domestic space. So the tension between the homely and the unhomely is of more interest to me than the strict function or ergonomics of a given piece.

That said, the question of functionality is at the heart of divisions between art, design, and craft: I could, for example, make work you can't sit on, but then you would have a chair-shaped sculpture and not a piece of furniture. Once you ascribe a function to an object, once it's intended to be used, our evaluation of it shifts, and that's most clearly played out in the art market. I'm interested in what would happen if everything in our homes, from our dining table to the bowl we eat from, wasn't just a thing to be used and easily replaced but instead had that aura you mentioned, had a personality or even its own agency.

MISHIMA It's interesting to think about functionality, especially when dealing with objects that have an inherently functional quality. But since domesticity is rather at the center of your practice, do you think you are somehow bound by objects that have an intrinsic link with the common idea of home? And is there a constant/evolutionary search for redefining that very idea of domesticity, in which this "tension between the homely and the unhomely" is further blurred?

LEE For now, my focus is on domestic objects that are commonly found in the home. I'm not attempting to redefine the home, but am interested in how that space changes over time with each successive technological and scientific innovation.

MISHIMA There is an obvious organic or biological quality that envelops all your work.

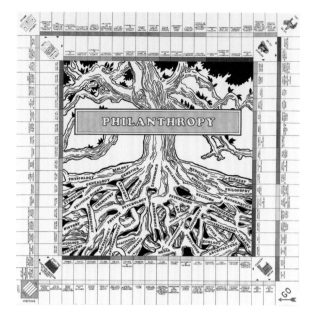

Tommy Mishima, Philanthropy Board Game, 2023–24, for the installation Game Room in *Making Home*

Do you imagine a very specific environment giving shape to your creations? Or do the shapes precede the landscape?

LEE For the most part, my furniture is loosely mimetic, slightly abstracted, and doesn't reference specific plants or fungi but instead relies on an imagined taxonomy. Forms found in nature are much more complex. This helps guide each piece to a place that provokes a feeling of semi recognition through slippages in legibility.

MISHIMA I've been interested for quite some time in Plato's philosophy. Plato believed in the supremacy of ideas and forms over the physical. In fact, Plato believed that the physical world was an imitation of an ideal realm. This would make your work an imitation of an imitation. Having said that, is there an ideal your work ultimately strives to attain, or is it rather defiantly moving away from the ideal?

LEE In a sense, each work approaches its own ideal form, growing toward an end point. But that end point isn't clearly defined as I work. So, my process is probably closer to freezing the form at a stage in its

very slow-moving development, much in the way one might prune and shape a plant over time as it grows from a single seed. I'm more interested in how the potentiality of the seed can be directed toward differences in form, and how each differentiation or deformation that occurs during its growth moves it farther from its ideal.

Our practices complement each other in that they both point to largely unseen networks—my furniture echoes fungal and floral forms, which have mycelial networks and roots that spread under the surface of things, growing, supporting, and communicating with each other, sharing and redistributing resources. What we see is only the fruiting or reproductive bodies on the surface. Similarly, philanthropic work is most visibly manifested in the physical form of performing arts centers, research institutions, museums, names on buildings, et cetera, and we rarely see behind the scenes. In mapping out Carnegie's philanthropic influence, what were some of the more surprising or unusual connections that you uncovered?

MISHIMA Perhaps the biggest surprise for me has been the compartmentalization of information in the annals of American history and the overt lack of historical confluence (consilience) between related people, events, and subjects. The twentieth century was for the most part the creation of a relatively small number of people who had fingers in many pies. This is nowhere more evident than in the system of interlocking directorates between foundations, corporations, and institutions. A combination of blood and ideological ties has been the driving force behind the unfolding of American culture and society.

SPEAK AND LET IT SCRATCH SOMEONE

Ha! Ei! Ohhhh! Mmm. Sa!
Wo ni veranda
Wo si wo bɛyɛ adui!
Obɛ veranda
Neo kor balɛ monkey!

Ghanaian highlife singer Samuel Owusu's hit "Veranda" returned to FM radio in 1999, the year I moved into an Accra compound house.

CATHERINE E. McKINLEY, winner of numerous distinctions for her writing and curatorial work, is the author of several critically acclaimed books, most recently *The African Lookbook: A Visual History of 100 Years of African Women* (2021).

A compound house is an intergenerational, multifamily abode with interconnected units around a courtyard, where much of the living is done, mostly communally. Compound houses are owned for generations by a "family head," who resides in the "main house" with their nuclear family and occupies a place of status related to traditional clan leadership systems and a role as a benefactor to poorer relatives who also reside there. A Ghanaian compound is, even today, much like an ancient-rooted cosmopolis. The world inside those walls is similar to a village, in size sometimes, and in governance. Each compound does not so much reflect the world, as it makes the world. One compound spreads out to another until a city is born. For centuries, the design is what shaped Accra, and the country—its rules and its voice. Below the surface of these now unremarkable twenty-first century, often declining and ugly structures, is a resilient cultural and metaphysic world that is centuries old.

When I lived there, I understood only a little of the two Ghanaian languages, Twi and Ga, combined in Owusu's lyrically dense but seemingly banal song:

You want to have a monkey
But you don't have a veranda!

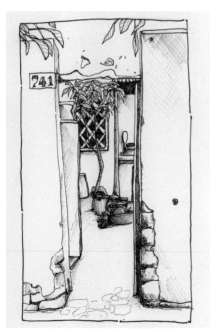

Valerie Aboulker, A view from the street into an open-air kitchen in an urban family compound, Accra (illustration 2024)

A drying line shared by residents in a compound yard, 2004

Ghana has a linguistic culture that is rich with proverbs. How often did you see a monkey in the city? Occasionally, one might leap out suddenly as you neared a house, chained to the front posts. But monkeys were not aspirations. They were considered mildly dangerous, nuisance animals, from the realm of hunters or fetish priests.

Houses were aspirations. As the tempo of "Veranda" rose, and the music slapped and rollicked, the song lost its banality, and you soon felt all its intended evisceration, innuendo, and aspirational joy.

Kasantwi! he declares at the bridge.
Speak and let it scratch someone!

My landlord at the compound house, whom we all called Madame, would unveil the meaning of these words to me. "Kasantwi! I go talk! I go scratch you!" she declared as I passed her in the yard. "With your American shoes! I heard you coming. Slap! Slap! Slap! Like monkey on concrete! Walking gor-geous-ly! I will collect those shoes from you today like rent! You! You are three days late, walking like you yourself own the papers to this house!"

"Madame, I can pay you right now," I said, happy to uncover a whole new ethos in that song.

"Veranda" would become an unofficial city anthem. Madame was using me to comment to the society of the yard, scratching us all. In a compound house, nothing escapes an ear. She was gathering up all of us—the strugglers, the moneyed, good Christians and *juju* people, family and strangers, lovers and foes, those with fancy shoes and private rooms with air conditioning and those in the servant's quarters or made to sleep on mats in the hall by the kitchen. She was reminding us of her power, that we were on ancestral land, that there was expectation, whether or not we were part of the *abusua*—her husband's clan. There was love for some. But, above all, we would do our unspoken part, and keep home the cosmos we all needed it to be.

By the 1980s, Nkrumaism, the founding tenets of the modern, Independent African state, a state pioneered by Ghana's Kwame Nkrumah in 1957, had traded an ethic of material modesty and responsible and fervent nation building for Western-inflected private-mansion building, funded by family members' remittances sent from foreign exile. *You want a house, but you've abandoned your birthright*: each trip to a money agent underscored the sentiments of the independence and post-independence generations.

SPEAK AND LET IT SCRATCH SOMEONE

Owusu's song scratched me in its own way. I was thirty. In what was then a decade of visiting and living in Ghana, a base for other Africa travels, I had come to think of the country as My Mother's House. But what really was this pursuit of some exquisite home?

My family, in truth, my home, had felt to me like an exquisite pain. I had spent my childhood in a small factory town south of Boston and on a rural Vermont farm that my parents would eventually retire to. I am their Black adopted daughter, and they are Scotch-Irish, not connected to the old country or to many people—even family—beyond my brother and themselves. I feel only vaguely attached to the house and city where I grew up. That home was a classic Cape Cod house, which was not terribly fancy, but its cedar shake siding, beautiful moldings, and Dutch split doors left their imprint, as did the Scandinavian-design ware, heirloom china, and sterling cutlery used at every meal. The street was oak tree–lined and quiet. Each family was left to its private ghosts and eccentricities.

My Mother's House was not one place—Accra itself, or any one home—but the birds, flowerpots, the noises of living; the people pounding *fufu*, cooking on the coal pot, ironing dresses, stopping to sell fish or lottery cards; the ambulant tailor with a sewing machine on his head; the singular people and pleasures that charge or animate domestic bliss—all experienced in the inner yard. Even the rats in Accra, they say, blow softly on you as you sleep in your bed, to "sweet you" as they chew the hard skin from your feet. Life can be that good. In Ghana, so much of life is transacted in open view—people leave their kitchens to cook in the yard over coal pots; they bathe in outdoor showers near drains at the property edge; they often hold conversations with someone on the street or in the next yard; they watch televisions pulled into the yards, joined by every child in the area and passersby. Interior living spaces are left to the most private functions.

For the first time in my life, I felt part of an anointed whole, as much as I was an outsider. In the homes of friends I had now known for a decade, I knew I was loved, and I could be a part of everyone and still not lose the big interior parts of myself I had always felt were at risk.

Even at Madame's I was necessary to the ecosystem, as much as to her vanities.

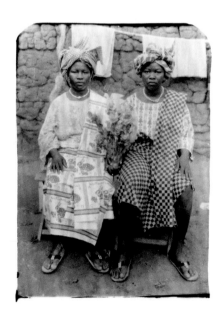

Dahomey women in a compound yard, Benin, ca. 1920s

Valerie Aboulker, A portion of the main quarters in a historic Akan family compound, Kumasi, Ghana, early 20th century (illustration 2024)

There were nearly forty people sheltered there, beholden to her moods and mercurial largesse. The compound was on the family's ancestral land, in an area off Oxford Street, the shiny expat commercial hub. It was close to the Gulf of Guinea, and with the dulled sounds of people turning in at night you could hear the roar of the waves. I would think about our family summers in a cottage on Cape Cod and how I would look at the horizon of the Atlantic and ask my mother, just to hear her answer again, "What's on the other side?"

"The west coast of Africa."

Every day at home was an open theater. Madame, always preoccupied with her businesses—a hair salon at the back of the yard and a small grocery store along the street—left a curtain swinging in her open front door so her words to some unseen companion could scratch us when they fit. We had a grand sheltering tree and grass in the yard—typically razed and cemented over to deter snakes and fire ants. The other household members and many children gathered there all day long. I would sit in my room many days and write.

I knew people who had grown up in what were called compound houses in the United States. One had an African father and had grown up partly on the continent, but the house was born several generations back, originating with her tightknit Los Angeles African American family escaping Texas. With others I knew, politically conservative Christian white families who set up affluent homesteads in New Jersey or middle America, the compound house was like a neocolonial dream. A remove from others. Privatization, social control, and a low-key militarism shadowed those places.

It is clear to me why Ghanaians have run—ever more fervently after widespread British destruction of their oldest architecture in the nineteenth century—from rural compounds to those transplanted, since the 1880s, to the cities. In the 1980s, as white paint became the prevailing color on the always restricted market, Accra grew a reputation throughout West Africa as "Small London," with white cosmetically modernizing its landscape. Compound houses began to slowly but radically evolve, to take in tenants, with looser

SPEAK AND LET IT SCRATCH SOMEONE

filial, clan, and financial ties, and growing slum-like attributes as the harm of the Structural Adjustment Programme unfolded. Single-family or limited extended-family concrete monsters with little Ghanaian design and impenetrable gates and walls became the city's jewels. These whitewashed Euro-style houses grew as if from an unspoken edict from the long-banished British Crown. Gone were the compounds made of rammed earth or, rarer, wood, that had once covered the countryside. In their place now are newer homes, shaped and reshaped over time by neglect or more Western ways of being. While enduring still, in surprising ways, the city's compound houses are nonetheless a fragile legacy, susceptible to being lost entirely from Accra's architectural history.

That legacy born of a form and spirit is deeply ingrained in me. It is My Mother's House. It is not a dreamscape. It is not a place where I was always apiece. Or even always liked. It is not a place without disgust. It is not a perfect safety. No monkey. But it is where I found a language and a metaphysics, a kind of loophole in which to fashion a self and a rope, like the monkey's, to bound from. The best Accra veranda was Madame's. In time, I began to travel in ever-widening circles, to make home in more of Africa and the world, and to recover little bits of my American home.

\mathcal{I}NTENTIONAL, HOME

When I earned a faculty position at Purdue University in West Lafayette, Indiana, I was thrilled. For the previous four years, I had lived in a very small town in east-ern Illinois and for the five years before that I had lived in a very small town in Michigan's Upper Peninsula. My entire adult life, my geographic circumstances had been dictated by professional urgencies. In each place, I had an apartment that was mostly fine. I had small circles of wonderful friends. But I had never felt at home—the remoteness, the isolation, and being one of very few people of color made that all but impossible. Lafayette was going to be different, I told myself. With a population of more than 100,000, the town felt positively cosmopolitan. There would be, I hoped, a lot more to do, places to go, the ability to live more than an imitation of life.

ROXANE GAY is a writer, editor, and professor who splits her time between New York and Los Angeles. She is the author of several books including *Bad Feminist* (2014) and *Hunger* (2017).

Even with all that Lafayette promised, I was determined not to live there but in Indianapolis. It's not that Indianapolis is para-dise, but it is a lovely city. It has a reasonably diverse population. I found a gorgeous, brand-new apartment across from a fancy mall near the interstate. Getting to work would be easy, a straight shot down I-65, less than an hour commute. I was going to have access to shopping and interesting restaurants and interesting people. I would buy my first real adult furniture from a store other than IKEA. Maybe I'd fire up the dating apps and have some measure of a social life. If I was lucky, I would find community. Things were looking up.

I am originally from Omaha, Nebraska, so I am no stranger to living in small towns. But as I've gotten older, my tolerance for isolation has diminished. I have spent too many years living in the middle of nowhere. Anything is tolerable for a finite amount of time, but after spending most of my adulthood living and working in the middle of nowhere, I had reached my limit. I didn't want to have to drive hours to the nearest airport. I didn't want to have to drive hours or, worse, fly to a city where I can get my hair done. I no longer wanted to feel like an object of curiosity simply by vir-tue of my race. I was done with quietly seething while tolerating bewildering acts of racism. I was tired of feeling out of place. For too long, I had yearned for something different. I had yearned to feel less like a stranger in a strange land and more like someone who is, finally, home.

In the months before my first semester at Purdue started, as I got to know my new colleagues, mostly via email, they were deeply concerned about my living arrangements. The commute would be difficult, they said. And sometimes the Indiana winters were harsh. As a lifelong Midwesterner, I was not worried. An hour's drive in the middle of nowhere is nothing at all, and after five years in the Upper Peninsula, where it snows more than three hundred inches a year, I was confident I could handle any occasional snowfall that blanketed Central Indiana. In truth, I was salivating over the prospect of living in a place with more than 15,000 residents. Eventually, though, I buckled under the pressure, because I am nothing if not a people pleaser—always to my own detriment.

The driveway of Gay's apartment in Hancock, Michigan, on a typical winter day

I ended up withdrawing from the lease on my beautiful new dream apartment and losing my deposit. Instead, I rented an apartment in Lafayette in a weird, creepy building with hallways that looked like they once hosted a series of horrifying unsolved murders. The apartments, though, were newly renovated, and it was a small town, so I had a three-bedroom, two-bath apartment with beautiful hardwood floors. My rent was a modest $1,400, and I consoled myself with the knowledge that a livable city was a mere hour away.

Living in Lafayette would be fine. It would be fine. Instead of driving an hour each way to work, I would have a breezy ten-minute commute across the river to West Lafayette. I would, as in the years prior, have large swaths of time to write. I would get to know my colleagues and maybe make some new friends. I would find my people and be more accessible to my students. I would be fine. It would be fine. It only took a few weeks to realize I had made a horrible mistake.

Lafayette was by no means the smallest town I'd ever lived in. It even had some of the creature comforts that make life a little easier without the liabilities of a big city—a multiplex, a Target, a few decent restaurants, a Starbucks with a drive-thru. But it was also Central Indiana, a place where people flew the Confederate flag without irony even though Indiana was never a part of the Confederacy. Because Indiana is an open-carry state, it was not out of the ordinary to see a man walking around in board shorts and a tank top, a gun holstered at his waist. And then there were

A 1970s apartment building in Lafayette, Indiana

the men driving around in oversized pick-up trucks with "Don't Tread on Me" flags and Ku Klux Klan imagery. Lafayette was inhospitable and lonely. When I left my apartment, I never felt safe. As a somewhat single Black lesbian, I found few local dating prospects. After a very brief foray on e-Harmony, I gave up on the idea that I might meet Ms. Right or even Ms. Right Now. My colleagues were nice enough, but I didn't feel like I had or was part of a community. It was overwhelming, at almost forty, to feel like I had no future beyond work. I wondered, not for the first time, if I would ever find home, or if I would ever feel home.

One afternoon I watched a large pickup truck with a massive Confederate flag drive back and forth in front of my apartment building. I lay down in bed and stared at the ceiling and thought, *I do not have to live like this. I do not want to live like this.* I was grateful for my job. I love teaching and working with students, but I was weary of the unbearable compromise professors, particularly in the humanities, must often make—professional security and satisfaction at the expense of personal joy. A good job was enough until it wasn't. Choosing to forgo living in Indianapolis was, ultimately, a valuable lesson in learning to trust my instincts and learning to allow myself the pleasure of doing what I want, even if it displeases others.

I am not an impulsive person. In general, I accept the way things are and have an annoying but useful ability to surrender to circumstances that feel unchangeable. There was a small glimmer of potential, though. My best friend lived in Los Angeles. One day, I was browsing flights and discovered that there were a few direct flights there every day from Indianapolis. The prices were fairly reasonable, so I bought a ticket, booked a hotel for a week, and flew west. I had no real plan, which was kind of thrilling. And then I did the same thing the next month, and the one after that. Before long, I was spending at least a week a month in LA.

Each time I stepped off the airplane into the grimy chaos of LAX, I felt more human. These sojourns were my first opportunity to spend a significant amount of time in a sprawling megalopolis. At first, I felt like a country mouse. Everything astonished me—the unfathomable and omnipresent traffic; the vibrant street art in bold, beautiful colors; the Mexican food and generally excellent restaurant scene; the museums; the weird little theater companies putting on weird little shows; the farmers markets with produce that didn't seem real it was so beautiful. There was so much

INTENTIONAL, HOME

to do all the time. The weather was exceptional all the time. And, of course, there was the ocean—crystalline blue, stretching as far as the eye could see. That's how I knew I had found a place where I belonged. I am not a beach person, but still I could appreciate the wonder of all that sand and water.

It was a relief to spend so much time in a very liberal place. More people shared my politics than not. There was a sense that the greater good matters. While there was a significant unhoused population, the city (mostly) didn't try to hide it, and a lot of good people worked tirelessly to help the most vulnerable people in their communities. We are forced to confront inequality every time we leave the house and, frankly, that's the way it should be until we figure out how to ensure that everyone has a safe, clean home they can afford, no matter what their financial situation is.

It was truly life changing having the ability to be intentional about where I spent the majority of my time. After about a year of hotel stays, I rented an apartment downtown and bought a car. I found the local writing community, made new friends, and had a fun but fairly disastrous relationship with a very lovely woman. Three years later, I bought my first house, something I never imagined I would be able to do, especially in an expensive city like Los Angeles, where people with trust funds or mysterious sources of wealth regularly made all-cash offers over the asking price. I was terrified about making such an adult decision. At the time, I didn't have a partner or kids or even a pet, all the things we tend to associate with home. It was just me, and as I signed thirty years of my life away, I tried to believe just me was enough.

The new house was perfect. I had space for all my books. I could paint the walls whatever color I wanted. I could hang things and not worry about losing a security deposit. In the backyard, there was a wizened old Japanese maple tree with a canopy of fecund branches covering the yard that I would, eventually, drape in sparkly Christmas lights simply because it made me happy.

Every day I see Black people just living their lives. I see all kinds of people, really. I feel more comfortable in my skin, and it's beautiful to be in a place where difference is both unremarkable and celebrated. I now realize how much I sacrificed for so long, how I whittled myself into someone who could survive anywhere, making myself believe survival was enough. I know I will never again compromise on having a real home.

A sunny day in Los Angeles, California

After I closed on the house and got the keys, I stood in the empty kitchen and looked around at all the bare walls. It was quiet and echoing because there was nothing in it to absorb the sound. I was going to have to fill all that space, which was somewhat daunting, but I also knew, down to the marrow in my bones, that even if I never brought a single thing into my new house, I was already home.

INTENTIONAL, HOME

MEMORY

MAKING HOME

BELONGING

MEMORY

UTOPIA

INDEX & CREDITS

MEMORY
Michelle Joan Wilkinson

they ask me to remember
but they want me to remember
their memories
and i keep on remembering
mine.
LUCILLE CLIFTON, "why some people
be mad at me sometimes"[1]

Michelle Joan Wilkinson, with her mother Pearlene V. Wilkinson, in one of Michelle's first homes, Brooklyn, ca. 1978

The work of making home is memory making; sensory reference points like sounds and smells create feelings that become stored in the memory banks as "home." We often process what home is through remembering and recalibrating the perceived attributes of our first homes. Memories of homes stay with us throughout our lives as we make and remake home as we age. In this section, Memory, the passage of time and the process of aging are recurring motifs. Through personal stories, photo essays, conversations, and reflections on "making home" in art and in life, the contributors reveal the potency of the past in shaping what we call home.

The Population Reference Bureau reports that "the US population is older today than it has ever been."[2] The United States Census Bureau found that, "in 2020, about 1 in 6 people in the United States were age 65 and over. In 1920, this proportion was less than 1 in 20."[3] The amount of available housing has to increasingly expand in order to provide for our nation's growing population of people over age sixty-five. To consider what it means to make home in the United States today is to consider how people across the nation's geo-graphical expanse will deal with the question of home as they age.

Connections between how we make home and how we care for memories were quite apparent to me on a recent visit to a senior living community, which I toured as a prospective home for myself, a fifty-something-year-old, and for a loved one who is over eighty. This community falls somewhere between a resort property and a sophisticated dormitory—on all counts, it is an amenity-rich residential experience. Although I knew it would likely be above my budget, I was curious about whether this type of home was something I might access now or aspire to in the future.

A major barrier to securing housing as we age is affordability. Do we stay in the homes we have been in, in some cases for decades, despite the fact that our family size may have shrunk due to children moving out, the family changing, and so on? If we live alone, is it appealing to consider cohabiting in our senior years, for companionship and cost savings? How

[1] Lucille Clifton, "why some people be mad at me sometimes," *Next: New Poems* (Brockport, NY: BOA Editions, Ltd., 1987).
[2] Regarding demographic changes, the Population Reference Bureau also notes: "The older population is becoming more racially and ethnically diverse.... The rising diversity among older Americans can't match the rapidly changing racial/ethnic composition of those under age 18, creating a diversity gap between generations." Mark Mather and Paola Scommegna, "Fact Sheet: Aging in the United States," Population Reference Bureau, January 9, 2024, https://www.prb.org/resources/fact-sheet-aging-in-the-united-states/.
[3] Zoe Caplan, "U.S. Older Population Grew from 2010 to 2020 at Fastest Rate Since 1880 to 1890," United States Census Bureau, May 25, 2023, https://www.census.gov/library/stories/2023/05/2020-census-united-states-older-population-grew.html.

Pearlene V. Wilkinson, Michelle Joan Wilkinson's mother, in the first apartment she purchased in the United States. After bad floods in 2023, the senior-only apartment building was deemed uninhabitable. Elmont, Long Island, 2022

many of us can afford costly senior living communities? How does the need for caregiving change our experience and requirements of home? And, perhaps most significantly, when we leave the homes we have known, what allows us to make home elsewhere? This is a central question explored in the pages that follow, in an essay by Sandra Jackson-Dumont, a conversation between Suchi Reddy and John Zeisel, and texts from the individuals behind residential projects for Hord Coplan Macht and Carehaus.

they want me to remember / their memories

Home can feel elusive for seniors who have memory loss or other cognitive impairments that can accompany aging. As short-term memory becomes less reliable, there is comfort in accessing memories from long ago and keeping them close. A strategy in some senior living communities is to have residents decorate the interior and, importantly, exterior areas of their rooms or apartments with mementos from their lives. As my loved one and I toured one of these communities, we noted

[4] John Zeisel, conversation with author, January 2023. See also John Zeisel, *I'm Still Here: A New Philosophy of Alzheimer's Care* (New York: Penguin Group, 2009).

the personalization of the spaces and the efforts to keep important life moments part of the present. Taking a cue from the design of residential spaces designated as "memory care" communities, the hallways were populated with memory boxes that are like windows into an individual's passions, their accomplishments, and their village of loved ones. These visual landmarks can also help residents with wayfinding and minimize the proclivity to wander that may accompany memory loss. The architects, environmental psychologists, and health professionals collaborating to design senior living communities understand that people who are grappling with memory loss return to the topic of "going home," whether they are in a new environment or in spaces that have been familiar, spaces they once called home. John Zeisel, a sociologist and dementia design specialist who has studied and built residential communities, explains: "When people with dementia say 'I want to go home,' it doesn't mean place, it means 'where my loved ones are.' . . . We create home. Home is vital to people living with dementia because if they don't have a physical and social environment that reinforces being present and being comfortable, they suffer. Home is really a treatment."[4]

The founders of Carehaus are innovating the social environment of home for seniors and disabled individuals. With a site planned for Baltimore, Carehaus has the goal of being the first intergenerational care-based cohousing project in the United States, in which those receiving care, the caregivers, and their families all live and are accommodated in the same building. The attention to both those receiving care and caregivers comes with built-in insight from cofounder Marisa Morán Jahn's artistic activism with domestic workers. By shaping a typology and

programmatic space that reflects the ways in which caregiving already happens within families and alongside paid home care, the planned design for Carehaus invests in the ecosystem of individuals, foregrounding relationships.

Another version of recreating home has taken shape in the "dementia villages" developed in the Netherlands and elsewhere, where the residents live in communities that resemble a quaint town with houses, a town square, and local businesses.[5] Although these village-style settings are not yet pervasive in memory care design in the United States, one residential community in the Midwest functions as "a kind of time capsule of 1930s and '40s small-town environments."[6] With indoor hallway ceilings painted with blue sky and clouds, the setting encourages residents to chat on faux front porches and gather in interior courtyards. Despite being designed to comfort seniors by reconnecting them to their pasts, such recreated neighborhoods draw from an American memory of residential life and domesticity that does not belong to all Americans.

"What if this wasn't your hometown?" one article on the design innovation has asked.[7] The truth is that despite the familiarity of its representations, this idealized model of home life may resurface memories of exclusion for some in the United States. As architect Dianne Harris notes in *Little White Houses*, "Postwar domestic environments became poignant ciphers for whiteness, affluence, belonging, and a sense of permanent stability for white Americans."[8]

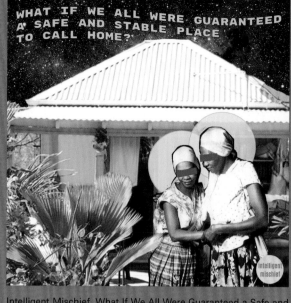

Intelligent Mischief, What If We All Were Guaranteed a Safe and Stable Place to Call Home?, 2024

Harris, like scholars before her, describes the racist policies of the Federal Housing Administration and the Home Owners' Loan Corporation alongside the complicity of the National Association of Home Builders in restricting where nonwhites could live or purchase property. Given that the current US population is the most diverse ethnically and racially ever,[9] it's feasible that a significant percentage of the nonwhite Census takers over age sixty-five would have experienced forms of housing discrimination, whether in the rental, purchase, loan, or appraisal processes. As Bryan Mason and Jeanine Hays of AphroChic write in this section about the challenges to Black homeownership, there is a "memory of Black life that differs significantly, in many cases, from the narratives of collective memory that surround but do not include us."[10]

[5] See Joann Plockova, "As Cases Soar, 'Dementia Villages' Look Like the Future of Home Care," *New York Times*, July 2, 2023, www.nytimes.com/2023/07/03/realestate/dementia-villages-senior-living.html; Annmarie Adams and Sally Chivers, "Deception and Design: The Rise of the Dementia Village," e-flux, September 2021, https://www.e-flux.com/architecture/treatment/410336/deception-and-design-the-rise-of-the-dementia-village/; and Larissa MacFarquhar, "The Comforting Fictions of Dementia Care," *New Yorker*, October 8, 2018, https://www.newyorker.com/magazine/2018/10/08/the-comforting-fictions-of-dementia-care.
[6] Dianne Lange, "An Innovation in Memory Care: Therapy through Design," Senior Planet from AARP, https://seniorplanet.org/an-innovation-in-memory-care-therapy-through-design/.
[7] Ibid.
[8] Dianne Harris writes that the federal government "institutionalized racist housing policies and practices in the offices of the Federal Housing Administration (FHA) with practices initiated by the Home Owners' Loan Corporation (HOLC) in 1933" and that "by 1945 the connections forged among homeownership, white identities, and citizenship had existed for decades in the United States, with the precise alignment of white identities and ideas about home shifting according to both time and locale." Dianne Harris, *Little White Houses: How the Postwar Home Constructed Race in America* (Minneapolis: University of Minnesota Press, 2013), 34, 14.
[9] Ibid., see note 2.

i keep on remembering / mine

Looking at what options await my senior living, I consider my own demographic makeup—African American and Caribbean American, female, raised in a city, accustomed to spatial density, attracted to elevated vistas that offer both prospect and refuge. What kind of recreated space might provide the glimmers of connection and reconnection to home for me? Where do I feel welcome?

Here, essayists bring their own perspectives to these questions—looking back and looking forward, musing on how our roots inform where we make home and how home informs the routes we can take. Joe Baker writes on the removal of his Lenape community from their ancestral lands, Sarah Lopez on the movement of people and building materials across the US–Mexico border, and La Vaughn Belle on how histories of resistance in Saint Croix, US Virgin Islands, are inscribed in its buildings. A conversation among residents of South Florida reflects on the varied communities that animate the Everglades, a region that is not only a protected environmental landscape but also a treasured cultural home.

Michelle Lanier, Gervais Marsh, and Camille Okhio contribute essays inspired by artists and designers who developed installations for *Making Home—Smithsonian Design Triennial*, while Elleza Kelley thoughtfully reflects on the aesthetics of "re-membering" home. Two visual essays reveal the quest for home across Black America(s)—coastal Georgia and the Sea Islands in a photo essay by Sheila Pree Bright and a never-before-seen landscape of Washington, DC, imagined with Artificial Intelligence by Curry J. Hackett. In capturing a nostalgia for what never was, Hackett shows how memory is both wistful and wishful. A recurring feature of these offerings is a longing for connection to ancestry and futures—both of which may be fractured in the present.

In 2016, for the exhibition *Home, Memory, and Future* presented at the Caribbean Cultural Center African Diaspora Institute, New York, curator Lowery Stokes Sims identified the dual impulse to mark spaces of community life and to affirm the continuity of one's presence in these spaces. She writes, "This sense of self-preservation—in all the senses of that term—conspires to force us all to interrogate how one defines 'home,' protects 'memory,' and projects the 'future.'"[11] Nearly a decade later, *Making Home* makes the case for protecting memory, particularly asserting generative memories of place and time as a way to carry the feeling of home into the future.

As contributors ranging from AphroChic to Carehaus affirm, making home is both a form of self-preservation and a function of communal care. While my home search continues, I think about the importance of being somewhere I will want to remember, somewhere that, when my memory fails, the path back to my place is lined with familiar mementos from those in my community. And for my loved one, I want space for both of us to age where aging is encouraged and making home is making new memories together.

[10] Bryan Mason and Jeanine Hays, "The Hard Work of Forgetting: The Black Family Home and the Two Sides of American Memory," in this volume, 118–24. See also Jeanine Hays and Bryan Mason, *AphroChic: Celebrating the Legacy of the Black Family Home* (New York: Clarkson Potter, 2022).
[11] Lowery Stokes Sims, "Home, Memory, and Future," in *Home, Memory, and Future* (New York: Caribbean Cultural Center African Diaspora Institute, 2017), 15.

BRYAN MASON
JEANINE HAYS

\mathcal{T}HE HARD WORK OF FORGETTING

The Black Family Home and the Two Sides of American Memory

Home is more than where you live; it's where you are remembered. Our story of home was shaped by the houses of our parents, relatives, and friends. Long before we met, married, or bought a home together, we were born into families with high rates of homeownership. We stayed at houses for long weekends, gathered at houses for special occasions, and frequently dropped by these houses on weekends, just because. We played, got into trouble, and learned in these houses. We are who we are, in part, because the culture of these houses, represented through their design, instilled in us a sense of memory.

While our childhoods were not unique, homeownership is not a common experience for the majority of Black Americans. Not every home is a house, and not every house a home. Home is a feeling that can be created nearly anywhere, conjured more from who and what is in a space than from the space itself. But it can also be taken away, replaced with persistent discomfort and the sense that you are somewhere you do not belong or are not wanted—a place that has no memory of you, that does not recognize you as central to its narrative. America perpetuates this feeling through instances of overt racism it enacts on its Black citizens and through the quieter misrecognitions, assumptions, and aggressions in between. In such moments, the memory of home is an invaluable reminder of who we are, braced against the weight of social prescriptions of who we can be. And in the dissonance of the dialectic between what we remember and how we are remembered, structures appear, woven into the fabric of our nation, illustrating a deep connection among homeownership, the

BRYAN MASON and JEANINE HAYS are the authors of *Remix: Decorating with Culture, Objects, and Soul* (2013) and *AphroChic: Celebrating the Legacy of the Black Family Home* (2022). Their media and design brand, AphroChic, celebrates African Diaspora cultures through their lifestyle magazine, podcast, and luxury home decor product lines.

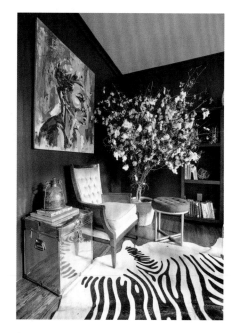

Shawna Freeman's cotton tree is an homage to her family roots. Her grandparents were enslaved in the deep South and picked cotton. They later became sharecroppers and eventually landowners who raised generations on the plant, providing their children and grandchildren with a foundation for a better life. Charlotte, North Carolina, 2022

MEMORY

[1] See Jessica Trounstine, *Segregation by Design: Local Politics and Inequality in American Cities* (Cambridge: Cambridge University Press, 2018).

[2] Common knowledge, a term developed by Bryan Mason, is a reflexive form of collective memory—the things that we know are true without our having to know exactly how or why, including misrecognitions and stereotypes.

[3] William Loren Katz, *The Black West: A Documentary and Pictorial History of the African American Role in the Westward Expansion of the United States* (New York: Simon & Schuster, 1996), 256.

[4] Mozell C. Hill, "The All-Negro Communities of Oklahoma: The Natural History of a Social Movement," *Journal of Negro History* 31, no. 3 (1946): 254–68. McCabe's plan to create Black voting majorities in every Oklahoma district resonated with the demographics of the territory at the time. In March 1890, an influential periodical noted, "At present, there are about 25,000 people in Oklahoma, 15,000 are Negroes."

[5] "The Encyclopedia of Oklahoma History and Culture: All-Black Towns," Oklahoma Historical Society, https://www.okhistory.org/publications/enc/entry.php?entry=AL009.

feeling of home, and the various uses of memory.[1]

The Black family home is a place that stands at the intersection of two distinct types of memory: America's collective memory and the individual memories of Black homeowners and families. In America's collective memory, the Black family home is mostly omitted—an erasure created and sustained by various mechanisms including the constructs we term "common knowledge," "the myth of happenstance," and "the hard work of forgetting."[2] But the social injustice of the Black family home in America serves primarily to justify and normalize the economic injustice of it, with the dramatic gap in homeownership between America's Black and white households making up a significant part of the massive wealth disparity separating the two.

Consequently, the Black family home exists, simultaneously, as it is known by those who inhabit it and as it is imagined by those who do not. The chasm between the two perspectives, filled with the processes, delusions, and oppressions that maintain it—and the many consequences that follow—is as deep as it is wide, with roots reaching far into our national past and implications for our future.

THE BLACK FAMILY HOME IN COLLECTIVE MEMORY

In 1890, Edward P. McCabe led a campaign to establish Oklahoma as an all-Black territory.[3] Though the effort failed, McCabe succeeded that year in founding the town of Langston, Oklahoma, with the dream of establishing Black political power in the state.[4] McCabe's agents searched the South for families willing to relocate. They were not hard to find. Early residents survived hard times and rough conditions, but eventually the town thrived. Langston is one of more than fifty African American towns and settlements founded in Oklahoma between 1865 and 1920, and one of the few remaining today.[5]

McCabe's story highlights the many roles African Americans played in shaping the nation, recalling levels of Black agency very different from what we assume of the time or imagine today. Conversely, popular notions of a white "Old West" support the erroneous view of African Americans as perennial outsiders

THE HARD WORK OF FORGETTING

[6] "Quick Facts: Oklahoma," United States Census Bureau, https://www.census.gov/quick-facts/fact/table/OK/PST045222.

[7] Bryan Mason and Jeanine Hays, *AphroChic: Celebrating the Legacy of the Black Family Home* (New York: Clarkson Potter, 2022), 10.

trying to forge a place in a country that is not our own, with no place in American history beyond the perpetual struggle for rights. It also relieves the nation of the burden of accounting for how Oklahoma's Black community, once more than 50 percent of its population, dwindled to less than 8 percent by 2022, a process we call "the hard work of forgetting."[6]

The hard work of forgetting is the act of shaping collective memory to fit a preferred narrative, obscuring history to minimize the importance of one group while privileging another. It is named for the level of effort it takes to constantly imagine and reimagine American history in ways that do not meaningfully or accurately include Black people.[7] Considering the many outlets through which collective memory is created and enshrined—from traditional, electronic, and social media to arts and academics—the scale of the work is exceeded only by the scope of its consequences.

Forgetting is one of many means by which the Black family home is excised from America's memory. Resultingly, within that conceptual tapestry, the Black family home is considered a peripheral and therefore unimportant symbol. It is given no meaningful place in the establishment of "American" identity, which defines itself, in the aggregate, if not as absolutely white, then resolutely Eurocentric. Mainly, America's collective memory limits the presence of the Black family home to a few narrow tropes: the majority—who are less fortunate than most white Americans; the exceptional—who are famous and therefore more fortunate; and the remainder—with "normal" homes presumably indistinguishable from those of white Americans. While these tropes elide the broad spectrum of the Black experience in collective memory, within the Black community, home is a place to remember and a means to resist omission.

MEMORY, CULTURE, AND DESIGN IN THE BLACK FAMILY HOME

For many African Americans, the relationship between memory and home begins with a simple dialectic: home is a place made of memories and a place where memories are made. The relationship allows Black homes to offer a memory of Black life that differs significantly, in many cases, from the narratives of collective memory that surround but do not include us.

Collective memory is ubiquitous. Colloquialized as "white gaze," it occupies nearly every public space. Consequently, home provides the best opportunity for Black Americans to remember, both individually and as a community, what collective memory

prefers to forget. Over time, this specific utilization of the home inspired a uniquely African American approach to interior design. Like all cultural artifacts, it functions in answer to universal human questions such as: Where are we safe? Where are we in control? Where are we recognized? Where are we celebrated? and Where are we remembered? Questions that, when answered, are foundational to the feeling of home.

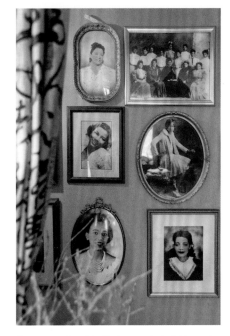

An ancestral wall in the home of chef Alexander Smalls, Harlem, New York, 2022

Respondent to these questions, African American design is distinguished against the global landscape of interior aesthetics by its lack of definitional rules concerning color palettes, furniture types, art preferences, or acceptable patterns— embracing diverse applications to facilitate an array of visual styles. A cohesive, if rarely studied, school of thought, the wide purview of African American design is rooted in wider cultural emphases on self-expression, which value personalization over strict adherence to form, enabling design to fulfill its required role in African American homes.

Design is the language of memory in the Black family home; one that, by necessity, differs in dialect from one home to the next. No two people will ever hold identical memories, nor will they be comforted by exactly the same furnishings or inspired by precisely the same colors. Therefore, African American design is far more concerned with its ends—creating feelings of safety, control, recognition, celebration, and memory—than with the means by which they are created.

Home is where our histories can be fully remembered and our identities fully expressed apart from the misrecognitions of common knowledge. Here family photos and framed remembrances pay homage to ancestors who braved the Great Migration; collected artworks reflect the beauty of Black bodies and the validity of our experience; and bookshelves hold the history of the African Diaspora and the reflections of its scholars.

While there is much to be said for the comforts of home as a site of memory, there is more at stake in the politics of collective memory than the discomfiture of a people in their homeland. The consequences of forgetting come in the harms visited on those forgotten and the myths woven by those who elect to forget.

THE HARD WORK OF FORGETTING

Through the processes of collective memory, the hard work of forgetting creates a veneer of normalcy around America's race-based socioeconomic inequalities, presenting them in common knowledge, not as predesigned outcomes, but as the "natural" results of an unbiased system of merit and personal choice. Though frequently disproven, this perspective, which we call "the myth of happenstance," obscures the causes and consequences of this condition, and the role of home in both.[8]

In 2016, the ratio of wealth between white and Black American households was a staggering 10:1, predicated largely on the inheritance of houses and property and intergenerational gifts enabling their purchase.[9] Such transfers have historically provided as much as 50 percent of American household wealth.[10] Yet, contrary to the myth of the American bootstrapper, this wealth was not built by the intrepid action of rugged individuals, but by the structured inequality of a system that facilitates the advancement of white Americans while ensuring that Black Americans remain marginalized.[11]

A 2015 study by the New School determined that:

> Throughout U.S. history, federal and state governments provided "wealth starter kits" for some Americans, giving gifts of land, education, government-backed mortgages and farm loans, a social safety net, and business subsidies to white families—sometimes exclusively, usually disproportionately, and subsidized precisely by those who were excluded: families of color. Beginning with the period of chattel slavery, when blacks were literally the property of white slave owners, and continuing through the use of restrictive covenants, redlining, general housing and lending discrimination—policies that generated a white asset-based middle class—and the foreclosure crisis (which was characterized by predation and racially disparate impacts), blacks have faced structural barriers to wealth accumulation.[12]

The policies that built the white middle class, including the Homestead Act of 1862, the New Deal, and the GI Bill, helped establish homeownership as the centerpiece of the American Dream.[13] Officially, efforts at restricting African American access to that dream have included exclusion from government-led wealth-building programs, the construction of the interstate highway system, urban renewal programs, and the doctrine of eminent domain.[14] Meanwhile,

[8] Mason and Hays, *AphroChic*, 251; Darrick Hamilton et al., "Umbrellas Don't Make It Rain: Why Studying and Working Hard Isn't Enough for Black Americans," The New School (2015); Amy Traub et al., "The Asset Value of Whiteness: Understanding the Racial Wealth Gap," Demos (2017), https://www.demos.org/research/asset-value-whiteness-understanding-racial-wealth-gap.
[9] United States Congress Joint Economic Committee, "The Economic State of Black America in 2020," US Congress (2020), 2; Hamilton et al., "Umbrellas," 3.
[10] Edward N. Wolff and Maury Gittleman, "Inheritances and the Distribution of Wealth or Whatever Happened to the Great Inheritance Boom?," US Bureau of Labor Statistics Office of Compensation and Working Conditions (2011), 2.
[11] Hamilton et al., "Umbrellas," 3.
[12] Ibid., 9.
[13] Brian H. Robb, "Homeownership and The American Dream," *Forbes*, September 28, 2021, https://www.forbes.com/sites/forbesrealestatecouncil/2021/09/28/homeownership-and-the-american-dream/?sh=48aee8d523b5.
[14] Mason and Hays, *AphroChic*, 132.

MEMORY

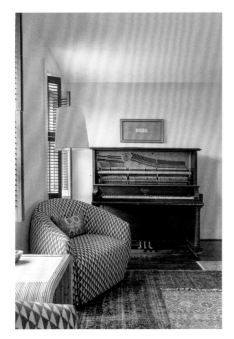

A vintage piano in Jason Reynold's town home, Washington, DC, 2022

unofficial acts include the explosions of violence that erased communities like Greenwood in Tulsa, Oklahoma; the town of Oscarville, Georgia; and Seneca Village in Manhattan.[15] Simultaneously, exploitative banking and realty practices target Black households, while an epidemic of racist practices in home appraisals drastically undervalues homes that Black Americans want to sell or overvalues homes we already own, either keeping us in or moving us out of the way.[16]

Memory is created in real time. Today, as a result of actions and policies that are neither natural nor happenstantial, only 44 percent of African Americans own homes, compared to 73 percent of white Americans.[17] Yet America's collective memory continually redacts itself, normalizing the impact of injustices it has given itself permission to forget.

THE FALLOUT OF MEMORY

The Black family home sits at the intersection of two distinct types of memory. At a glance, the difference between the two may seem insignificant. Beyond the social niceties of representation—the affirmation of being "seen"—there is presumably little importance in which homes appear more or less frequently in magazines, or how many boom towns we collectively remember came and went in the Old West. With further examination, however, connections appear, many of them rooted in the relationships between assumption and outcome, prejudice and marginalization, omission and forgetting—between memory and expectation.

Memory is the basis of future expectation. As human beings, what we believe can happen is largely predicated on what we believe has happened. If a society reshapes its memories through omission and fabrication to limit the range of possibilities or level of impact that a people can be allowed to have had in its history, it directly reduces the scope of both going forward in terms of what those limited can imagine and what the society can

[15] Ibid., 77.
[16] Elizabeth Korver-Glenn, "Compounding Inequalities: How Racial Stereotypes and Discrimination Accumulate across the Stages of Housing Exchange," *American Sociological Review* 83, no. 4 (2018): 627–56; Jonathan Rothwell and Andre M. Perry, "How Racial Bias in Appraisals Affects the Devaluation of Homes in Majority-Black neighborhoods," Brookings, December 5, 2022, https://www.brookings.edu/articles/how-racial-bias-in-appraisals-affects-the-devaluation-of-homes-in-majority-black-neighborhoods/; Jacob S. Rugh and Douglas S. Massey, "Racial Segregation and the American Foreclosure Crisis," *American Sociological Review* 75, no. 5 (2010): 629–51.
[17] Brenda Richardson, "More Americans Own Their Homes, but the Black-White Homeownership Rate Gap Is the Biggest in a Decade, Survey Finds," *Forbes*, March 4, 2023, https://www.forbes.com/sites/brendarichardson/2023/03/04/more-americans-own-their-homes-but-the-black-white-homeownership-rate-gap-is-the-biggest-in-a-decade-survey-finds/?sh=1bdd628b3563.

accept. Simultaneously, it manipulates the environment within which such possibilities take shape, curtailing them to fit expectations while hiding the effort of constructing the result. Oppression becomes reflexive, ubiquitous, and home becomes the only space available for telling the story another way, for maintaining alternative expectations by expressing memory, sometimes in something as simple as the color of a wall, an arrangement of patterns, or choice of art.

So, what would it mean for Black Americans to own more homes and for America to have a more accurate memory? Recalling the entirety of our collective past would mean acknowledging the level of assistance historically afforded white homeowners and establishing restorative frameworks for Black Americans, closing gaps in wealth and inheritance that have existed for centuries. It would mean strengthening the Fair Housing Act to end discriminatory real estate and lending practices, addressing a string of harms that encompass, to this point, the entirety of American history. Most of all, it would mean successfully reconciling the two memories of the Black family home, changing our collective definition of America and our expectation of who can be at home here.

MEMORY

CURRY J. HACKETT

DC, SOMEDAY, SOMEWHERE

CURRY J. HACKETT is a transdiscipli-
nary designer, artist, and award-winning
educator. His practice, Wayside, explores
relationships between culture and land to
inform meaningful art and critical research.

DC, Someday, Somewhere is a series of scenes made with Midjourney, a program that creates images from text prompts using generative artificial intelligence. I have used this tool to conjure hundreds of scenes that insist on the existence and inevitability of Black joy and abundance. While I consider these images to be part dream, part memory—fictional near-futures—they are rooted in the very real cultures and histories that structure Black daily life.

The series takes inspiration from memories of my "chosen" home of Washington,

DC, from 2008 to 2020. The images look to bodies of water, streetscapes, and infrastructure as plausible sites of reclamation by Black Washingtonians in a speculative future. Moreover, these scenes crosspollinate Black life in DC with other Black aquatic cultures of the American South—Southern Appalachia, South Carolina's Lowcountry, and the Mississippi Delta—were of particular interest in the creation of this series.

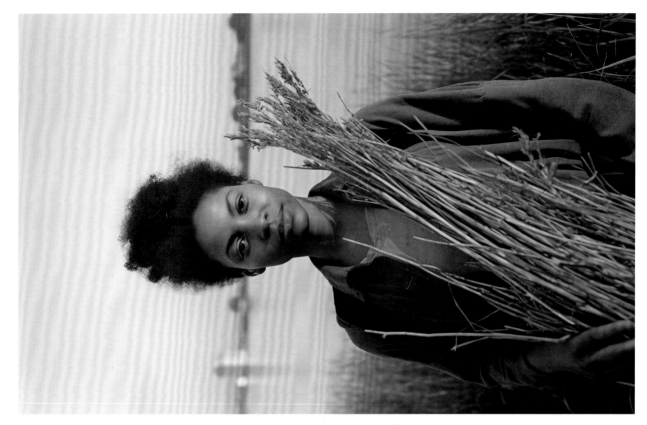

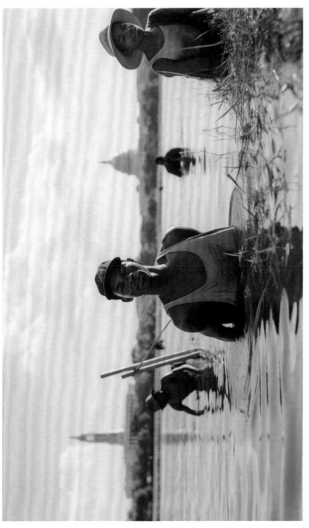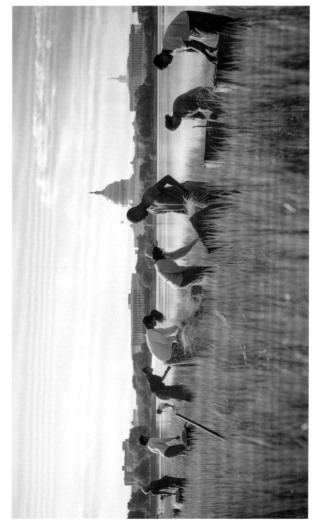

Black farmers appropriating a flooded tidal basin as a rice field and wading pool, 2023

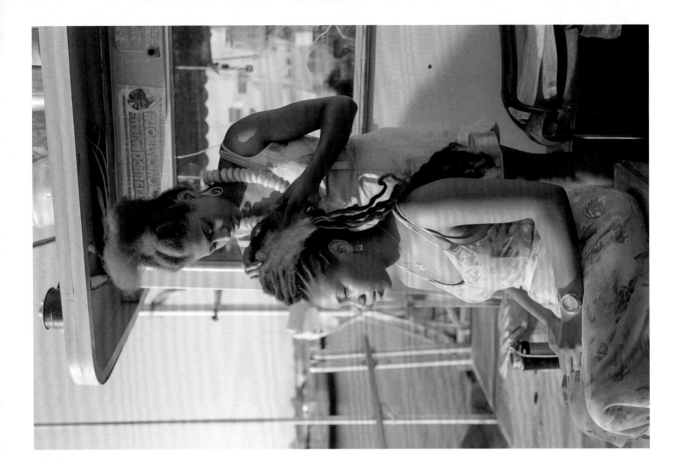

A Black woman-owned beauty kiosk at the fish market along the Potomac River, 2023

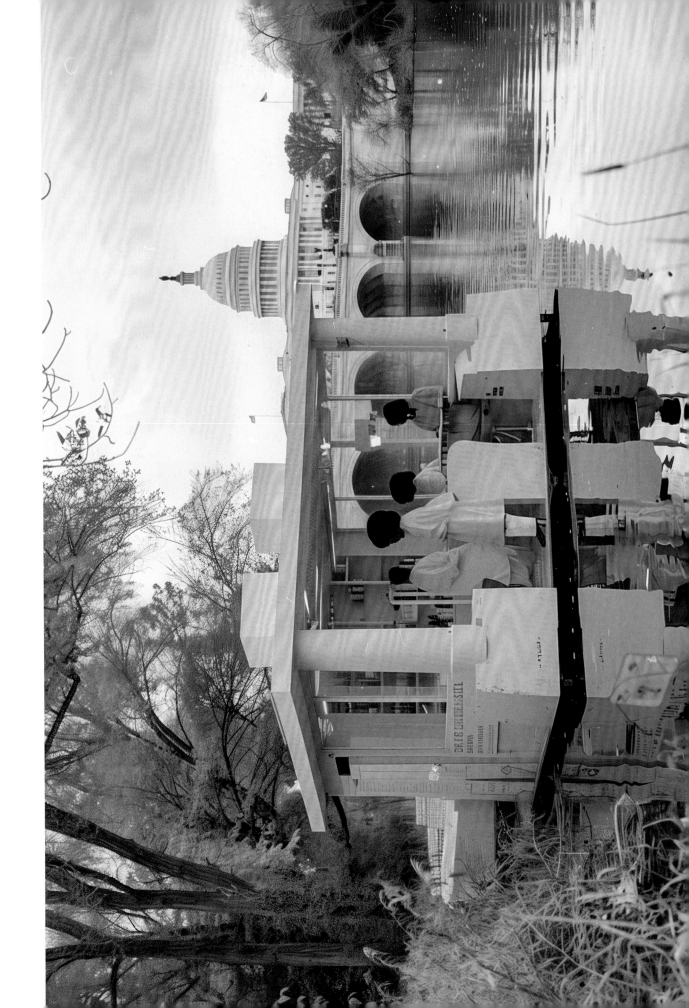

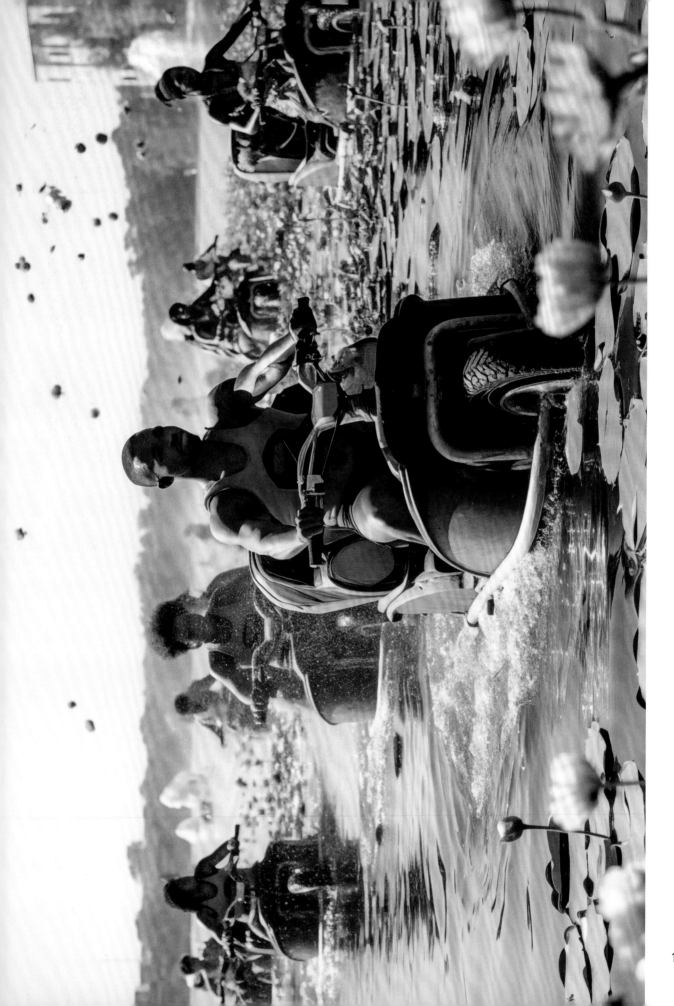

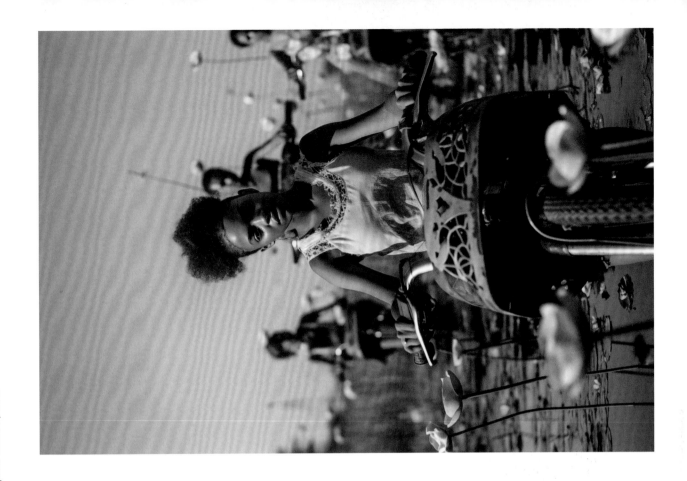

Black youth ride aquatic four-wheelers through lily pads in bloom at Kenilworth Park and Aquatic Gardens, 2023

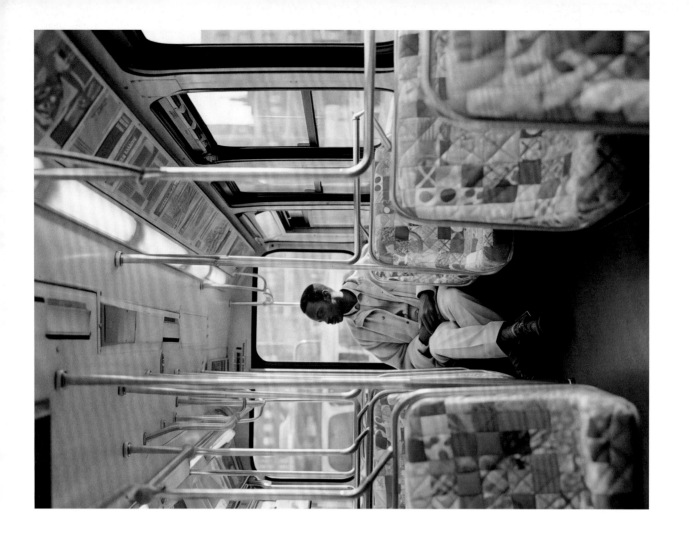

A quilted streetcar cruising down H Street NE, 2023

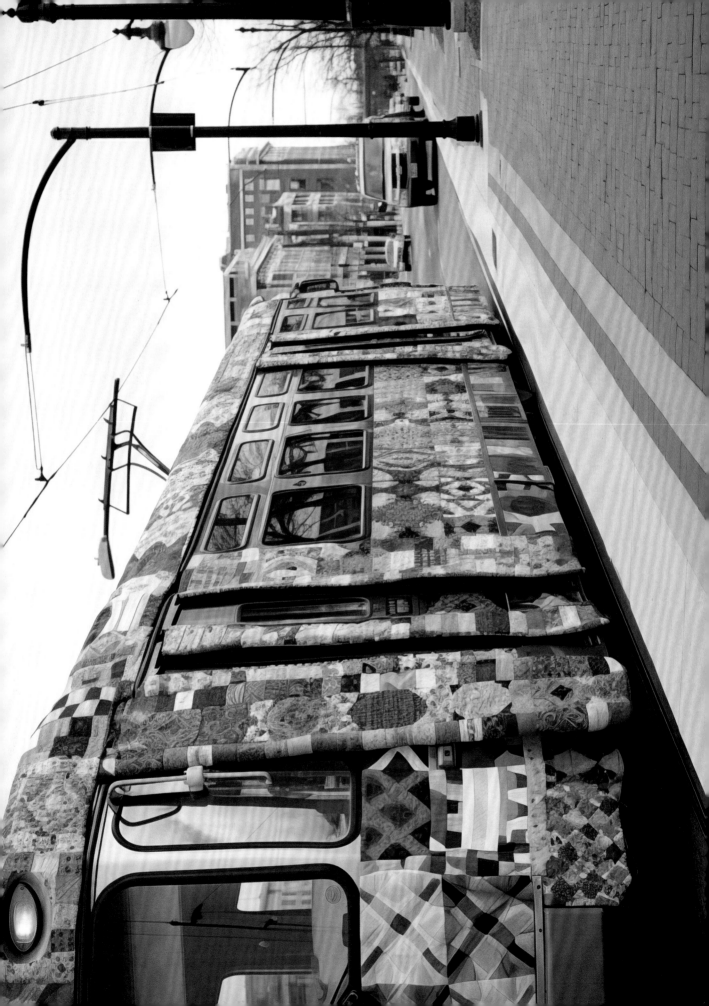

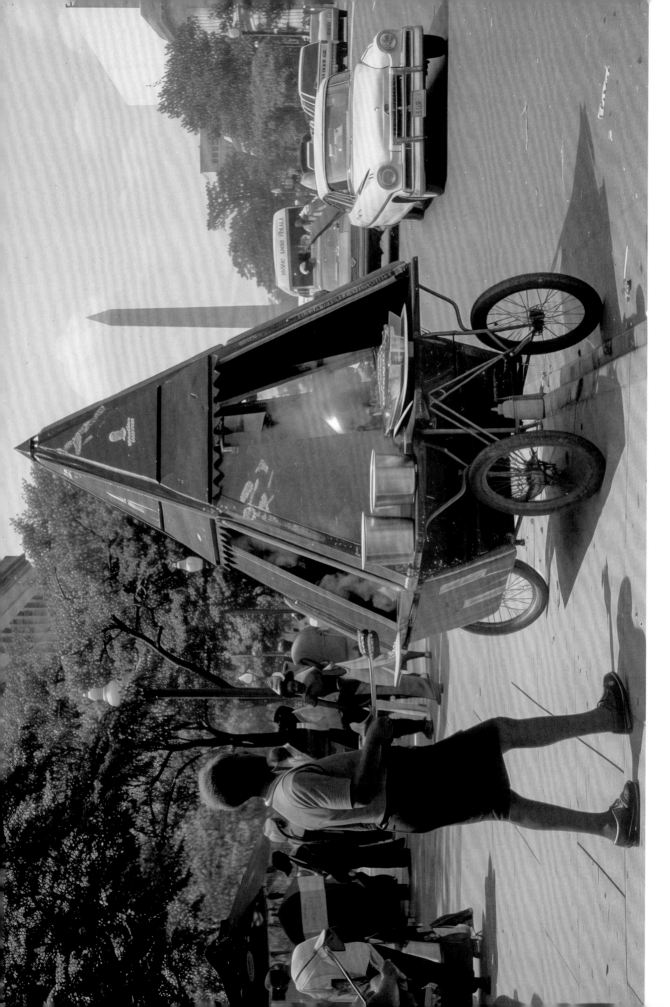

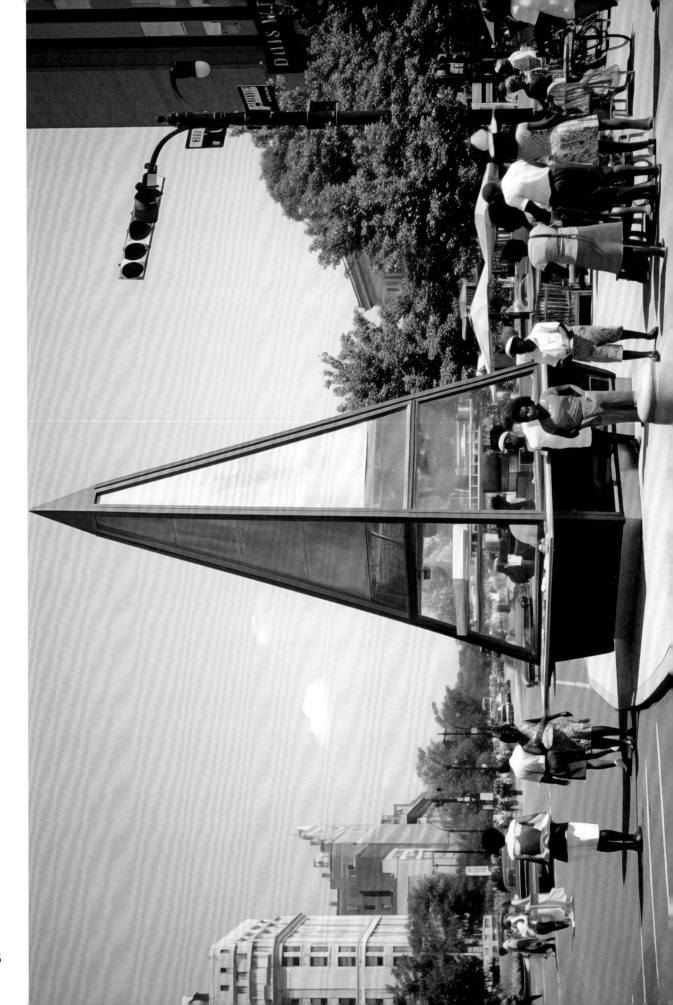

Black-owned food kiosks, invoking the Washington Monument's pyramid, along Pennsylvania Avenue, 2023

𝒜 FAMILY STORY

This is not just the story of my grand-mother, Stella Whiteturkey Fugate, known to the US Government as Delaware Roll Number 31156, and holder of Certificate of Homestead Allotment Number 16480. It is a Lenape story, a tale that spans both the past and the present.

JOE BAKER is an artist, educator, curator, and culture bearer who has been working in the field of Native arts for forty years. He is an enrolled member of the Delaware Tribe of Indians of Oklahoma and cofounder and executive director of Lenape Center in Manhattan. He is a member of the Simon Whiteturkey family and direct-line descendant of Lenape leaders. Baker is an adjunct professor at the Columbia University Mailman School of Public Health in New York.

On February 8, 1887, Congress passed the Dawes Act, named for its author, Senator Henry Dawes of Massachusetts. Also known as the General Allotment Act, the law authorized the US president to break up reservation land, which was held in common by the members of a tribe, into small allot-ments to be parceled out to individuals. Thus, Native Americans registering on a tribal "roll" were granted allotments of reservation land. The purpose of the Dawes Act and subsequent acts extend-ing its initial provisions was purportedly to protect Indigenous property rights, particularly during the land rushes of the 1890s. However, the results were devasting for Native communities and caused the loss of vast acreage of tribal lands.

The Lenape, whose ancestral land was situated within what we know today as the states of New York, New Jersey, Delaware, and Pennsylvania, were subject to the Dawes Act. Two centuries of European encroachment ultimately led to the forced removal of the Lenape from the Delaware Valley and Hudson River Valley to the frontier. The Lenape were given the name "Delaware" by Sir Thomas West, 3rd Baron De La Warr, in 1610, and it is the name used in all Lenape treaties and among most tribal members today.

Beginning in 1829 and ending in 1831, the Delaware tribe moved to the junction of the Kansas River and Missouri River in present-day northeastern Kansas. Following the Civil War, white en-croachment and railroad speculation increased, and the Delawares were pressured to cede their lands in Kansas and relocate to Indian Territory. The lands were select-ed to be in as compact a form as possible and included an area equal to 160 acres for each man, woman, and child. Given that a total of 985 Delaware were removed to lands within the boundary of the Cherokee Nation, Delaware tribal members also became citizens of the Cherokee Nation (dual enrollment).

Stella Whiteturkey Fugate, early 1900s

My family, the Simon Whiteturkey family, was among those Delaware families that were removed to Indian Territory in 1867. Thus began the complex and violent story of a family whose allotment lands were discovered to have vast pools of oil just below the ground's surface.

Stella, Pearl, and Bess before boarding the train in Bartlesville, Oklahoma, to go to finishing school in Missouri in the early 1900s; they attended for only a year before the "Reign of Terror" murders in Osage.

The unresolved mysteries surrounding the allotment, the death of my grandmother, and the tragic events that befell our family have remained a haunting presence in my life since childhood. The stories of my Lenape ancestors, entangled in a web of greed and lawlessness on Indian lands, continue to resonate with me. I am painfully reminded of the injustices inflicted upon our people, from the forced removal from our ancestral lands in the Northeast to the silence and lack of recognition in response to the genocide that shaped our American identity.

The journey begins in 1904, where my family's history converges with the 80.95 acres of land granted to Stella Whiteturkey Fugate by the Cherokee Nation and officially recorded on May 12, 1908. The Whiteturkey Fugate family were allotted a total of 610 acres of oil-producing land. The land was located north of Dewey, Oklahoma, in Washington County. However, questions arise regarding the validity of the oil and gas leases granted by Stella's father, James R. Fugate, who acted as her guardian without any recorded authority or legal guardianship. The existence and renewal of these leases remain shrouded in uncertainty. Why were the assignments of the 1904 lease not recorded until 1944? Did the lease expire in 1915 or was it voided due to non-consent of the titleholders?

In a series of unfortunate events, the surplus land allotted to Stella Whiteturkey Fugate was eventually deeded to Cecil Peters after a sheriff's sale in January 1932, prompted by a defaulted mortgage. The legality of this sale is highly questionable, as the minor children, including Stella's heirs, were not bound by the mortgage due to its partial release in 1924 and the absence of recorded guardianship by Lillie Whiteturkey Fugate. The fate of Stella's son, Wilbur Wright, adds another layer of tragedy, as he met a gruesome end in 1934. *The Bartlesville Examiner Enterprise* reported his death in 1934:

> Killed by Train
> Mangled Body Identified as That of Wilbur Wright
> by his Fingerprints

A FAMILY STORY

The body of a young man found at 6 am this morning mangled beyond recognition on the Santa Fe tracks a mile North of Dewey was identified as that of Wilbur Wright, 18, of Dewey. Identification was made by comparing fingerprints taken by John Creed Jr. with Sheriff Office records. Wright's prints had been taken when he was jailed in connection to the Wadie Whittenberg forgery case. He was later acquitted of the charges by a jury. Parts of the body were scattered for 28 yards and the arms and legs were severed from the body and badly mangled.

Was this a murder connected to the series of land grabs and defaulted mortgages surrounding the family? Unfortunately, no investigation into his death took place, a common occurrence for deaths of American Indians during that time.

The intricate web of lease swapping (trading of leases without knowledge or consent of the owner) involving the Cherokee Development Company, the Prairie Pipeline Company, and numerous other entities further complicates the narrative. It is essential to highlight that these activities were taking place without proper authorization or permission on Native lands.

During the 1960s, under the careful stewardship of my mother, Liberty Wright Baker, the Stella Whiteturkey Fugate allotment appeared to find some semblance of peace. With no active oil production, the wells were capped, and efforts were made to mitigate the damage caused by saltwater. The land was instead leased for farming purposes, allowing crops like alfalfa and soybeans to flourish in the fertile river-bottom lands of the Caney River.

In a poignant turn of events, it took ninety years after the unauthorized construction of a pipeline by Prairie Pipeline through the allotment for the Plains All American Pipeline LP to announce its plan to build a new pipeline in 2004. This new pipeline, following the exact path of its 1914 predecessor, would cross the Stella Whiteturkey Fugate allotment. My mother fought tirelessly against this encroachment. The courts ruled in favor of the Plains All American Pipeline LP, citing the unauthorized 1914 Right of Way on Native lands granted to Prairie Pipeline, and the pipeline was constructed without the consent of our family. Such action impacts land that is now being farmed and perpetuates government interference on allotment land.

While the Dakota Access Pipeline protests beginning early in 2016 as a grassroots opposition to the pipeline construction in the northern United States brought national and international attention to the pipeline, thousands of individual protests among Native families have been underway for generations, as in the case of my family. This history of ongoing violence directed toward Native people and Native lands is largely unrecognized by the general

Baker walking on ancestral lands in Dewey, Oklahoma, 2018

population, as is the genocide of the founding of the United States of America.

Amid this ongoing struggle for recognition and justice, *Making Home—Smithsonian Design Triennial* serves as a beacon of hope and understanding. It shines a light on the far-reaching consequences of a complex history of colonization and brings forth a silenced narrative that deserves to be heard. Through the unfolding of this exhibition, visitors are reminded that Indigenous people are not mere relics of the past, but vibrant members of contemporary society. We exist in the present, and our voices, our stories, and our lives are equally deserving of acknowledgment and respect.

MEMORY

A FAMILY STORY

\mathcal{T}HE HOUSE THAT FREEDOMS BUILT

I live on an island that was originally called Ay-Ay by its first inhabitants but was renamed Santa Cruz by Christopher Columbus and then again renamed Saint Croix by the French. We, however, pronounce it like the English, who, along with six other nations, claimed us at one point or another and sometimes at the same time. The French were the first to build lasting structures, and when the Danes purchased the island, they overlaid "Christiansted" on the French town of Le Bassin, making it the capital of the Danish West Indies. They later created other towns, also to be named after Danish royalty, Frederiksted and Charlotte Amalie, the first located on the western end of Saint Croix and the latter a port town on the island of Saint Thomas.

LA VAUGHN BELLE is a maker of maps, myths, and monuments. In her multidisciplinary practice, she creates narratives from the whispers and fragments found in various kinds of archives, including the sea, the trees, the land, and the body. Her studio is based in the Virgin Islands.

I work in Christiansted, a town laid out on a grid with many public buildings on its waterfront integral to the colonial project: a fort equipped with cannons and dungeons, a scale house, a customs house, and a chapel (of course). With many of these buildings now federalized, as part of the United States National Parks system, there are some elements that are now gone—like the slave auction block—or removed from public view—like the whipping post. Despite attempts to erase some of these painful components, history leaves scars.

Looking at the Danish building codes of 1747, there are traces of how race became atomized into everything. The forbiddance of thatched roofs and wattle-and-daub structures often used at the time in West Africa was not just about the fear of fire and a quest for less combustible materials. The attempt to corral the free Black population into a specific area of town named Neger Gotted (later to be known as Free Gut) had no non-racialized cover. It, too, was about social control. Many of the wooden cottages that the

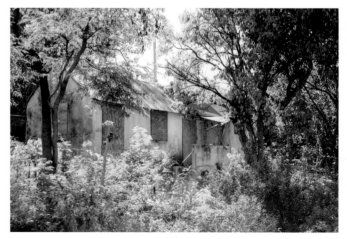

La Vaughn Belle's artist studio in the Free Gut area of Christiansted, St. Croix, before renovation in 2011

MEMORY

formerly unfree built still stand today. However, since some are abandoned and derelict, they are susceptible to fire yet again. As their transient occupants are often addicted to illicit drugs, fires can occur as a result of careless stupors.

My artist studio was one of those abandoned cottages. It, too, had been neglectfully burned and then degraded to another, deeper form of abandonment, the kind that slips into invisibility, as can also happen with people. Located in the Free Gut on the western end of East Street, the property transformed my art practice. During the long renovation process, I developed an intimate knowledge of its materials, researched the history of its former owners, and conducted dozens of interviews with neighbors and former residents of the town, which led me on a journey that was speculative, a little fantastical, and protoscientific.

I wanted to know how someone who was born free, then cargoed across the Atlantic, worked from dayspring to eventide, managed to elude the death covenant of the cane field, managed to make enough money to buy themself back, and then make more money still to purchase a house. I wanted to know what these spaces meant to someone whose freedom was tenuous. What is freedom when manumission means, if you are a man, you must hunt runaway slaves; if you are a woman, you cannot wear lace or chintz; if you are either, you must be in the house by ten p.m., you must not gather in public, you must carry your free papers at all times, you cannot marry whites (although if you are a woman you can be a man's "housekeeper"), you cannot hold a license for trade or for a tavern, and you certainly better not be harboring any runaway slaves, although you can own slaves, and some most certainly did.

This long process of wonderings and inquiry led to the work Constructed Manumissions (2017), an installation of three small wooden houses made entirely of fretwork, ornamental open designs made by cutting patterns with a bandsaw. Fragile by design, they have no frame and were made without nails or glue. Instead, the walls are mortised with removable metal pins and the roof is buttressed by its own weight. Reaching just under two feet, the structures also have no

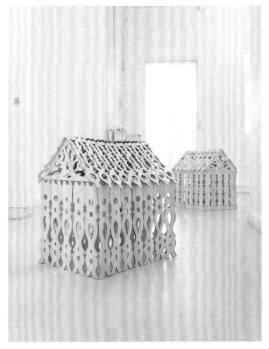

La Vaughn Belle, Constructed Manumission, featured in the solo exhibition *Ledgers from a Lost Kingdom* at meter, Copenhagen, Denmark, 2017

THE HOUSE THAT FREEDOMS BUILT

windows or doors, like magic houses in a fairy tale requiring a secret phrase or password for entry.

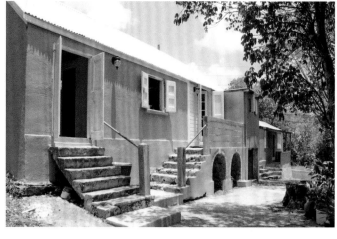

La Vaughn Belle's artist studio in the Free Gut area of Christiansted, St. Croix, after renovation in 2016

The shape of the houses is drawn from the architecture of my studio and the houses of Free Gut that are of a similar design. The interlacing patterns in the walls and roof are taken from fretwork that is prominent in the town of Frederiksted. Located on the other side of the island on the western coast, Frederiksted was built later than Christiansted, and has wider streets, a small harbor, and its own fort with cannons, dungeons, and customs house. Christiansted and Frederiksted are considered twin cities with a similar layout and similar street names. Today the marked difference in Frederiksted is its history as a site of rebellion, made visible by its abundance of Victorian-style fretwork. These wooden ornamental designs were added to buildings during the reconstruction of the town after the largest labor revolt in Danish colonial history occurred there in 1878. Known as the Fireburn, the revolt began on the day that laborers' annual contracts would be effectuated. On that day, workers who had not seen much improvement in their living and working conditions since slavery (with some effectively arguing that conditions were worse) burned down a third of the town and over fifty plantations. In the aftermath of the death and destruction, wages did go up, conditions did improve, and the revolt set into motion the beginning of labor unions in Saint Croix. I am intrigued by how this history of resistance was inscribed in the buildings' reconstruction and proliferation of fretwork patterns. The reconstruction is a kind of monument, as it collapses time and is a record of negotiated power.

Making Constructed Manumissions larger, closer to the scale of a human, created a different set of considerations. I thought about bodies and home, how we create safety, and how we live within those limits and boundaries. But mostly, changing the scale gave me another opportunity to think through the relationship between freedom and memory and how both seem to be spaces that we not only construct but inhabit.

"The House That Freedoms Built" is an edited excerpt from the essay "The Alchemy of Creative Resistance," originally published in *Small Axe 23*, no. 60 (November 2019); 119–30.

MEMORY

WHAT'S IN A MATERIAL?
Echoes of a Mexican Homeplace in a Texan Exurb

The ephemeral movement of capital, people, and ideas across the US–Mexico boundary has always been mirrored by and intrinsically related to the movement of everyday objects, goods, and materials— even heavy inertial matter like stone, excavated hundreds of miles from the US–Mexico border and carried north. As an architectural historian working at the intersection of material history and US–Mexico migration, I have been studying Mexican stone since I first noticed it about ten years ago. During research trips to Guanajuato, Jalisco, and Michoacán, I became aware that many of the buildings projected similar aesthetics; all were made from so-called local stone. This set me down a path that has spiraled into a larger book project on the history of Mexican stone and networks of labor, through which I met a stone distributor and architect from Nuevo Leon (but living in Austin, Texas) who introduced me to Oliver Cueva, the protagonist of this short essay. Here, I explore how his life, entangled with Mexican and American places and peoples, has resulted in a home that speaks not only to his personal trajectory but also to a macro history of inter- and intranational exchange. Indeed, evidence of an ecology of home building tethered to migrations and movements is nested in the history of Cueva's house in Manor, Texas.

Cueva's migration history mirrors in some ways that of his family. The Cueva family lost land and wealth during the Mexican Revolution of 1910–17 when his great grandfather's hacienda was expropriated; the land was broken up into small parcels and redistributed in national efforts to abolish indentured labor and create a self-sustaining class of small-scale land-owning farmers. Political and social tumult ignited movement that continued four generations later. Born in Los Angeles, Cueva moved with his family back to Jalisco when he was a baby, only to

SARAH LOPEZ, a built environment historian of twentieth-century Mexico and the United States, is an associate professor at the University of Pennsylvania in the Stuart Weitzman School of Design, Philadelphia. Lopez is the author of *The Remittance Landscape: Spaces of Migration in Rural Mexico and Urban USA* (2015).

MEMORY

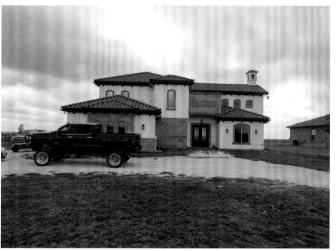

Oliver Cueva's home in Manor, Texas, 2020

return to the United States when he was six. Thereafter, he would make annual visits to Mexico during the summers, and it was in Mexico on his grandfather's agave ranch that both Cueva and his father learned how to work heavy equipment. In Austin, Cueva's father worked as a hauler, moving trash to landfills. Cueva remembers being eight and going to the yard where they parked the dump trucks. "I didn't like it, but it shaped me....I know what it is to start at the very bottom and build something."[1]

Oliver Cueva in front of his home in Manor, Texas, 2019

In 2012, Cueva was able to buy his first dump truck and start his own hauling business; by 2020, he owned six trucks and contracted drivers with their own trucks, dispatching fifteen to twenty trucks a day. His business expanded alongside Texas's booming construction industry, which eventually enabled him to pivot from hauling the construction materials of others to realizing a construction project of his own.

In the city of Manor, Texas, twelve miles northeast of Austin, where "it feels like you are entering Mexico when you drive east"[2] as serial rows of single-family houses give way to plots of undeveloped farmland, Cueva built a stately "Spanish-style" house. White stucco exterior walls are partially clad in stone, red Spanish tiles protect the roof, ornate iron grillwork covers the windows, and Doric-style columns emphasize the exterior facade and interior entryway and frame the view from the back porch. Most homes in this majority-white city are suburban ranch-style houses with brown shingle roofs. By contrast, Cueva's home presents evidence of hard-earned fiscal health and a commitment to Texas through distinct formal characteristics. He explained, "I think by the end it will really stand out....I already know what the final product will be. It will be just like I want it. I am proud of the house and want the house to define me."[3]

But Cueva's house is not a generic Spanish-style home, the likes of which are found throughout cities like Los Angeles, Phoenix, and San Antonio. Rather, the labor and artisans he employed to construct the home and the materials he used, including Mexican *cantera* for the exterior, ensure

[1] Oliver Cueva, interview with author, April 2019.
[2] Cueva's architect Roberto Escamilla, interview with author, April 2019.
[3] Cueva, interview with author, October 2020.

that his home is recognizable to people from (and familiar with) Mexico. In Mexico, cantera—a Spanish word that means "quarry" but also doubles as a commercial term to describe "Mexico's marble"—is a mottled volcanic rock found in approximately ten Mexican states and is also known as "tuff." While some pre-Columbian sites like Mitla, Oaxaca, are built with cantera, it is more characteristic of the plazas, cathedrals, municipal buildings, haciendas, and elite residences of the Mexican colonial period. More recently, since at least the 1970s and increasingly since the 1990s, Mexican migrants living in the United States have engineered a market to bring Mexican cantera north, catering to a predominantly Mexican and Mexican American clientele. The sedimented mass of compressed volcanic matter—including cubic miles of ash and the Earth's crust burst into millions of fragments—when cut, reveals a rough surface interrupted by seemingly random sparkling crystals that create a unique composition recognizable to a discerning eye.

Geographic specificity was key to Cueva's design process. He hired a Mexican architect—Roberto Escamilla from Nuevo Laredo—as well as construction workers, ironsmiths, masons, and artisans from different places across Mexico who were working in Texas. Together they realized exterior and interior finishes that consciously reference and reproduce spatial and material norms found in Mexico. The home includes cantera flooring, a hand-chiseled cantera fireplace, a tripartite niche for the Virgin Mary or other sacred relics finished with cantera tiles, frosted glass double-hinged windows that cover ornate wrought-iron grilles, and neoclassical columns framing a view out the back patio. Wood-frame construction—common in the United States and very rare in Mexico—is plastered over and used to support such large blocks of cantera that it looks, at first glance, as if the house is masonry construction.

"Mexican cantera" generalizes what is a highly specific and regional material. Cueva did not use just any Mexican cantera; instead he imported *cantera piñon* from his home state of Jalisco, known for its coral-pink hues deepened with brown undertones that distinguish it from cantera found in places like San Luis Potosí and Querétaro (remarkably, cantera from Oaxaca is a beguiling green). According to Cueva, "the whole idea of this [house] is to remind me of where I'm from, [to] bring a bit of Mexico here. My grandmother lived in a *portal* [house with a covered and arcaded porch]; that's why I have a lot of arches." In addition to arches, Cueva's choice to build

[4] Cueva, October 2020.
[5] Abigail Van Slyck, "Mañana, Mañana: Racial Stereotypes and the Anglo Rediscovery of the Southwest's Vernacular Architecture, 1890–1920," *Perspectives in Vernacular Architecture* 5 (1995): 95–108.
[6] Phoebe Young, "The Spanish Colonial Solution: The Politics of Style in Southern California 1890–1930," in *Design in California and Mexico 1915–1985: Found in Translation*, ed. Wendy Kaplan et al. (New York: Prestel, 2017), 46–83; Phoebe S. Kropp, *California Vieja: Cultural and Memory in a Modern American Place* (Oakland: University of California Press, 2006).
[7] See "Latino/a and Latin America," in Mauricio Tenorio, *Latin America: The Allure and Power of an Idea* (Chicago: University of Chicago Press, 2017), 76–101.

WHAT'S IN A MATERIAL?

in Manor enabled him to also conjure a vista, a horizon that echoes the expanse found in his grandfather's agave fields: "Now I am in Texas, [but] in the country. That's me."[4]

Scholars have shown how generic Spanish-style architecture in places like California and Texas was often commissioned and designed by Anglos to cul-

Oliver Cueva's *cantera portales* (arcaded porch) under construction, with a view of undeveloped land in Manor, Texas, 2019

tivate a "historic" regional style intended to assert the racial superiority of whites[5] by, in part, encapsulating Mexicans as part of a past nostalgic narrative.[6] Cueva's Spanish hacienda–style house allows him to stake claim to both American cities and his Mexican homeland, forging a highly specific and personal identity that carries past memories into an ongoing present. Rusty pink cantera blocks secured to his facade do cultural work, announcing his arrival in the United States, arrival to a new socioeconomic class, while also exhibiting enduring ties to both a colonial and prerevolutionary Mexico. Cueva, after four generations of continuous migration, displacement, war, peace, and confrontation with the hegemony of US "assimilation"[7] and involvement with the Mexican construction industry, uses cantera piñon, the same material once used in Jalisco's dismantled haciendas, now presented to new audiences in Manor. Such efforts are tactical, strategic, and emotional. Rather than referencing a homeplace through ephemeral objects like photographs and tapestries, a piece of ground excavated from "home" is carried a great distance and planted in and on another piece of ground. While moving materials from a home left behind to a home under construction might achieve the feeling of home, it is actually through the process of designing and constructing such a home that one's connections to distant lands are fortified and nurtured.

REVEREND HOUSTON R. CYPRESS
DINIZULU GENE TINNIE
DR. WALLIS TINNIE
TRACEY ROBERTSON CARTER
CORNELIUS TULLOCH

EBB + FLOW

Design in Dialogue with the Florida Everglades

In South Florida, the homes of many marginalized communities are under threat from the effects of climate change. The homes of the region's wildlife species are also in danger. With the future preservation of the Everglades uncertain, how are its stakeholders advocating for and protecting this unique ecosystem for future generations? This question was at the center of a series of roundtable discussions hosted by Artists in Residence in the Everglades (AIRIE) and Cooper Hewitt, Smithsonian Design Museum. In these conversations, the knowledge and experiences of Seminole, Miccosukee, and Black communities in South Florida were discussed alongside the role of institutions in engaging communities and inspiring value systems. Everyone can play a vital role in the transfer of knowledge, safeguarding, and restoration of the Everglades by amplifying local histories and advocating for lifestyle and policy changes. These conversations, condensed here for *Making Home*, examined environmentally conscious approaches to building technology, the ways we exist within our cities, memory keeping, and shared Indigenous design strategies across the Caribbean as forms of advocacy for the Everglades.

MEMORY

REVEREND HOUSTON R. CYPRESS is a Two-Spirit poet, artist, and activist, from the Otter Clan of the Miccosukee Tribe of Indians of Florida. Through his artistic practice, Houston explores and articulates queer ecological knowledge through community-based artistic, mystical, and shamanistic techniques.

DINIZULU GENE TINNIE is a New York-born visual artist and designer, writer, educator, and an activist in historical preservation and cultural affairs. He relocated to Miami in 1974, where he joined the iconic Miami Black Arts Workshop, cofounded the broader Kuumba Artists Collective, and chaired the newly formed Art Department while teaching at historically Black Florida Memorial University. The legacies of the Transatlantic slave trade inform his artwork and advocacy.

DR. WALLIS TINNIE, granddaughter of the late Seminole Maroon Florence Ealer Jones Hamm, was born in West Palm Beach, Florida. Her work focuses on the presumptions and agendas of colonization prevalent in the language of literature, criticism, and law. Dr. Tinnie serves as President of the Florida Black Historical Research Project, Inc. A Miami Dade College Professor Emerita and former protocol officer of the City of Miami, she has served as a long-time cultural programmer. She was one of the chief organizers of South Florida's Annual Pan African Bookfest and Cultural Conference spearheaded by the nonprofit African American Caribbean Cultural Arts Commission, which she cofounded.

TRACEY ROBERTSON CARTER is a former marketing executive and entrepreneur who is dedicated to uplifting equity, diversity, inclusion, and belonging in the various philanthropic efforts she is involved in, supporting youth, arts, and the environment. She was the Founding Board Chair of a local group mentoring initiative focused on the social and emotional wellness of challenged youth in Florida, with a focus on teen parents and incarcerated youth. Tracey serves as a trustee with New World Symphony, AIRIE, Art in Public Places Miami-Dade, Shelburne Farms, Vermont, and the Chicago Sinfonietta.

CORNELIUS TULLOCH is a Miami-based interdisciplinary artist and designer and the artistic director of AIRIE. With work transcending the barriers of architecture, visual art, and photography, Tulloch focuses on how creative mediums can be combined to tell powerful stories inspired by his Jamaican and African American heritage. His work has been exhibited in institutions including the Kennedy Center for the Performing Arts, Washington, DC, and the Museo Nazionale Delle Arti Del XXI Secolo, Rome, Italy. In 2016, he was named a Presidential Scholar in the Arts and is included in the permanent collection of the Studio Museum in Harlem.

REVEREND HOUSTON R. CYPRESS I'm from the Otter Clan, one of the families that make up the Miccosukee Tribe of Indians of Florida. My community is based in Western Miami, in the heart of the Everglades, right next to Everglades National Park and the entrance to Shark Valley. I'm also with the Love the Everglades Movement, a nonprofit that seeks to educate, inspire action, and make art. And I'm on the tribe's environmental and Everglades advisory committees.

One of my concerns is to make sure that there's public awareness for the greater Everglades—not just the national park. It's a watershed that unites the expanse from the Kissimmee River all the way down to Lake Okeechobee and, because of its connection to the St. Lucie Canal and the Caloosahatchee River, out to the eastern and western coasts, down through the agricultural area, and then to the national park and out to the Florida Bay. Having a broad view of the greater Everglades is important; it should be a place that anybody can access. We must honor the fact that people currently live here, from the Miccosukee and Seminole peoples (federally recognized tribes) to the independent Indigenous community, and that people have lived here before—Calusa and Tequesta peoples in the past, and others. There are coalitions like the Gladesmen coming together to care for these places. Any initiatives should highlight communities of color, Black, and migrant communities—people who are coming here and making this place their home. It's essential that we have an expansive embrace of the variety of communities that are living here and that we're able to highlight some of the challenges that we're dealing with, from invasive species to broader climate and spiritual concerns. This is a place of healing, a place of reconciliation that brings communities together; it's a place for convening.

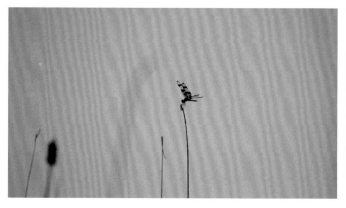

Ania Freer, Still from *Kaa-Ha-Yut-Le*, 2023

ALEXANDRA CUNNINGHAM CAMERON Houston, one issue in particular you have created awareness around is how Miami's built environment relies on the Everglades. In particular the significance of Everglades water and how it's the primary source of water for greater Miami—drawing a link across the ecosystem, neighborhoods, and individual houses.

CYPRESS Yes, hydrology is foundational for a variety of species, not only plants and animals, but also people who rely on the drinking water that flows through our communities, providing essential services. It's also important to note energy and electricity concerns: the nuclear power plant uses millions of gallons of water daily to cool its machinery, which allows us to power our gadgets. That's another way to connect—people enjoy social media. It makes communication and storytelling possible, so energy production and its connection to water is something that we can also bring attention to.

DINIZULU GENE TINNIE You mentioned the water factor, Alexandra, because we're in Miami, we're on this narrow strip between the ocean and the Everglades. With all this overheated development, more people are moving this way all the time, and with more people on the planet, our population continues to increase.

MEMORY

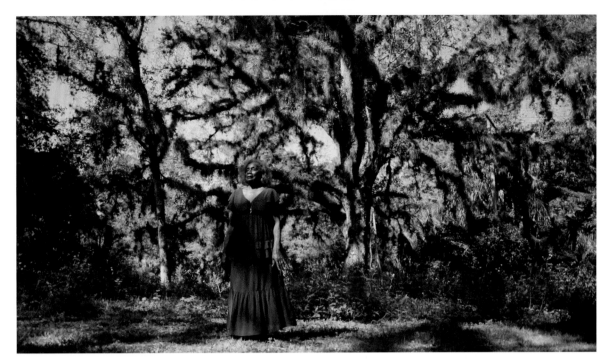

Ania Freer, Wallis Tinnie, 2024

CUNNINGHAM CAMERON Yes, Miami is growing as it becomes more fragile. It has had this kind of heavy development, redevelopment, and reimagination cycle for the last century, and is now dealing with highly visible environmental concerns, like flooding. It's no longer possible to hide the impact of global warming on the day-to-day experience.

CYPRESS The land remembers how the water used to flow. We're dealing with communities flooding regularly, because these are places where water flowed in the past. The Miccosukee and Seminole communities have great scientific departments that analyze these sorts of things. The Miccosukee set the water quality standard that the broader community is trying to achieve with the criterion of ten parts per billion of phosphorus. In a broader context, we can look at universities, state agencies like the Florida Fish and Wildlife Conservation Commission, South Florida Water Management District, and others that are doing great work with science and technology to track environmental shifts.

CORNELIUS TULLOCH The strategies of dealing with flooding, like increasing the height of the streets, are not good examples of soft infrastructure. But the Everglades has a long history of infrastructure that works with the landscape—like the shell islands[1] built by Indigenous communities. They touch on very human ways of designing in, with, and for the landscape. It's not an infrastructure that fights against or encroaches on the Everglades ecosystem, but allows coexistence. How do we exist in or use natural spaces, resources, or materials in ways that allow us to work with the environment? To "reclaim" in terms of us existing in the current state—especially with Miami as a city and all South Florida pushed up against the Everglades, there is as an opportunity for us to provide not necessarily a solution, but ideas that reimagine how we move forward. How do we use design as a tool to be in dialogue with the

[1] Shell works are large formations of hand-piled oyster shells that formed built villages. Archaeologists track shell works to the late-archaic to sixteenth-century Calusa tribal villages (1000 BCE–1500 CE). Traces can still be found in the Everglades today.

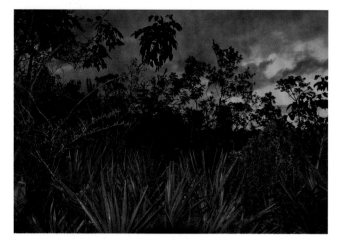

Cornelius Tulloch, Everglades Portrait, 2022

landscape in a more symbiotic or positive way?

CUNNINGHAM CAMERON What I'm hearing is that the concept of the Everglades having borders—as being a destination—is a fallacy because most people in South Florida are actually living in the Everglades; it's tied up in daily experience. A challenge is representing issues like biodiversity, technologies of conservation, and all these histories in a way that is tangible.

GENE TINNIE You made me think about the role of traditional knowledge systems—Indigenous, African, Asian, Caribbean—that are gathered here as something that we can return to. Until recently, I was part of the Virginia Key Beach Park Trust, which is working to reclaim and restore what was the historic Black beach in Miami, but it's also an environmental site on one of the two most monetarily valuable southern islands in the city. One of my fellow trustees, Dick Townsend, did a presentation for us that I was very impressed by: he took one square foot of turf out of this eighty-two-acre park and said, "Let's take a closer look at all the life in that square foot that you just walk on." We don't even think about all the ecosystems there. That kind of approach shares the micro as well as the macro, which gets

to Houston's point about thinking beyond the national park.

CUNNINGHAM CAMERON Are there any specific architectural or building experiments happening that are designing with the ecosystem or building for flooding and allowance for water flow?

GENE TINNIE The vision for Virginia Key Beach is to make the entire eighty-two-and-a-half-acre park an interpretive museum experience. The whole question is how we build a structure that is totally harmonious with the land, the environment, and the ongoing challenges of sea level rise. We're very mindful of the sociology factor because the site is coveted land in Miami, it's like the now desirable high ground in Lemon City or Liberty City (what's being called "Little Haiti"), where you have lower income, mostly Black communities that are being threatened because the property value has increased, in part because the land is less susceptible to flooding.

DR. WALLIS TINNIE The whole idea of the Everglades being a source of healing, as Houston mentioned, and the mythologies that are a part of its history are really significant. It's so important to help people understand why the land was here the way it was before people arrived and decided to "develop" it, but also what could be next for this wonderful resource, this home.

Historically, many of the structures on this land were built to accommodate the environment. This was necessary to survival. I am thinking specifically of the Bahamian influence. These—whether or not you would call them houses, per se—had porches and were built of wood and designed for passive cooling. But what we're building now is not to stay. I don't think it's sustainable.

GENE TINNIE We need to consider local innovations from Seminole chickees and Bahamian architecture, which is rooted in African principles like allowing warm air to rise and escape through the roof. We're also looking to biomimicry such as termite mounds with natural, built-in climate control. We have to look to the past and to nature to plan for the future.

TULLOCH Wallis, when you mentioned the mythology of the landscape, it occurred to me that we're also talking about the methodologies of how we're approaching it. Those two words stick out: mythology and methodology, in terms of ways of living or ways of making home. They touch on the ecological and cultural significance of these discussions, and I think that's what makes talking about the Everglades so complex. It's filled with stories and narratives. I'm constantly learning something new through the Everglades, understanding this space and my position and history in it.

GENE TINNIE I like the idea of the Everglades as a centerpiece of telling the larger story of the Florida peninsula. The land and history are one and the same thing. The land remembers everything and is the record of everything that has happened.

WALLIS TINNIE I like to look forward. I'm not trying to go back to what we were. But it would be good for people to understand why the land was here, the way it was when people got here, as a means of understanding what's there to protect.

CYPRESS We've been talking about giving personhood to the land, and respecting its imprint.

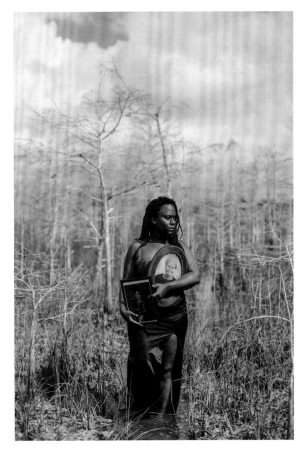

Arsimmer McCoy, from the photo series The skin your ancestry adorned you with, 2022

SHEILA PREE BRIGHT

BELONGING

SHEILA PREE BRIGHT is an international photographic artist and the mind behind the celebrated book *1960Now: Photographs of Civil Rights Activists and Black Lives Matter Protests* (2018). Bright's expansive artworks weave insights into contemporary culture. Her iconic series include Invisible Empire, #1960Now, Suburbia, Young Americans, Plastic Bodies, and an evocative portrayal of the 1990s hip-hop scene.

This photo essay delves into the intricate relationship between emotional attachment and physical space, serving as a tribute to my personal journey toward finding a home amid the echoes of my family history and ancestral heritage. I was raised in a military family, so the concept of a stable home was elusive to me. Yet recent revelations about my great uncle—a respected physician in Brunswick, Georgia, during the 1960s, especially cherished by the Gullah Geechee communities on the coastal islands of Sapelo and St. Simons—have ignited a quest to connect with my roots.

Through a series of emotionally charged black-and-white landscapes, I aim to encapsulate the nuance and complexities inherent in the African American experience. These images extend beyond mere scenery; they reach back in time to touch the memories and legacies of our ancestors, offering a tangible sense of place and belonging that has often been withheld from marginalized communities.

My ultimate aspiration for this photographic exploration is to spark thoughtful dialogue on race, identity, and the significance of place in shaping Black lives. By shedding light on how African Americans forge connections to their ancestral landscapes, I hope to evoke a sense of communal pride and cultivate a broader empathy and understanding of home.

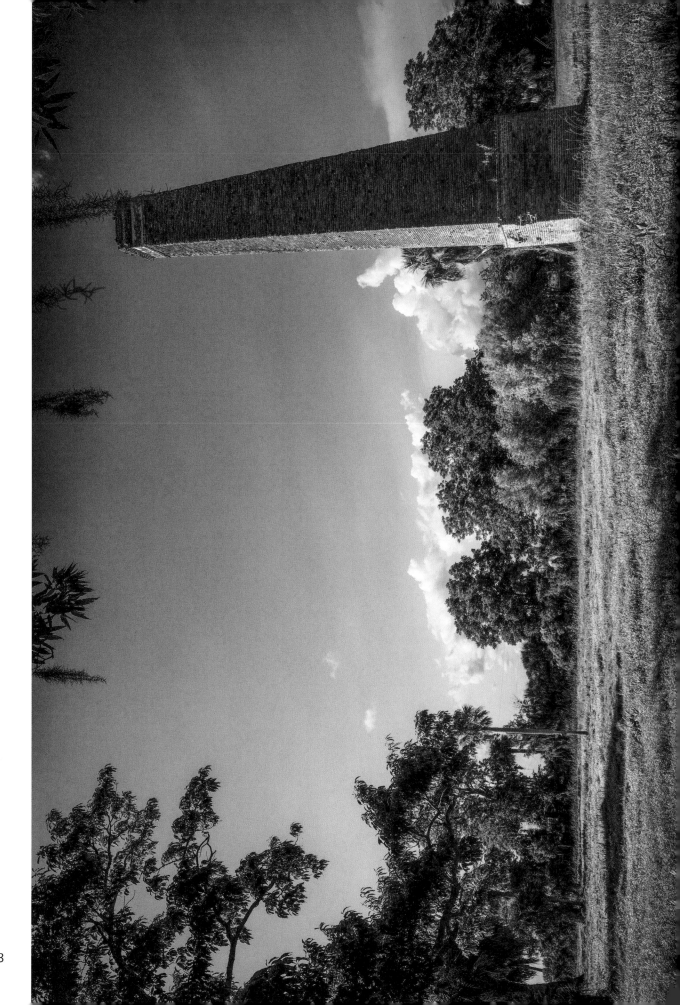

Harvest, Butler Island, Georgia, 2023

Belonging, Sapelo Island, Georgia, 2022

From Whence We Came, Jekyll Island, Georgia, 2022

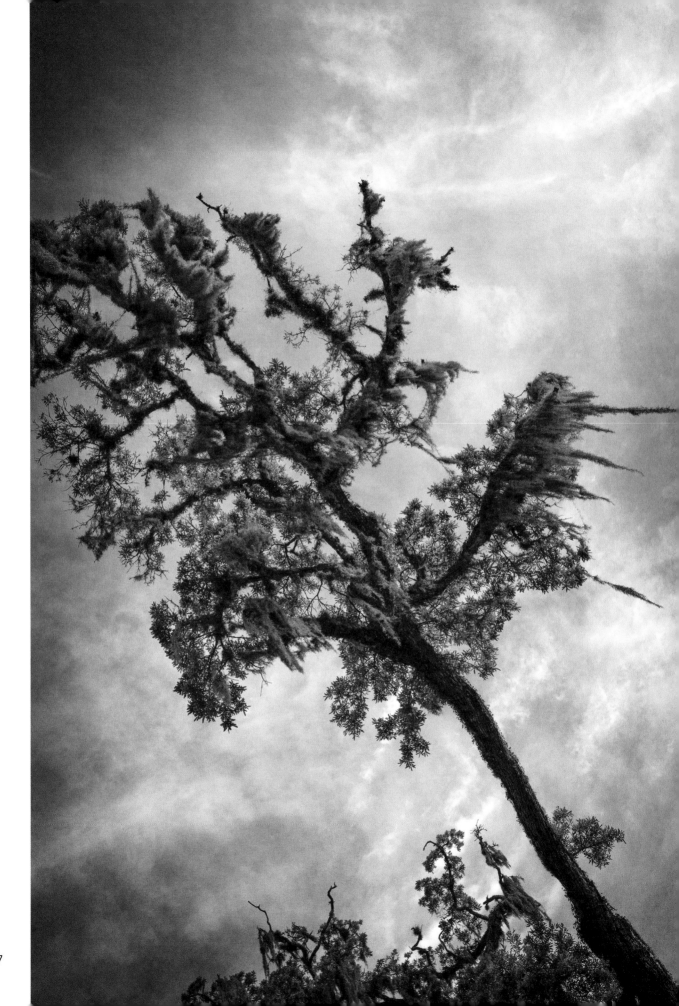

Weeping Moss, Darien, Georgia, 2023

Sweetgrass, St. Simons Island, Georgia, 2023

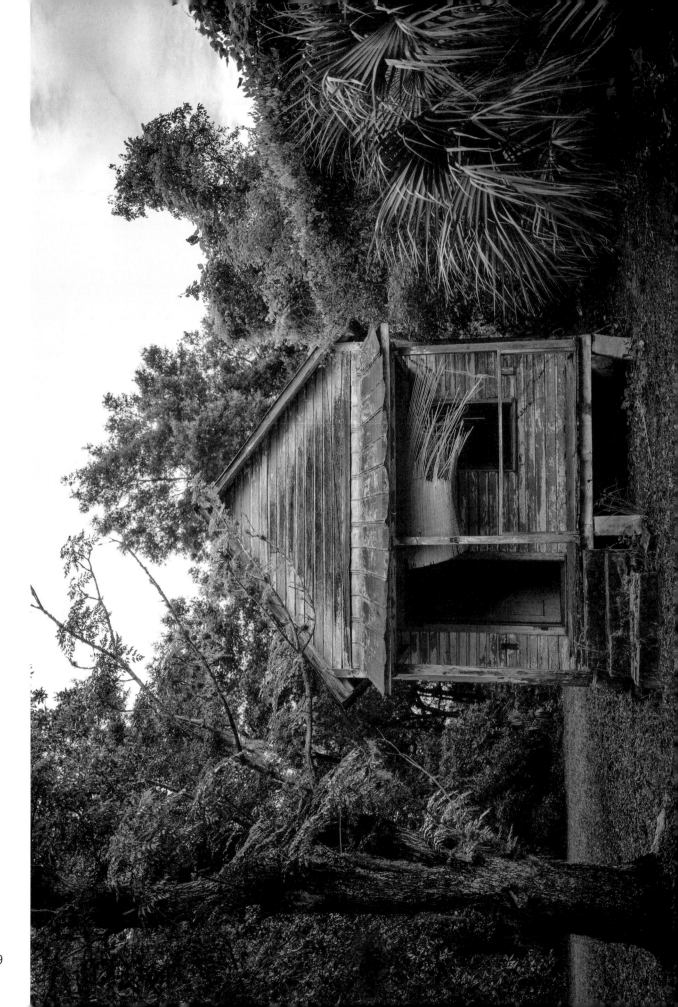

Ebo Landing, St. Simons Island, Georgia, 2023

Healer, Butler Island Plantation, Darian, Georgia, 2023

REVISITING HOME
A Conversation with Suchi Reddy and John Zeisel

The field of neuroarchitecture examines how individuals experience designed environments. Our experience of architecture is informed by how our brains react to different stimuli in these spaces, from homes to healthcare facilities. These stimuli also contribute to how we form memories and how we care for them, as the design choices in "memory care" residences demonstrate. Having noted connections across neuroscience and architecture in the work of architect Suchi Reddy and sociologist John Zeisel, Michelle Joan Wilkinson invited them to speak about home, memory, and design. Here, they reflect on their own memories of home and how their respective interdisciplinary design approaches are influenced by neuroscience and neuroaesthetics.

SUCHI REDDY founded Reddymade in 2002 with an approach to design that privileges the emotional quality of human engagement with space. Reddy's architectural and artistic practice is informed by her research at the intersection of neuroscience and the arts. Working toward a larger idea of "design justice," she is dedicated to expanding notions of empathy, equity, and agency—where the importance of design is recognized as an asset for the benefit of all, not just for some.

JOHN ZEISEL is the founder of the I'm Still Here Foundation, Hopeful Aging, and Hearthstone Alzheimer Care. He is the author of *Inquiry by Design: Environment/Behavior/ Neuroscience in Architecture, Interiors, Landscape, and Planning* (2006) and *I'm Still Here: A New Philosophy of Alzheimer's Care* (2009). His mission is to change the public narrative of dementia from despair, disease, and drugs to hope, disability, and "ecopsychosocial" treatment.

HOME

MICHELLE WILKINSON What does home mean to both of you?

SUCHI REDDY For me, home is a mind/body state. In neuroaesthetic terms, we would call it a state of embodied cognition, where your body reflects certain physiological characteristics of relaxation or belonging that I think translate to a sense of home. It really is a state of being rather than a place, when you think about it in an individual perspective, but in a larger perspective, like in a community, city, or country, then cultural influences start to play a role in the sense of belonging. It becomes a state of feeling at home because your emotional, psychological, and spiritual and political beliefs are being met—senses of freedom, and how you are an immigrant in these places, are particularly resonant for me.

JOHN ZEISEL Suchi used the term "embodied cognition," which is a nice way of saying "feeling." The colloquial way of saying it is, "I feel at home." I feel at home in nature. I feel at home when I'm cooking. I feel at home when I'm with my kids. I feel at home when I'm all by myself and I'm listening to music. So, it's really not place-specific. It's the way we feel in these places. And again, as Suchi mentioned, it can be a whole culture. All our parents or we ourselves immigrated from places, and somehow our parents, relatives, and we ourselves got to feel at home, we made it home. Home is not something that is there before we get there.

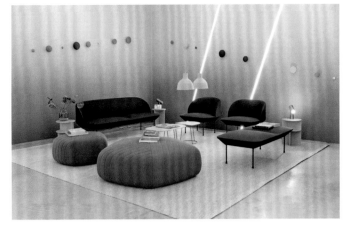

A Space for Being, exhibited at the Salone del Mobile Milano, April 9–14, 2019, explores how thoughtful design can impact us. Informed by neuroaesthetics, an interdisciplinary field of study that strives to understand how the brain responds to aesthetic experiences, Google's Ivy Ross, Muuto's Christian Grosen, and Reddymade's Suchi Reddy developed A Space for Being as an interactive installation that incorporates diverse stimuli.

It's also not something outside of ourselves. "Embodied" means it's part of us. And really, it's a dialogue between us and the environments that we're in, and then it's our feelings that define it. So feeling at home is wherever you have that feeling.

REDDY I completely agree. The mantra of my practice is "form follows feeling." It has been a quest over the years to achieve that feeling no matter the typology of architecture or design that we're engaged in—whether it's a hospital, a home, or a city. We have to think about what that sense of "feeling at home" is like. I've been on a crusade to reorient compasses of design toward this angle.

MEMORY

WILKINSON Can each of you share what your first memory of home is?

REDDY My first memory of home is the garden of my childhood home. I was very much surrounded by plants, this incredible feeling of belonging, in nature, in that space. I was three or four when that house was built, and I remember running around in the construction site. I even have a scar on my leg from when I tripped over some metal and I cut myself. One day when I was about ten—I remember the temperature, the time of day, and the air around me—I felt like my house was informing me, that it was making me the person I was. I felt that I was different than my friends because of my house. And it wasn't better, it wasn't worse, it was just different; it was a protagonist in the person I was becoming. So, my first epiphany had to do with space. It truly has remained a powerful one that continues to drive me.

ZEISEL Mine is an apartment on the fifth floor of 431 Riverside Drive on the Upper West Side of Manhattan. It's got a long hallway. At the end of the hallway, after the kitchen, there was a left-hand turn, and at the end there was my bedroom. We had a bunkbed in it. I remember the living rooms as two large spaces with windows looking out over Riverside Drive and the Hudson River to Palisades Amusement Park with a roller coaster in the distance on top of the New Jersey bluff. And going downstairs, going outside, crossing the road, and being on Riverside Drive, that was all home.

That's my first memory. I thought it was huge. It probably wasn't huge. But that was it, this long hallway, turn left, the little room at the end, the views out over the Hudson River looking west, so we always saw the sunset.

I have many other places I called home in my life because the other thing that happens with all of us is that we move a lot and home changes, home moves with us. And that's when we go back to this embodied cognition, and our bodies, and ourselves, it's us who make home.

WILKINSON I'm so interested in the level of detail that you shared, John, about the physical space, and the fact that you

REVISITING HOME

can remember it that closely. And for you, Suchi, the garden space, and a certain type of feeling that comes from that—it's formative, it's forming who you are. Do you often think about the physical spaces you just mentioned? How do you think home and memory are related?

ZEISEL Memory is overrated. I recently read a book on memory in which the authors wrote about procedural memory, working memory, semantic memory, episodic memory, long-term memory, and short-term memory, as if memory is the same as experience. It ain't. I think the important thing is that our past and our present feed our experience.

Together with an interior designer I designed the newsroom for the Minneapolis Star Tribune. We started by observing all the reporters where they worked. Each reporter had made where they worked their home, every one of those cubicles was someone's home. Each person decorated their workspace with something meaningful to them: sports memorabilia for sports reporters; postcards for travel reporters; and, of course, family photos for all. It wasn't their home where they got up in the morning and had breakfast; it was their work home. We all carry home; we move home with us. We create experiences around the concept of home constantly.

REDDY I think spatial memories are different from memory as we think about it generally. For me, spatial memory is a resonance of place—it's a physical memory that you hold in every cell of your body. I don't "remember," I "revisit." I often go back into that place and I re-feel that feeling of where the walls were, their textures, the light as it moved, where the air was coming from. For me that is a very comforting thing to do. And what I think is so rich about

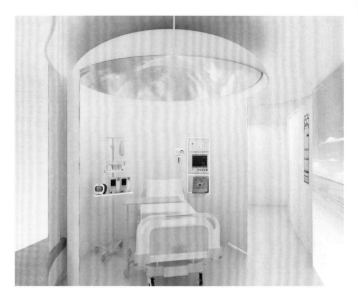

Reddymade designed this prototypical hospital room as a "sensory healing space" to be inserted into a standard hospital room space as an experimental "spatial prescription" to amplify the medical treatment of patients suffering from disorders of consciousness, which impair self-awareness and interaction with the environment. (Examples are a coma, a vegetative state, and a minimally conscious state.) The concept was created in collaboration with the International Arts + Mind Lab at Johns Hopkins University.

being a human in the world is that we can do that anywhere. Whether architecture is transcendent, or it gives you a sense of awe or wonder, all these things are spatial memories, sets of feelings. As an architect, as a designer, it's my challenge to see how I can encourage that through my work. As John was speaking I had this vision of being able to flow through the world feeling like every environment gave you that sense of home. Wouldn't that transform the kind of human we were, if we could do that for everybody?

ZEISEL It would also transform the world's societies.

REDDY Yes, it would. It would change everything. And that's the power of space, that's the power that we have. If it's possible to imagine, we can get close to it.

ZEISEL Suchi used the word "revisit." The "revisiting" is a very important dimension of memory. We revisit places that we create in our mind at that moment. In

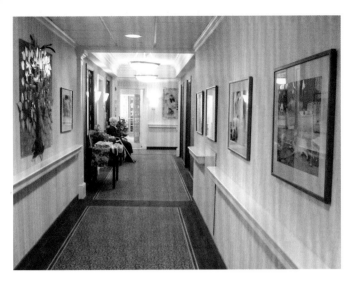

Destinations orient: Hallway with orienting photographs and clear destination turns wandering into walking, Hearthstone Memory Care Residence at The Esplanade Manhattan Senior Residence (formerly Esplanade Hotel), New York City, 2012

other words, what I just told you about that apartment on Riverside Drive is my recreation of that moment. I take pieces of experiences and put them together. We revisit. And it's not only space—when we're revisiting the spaces, we're recalling, recreating, and revisiting the images of those spaces. Memory is a process of mental recreation. All memories are recreations, and a lot of them are visual. The spaces we are imagining are not in our brains in words, they're pictures, because those are also embedded in our brain. Revisiting is a very good way of talking about memories of home.

NEUROAESTHETICS AND ENVIRONMENTAL DESIGN

WILKINSON You've both used neuroaesthetics in your work. Can you speak to how you approach design using that framework?

REDDY When I first came across the term "neuroaesthetics," I was incredibly excited because I've always been interested in science and architecture. Neuroaesthetics is a translational field that allows us to understand the effect of experiences and environment on our brains and bodies. I'm

separating brains and bodies specifically in this way because we know a fair bit about how spaces, in terms of painting or temperature for example, affect our bodies, but we don't know that much about the brain. I have a firm belief that architecture works with the technologies of its time, and neuroscience is a field that has made large leaps in the last fifty years. Part of my interest in it comes from trying to inform the idea of form following feeling. The vast majority of people who work in the field of neuroaesthetics are cognitive scientists, neuroscientists, neurobiologists, environmental psychologists, and psychologists. These people are thinking about how space and experience affect us. Somebody could be studying how curves work, somebody could be studying how we make decisions, and how all those things come together. I'm using the information that I can glean from the field, which is constantly evolving, to amplify what I do, my natural skill and developed skill, as an architect, to see how I can encourage a certain kind of feeling.

I got a question recently, John, and I'd love to ask you what you think about it. I was giving someone a tour of my recent public installation, and they said they had read an article about neuroarchitecture, and they were afraid that this meant we were trying to manipulate them. I said, "Well, you're always being manipulated by everything, and it's up to you to understand what its effect is on you and what your relationship is to that effect. Whether that's politics, or whether that's society, or whether that's your environment, you are being acted upon, and you are acting on it, so you have to understand that relationship, that interaction, that dialogue." And to me, neuroaesthetics is a way to really inform that dialogue and to understand more about it. We've got a long way to go; everybody wants a handbook, and a means and

a method, but that doesn't quite exist. It still depends on the skill of the interpreter and how we understand all the knowledge that's at our disposal.

ZEISEL Suchi touched on all the major points. The environment is a dialogue with users—the environment is not a thing within which we do things, it's a thing with which we do things. In other words, the environment is not a box within which we are, it is a thing we act with continually. Do we manipulate the environment or does the environment manipulate us? It's neither; it presents itself to us and we deal with it, whether it's the height of the trees, the ticks on Martha's Vineyard, or that more mosquitos happen to be out today. These are all parts of the environment—you go out a little bit less, or you spray on more mosquito repellent, or you check the dog and your body for ticks more often.

This idea of neuroscience and design wasn't originally called neuroscience and design. When the Environmental Design Research Association started over fifty-five years ago, everybody was talking about the relationship between people and their environment. When I first presented my own research there, people said: "You're going to design a place for low-income Italian families in Boston's West End based on what you know about their lifestyle? That's ridiculous." My partner at that time, architect Brent Brolin, and I had based our design on our translation of descriptions of this group's lifestyle into what would eventually be called lifestyle "patterns," after architect Christopher Alexander. The descriptions were from sociologist Herbert Gans's 1966 book *The Urban Villagers: Group and Class in the Life of Italian-Americans*. The idea that you can identify a group's lifestyle and design for it was anathema. We were laughed off the stage. Now everybody's doing that.

Years later, John Eberhard started the Academy of Neuroscience for Architecture which promoted the idea that we have to understand the experiences people have in church design, in hospital design. This feeds back into embodied cognition—the feeling, the sense of environments. At the same time, we broadened the definition of physical environment to include more explicitly the impacts of the sensory environment on our brains. What about music, what about theater, what about colors, all interior design, what about smells? What about beauty? Neuroscientist Semir Zeki, who coined the term "neuroaesthetics," identified brain regions, such as the orbitofrontal cortex, that respond to "beauty" in our environment.

People ask me why I am involved with research and design for people living with dementia. My answer: If we can solve the problem of people living with dementia through environmental planning, environmental design, and environmental management, we can solve it for anybody. The purpose of designing an environment for people living with dementia is to create an environment where they are competent, where who they are is coherent to them. Success is an environment in which

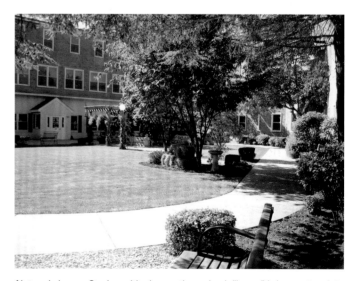

Nature is home: Garden with clear pathway back "home" brings nature into life, Hearthstone Memory Care Residence at New Horizons Marlborough, Marlborough, Massachusetts, 2014

whoever they are, whatever they bring to the environment is respected, supported, and engaged with. Which, by the way, is every environment that you want—an office, a hospital, whatever it is. If we can do this for people with dementia, it helps all of us better understand how to create environments that support our health.

One of the things we know is that living with dementia can make it difficult to remember what's around a corner, even if you go around that corner often. If you want to go to the living room and the living room is out of sight, it is difficult. You don't want to put that kind of burden on somebody living with dementia. You want to have a place where everything they need to do, everywhere they need to go is right in front of them, or along the way, so they don't need instructions or a memory of that place to find their way. That's natural mapping.

Another design contributor to feeling coherent is having a space of your own where you can have your things like at home, the things on the walls that say this is me and I feel comfortable. Being in contact with nature is another. Not only looking out a window, but being able to walk outside. Having destinations where you're walking so you end up someplace, not no place, even if you didn't start with an exact idea of where you were going. All these design principles contribute to making spaces that feel like what we're speaking about: making "home."

I learned from interviewing people with dementia about what makes them feel at home. When I work on designs, I make sure not to merely put something together that I would feel a certain way in; instead, it's putting something together that the neurosciences, social sciences, and psychological sciences have taught me other people will bring to the situation, so that

they can negotiate their own relationship with home.

REDDY Using neuroaesthetics, I usually break it down into typologies: How do we think about it in residential versus commercial spaces? In residential projects, it's very personal. If I understand the person is looking for a place to be creative in the house, or a place to get away from everybody else, it's not a question of just hanging a picture on the wall because the wall is empty. Does that picture offer you depth of perspective? Do you actually need to look through a window? If so, should it be a small window or a big one, or do we embed a little diorama in the wall because that gives you the sense of being able to escape into another world that you want? The thoughtfulness that goes into the placement of things and your relationship to those things, that's how we use neuroaesthetics.

EQUITY, EMPATHY, AGENCY

REDDY I have been engaged in design of healthcare environments for about four years, including designing prototypical hospital rooms that can be used as a physical instrument tuned to a patient's needs—a spatial prescription—alongside medical prescriptions. As a society, we know how to make people feel terrible. In prison design, for example, people are put in a cell, and we know how to take away every bit of hope a person has. In opposition to that, why can't spaces be calibrated to make you feel the greatest you can feel, the most competent you can feel. The idea of competence is undervalued. That idea could be understanding the geometry of the space or feeling a sense of wonder. Then the occupant has choice, which to me equates to agency. Equity in spaces means we're designing so that people can

bring whoever they are into a space, which also relates to empathy and understanding more about the human condition. There are lots of different ways in which you can interact with an environment, and that equates to agency. That's why I always say equity, empathy, and agency are what should underpin and drive the work. That's how I aim to use neuroaesthetics in all the work that we do.

ZEISEL Equity is essential for people living with a disability like dementia, because we all deserve to be respected. To achieve this, we have to create environments where people living with dementia, people in wheelchairs, people with other neuro conditions are treated as equal to everybody else. We can't just say we're designing for a certain type of people and the rest go someplace else. The second principle, empathy, does not just focus on others. It's not "I feel empathy for another person," but rather, "I feel empathy for all of us." Empathy is a way to include everyone, being open to their experiences. Agency, the third principle, is the whole point of everything we're talking about, namely being able to be ourselves and be in control of our lives and our world in every environment we inhabit. We must not be disempowered, as Suchi is saying, by our environments. We know how to create environments that rob people of themselves; let's use the same know-how to provide environments that give them agency. Reflecting on the three principles of equity, empathy, and agency is a good way to think about our conversation in greater depth.

AGING AND THE MEANING OF HOME

Home offers a place of safety, sanctuary, inspiration, and pride. The presence of home—or the loss home—fundamentally affects people's sense of well-being. This is particularly true of people who are aging. Continuing to live in one's own home is a nearly universal goal of people over age sixty-five. The reality, however, is that the majority of aging people will eventually need a level of help that is impractical without relocation to a senior living community.

HORD COPLAN MACHT is an innovator in senior living design, nationally recognized for creating buildings that enrich the lives of residents and enhance their communities. Its passion is to build enduring relationships with clients, support lifelong learning, and promote physical, social, and environmental well-being.

A critical component of designing these communities is not only accessibility and efficient care delivery, but also the intentional recreation of home for the residents. Providing for the physical needs of aging individuals is only part of the job of these buildings; seniors' social, emotional, and intellectual well-being is equally important.

Hord Coplan Macht (HCM) works in architecture, interior design, and landscape architecture to consider the impact of aging on design and how design can impact aging. The firm is a leader in the effort to create holistic environments that become a true home for their residents.

Housing older people in need of care is a significant task, especially as this population is growing much faster than the overall population. Improvements in life expectancy coupled with a slowing birthrate have resulted in unprecedented increases in the number of people over age sixty-five.

In 1950, people over age sixty-five constituted 7.5 percent of the total population of the United States, growing to 10.4 percent in 1975. In 2024, the percentage is 17 percent, and the share of the population over sixty-five is projected to increase to between 21 and 25 percent by 2050, depending on immigration.[1]

An aging global population is a medical, social, and demographic challenge worldwide. The World Health Organization (WHO) defines healthy aging as the process of developing and maintaining the functional ability that enables well-being in older age. Functional ability allows older adults to continue to do the things they value with dignity.

The design concepts HCM has developed to optimize seniors' living conditions are closely aligned with WHO's view on

[1] "Chapter 4. Population Change in the U.S. and the World from 1950 to 2050," Pew Research Center, January 30, 2014, https://www.pewresearch.org/global/2014/01/30/chapter-4-population-change-in-the-u-s-and-the-world-from-1950-to-2050/.

MEMORY

healthy aging. WHO's view is based on universality and characterized by diversity and equity. Universality respects the mental, social, and physical capabilities and capacities that vary from person to person. Great care is taken to ensure that historical societal inequities do not constrain the potential of residents to age well.

[2] G. Passarino, F. De Rango, A. Montesanto, "Human Longevity: Genetics or Lifestyle? It Takes Two to Tango," Immune Aging, April 5, 2016, doi: 10.1186/s12979-016-0066-z.

WHAT IS AGING?

On a biological level, aging leads to a gradual decrease in physical and mental capacity and a growing risk of disease and disability. The effects aging will have on a body depend on lifestyle, genetics, and any chronic health conditions. According to one study, 20 percent of lifespan is dictated by age and 80 percent of lifespan is predicated by lifestyle.[2] The effects of aging are also shaped by an individual's economic and social circumstances, behaviors, community, environments, and other factors.

The key to mitigating the negative impacts of aging is providing housing based on evidence-based design that supports an active lifestyle and improves longevity.

MINIMIZING THE IMPACTS OF AGING THROUGH DESIGN

Functional, creative, and efficient spaces seek to combat common, predictable changes associated with aging, including:

- reduced energy reserves and musculoskeletal system flexibility
- diminished senses of taste and smell
- changes to eyesight and hearing
- declining hunger and thirst
- slowed cognition and diminished short-term memory capacity
- fragmented sleep and insomnia

An optimized living environment improves cognition, mood, and longevity. Designers create residential-scale spaces to minimize the negative effects of aging through architectural, interior, and landscape design elements that enhance both physical and mental engagement. By orchestrating spaces, lighting, furniture, fixtures, and technology to offer greater flexibility and choices, designers ensure that deficits caused by aging are offset and compensated for, and well-being is greatly improved.

MEMORY

GENERAL DESIGN CONSIDERATIONS
FOR THE SOCIAL SPACE

Spaces should be barrier-free, physically safe, and incorporate the following:

ENTRANCE

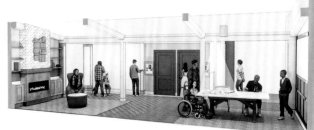

Main living spaces of an assisted living household, 2024

- Space to allow room to change assistive mobility devices, such as from walker to wheelchair, or scooter to cane.
- Easy-to-access storage for low-vision assistive devices, such as magnifying lenses, audible announcement devices, and remote controls, to make the transition from outside to inside seamless and not a deterrent to movement.

LIGHTING AND COLOR CONTRAST

- Artificial lighting automatically adjusts to mimic natural lighting changes, and other equipment reduces the risk of trips or falls. Voice- and motion-sensor lighting, with adjustable levels to avoid glare or brightness, allow for perception adaptation to accommodate vision changes that occur with aging.
- The use of color contrast at an entrance can help people with low vision better distinguish between objects, which is important to accommodate the ocular changes that come with aging.

SAFETY, SECURITY, AND MOBILITY

- Locks and hardware that do not require fine dexterity, such as digital keys, offer a sense of independence and ownership.
- Nonslip flooring and surface choices that minimize environmental impact and enhance ease of cleaning and odor elimination. Flooring should be slip-resistant for all musculoskeletal capacities, accommodate accidental spills, and be physical and neuro-inclusive, with consideration for stimulation to neuropathic feet.
- Exposure to accessible outdoor spaces, along with raised planters to encourage individual garden-to-table herb and vegetable cultivation. Balconies, patios, and porches are places for socialization, providing opportunities for interpersonal connections outdoors. The value of these spaces became very evident for reducing isolation during the COVID-19 pandemic.

MEMORY

INTEGRATED COMMUNICATION

- Bluetooth, infrared, and near-field communication in all spaces offers access to information, telemedicine, entertainment, education, and family and friends.

FUNCTIONAL FURNITURE

- Furniture options that are adaptable for size, height, and flexibility. Lifts, lift chairs, and height adjustable surfaces allow inclusion.
- Ease of reach in social and kitchen spaces reduces back injury and falls.

Many aging people hope to stay in their existing homes rather than move to a senior living community. This reticence is largely driven by outdated assumptions about what senior living entails. For more than half of seniors, however, the impacts of aging will eventually make living in their homes unsafe and isolating. Carefully designed and operated senior living environments informed by evidence-based best practices can actually support greater independence, improved health, and higher levels of happiness for seniors.

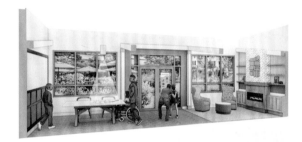

View of glazed exterior wall and garden beyond, 2024

GIVE ME SHELTER
Re-membering the Black Home

"I grew up in an ugly house," wrote bell hooks. "No one there considered the function of beauty or pondered the use of space.... In that house things were not to be looked at, they were to be possessed—space was not to be created but owned—a violent anti-aesthetic."[1] She compares this house to that of her grandmother, "A place," she writes, "where I am learning to look at things, where I am learning how to belong in space. In rooms full of objects, crowded with things, I am learning to recognize myself.... [Baba] has taught me how to look at the world and see beauty. She has taught me 'we must *learn to see*.'"[2]

Seeing, hooks suggests, is not what happens naturally when our eyes perceive shape and color; it is something we must learn, a (s)training of our eyes to glimpse beyond the immediately perceptible. To see beauty is to see "things" not as commodities, but to observe "what light does to color," or to remember that "objects are not without spirit."[3] Where "things" are untethered from the logics of property and ownership, we find and create beauty. Thus, beauty, for hooks's grandmother, is precisely what slips away from capitalist capture. It is what the market cannot comprehend, evaluate, or commodify.

On the contrary, "The general understanding of home in America," scholar Fred Moten observes, is "your home is your castle, it's your sovereign space. You put a fence around it and barbed wire, if you can get some, and you get some goddamn surveillance equipment, and some dogs, and whatever the hell you can do to make sure that nobody comes up in your home."[4] Here, Moten describes the American home as a bounded enclosure, fortified against the threatening "surrounds."[5] The home is not only a physical enclosure—a contained area encircled by definite borders—but also the embodiment of ongoing processes of enclosure that transform land, space, and life into private property.[6] As both a figure and a historical process, enclosure is one of racial capitalism's most vital technologies. Thus, the

ELLEZA KELLEY is an assistant professor of English and African American Studies at Yale University. Kelley writes and teaches on a range of subjects, from Black aesthetics and Black geographies to archives and historical fiction. Her writing can be found in the *New Inquiry*, *Cabinet*, *Deem Journal*, and elsewhere.

MEMORY

[1] bell hooks, "An Aesthetic of Blackness: Strange and Oppositional," *Lenox Avenue: A Journal of Interarts Inquiry* 1 (1995): 65.
[2] Ibid (emphasis mine).
[3] Ibid.
[4] Fred Moten and Stefano Harney, "Give Away Your Home, Constantly," July 11, 2020, in *Millennials Are Killing Capitalism*, podcast, 1:01:54, millennialsarekillingcapitalism.libsyn.com/give-away-your-home-constantly-fred-moten-and-stefano-harney.
[5] See Fred Moten and Stefano Harney, *The Undercommons: Fugitive Planning and Black Study* (Chico, CA: AK Press, 2013). See also AbdouMaliq Simone, *The Surrounds: Urban Life within and beyond Capture* (Durham, NC: Duke University Press, 2022).
[6] The most well-known historical example is England between the fifteenth and nineteenth centuries, in which enclosure began as a series of parliamentary acts. These acts legally determined and enforced boundaries onto expropriated common land, converting it into private landholdings.

promises of privacy, protection, safety, and refuge offered by this image of home are inextricable from the brutal machinations of capital, property ownership, exclusion, and containment. But this conventional or "general" understanding of home speaks more to the aspirations of the American Dream and the imposition of the American political project than to the realities of American life. After all, Americans inhabit a wide variety of building types and socio-spatial arrangements; many Americans experience home-lessness or housing insecurity. As the work of hooks and other African American cultural producers demonstrates, the Black home tends not to conform to—and even *opposes*—this under-standing of home as enclosure.

Remembering his own childhood home, Moten testifies to this lived nonconformity. His mother was a schoolteacher, and students often circulated in and out of his home. He remembers one in particular, who was like a brother to him: "The greatest feel-ing in the world for me," Moten recalls, "was to hear or see Mike walk through the front door. Without knocking. You understand? Without knocking."[7] For Moten, home is "the experience of the constant violation of the boundaries of the so-called home." The beauty of home is not its sovereign, hermetically sealed, fenced-in enclosure, but the *not knocking* by which the nuclear family unit constantly expands, becoming more than itself, by which we become more than ourselves with others. "Homelessness is the condition in which you share your house," Moten proposes, "in which you give your house away constantly as a practice of hos-pitality ... home is where you give home away."[8] In its violation of the boundaries that constitute the house, the Black home is made through Black sociality's refusal and critique of enclosure.

Turn down any unmarked path in the novels of Toni Morrison and you will find a waystation—a place of temporary shelter, where home is constantly given away. In *Jazz*, "Woodsmen, white or black, all country people were free to enter a lean-to, a hunter's shooting cabin. Take what they needed, leave what they could. They were [waystations] and anybody, everybody, might have need of shelter."[9] The haunted house that achieves the status of protagonist in *Beloved*, 124 Bluestone Road, was a waystation in its previous life, "the place they assembled to catch news, taste oxtail soup, leave their children, cut out a skirt."[10] The converted convent in *Paradise* is a waystation, too, for all wayward and wan-dering women living in excess of patriarchal regulation and do-mestic convention. All the journeying folk across Morrison's novels—from *A Mercy*'s Florens, to *God Help the Child*'s Bride, to *Song of Solomon*'s Milkman—encounter

[7] Fred Moten and Stefano Harney, "Give Away Your Home, Constantly," July 11, 2020, in *Millennials Are Killing Capitalism*, podcast, 1:01:54, millennialsarekillingcapitalism.libsyn.com/give-away-your-home-constantly-fred-moten-and-stefano-harney.
[8] Ibid.
[9] Toni Morrison, *Jazz* (New York: Plume Books, 1992), 170.
[10] Toni Morrison, *Beloved* (New York: Vintage, 1987), 293.

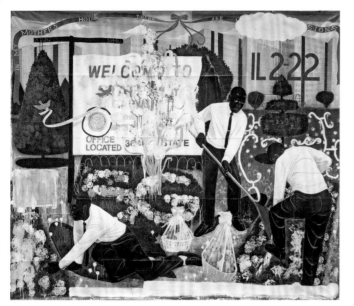
Kerry James Marshall, Many Mansions, 1994

waystations where they rest and are fed, where they receive care at no cost. The waystation sometimes takes the form of a house, but its perpetual offer of shelter is a constant violation of the house's boundaries. With each of these novels, Morrison asks us to remember the past life of the Black home as a refuge, a shelter, a haven for alternative forms of sociality.

In her poem "kitchenette building," Gwendolyn Brooks remembers sounds and smells floating through the walls of the subdivided apartment: "onion fumes / Its white and violet, fight with fried potatoes / And yesterday's garbage ripening in the hall."[11] She wonders if a dream, too, could "flutter or sing an aria down these rooms." The kitchenette, for Brooks, is defined as much by its partitions as by the contaminating forces that defy them. Artist Kerry James Marshall conjures a similar contamination in his 1994–95 Garden Series, five paintings that depict Black life in and against public housing in Chicago and Los Angeles. Atop highly detailed and realistically rendered depictions of project buildings, Marshall layers lovers, gardeners, and children playing; expressionist "blots" of dripping paint; and nostalgic iconography—doilies, lovebirds, and banners. These intimate embellishments, which hover in the space between vévé[12] and a diary's private marginalia, violate the boundaries of Western painting's traditional genres and the architectural aesthetics of racial enclosure. While their techniques and mediums differ, both Brooks and Marshall highlight the character of the violation of enclosure as integral to the representation of the Black home.

Merry Clayton remembers recording the memorable background vocals for the Rolling Stones' "Gimme Shelter" as a time of heartbreak.[13] The day after the grueling session, she suffered a miscarriage. Her voice is the wailing spine that gives the song its power. Her cry, "It's just a shot away," is the song's architecture—its house, which nearly bursts at the seams, sagging under the weight of what she sustains. While the song is an insistent, desperate cry for shelter from the violence of the modern world, Clayton herself bears the brunt of exposure's effects. The texture of her voice underscores the necessity of a shelter against

[11] Gwendolyn Brooks, "kitchenette building," from *A Street in Bronzeville* (New York: Harper, 1945), 2.
[12] A vévé is a ground drawing in Haitian Voudou, used to communicate with the lwa.
[13] "Merry Clayton: 'Gimme Shelter Left a Dark Taste in My Mouth,'" interview by Robert Ham, *Guardian*, April 8, 2021, https://www.theguardian.com/music/2021/apr/08/gimme-shelter-left-a-dark-taste-in-my-mouth-merry-clayton.

GIVE ME SHELTER

the brutal churning of a world that relies on Black women's exploitation and disposability in equal measure. In her searing wail, Clayton gives deeper meaning to the song. She reminds us that the shelter must exceed the conditions of its emergence, it must reach beyond its grasp, it must perceive what it cannot see, it must train toward a new world. The Black home in literature, in art, in music is perpetually the projection of a world yet to come, made from nothing and improvised on the run: an anti-architecture of American domesticity.

In "Characteristics of Negro Expression," Zora Neale Hurston writes, "The pictures on the wall are hung at deep angles. Furniture is always set at an angle. I have seen instances of a piece of furniture in the *middle* of a wall being set with one end nearer the wall than the other to avoid the simple straight line."[14] Hurston suggests here that at the foundation of Black interior design aesthetics is an evasion of the "simple straight line," the line that articulates the border, the boundary, the fence, the barrier. Thus "Negro expression" is a constant violation and rearrangement of the line, a practice of what Cheryl A. Wall might call "worrying the line," after the predilection of blues musicians to bend a musical phrase. We might read this deep angle as a refusal of racial capitalism's aesthetics and geometries, a refusal of the capture and containment the line makes possible. In the beauty of the Black interior is not only style and sensibility, not only "a will to adorn" and "a proclivity for the baroque," but also a transfiguring theory and method of home that dislodges it from the confines of enclosure. We find a vision of home that refuses property, a practice of home that gives itself away.

[14] Zora Neale Hurston, "Characteristics of Negro Expression" (1934), in *The Norton Anthology of African American Literature*, vol. 1 (New York: W. W. Norton & Company, 2014), 1022.

\mathcal{U}NEARTHING THE UNDERGROUND LIBRARY

A library is a home in itself. In its simplest form, as a collection of books, it is a portrait, a reflection of the individual or group that assembled it. It reveals priorities, fixations, concerns, and mysteries. Malene Barnett and Leyden Lewis, cofounders of the Black Artists + Designers Guild (BADG), explore and expand the possibilities of the archive within the physical confines of Andrew Carnegie's former library at Cooper Hewitt, Smithsonian Design Museum, which is housed in the former home of the industrial magnate. BADG is a nonprofit organization pushing for justice in the worlds of art and design. The Underground Library is their site-specific project for *Making Home*. Black Artists + Designers Guild's intervention in Carnegie's library—a place for reflection, study, and socialization—is loaded.

CAMILLE OKHIO is a New York-based writer, curator, historian, and senior design writer at *Elle Décor*. Her work has also appeared in *Apartamento*, *W* magazine, *Architectural Digest*, the *New York Times*, *Art in America*, *Wallpaper**, *PIN-UP*, and *Vogue*. Her practice centers on fine and decorative arts and their narrative potential.

Libraries permit experimentation. They are places where questions meet answers, places with peripheries but not borders. Their existence is proof of the indestructible nature of truth. Knowledge once released can never be contained again, but it can converge to generate new knowledge. BADG, which counts architects, interior designers, textile artists, furniture makers, and ceramicists among its members, is also an exercise in convergence. The Underground Library, as they have conceived it, aims to reflect the rich tradition of the library as a repository of storytelling and memory.

A bustling, central element to Carnegie's domestic topography, the room in which the Underground Library lives, was once a nucleus from which the nineteenth-century tycoon plotted. Who was he, aside from one of the richest men in the world during his lifetime? How can one space be made to hold the ruthlessness of early capitalism alongside a seemingly earnest philanthropic urge? Carnegie embodied the American myth of upward mobility. He amassed his wealth in the steel industry and "gave back" once that wealth reached astounding levels, guarding his excess from critique by contributing to several causes, some of which, like most philanthropists, he was partially responsible for. Among his beneficiaries was the historically Black Tuskegee University, then named the Tuskegee Institute, under the direction of Booker T. Washington.

MEMORY

At Tuskegee, he funded a library building, one of several such Carnegie libraries on historically Black college and university campuses. Although such an endeavor was righteous, Carnegie was still a man of contradictions—a pacifist who wouldn't support his own steel workers union. Perhaps his library was a reflection of his complexity. Perhaps it was simply a vessel for his anxiety.

Black Artists + Designers Guild (BADG), Sketch for The Underground Library, 2023

The Underground Library cannibalizes the genesis of the space it takes root in, like a placenta consumed post-birth. It extends a centuries-long tradition of deliverance, enacted entirely by the delivered peoples themselves. Summoning their forebears' determined bids for autonomy, both of the mind and of the body, Barnett and Lewis assemble a framework encompassing the physical and visual, expressing human needs ranging from tactile connection to shared spiritual understanding. In this space, the body is freed rather than restrained, the mind is encouraged rather than restricted. We are reminded that expansion, growth, and solidity do not require eradication, erasure, or genocide.

The written word has held the possibility for both destruction and emancipation since its first use. Today, books are banned for mentions of natural bodily functions, for descriptions of human emotion, for recounting historical facts. This recent shift was at the center of Barnett and Lewis's choice to reconsider and contextualize the library as a space. Knowledge was never revered in mainstream American culture and still is not. How could it be, when our earliest definitions of freedom were irrevocably flawed?

There is no such thing as a partial truth. Racism crushes the intellectual capacities and psychological health of those who accept and perpetuate it. In decrying freedom for all while promoting the purchase and trade of human flesh, and the subsequent devaluation of all human life, the relationship between reality and its recounting is made unstable. But in Black American and diasporic communities, knowledge has carried enormous, consistent weight. We cannot look away. Lies do not do for us what they do for others. From our earliest existence on this land as bodies owned, for whom learning was strictly forbidden, the written and spoken word held and holds immense promise and possibility.

In the hands of Barnett, Lewis, and their collaborators, Carnegie's former library has become a space for truth to be not

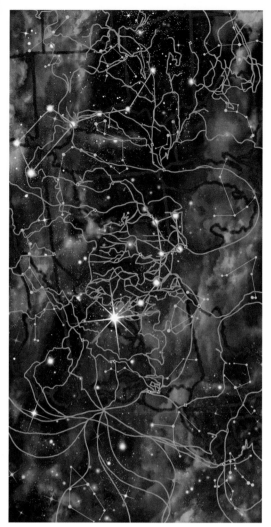

Malene Barnett, Design for Liberty Line carpet, 2024

only shared but relished. Layers of lived experience, interpretation, experimentation, discovery, and invention are gathered into one room and put into play with incontrovertible truths. Any library is a project of preservation, affording the objects that live within a space value that might have previously been denied. The Underground Library emphasizes the power of preservation alongside the power of context, examining how we define and decide what is treasure.

In Carnegie's former library, with its wood-paneled walls and bookshelves, soft, creaking floors, and carved ceiling, a new archive is put into place. Black Artists + Designers Guild claims the space in order to free it. In an inversion of Manifest Destiny, Carnegie's bookshelves are unbound, his floors trod freely, his ceilings the locus of any thoughtful visitor's contemplation. The final step in a gradual journey from private, to restricted, to open and inviting.

As the name suggests, the Underground Library is an exercise of unearthing, in which what was once forced into hiding returns with renewed strength. A library, particularly this one, requires veneration as much as interrogation for it to survive. It is a collective soul, a time capsule, a lab, where the past, present, and future collide. To be human is to remember. And to remember, we must first speak of what we know to be true.

JOY AND PAIN
Finding a Loophole of Retreat

In Harriet Jacobs's *Incidents in the Life of a Slave Girl* (1861), she describes a tool, a gimlet, that was left in a crawlspace in her grandmother's house where she found refuge from enslavement for seven years. She says:

Curator, author, educator, administrator, and public advocate for reimagining the role of art museums in society, SANDRA JACKSON-DUMONT has served as director and CEO of the Lucas Museum of Narrative Art since 2020. She lives in Los Angeles with her husband and two godchildren.

> One day I hit my head against something, and found it was a gimlet. My uncle had left it sticking there when he made the trapdoor. I was as rejoiced as Robinson Crusoe could have been in finding such a treasure. It put a lucky thought into my head. I said to myself, "Now I will have some light. Now I will see my children." I did not dare to begin my work during the daytime, for fear of attracting attention. But I groped round; and having found the side next the street, where I could frequently see my children, I stuck the gimlet in and waited for evening. I bored three rows of holes, one above another; then I bored out the interstices between. I thus succeeded in making one hole about an inch long and an inch broad. I sat by it till late into the night, to enjoy the little whiff of air that floated in. In the morning, I watched for my children.[1]

Until I read Jacobs's account of her time in that cramped interstitial space, I had exclusively known a gimlet to be an elegant cocktail. But when I read her chapter "The Loophole of Retreat," I learned that a gimlet is also a small T-shaped tool with a screw tip for boring holes. Jacobs used a gimlet to bring light and air into the garret where she was being hidden for her protection. The space was only nine feet by seven feet, and "the highest part was three feet high, and sloped down abruptly to the loose board floor."[2] With the gimlet, Jacobs created the holes through which she could observe her children.

This tool seems perfect in size and function for many things. I started thinking, wouldn't it be wise to carry a gimlet everywhere one goes? Wouldn't it be a good intention for a Black woman to walk around with a gimlet sewn in the hem of a sleeve or, depending on its size, tucked like a twenty-dollar bill just inside her bra?

[1] Harriet Ann Jacobs, "Chapter XXI: The Loophole of Retreat," in *Incidents in the Life of a Slave Girl*, ed. Lydia Maria Francis Child (Boston: Published for the Author), 1861.
[2] Ibid.

Eadie Mae Jackson, ca. 2019

MEMORY

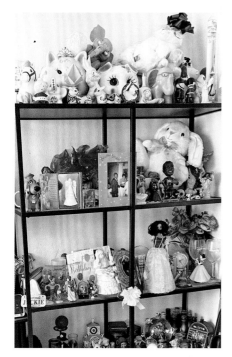

Eadie Mae Jackson's whatnot shelf, ca. 2021

Perhaps one should not only consider carrying an actual gimlet, but also to have a metaphorical gimlet at one's disposal, a little something for those times when matters feel precarious and unsafe.

Imagine that for a second. Think about a time when you were experiencing darkness and you needed light to shine your way. Imagine being able to access your little gimlet in those moments or in those spaces when and where you need *to* retreat, you need *a* retreat. You could reach for your gimlet and, like Jacobs, you could bore three rows of holes, one above another, and you could, amid your situation, quietly, unbeknownst to anyone, succeed in making at least one hole about an inch long and inch broad to enjoy a breath of fresh air.

I have been thinking about narratives, like Jacobs's, or stories as paths for self-determination, and about memory as medicine.

With that in mind, let me introduce you to Eadie Mae Jackson, also known as my mother or my maker. She was born in 1938 in rural Mississippi to my grandmother, who had the same name. So, I guess my mother could be called Eadie Jr., but instead they call her "Sweet," or as my cousins say, "Ain't Sweet."

Every day when she rises, she washes her face, first with warm water, and then with cold water. Immediately after, she applies red lipstick. She then presses and rubs her thin lips together, while making smacking sounds to ensure she has them covered. Then, she puts a dab of red lipstick on each cheek and smooths the dot of color across her high cheekbones to make blush. She pulls out her pocket mirror, holds it up to her face to look at herself, lets out a little chuckle, and says, just above a whisper, "Umph, you a bad bitch. Look at God."

My mother has always been a woman about town. As she has aged, her various illnesses have required her to use a wheelchair. This has not kept her from, in her words, "running the streets." From rolling up on conversations at the corner spot or showing up for Sunday service at Union Springs Missionary Baptist Church to attending funerals for friends and catching public transportation to far-afield neighborhoods for bingo games, this woman harnesses little to no respect for fear.

These last few years have delivered significant health challenges and life changes to my mother's doorstep. As a result, she has gone from enacting her lipstick ritual and using her electric

JOY AND PAIN

wheelchair to traverse the city to needing around-the-clock care. This major shift has come under the cover of dementia and therefore is accompanied by bouts of stress, frustration, anger, joy, and unbridled happiness.

My mother and I speak every day. While our conversations are textured and detailed, for the most part they have become very repetitive, like the hook to a song we both know that is on constant rotation.

As her condition evolves, I have noticed that, for her, time is elastic. I have learned that people with dementia can lose their sense of duration and their ability to comprehend how much time has passed. Because of this, she is often experiencing what is called time shifting, meaning that she is living at an earlier time in her life and she is talking to me as if I were there with her—only I may not have been there. This time shifting leads to disorientation and confusion, affecting how she understands the world around her.

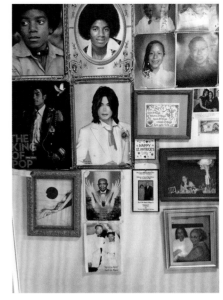

Eadie Mae Jackson's apartment wall, ca. 2021

For the last few months, our conversations have been mainly shaped by her short-term memories, but there are those watershed moments when she shares detailed accounts of experiences, real, reconstructed, or imagined. Those moments seem to have been buried deep in her personal archives. Sometimes her words are gentle and full of tender loving care, like when she says, "You know God gave you to me," as if God walked up to her and handed her a beautifully wrapped gift box and I was inside. Then there are days when she is beside herself with anger, screaming with frustration for being misunderstood or for not being able to do what she is accustomed to doing.

I was recently rereading Audre Lorde's "Eye to Eye: Black Women, Hatred and Anger." She writes:

> Every Black woman in America lives her life somewhere along a wide curve of ancient and unexpressed angers. My Black woman's anger is a molten pond at the core of me, my most fiercely guarded secret. I know how much of my life as a wonderful feeling woman is laced through with this net of rage. It is an electric thread woven into every emotional tapestry upon which to set the essentials of my life—a boiling hot spring likely to erupt at any point, leaping out of my consciousness like a fire on the landscape. How to train that anger with accuracy rather than deny it has been one of the major tasks of my life.[3]

[3] Audre Lorde, "Eye to Eye: Black Women, Hatred and Anger," in *Sister Outsider: Essays and Speeches* (Trumansburg, NY: The Crossing Press, 1984), 145.

MEMORY

When I revisited this text, I realized that my mother's condition could be an effect of dementia or an outcome of her Black womanhood. In any case, Lorde helped me understand that I should not be dismissive of my mother's narratives, but instead embrace and explore the potential accuracy with which she is telling her stories. It is in these moments of complete frustration, when I am witnessing my mother relive her life's script, that I wish I had a gimlet to give her.

We recently packed up her apartment. In doing so, I paid attention to how she had covered the walls with images, items, and objects that are of interest or importance to her, including pictures of our family, her friends, Michael Jackson, James Brown, Aretha Franklin, Reverend Ike, and President Barack Obama. There were awards, articles, and honors of mine from years past. There were plastic flowers, obituaries, Kama sutra poses, knickknacks, and exercise instructions. When I stood back and looked at the walls, I realized her apartment was an installation.

I felt like I was in her memories, in her hopes and aspirations. I was in her loophole of retreat. Those objects, these things are her gimlet. They are the tools that she used to bore holes through the opaque and inconsiderate slippage called dementia. Each of those objects that she brought to those walls allows her access to life as she once knew it, or how she hoped it would be. They are the holes that grant her access to air and light.

As someone whose work is about making museums meaningful, functional, and bound up in the everyday lives of people, I am moved by my mother's deep and incisive understanding of how to make lives relevant through "things." This is a powerful way to approach why we make things like objects and why we have museums in the first place.

My mother—my maker, Eadie Jackson, Sweet—recently experienced her eighty-fourth rotation around the sun. While celebrating, she told us stories, so I told her about Jacobs and the seven years she spent in her loophole of retreat.

She said, and I quote: "Seven years, what? She spent seven years in that tiny little space watching her kids play?"

I said, "Among other things, yes."

And then she said, in the most complimentary way, "Umph … now that's a bad bitch."

To which I replied, "Do you think she wore red lipstick?"

A version of this essay was first developed and presented at Simone Leigh's Loophole of Retreat in Venice, Italy, October 8, 2022.

MEMORY

JOY AND PAIN

\mathscr{E}XPRESSION OF GRATITUDE

"I am constantly trying to find
ways to utilize elements."
"Everything has a pattern."
"Everything can be something."
"There are no mistakes in art, and there are
no expiration dates on ideas."

I have heard variations on these statements throughout the two years I've been collaborating with and learning from artist Robert Paige. The notion that design can be perceived everywhere is integral to my understanding of his practice, which is rooted in the experiences of quotidian life. He emphasizes moments that, while seemingly ordinary, richly illustrate how people make meaning in their lives and negotiate the world around them. This infuses Paige's multidisciplinary approach, which spans more than sixty years, and encompasses textile dyeing, painting, drawing, collage, sculpture, and installation. His critical eye toward juxtaposition brings seemingly incongruous colors and shapes together to accentuate underlying hues and shades and brings dimensional elements into intricate dialogue. Always maintaining his position as both a fine artist and commercial designer, Paige continues to grow his practice as he experiments with new mediums and methods of making, fueled by his belief in ever-shifting modes of creativity.

GERVAIS MARSH is a writer, curator, and scholar from Kingston, Jamaica, whose work is deeply invested in Black life, concepts of relationality, and intimacy. A curatorial fellow with the Whitney Independent Study Program, they have written for the *Financial Times*, Hyperallergic, the *Brooklyn Rail*, and *Nka: Journal of Contemporary African Art*, among other publications.

In an iconic image from a magazine advertisement, Paige sits amid lush greenery, surrounded by his designs adorning pillowcases, duvet covers, and drapes. Seated cross-legged in a brown suit, his calm, intent stare pulls the viewer into his world of geometric shapes in vibrant, warm tones. The image is an ad for Paige's Dakkabar home furnishing collection, which was inspired by patterns, colors, and object designs from Senegal and distributed across 126 Sears stores throughout the United States

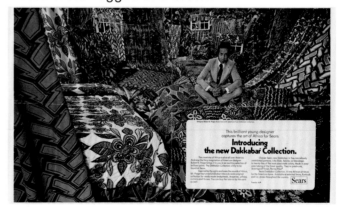

Advertisement for Robert Earl Paige's Dakkabar home textile collection for Sears, circa 1976

Robert Earl Paige in his studio, 2024

in the early 1970s. Released at the tail end of the civil rights movement, the distinctly West African diasporic aesthetic approach of the collection affirmed both the rich artistry of this region and the complex histories of Black life in the United States. Paige gestured to more expansive conceptions of home by situating African American placemaking within the quintessentially "American" brand of Sears. Reflecting on the collection, he emphasizes a pleasure in creating accessible home interior designs that resonated with Black communities, so they felt seen: "It gave my community and friends something to be elated over. It gave you the idea that there are not only possibilities, but no limits on how you can extend yourself."[1]

Scholar Kevin Quashie theorizes "quiet" as an orientation toward the interior self, and interrogates the expectations placed on Black life to be understood predominantly through public expression, often overlooking emotional depth. He writes: "So much of the discourse of racial blackness imagines black people as public subjects with identities formed and articulated and resisted in public."[2] With the Dakkabar collection, Paige markedly shifts how creative expression from Black communities can be imagined, shaping the intimate, often quieter refuge of the home.

Paige grew up in the Woodlawn neighborhood of Chicago in the 1940s, among a Black community establishing itself in the city during the Great Migration from the South. His family came from Mississippi, and this history reverberates in a saying he often repeats: "The beauty you see is the Mississippi in me." For many in Black communities that moved to the Midwest, ties to the South shaped ideas of home that value collectivity, understanding that family extends beyond biological connections. They also maintained a respect for the natural environment, recognizing that the land is crucial to sustenance. In his piece Pat Kelly, Paige celebrates the famed fashion designer Patrick Kelly, who also hailed from Mississippi and whom he greatly admired for his innovative designs; the work emphasizes the connection between Black communities in the South and Midwest. Against a violet background, Paige interweaves the words "Pat Kelly," "Chicago," "Mississippi," and "Paris" with graphic images such as bright red lips, multicolored hearts, and watermelons, referencing the bright buttons that adorned Kelly's clothing and subversively contending with racial stereotypes.[3]

[1] Robert Paige, conversation with author, 2021–22. All subsequent direct quotes from Paige in this essay are from these conversations.
[2] "Quiet is antithetical to how we think about black culture, and by extension, black people. So much of the discourse of racial blackness imagines black people as public subjects with identities formed and articulated and resisted in public. Such blackness is dramatic, symbolic, never for its own vagary, always representative and engaged with how it is imagined publicly. These characterizations are the legacy of racism and they become the common way we understand and represent blackness; literally they become a lingua franca. The idea of quiet, then, can shift attention to what is interior." Kevin Quashie, The Sovereignty of Quiet: Beyond Resistance in Black Culture (New Brunswick, NJ: Rutgers University Press, 2012), 8.
[3] Eric Darnell Pritchard, "Race WERK: Willi-Wear and Patrick Kelly Paris," in Black Designers in American Fashion, ed. Elizabeth Way (London: Bloomsbury Visual Arts, 2021): 239.

EXPRESSION OF GRATITUDE

In doing so, Paige displays his talent of balancing form while exploring saturation.

[4] Paul Von Blum, "Recovering the Rubble: African American Assemblage Art in Los Angeles," *Journal of Pan African Studies* 4, no. 5 (2011): 248–62.
[5] "Agree not merely to the right to difference but, carrying this further, agree also to the right to opacity that is not enclosure within an impenetrable autarchy but subsistence within an irreducible singularity.... The right to opacity would not establish autism; it would be the real foundation of Relation, in freedoms." Édouard Glissant, *Poetics of Relation* (Ann Arbor: University of Michigan Press, 1990), 190.

While racial segregation dictated that Black residents mostly lived in the city's South Side and West Side neighborhoods, Paige articulates that there was no need for him to venture past downtown, for Chicago's South Side was coursing with life, businesses, and recreational activities. He was given free rein to explore his childhood curiosities, with "home" broadening beyond the confines of the building where he lived. Paige recalls running through Jackson Park with friends, collecting the rocks, twigs, and leaves that he assembled into his early artworks. As for many assemblage artists emerging in the 1960s, all objects became materials for creating, a practice that remains evident in his sculptural works, which can incorporate flattened soda cans, candy bar wrappers, pebbles, and scraps of cloth.[4] This innovation continued into the Black Arts Movement of the 1960s and '70s, a period he has described as overflowing with creative potential. He had frequent run-ins at that time with artists and design professionals, from graphic designer and art director Emmett McBain to Paige's fellow members of the collective AfriCOBRA, Bill Abernathy and Gerald Williams. Black artists were collaborating and seeking to strengthen their practices. "It was electric.... It was the establishing of an aesthetic conversation that had everybody in sync. We were in harmony." There was a focus on the nuanced layers of Chicago itself, a city teeming with possibility even amid difficult sociopolitical realities.

For Paige, creating home does not signify annexation, but rather an opportunity to foster new adaptations for livable moments. In constant observation of his surroundings, he invests in deep relationality and the interconnections among human beings, animals, and the natural and built landscape. He echoes the decolonial and environmentally conscious theories of Martiniquan philosopher Édouard Glissant, claiming that we are all in relation and thus should embrace the complexities of specificity, even if it cannot be fully grasped, rather than flatten in an attempt to understand "completely."[5]

On one of our walks through Hyde Park in Chicago, Paige gestured to a tree limb inching toward a window and pointed out the shapes made between the branches. He pulled my eye to the intertwined spatial possibilities in the architecture of the building, the colors of the leaves, and the light reflected in the glass. "If we allow ourselves to understand everything is connected, completely, you shouldn't try to break the chain. I am connected to everything, so I am appreciative of that knowledge; it is all humanity."

MEMORY

THE OFFERING
A Feast for Black Livingness

This is a calling and a heeding of a call. This is an homage to the rooting and uprooting of a people, the nest eggs, the off-limits parlors, the sideboards, the groaning boards, the hope chests and chests of drawers, the good porcelain and cushioned chairs reserved for the grown, the growing, and the gone on to glory.

MICHELLE LANIER is a folklorist of the Black South, rooted in AfroCarolina. A faculty fellow at the Center for Documentary Studies at Duke University, Durham, North Carolina, Lanier also leads twenty-seven museum spaces as the director of North Carolina Historic Sites. Lanier believes in the transformative power of place as witness.

Perhaps this is the place where we suture the wounds, where we say things from the heart, from the soles of our feet, the place where we work it out in a dining room of our dreams.

> "It's always there ... this binding together of these terrestrial things."
> HADIYA WILLIAMS

> "I would always pick the sweetest blackberries."
> NICOLE CROWDER

> "I always wanted it to be about movement and maps, wayfinding."
> HADIYA WILLIAMS

Always, always, always, we begin with "always," a desire for permanence, a yearning for the eternal.

Nicole Crowder and Hadiya Williams, two multimodal designers inspired by the sacred material culture of Black interiors,[1] are descendants of the migratory Black South. These artist collaborators hold differing memories of their origin story, like most kin. Crowder remembers meeting at a celebratory brunch gathering of Black women. Williams finds it hard to pinpoint where they first shared space, but she recalls there being an exchange of stories of Black people engaged in the act of flight.

One of their most emotionally affective recollections is the archival-inflected exhibition they participated in at an antebellum historic space in 2018, once witness to human slavery, the Woodlawn & Pope-Leighey House Historic Site in Arlington, Virginia. Here Crowder and Williams reclaimed the humanity and wonder of those

[1] See Elizabeth Alexander, *The Black Interior* (Minneapolis: Graywolf Press, 2004).

MEMORY

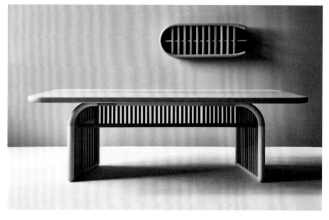

Hadiya Williams, A rendered table in the artificial-intelligence program Midjourney that inspired a custom-designed dining table in The Offering

whose labors and lives often go unnamed and unknown, by installing a dining space for those once forced to serve.

The dream behind the tablescape and surroundings of The Offering is not bound by the era of slavery, or any time, for that matter. It grew, instead, out of a shared desire to contend with the search for home.

Crowder and Williams see objects—carried and found along the way—as metaphor and material evidence of "a new home." They center the sacred place for commemorative and speculative ceremony at a "new altar," the dining table.

Crowder is an upholsterer known for resurrecting the old wood of former lives and consecrating the backs of those in search of rest with fabrics lush in both material and meaning. She turns readily to the inspirations of nineteenth-century cabinetmaker, furniture artisan, and free man of color Thomas Day, whose workshop still stands in Milton, North Carolina, near the banks of the Dan River. Two other AfroCarolina names emerge when seeking the inspirational universe of Crowder and Williams: famed potter and poet David Drake of Edgefield, South Carolina, and textile magnate Warren Clay Coleman of Concord, North Carolina, who was born just minutes from a different kind of conceptualist, the architect of the Parliament-Funkadelic "Mothership," George Clinton.

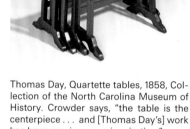

Thomas Day, Quartette tables, 1858, Collection of the North Carolina Museum of History. Crowder says, "the table is the centerpiece . . . and [Thomas Day's] work has been serving as an inspiration."

Williams regularly turns to her genealogy for inspiration. From her ancestral reimaginings and talismanic ceramic adornments for breasts and walls, to mugs for the hands and patterns for the marking of times yet emerging, Williams crafts a choreography[2] for worldmaking. She offers up still lifes of Black femme rituals, declared in saturated color and curvature. In her artificialintelligence rehearsals, made via the program Midjourney, I see liberation from the tethers of rigid nostalgia, an ancient future vibrating in the voids. Her praxis moves beyond trauma or melancholy through the traditions of Black, migratory South "plotting."[3] Her own mothership, her matrilineage via her grandmother Ora Lee, found root in and later flight from Johnston County, North

[2] See Aimee Meredith Cox, Shapeshifters: Black Girls and the Choreography of Citizenship (Durham, NC: Duke University Press, 2015).
[3] See J. T. Roane, Dark Agoras: Insurgent Black Social Life and the Politics of Place (New York: NYU Press, 2023).

MEMORY

Carolina, a place known for cataclysms of race and war. Ora Lee ran north, to Washington, DC, from the land of her birth.

Ora Lee Barnes—then Williams, then Haywood—rented the necessary things for her home from a company intent on keeping her in a state of perpetual debt, in a system not unlike sharecropping. Her very name is included in the court case that ruled the practice illegal.[4] Williams v. Walker Whitman is a case still taught in law schools.

Her granddaughter, Hadiya Williams, possesses few other details about the life story and life ways of Ora Lee Barnes Williams Haywood, or why she ran. Williams says this of her grandmother's story: It was "walled up . . . She was walled up."

And yet, in The Offering, I hear Ora Lee, un-walled, released, in full possession of her things, taking her time, eating breakfast meats and grits made just for her. She is holding a ceramic mug, crafted by her granddaughter, marked with the secret codes of her life. Regal in this imagined dining room, she dines alongside Crowder's grandfather, Roosevelt Prouder of Victoria, Virginia, in the presence of his acres of fruit. These guiding ancestors are ceremonially seated in chairs created by Crowder, dreamed and carved into being for the rest and delight of Black bodies and Black love. It is clear as good well water that our very own ancestors will be invited to sit and dine and laugh as well. Upholstered for the bones of those gone, here, and on the way, these chairs surround a table of welcome.

In the worlds Crowder and Williams create, we are all always coming home to the tables and beds of our people, including our future selves.

We rest to rise from tucked cloth, tucked blankets, cool sheets, bellies full of berries. We have been told to "lay down somewhere" in the spirit of Tricia Hersey's Nap Ministry, and we do.[5] This is the inner sanctum of the Black femme South power passed from Tina Knowles to her daughters. Here we are cozy. Here, beyond the strictures of stereotypical and servile Black matriarchy, there is elegance, drama, sensuality, wit, and magic.

Crowder and Williams treat the room as a body, shaping space with the reliquaries of memory and Afro-futurity, the evidence of ritual and reimagined traditions. This is a sacred inner sanctuary. As a womanist cartographer, I recognize the maps, the footprint of spirit, the recollection of wandering ways and wondering days. Their lines are sharp and plush, interdimensional, but never overwrought.

The vision behind this work recalls the hotlines between spirit and matter, threads, thrumming and golden hot, hot-comb hot,

[4] Williams v. Walker Whitman, 1965.
[5] See Tricia Hersey, *Rest is Resistance: A Manifesto* (New York: Little, Brown, 2022).
[6] Katherine McKittrick writes and speaks about "Black livingness" as a theoretical framing; see *Dear Science and Other Stories* (Durham, NC: Duke University Press, 2021).

THE OFFERING

hot-plate-in-a-basement-apartment hot, hot-sauce hot. The air in this Black imaginary is electric between us scattershot Black South babies of the night. This air, thick with the intimate distance of so-called "outside children," is charged with the ones who call our names.

The smirk of soft things for hard-earned lives pulls these threads, whole spools, rolling across lemongrass-oiled floors, gleaming under laughter and chandeliers—and there they all are and there we all are, gathered for a living feast, a feast of what Katherine McKittrick would call "Black livingness."[6]

Strangely, in the light of such fullness, I cannot stop thinking about our kin who subsist on and even crave cans of gas station meat, corner store candy, and moonshine. They, too, are invited to the feast, brown bags and all. We have all been called to gather, as the old folk say, "for such a time as this."

I see Black women preparing tables in the presence of lived memories. Our feasting in the wake of "rough side of the mountain" things is an interruption of the loop, a hacking of systems meant to keep us unfree.[7]

I am reminded, through Crowder and Williams, of famous Black tables and tablecloth gathering grounds of Black South kin: the beach feast in the 1991 film *Daughters of the Dust*, the table anchoring the opening holiday meal in *The Wiz* (1978), the Easter table in *The Color Purple* (1985), the dark-sensual and raw witness of Carrie Mae Weems's tables, Elzora's table in *Eve's Bayou* (1997), and the under-told story of Harriet Ann Jacobs's tables set for her formerly enslaved sistren in honor of their liberation and in the spirit of her grandmother, Molly Horniblow, an innkeeper and baker of breads.[8] There is a cadence to this work—the gathering of the pieces of us, the determination of a gulp and a grit, the piercing through the coordinates of fugitivity to find the self.

It is an innkeeper's hand that knows how to reach across time into the thick of spirit, through the setting of tablescapes, to present the rhythmic alchemy of connectivity, of reenactment, of intimate monumentalization through the act of feasting.

We are all always feasting on something, these artists remind us, and something is always, always seeking to feast on us.

What if we are some kind of free here? What if there is abundance here? These questions flood and fall like sea-level rise.[9]

There is also the Black tradition of humming when the food is good, of hitting the table with a high hat, of rocking in the

[7] See Christina Sharpe, *In the Wake: On Blackness and Being* (Durham, NC: Duke University Press, 2016). "The Rough Side of the Mountain" is a gospel song by F. C. Barnes, published in 1984.

[8] Molly Horniblow, called "Aunt Marthy" in *Incidents in the Life of a Slave Girl* (1861), was the maternal grandmother of freedom seeker, memoirist, journalist, abolitionist, educator, and Civil War aid worker of the author, Harriet Ann Jacobs. Horniblow, Jacobs, and Jacobs's daughter (Louisa Matilda) all used the act and art of keeping boarding houses and catering meals as a mode of survival. Harriet Ann Jacobs is known to have grandly hosted formerly enslaved women in Washington, DC, during the winter holidays, as noted in Jean Fagan Yellin, ed., *The Harriet Jacobs Family Papers* (Chapel Hill, NC: University of North Carolina Press, 2008).

[9] Alexis Pauline Gumbs offers a poetic portal into the aquatic paradigms of Black femme survival in *Undrowned: Black Feminist Lessons from Marine Mammals* (Chico, California: AK Press, 2020).

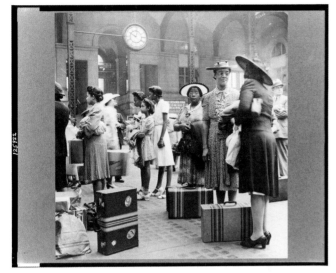

Passengers waiting for their train at Penn Station in New York City, photographed by Marjory Collins, 1942. Lanier writes, "The recollection of wandering ways and wondering days."

rhythm of the meal, of flooding our plates to overflow such that even the dead and gone will rub their bellies in delight. These offerings are an invitation to joy beyond death, joy beyond life and death, where there will of course be music in the air, always. In this place, there is the hum of love.

THE OFFERING

MAKING CAREHAUS

Carehaus is the United States' first intergenerational care-based cohousing project. Carehaus provides quality care and homes for disabled adults as well as quality jobs and homes for caregivers and their families. Carehaus codesign workshops have iteratively taken place since 2020 but are imagined here as a single session. These vignettes capture some of the critical discussion points informing the design of Carehaus Baltimore, which is slated to open doors in 2026.

Guillermina Castellanos walks us around the Mission, a neighborhood in San Francisco that is home to her and many of the Latinx nannies, housekeepers, and caregivers from La Colectiva de Mujeres, the organization she helps direct. About the neighborhood she says, "It's gone through so many changes—from the huge rent swell due to Silicon Valley to the opioid crisis today. Still, it's hard to make rent, and it's hard to imagine what's going to happen to us in the future. Who will take care of us and where will we live?"

CAREHAUS was founded by Marisa Morán Jahn, an artist of Ecuadorian and Chinese descent; Rafi Segal, architect and professor at Massachusetts Institute of Technology, Cambridge; and Haitian American developer Ernst Valery. Presented at the White House, the United Nations, the *New York Times*, Venice Biennale, and more, their respective work has shaped the public imagination around care, housing, and design.

Castellanos's concerns echo the worries of the United States' 2.2 million domestic workers, over 90 percent of whom are women.[1] While the United States relies on the help of domestic workers to ensure the well-being of our homes, they themselves face significant challenges in their home lives: 84 percent experience food scarcity, and 51 percent are housing insecure.[2] In turn, the low wages and high turnover in the industry directly impact the well-being of those who rely on care to go to work—or even simply to get out of bed, take a shower, or eat a meal.

Since 2010, artist Marisa Morán Jahn has collaborated with domestic workers groups and individuals like Castellanos on various public artworks and films. In response to the urgency of our nation's care crisis, Jahn began thinking about the role of architecture in shifting how we value care and design to better meet domestic workers' needs. Jahn then began collaborating with architect Rafi Segal to lead the design of Carehaus. Jahn and Segal involved Baltimore-based real estate developer and urban planner Ernst Valery, who is committed to increasing wealth in low-income Black and brown communities.

[1] Asha Banerjee, Katherine DeCourcy, Kyle K. Moore, and Julia Wolfe, "Domestic Worker Policy ChartBook 2022," Economic Policy Institute, November 22, 2022. accessed Aug 20, 2024, https://www.epi.org/publication/domestic-workers-chartbook-2022/.
[2] La Alianza surveys, National Domestic Workers Alliance, "Domestic Workers Economic Situation Report with Analysis from the second quarter of 2024," July 9, 2024; based on the United States Bureau of Labor Statistics (BLS) Employment Situation Report in the second quarter, 2024.

MEMORY

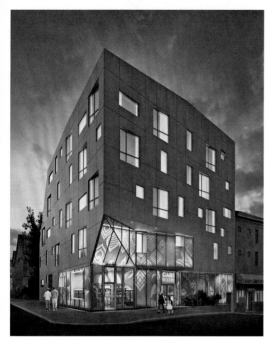

Carehaus Baltimore, rendering 2020. Architect: Rafi Segal A+U with collaborating artist Marisa Morán Jahn. The first location, in central Baltimore, features twenty units, housing seventeen older adults and disabled people, four caregivers with their families, a site manager, and a team of experts in nutrition, fitness, art, and wellness. In the co-living community, Carehaus residents share utilities, meals, appliances, and tools. By optimizing energy consumption, food waste, care, and labor, Carehaus is able to pass these cost savings on to residents in the form of benefits—higher-quality care for residents and sustainable wages for caregivers.

We're sitting around a table jotting notes and sketching on the floor plans of Carehaus's first building designed for Baltimore. Joining is Jamaican-born caregiver June Barrett, social movement leader Ai-jen Poo, Castellanos, and other members of the National Domestic Workers Alliance. Those joining us via Zoom from around the country have copies of the floor plans they can mark up and share.

Valery has chosen a historically disinvested site in Baltimore whose strategic location could benefit from a few key infrastructural investments. Turning to the group, he says, "We'd like to open up the bottom floor so that it can be used by local communities. Like exercise classes where other elders from the community can come participate, or shared meals and art programs. But what do you think?"

"Well, maybe it makes sense, then, for us to place an office toward the front of the building, so that someone is there to greet people and make sure people are safe when they walk in," says one of the neighbors.

"That would require us to move one of the living units for those with limited mobility and wheelchair users to a different floor," Segal notes. He says, "We originally were going to locate those on the ground floor so that it's easy in and easy out. What do you think?" Lilith Siegal, a disability attorney, points out that those with limited mobility rely so much on elevators, but then concurs that if the first-floor kitchen and multiuse space is focused on ensuring social integration among residents and neighbors, locating most residential units to the second floor would feel safer. We sketch out a few floor plans that offer alternate scenarios.

Thomas Cudjoe, a physician who works with low-income communities of color, weighs in on how to design for proactive care: "When I walk into a client's home, I can immediately assess how easily they can get around. And if our goal is to keep Carehaus residents as active for as long as possible, I want to be able to make sure their unit is equipped so they can do that."

Emanuel Opati, a pediatrician whose expertise includes telehealth, agrees. He points out that, given the nation's physician shortage, we will soon see a greater reliance on telehealth. "As a doctor, it doesn't help me to see my patients in a generic office.

I want to see what their home environment is. That gives me the best big picture about their health."

Segal, who has led the design of Carehaus, asks the caregivers in the group for their input on the plans for the caregivers' shared spaces. "Just as a reminder, everyone has their own individual units—bathroom, kitchenette, and the caregivers' units have multiple bedrooms to accommodate their families' needs." He asks: "If the shared communal area for caregivers is on the third floor, what kind of space should this be?"

A participant from La Colectiva jumps in. "I would love a space where my youngest kids can play together."

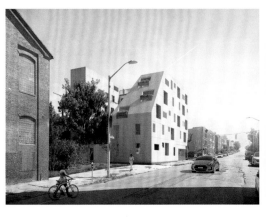

Carehaus Baltimore, rendering 2020. Architect: Rafi Segal A+U with collaborating artist Marisa Morán Jahn. Carehaus Baltimore is a five-story building designed around a shared courtyard allowing ground-level access from both the street and alley. To ensure light and air circulation, each floor has a shared terrace facing the courtyard, and each residence has windows facing at least two directions. Built to withstand a pandemic and encourage social integration, Carehaus's architectural features include outdoor gardens, terraces, an absence of corridors, and drop-off locations for packages.

"I would love an exercise room," says another participant, who is interrupted by a colleague who reminds her that there is a shared gym located on the second floor and a space for yoga classes on the first-floor patio garden.

"I would love a space where we can project movies," Guillermina adds, "but also where we can play games and do other activities—maybe a place where elders can do homework with the kids." A half dozen others quickly agree.

We decide to make the third floor a lounge dedicated to cognitive stimulation.

The conversation then turns to an evaluation of whether the top floor should remain an art studio space. "Carehaus is one block away from the nation's largest maker space, where they already have a senior art and woodworking program, so we don't need to replicate that," Jahn points out. "Plus, it incentivizes residents to go outside of Carehaus and integrate into the neighborhood."

"And that's what we want," adds a local resident. "More eyes on the street to make the neighborhood feel safe."

The group agrees that we should minimize the small studio space in the fifth-floor communal area and combine it with a reading room.

Segal, whose architectural practice involves designing co-living spaces in communities around the world, explains that the way most of us have been living in the United States emphasizes a binary between private and public space. However, when we design environments to meet the particular needs of today's families, we can expand these definitions to include the concept of semi-shared spaces (such as a shared kitchen) and semiprivate spaces

(shoe and coat storage in an entryway). This is an opportunity to further expand which resources we share, how they are shared, and how they are managed. Looking at the floor plans again, we start shading in areas and coming up with a new taxonomy of how this might work in Carehaus.

Lastly, the group turns its attention to Carehaus's colorful facade made from metal perforated with a geometric and free-form pattern. Jahn reminds the group that the metalwork on the one hand draws on the Baltimorean tradition of screen painting that started in 1913 when a grocer painted a vernacular landscape on the metal mesh of his store's entryway. The decorated screen provided privacy to those inside while its porosity enabled them to stay visually connected with street-level activity. In Carehaus, the facade would provide these functions while illuminating the neighborhood with color—an ornamental and safety feature that neighbors explicitly sought.

On the other hand, the facade's design adapts the Chinese and Mesoamerican traditions of *papel picado* (perforated paper), whose holes are said to let the past come through. Turning to the group, Jahn asks, "At Carehaus Baltimore, which memories, histories, and traditions do we welcome?" For our residents, previous self-knowledge is important, as is forging new experiences and creating new memories as a group who is aging in place together. How might the facade—and Carehaus as a whole—celebrate these values? As Carehaus scales to different cities and contexts, its design will change in response to its site, demographics, zoning, urban conditions, and most importantly, the new intergenerational group it serves.

MEMORY

MAKING HOME

BELONGING

MEMORY

UTOPIA

INDEX & CREDITS

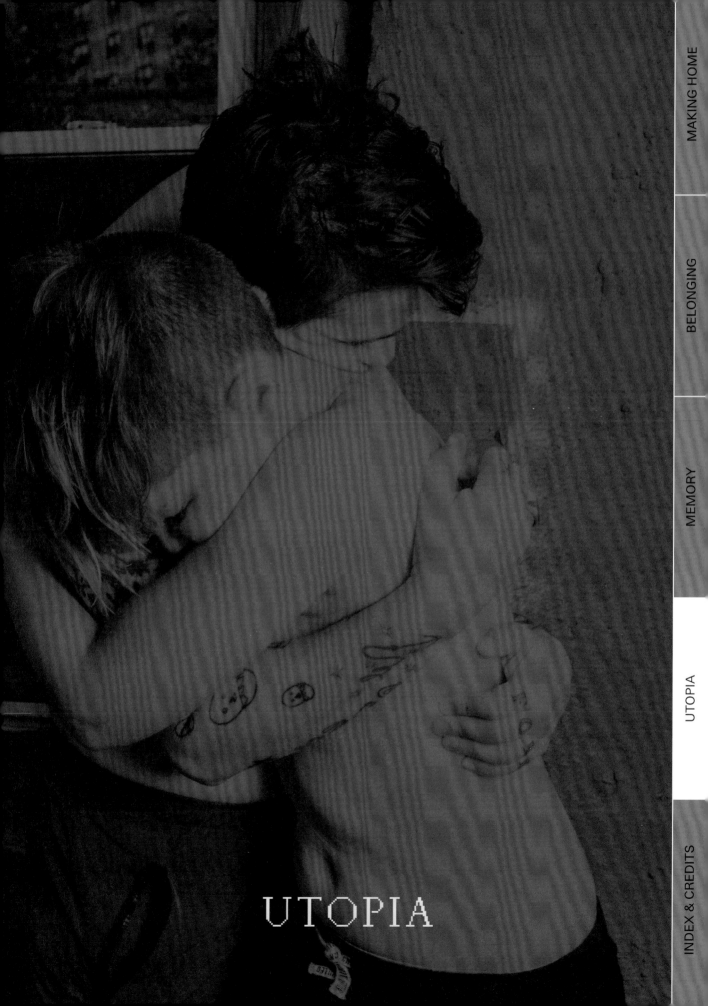

UTOPIA

UTOPIA
Alexandra Cunningham Cameron

She put on a record by Mahalia Jackson,
In the Upper Room, and sat at the window, her hands
in her lap, looking over the sparkling streets.
JAMES BALDWIN, *Another Country*[1]

As the Declaration of Independence was being signed in 1776, the United States adopted the Latin phrase *E pluribus unum*—"Out of many, one"—as its de facto motto. This phrase encapsulated the nascent country's aspiration to gather diverse people around a shared cause, an objective immediately at odds with the very limited human rights practices of the time. The sentiment bannered nearly two centuries of calamitous nation building—the breaking free of colonial foundations and establishment of independence from Great Britain, land seizure and forced displacement, economies built by enslavement, warfare with Native American tribes, Civil War and Reconstruction, arts cultivation, industrialization, urbanization, waves of immigration, and efforts to establish standards of living—before being usurped in 1956 by "In God We Trust," the Christian majority's reaction to the perceived threat of Communism with a show of divine providence.

This battle between utopian plans for a just society and ascendant ideologies characterizes the ongoing project of the US, a place that has prided itself on fostering both equity and disruption. Indeed, the utopian paradox arrived as a sort of metaphor for this country. First articulated in 1516 by Sir Thomas More as a "new world" condition, *utopia* translates from Greek to "no

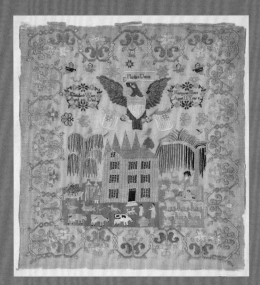

Margaret Moss, Sampler, 1825; Cooper Hewitt, Smithsonian Design Museum; Bequest of Rosalie Coe, from the collection inherited from her mother, Eva Johnston Coe, 1974-42-8

place." More's *Utopia*, a sociopolitical satire set on an island republic, depicts the Americas as lands upon which to strive for the presumably unachievable beau ideal.[2] The US has come of age adapting this script. From the ideal societies envisioned by early religious colonizers to the Constitution's checks and balances, through abolition, suffrage, the New Deal, the space race, digital democracy, and on, we have pursued and reimagined utopias—only to see them undermined and reshaped by the turbulence of human behavior.

In the twenty-first century, two issues best characterize the US's utopian paradox: threats to liberal values, which pit social justice reforms against

[1] James Baldwin, *Another Country* (New York: Dial Press, 1962).
[2] The text has served as both a critique of colonialism and minimization of the civilizations already populating the Americas.

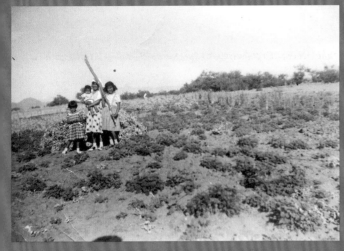

Sisters Thelma, Vivian, Mary, and Betty preparing to thrash beans at the Pancho Farm, 1950s

Shumon Basar, 300 DAYS ----------- 300 YEARS, 2024

individual freedoms, and our accelerating immersion in the simulated realities of digital and virtual realms, commercial media, and consumer culture.[3] The US's liberal democracy—which aims to accommodate resistance while accepting difference—strains as the nation works to adopt more inclusive frameworks, transitioning, as the Smithsonian itself acknowledges, "from a society dependent on coherence of a singular set of values and practices to one that derives its strength and unity from a deep tolerance of diversity."[4] We have become both unprecedentedly isolated and at odds with one another while being more connected than ever. The echo chamber of algorithmically homogenized digital experience has further diminished our ability to embrace the multiplicity of our national narrative, contributing to a loneliness epidemic.[5] Exposed repeatedly to shared values and experiences in the virtual realm, we reify what political scientist Robert Putnam calls "bonding social capital"—connections with people *like* ourselves—rather than the "bridging social capital" needed to develop empathy for people *unlike* ourselves. Open-minded debate as a productive form of democracy is being edged out by social

detachment, factionalism, and political polarization.

Perhaps more than anything, a loss of neighborliness has informed a loss of trust in institutions. Without mechanisms, muscle, and outlets for respectful exchange, we become overwhelmed by the perceived futility of challenging systemic oppression. Coupled with near-constant immersion in today's ad and personality-focused internets, the information and image overload incites apathy and skepticism, affecting a mood of helplessness veering into misdirected rage that too frequently plays out in posts, chats, and comment sections rather than organized advocacy. Cultural critics are left with putting words to the numbing cycle of constant virtual participation. Writer Shumon Basar perhaps best captures the contemporary mood of desperation caused by relentless exposure to global and personal conflict. Caught up in the realm of atrocity normalization, despairmaxing and doomscrolling, utopia, in the grand sense, appears futile.

The following essays, photographs, dialogues, and drawings capture reactions to this moment in time, suggesting new ideas about the utopian project of the US through

[3] See Jean Baudrillard, *Simulacra and Simulation*, trans. Sheila Faria Glaser (Ann Arbor: University of Michigan Press, 1994).
[4] Walter E. Washington, "Report of the Commission on the Future of the Smithsonian Institution," Smithsonian Institution, 1993.
[5] "Our Epidemic of Loneliness and Isolation: The U.S. Surgeon General's Advisory on the Healing Effects of Social Connection and Community" (2023), https://www.hhs.gov/sites/default/files/surgeon-general-social-connection-advisory.pdf.
[6] Wesley Morris, "Larry David's Rule Book for How (Not) to Live in Society, *New York Times*, April 5, 2024, www.nytimes.com/2024/04/05/magazine/larry-david-curb-your-enthusiasm.html.

discrete analog intercessions in the face of what appears to be peak dystopia: playing cards on the bed, archiving in Appalachia, homebirth in Alabama, cross-species co-habitation, informed consent, dry-land farming in Arizona, and hotel self-care, to name a few. These utopias, more as acupunctures than surgeries, rescale what has been understood as a mass social project, settling instead for private contentment, seeding social change, correcting the record, and other intimate expressions of kinship. These utopias engage what writer Wesley Morris calls our "nation of etiquettes,"[6] in which we must navigate one another's traditions and tolerances to achieve moments of harmony. More than coping mechanisms, these interventions are tactical, necessary, and dynamic means of advocacy, transforming the status quo in this bewildering era.

The spaces we feel at home (or are expected to) are likely sites in which to design these utopic gestures: our rooms, houses, neighborhoods, communities, lands. These are the spaces buried in our subconscious that "protect the dreamer," as Gaston Bachelard would say. In contrast to the powerlessness that can be experienced in vast digital spaces, where simulated access and intimacy eventually exacerbate isolation, the contributions in *Making Home* are born of proximity to others. Rather than submit to the trends of apathy, rage, and otherness, so entangled with twenty-first-century experience, they remind us that utopias are in reach. Like pieces of a puzzle, they can be assembled, dissembled, and reassembled over time—attempting to make one out of many, forgoing fixed ideals and ideologies for an experimentalism akin to the best idea of "America" itself.

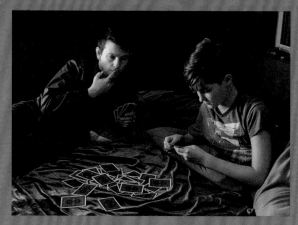

Leah DeVun, Card Players, 2024

CUNNINGHAM CAMERON

LEAH DEVUN

ACTING OUT AT HOME

LEAH DEVUN is a scholar and photographer. She received a PhD from Columbia University, New York, and is a professor in the History and Women's, Gender, and Sexuality Studies departments at Rutgers University–New Brunswick. DeVun is also the author of three books and collections, including, most recently, *The Shape of Sex: Nonbinary Gender from Genesis to the Renaissance* (2021).

Conservative politicians in the United States have long viewed expanding LGBTQ rights as a threat to "traditional" family structures. And they aren't exactly wrong; many queer people do refuse assimilation and challenge heteronormative demands for a certain kind of family or home as part of an expression of their own political beliefs. Rejection of home—or home's rejection of LGBTQ people—has also functioned as a key turning point in many coming-out stories. Throughout the twentieth and twenty-first centuries, coming out narratives have often unfolded as tales of migration, with newly out queer and trans young people fleeing their oppressive homes to find accepting communities, sometimes in distant cities.[1] Far from being places of refuge, in this context homes have been sites from which LGBTQ people need escape.

Yet we might also think of home as the ideal place to be most true to ourselves. Our best and worst traits are often on full view to the people who live with us. With our intimates, we may feel we have permission to act badly—to "act out." "Being out," of

course, means being visible as a queer or trans person, announcing one's identity as a part of accepting and making public one's true self. Identity—that individualized sense of being that makes a person a self, makes a person want to be out—perhaps finds its most genuine expression, then, paradoxically, when we are not out in the world but when we are in at home. But what does it mean to be out while being in?

For two years, I have photographed my partner, a transgender father, and our son. Many of my photographs take place in and around our home and at my parents' home, recording moments from our daily life. At home we play, eat, dance, draw, hug, sleep. Much of what we do is joyful, and the photographs offer a counterweight, in part, to stories about anti-LGBTQ violence and trauma that dominate the news and our social media feeds. The onslaught of grim stories about LGBTQ life is not inaccurate, but it does wear on us. These photographs, in contrast, are a visual reminder that trans life can also be full of safety and care. Queer and trans kids can survive; they can grow to

adulthood; they can create families and have kids of their own, if they want to. But in the photographs, too, there are threads of ambivalence. I resist presenting a perpetually smiling, idealized trans family, reassuringly one-dimensional and respectable enough to merit the approval and acceptance of straight society. The security we feel in our home means that we, too, can "act out": we can feel tension and conflict, sadness, or boredom. Acknowledging all these experiences in our domestic lives is also a form of being out. Our interior, familial space emerges into visibility neither through fulfilling nor rejecting straight society's expectations (as if our lives are defined by how they conform to or resist some majoritarian norm), but through our uniquely queer and trans styles of intimacy, parenting, and home building, in all their complexity.

While I have been making these photographs with my family, scholars and artists have been thinking about the relationship between queerness and home, as well as the politics of staying in.[2] Our visual lexicon of queer and trans liberation usually focuses on what happens outside, in the clubs and bars and streets. Out there, we imagine, is where connections are made, collectivity leads to movement, and social change is possible. But what if politics and visibility could be not only what happens out in the world, but also what happens inside, at home? A home is more than just a residence; it is an expression of societal position and of identity; making a home is thus a political act. Domesticity may not be something we readily link with LGBTQ life, but our politics can happen not only out in the world, but also in our interiors, and within our smallest communities. And those home lives can be liberatory, too.

[1] Kath Weston, "Get Thee to a Big City: Sexual Imaginary and the Great Gay Migration," *GLQ* 2, no. 3 (1995): 253–77.
[2] See Stephen Vider, *The Queerness of Home: Gender, Sexuality, and the Politics of Domesticity after World War II* (Chicago: University of Chicago Press, 2021); Xueli Wang, "The Possibility of Home," *Aperture* (Summer 2023): 93–99; Summer Kim Lee, "Staying In: Mitski, Ocean Vuong, and Asian American Asociality," *Social Text* 37, no. 1 (138) (March 2019): 27–50.

Below: Everyday Realities, 2023. Next: Vacation (Wood Panel Hotel Room), 2023

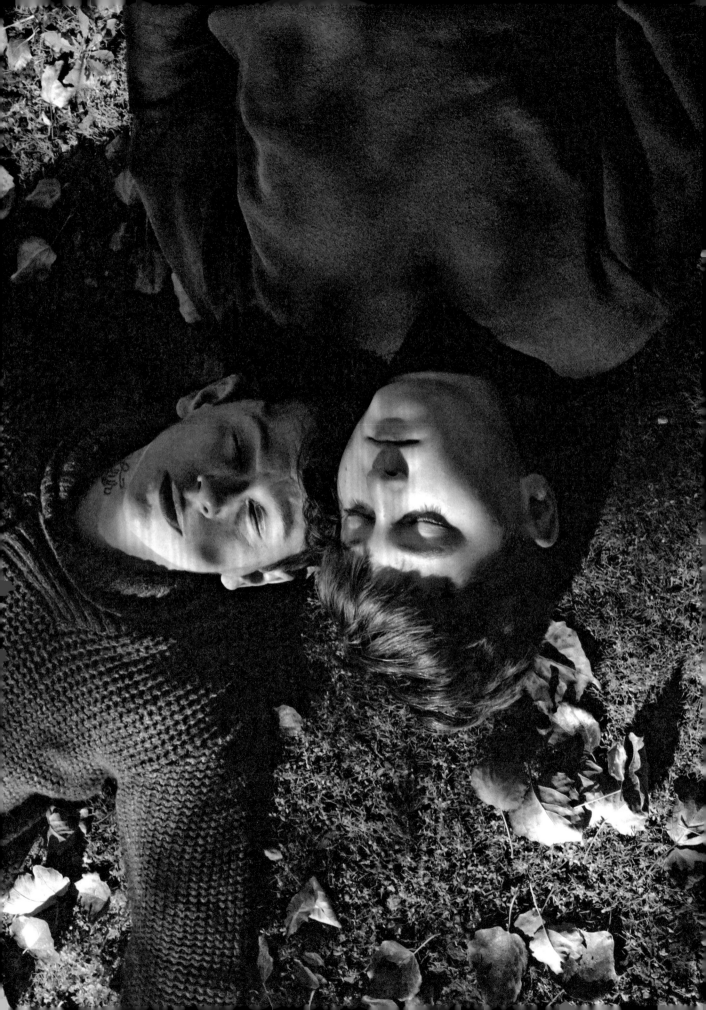

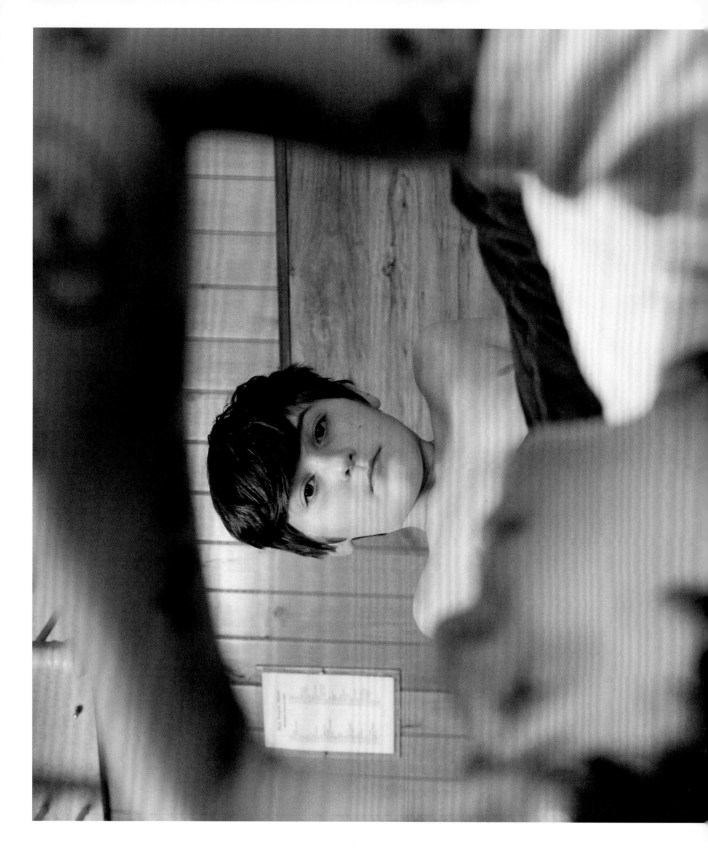

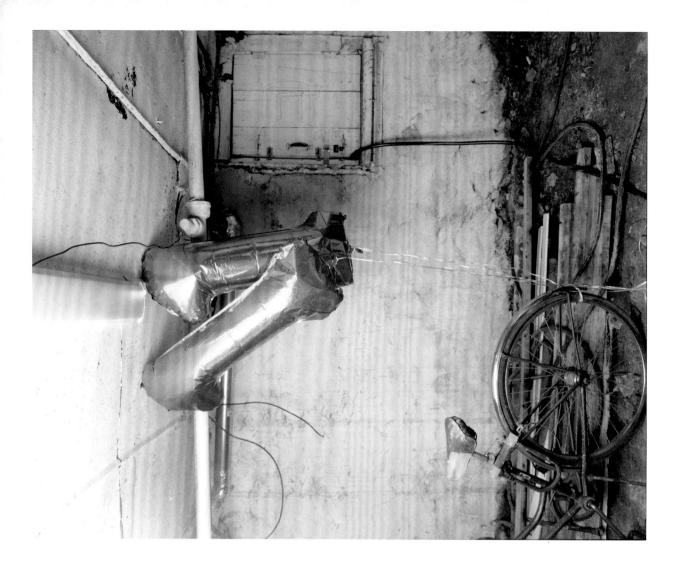

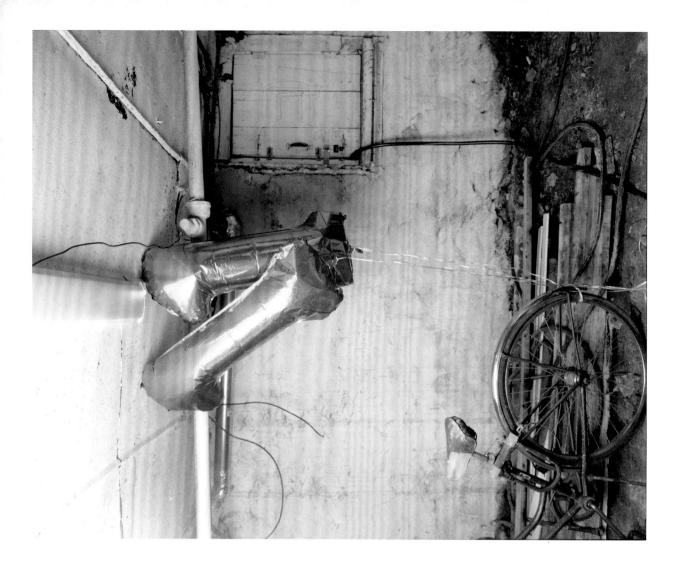

Above: After the Party, 2022. Below: Daddy Wall, 2022

10/23/20

3/19/20 Sept x
"St Cyr" x
St Cyr = 4' 5"
4.5½

Skye = 4'6"

10/20/19 Skye

4'4.5" — Sonya

Sault Cyr May 26 2018 → 4'1 3/4"

DADDY wall

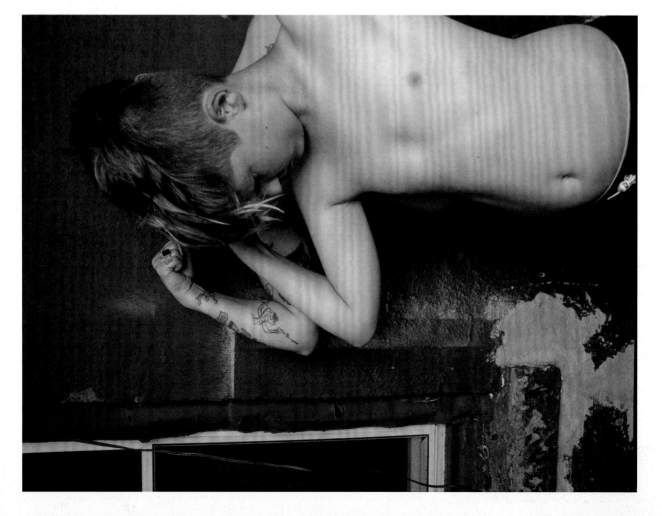

Previous: Theory of Light, 2020. Above: Resemblance, 2022. Below: Embrace, 2022

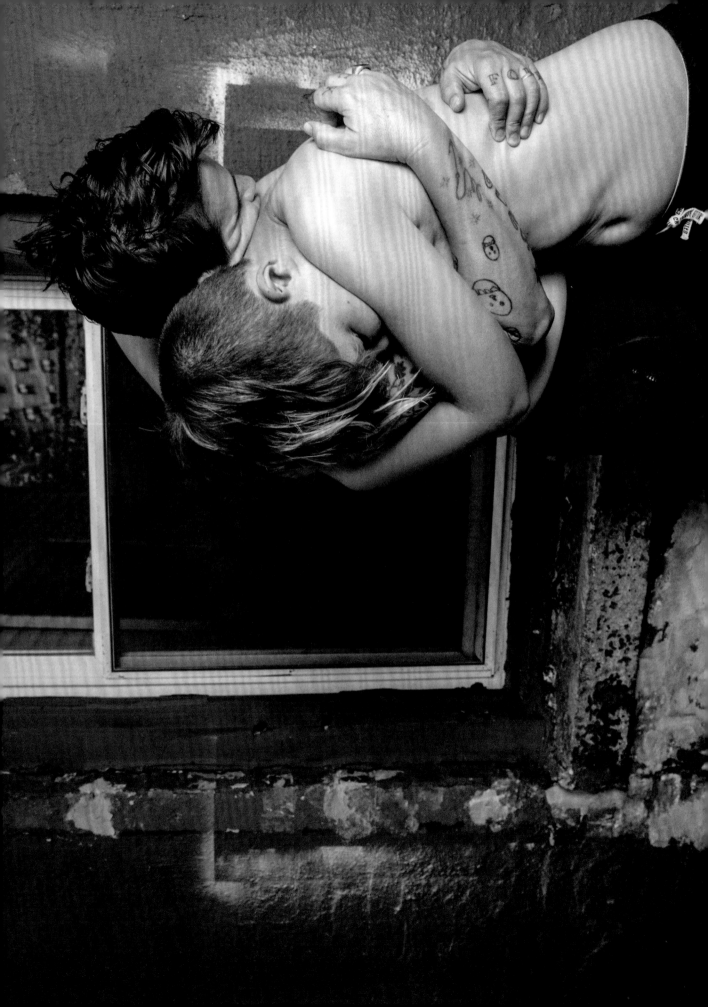

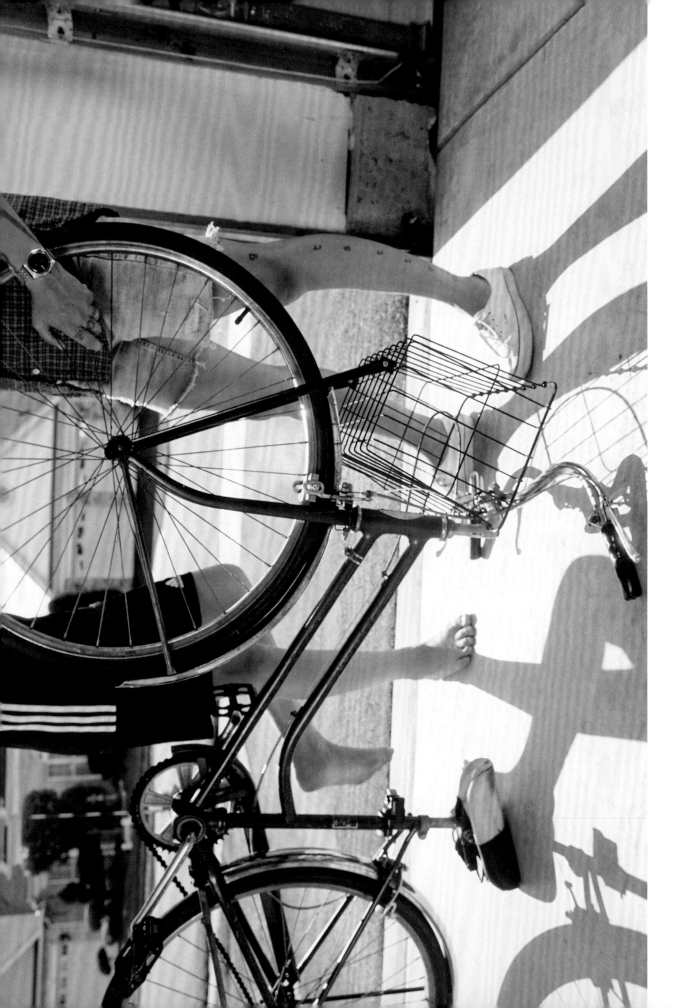

Mr. Fix-It, 2023

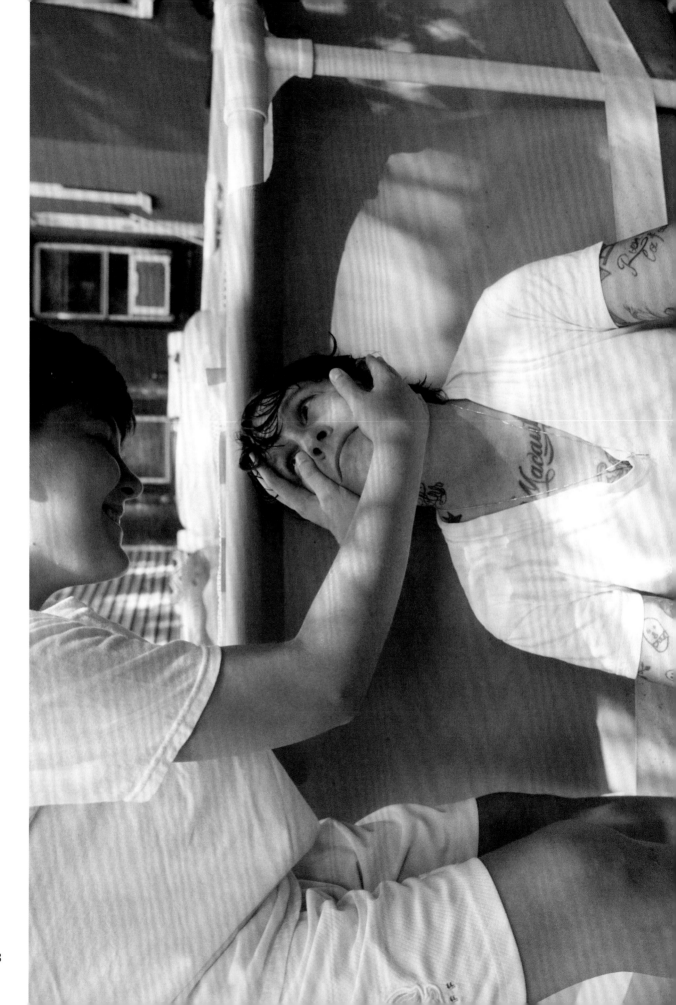

Below: I've Got You, 2023. Next: Self Portrait with Camera, 2022

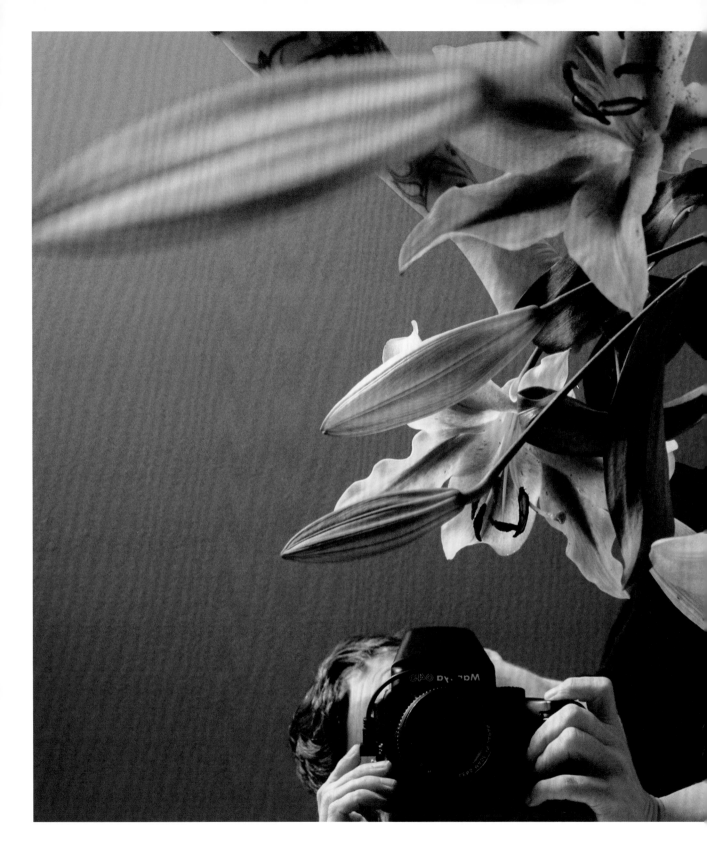

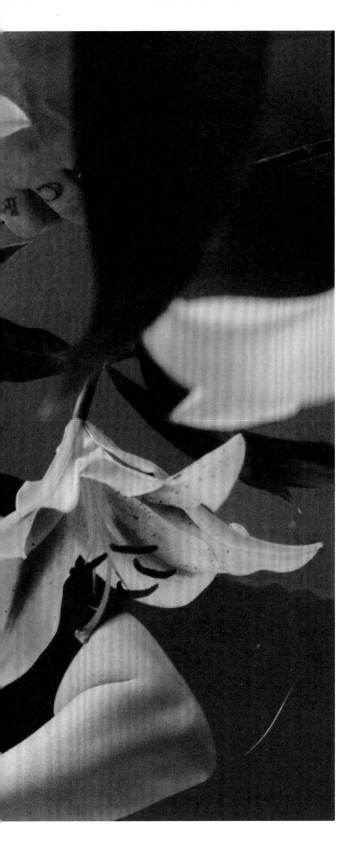

AFFAIRS OF PLAIN LIVING

After her father's death, Josephine Halvorson made paintings of his home office. Nothing exceptional, just his regular stuff arranged as he had left it. In one, Dad's Bookshelf (2020), books on gardening and Massachusetts history are wedged beside a tube of Bengay, a stick-on gift bow, and a stray Christmas ornament. At the heart of the painting is a thick spine that reads *Foxfire*. The cover is only partially visible, listing the book's contents: ironmaking, blacksmithing, flintlock rifles, and bear hunting. Halvorson's father, John, was a blacksmith who installed woodstoves around Cape Cod for half a century. In this haphazard portrait, the book acts as a stand-in for his working life.

JARRETT EARNEST is the author of *What it Means to Write About Art: Interviews with Art Critics* (2018) and *Valid Until Sunset* (2023). His writing on art has been published in exhibition catalogs and publications for art institutions internationally and appears regularly in the *New York Review of Books*. Earnest edited the collections *Hot, Cold, Heavy, Light: 100 Art Writings 1988–2018* by Peter Schjeldahl (2019), *Painting Is a Supreme Fiction: Writings by Jesse Murry, 1980–1993* (2021), and *Feint of Heart: Art Writings, 1982–2002* by Dave Hickey (2024). At David Zwirner, New York, he curated the exhibitions *The Young and Evil* (2019) and *Ray Johnson: What a Dump* (2021) and, with Lisa Yuskavage, co-curated the traveling exhibition *Jesse Murry: Rising* (2021–23).

My dad also had *Foxfire* books—actually, they were the only books I knew him to care about. Our family gifted him one every holiday, birthday, and Christmas throughout my childhood, each one dated and inscribed "With love" in loopy kid-cursive. When he died, in 2021, the stack of *Foxfire* books was his only possession I wanted for myself. Now the dozen-some books reside in my Brooklyn apartment, where I glimpse them peripherally throughout my day.

Halvorson's painting is both a memorial of her father and a meditation on transience itself: a picture of life arrested, made suddenly meaningful by her loving transcription of it. That real-life bookshelf must be packed away by now, or at least reorganized, destined, like everything, to change. While her painting may be a reminder that all things must pass, it also suggests that, if properly cared for, the things we live with can endure. The spaces we inhabit are always provisional and

Josephine Halvorson, Dad's Bookshelf, 2020

UTOPIA

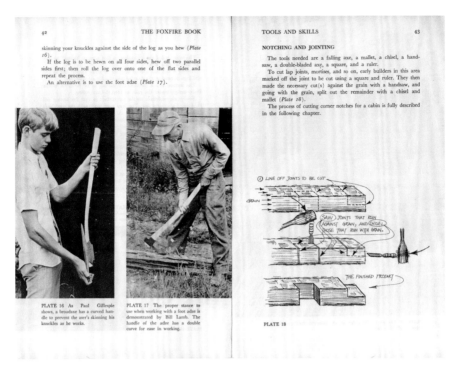

contain a random assortments of things—junk and treasure, by turn—given meaning by the lives they bind together and the qualities of life they enjoin.

Foxfire started in 1966 as a quarterly magazine made by a high school English class at the Rabun Gap-Nacoochee School in rural north Georgia. The students named it after a local phosphorescent fungus that grows on decomposing wood. The inaugural issue has three sections. The first is devoted to oral histories from the people who lived nearby, including a transcript of a retired sheriff describing the Clayton Bank robbery of 1936, an interview with an "anonymous Rabun Gap Man" about moonshining stills, and assorted home remedies. The second section includes works by professional writers, such as the poet A. R. Ammons, with the third section reserved for creative writing by the students. It is illustrated by woodcut prints and amateur photographs, all laid out and produced as inexpensively as possible by the students themselves.

A decisive turn came for the trajectory of *Foxfire* when the class agreed they were most interested in the first section, charting their own lives by engaging the place they inhabit. Locals also responded to those pieces, creating a clear audience to address. Soon *Foxfire* came into focus: students would go out and talk to folks tucked in the mountains, asking to be taught various skills. These people, rural Southern whites, are regularly degraded in the popular imagination as backward hillbillies. But the students recognized a vanishing world around them, where people made almost everything they had, primarily bartering goods and services outside of the monetary system. It might not be "better" than the

AFFAIRS OF PLAIN LIVING

[1] *The Updated Last Whole Earth Catalog* (New York: Random House, 1974), 152.
[2] Foxfire assignment sheet, student Jean Kelly 1969, Foxfire Archive, Mountain City, Georgia.
[3] Ibid.

world they were entering in prosperous, increasingly connected, postwar America, but it certainly had its own integrity that deserved recognition.

Foxfire took off nationally, unexpectedly intersecting with the counterculture's interest in experimental education and back-to-the-land movements. A write-up in the *Whole Earth Catalog*, the bible of alternative living, concludes: "The thing I like most about it is the way these kids are looking immediately around them for their inspiration, instead of taking cues from New York and California. In their own way, these people are as hip and sophisticated as any young people putting out a magazine on either coast. More so, even. They're cooler, more adult. These kids in Georgia are living in a real world, studying real things, and in consequence they are creating a wonderfully real publication in *Foxfire*."[1]

The *Foxfire* archives—comprising approximately 3,000 hours of audio, 90,000 photographic slides, and 2,000 oral histories—reveal the unique process of putting together this publication and the seriousness with which these high schoolers regarded it. An "assignment sheet" from fall 1969 begins with the direction: "Make sure the material you turn in is absolutely accurate and complete. At the very least, we owe our readers that. They paid for it. And we have a reputation to protect."[2] Editor Paul Gillespie charges his classmate Jean Kelly with interviewing Mrs. Ada Kelly:

Your Assignment: As you may know, the next issue of the magazine is devoted to all the ways a person could finish and furnish a log cabin after the walls were up and the roof on. In other words, what did he do next? What part would the woman play, and what would the man contribute?

Having talked to your grandmother several times in the past, we thought you might ask her for some leads for the next issue since she's been so helpful before. She might be able to give us ideas, and even show us several things that might have gone into an old log house that the family would have made themselves. We need directions for making many of these things, and photographs of them if possible.[3]

At the bottom of the page, Jean Kelly typed a response:

My grandmother has these things which might be helpful:
Smoothing irons
churn and dasher
Kraut cutters
scales

beeswax for sealing
Trove for splitting boards for roof
Photograph of the log cabin where she was born
A large pot used for washing clothes
Butter mold and paddle
Coverlet made by her mother (a rose and vine design)

She says it's o.k. to make pictures.
She also said the cracks between the logs in the cabin were filled in with red clay mixed with water and left a little rough on the outside usually smooth as possible on the inside with a small paddle. Some of the cabins were left with the red clay showing but many were white-washed every day, with a white clay mixture making the cracks smooth and white.[4]

This simple document captures so much of what is extraordinary about *Foxfire*. Unlike trained anthropologists, outsiders who invariably bring their own cultural biases to their studies, these students were reaching out to their own extended families, forging a unique framework of trust and accountability. There was equal attention given to the labor of women and men, and the predominant whiteness of the region is complicated by the regular inclusion of Black Appalachian neighbors like Beula Perry, who demonstrated basket weaving, and an early issue on Cherokee life in the region. The evident respect with which the students approached their "contacts" was not left to an unspoken agreement; a contract was formalized with the people they photographed and interviewed, stating, "I understand that at no time will this material be used in a way slanderous or detrimental to my character."[5] Such a statement is a measure of the contacts' sensitivity and the trust they shared with the students, a consecration of their entire way of life.

By the end of the 1960s, the magazine's small print runs were swiftly selling out with increasing demand for back issues. The students were approached by an editor at Anchor Books, a division of Doubleday, about compiling an anthology. *The Foxfire Book* was published in spring 1972 to wildly enthusiastic reviews in the national press, with *Life* sending a reporter and photographer to Georgia to write a feature. The result was a genuine phenomenon, with the book shooting to the top of the *New York Times* best-seller list and staying there for thirty-five weeks. All the royalties went directly to the *Foxfire* organization, which the students administered and where they reinvested in their project, buying new equipment and paying for administrative help.

The cream-colored cover of *The Foxfire Book* promises hog dressing, log-cabin

[4] Ibid.
[5] Foxfire permission form, Foxfire Archives, Mountain City, Georgia.

AFFAIRS OF PLAIN LIVING

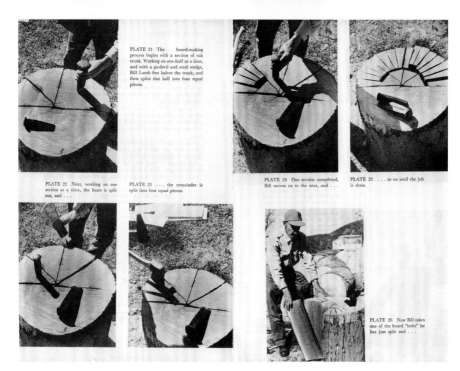

Spread from *The Foxfire Book*, Book One, 1972

building, mountain crafts and foods, planting by the signs, snake lore, hunting tales, faith healing, moonshining, and other affairs of plain living. There has been so much fascination regarding the subject matter that relatively little attention has been paid to the sophistication of the book's form. Take an early piece, which introduces one of the great stars of the *Foxfire* series, Aunt Arie, a woman in her eighties who lives by herself in a small mountain cabin without electricity or running water. Readers first encounter her trying to pull the eye out of a severed pig's head. The setup: "Aunt Arie's conversation was so interesting that, rather than summarize what she told us, we have let her speak for herself."[6] When asked if she minds doing such bloody work, she replies: "I don't care fer't bit more'n spit'n'th'fire. Ah, I've just done anything'n'ever'thing in my life 'til I don't care fer nothin' 'at way. I don't. Nothin' just don't never bother me, what I mean, make me sick. They lot's people can't when t'blood comes'bad'n's'bad'n's'bad—they run off'n leave it. They can't stand it. I don't pay it a bit'a'tention in th'world."[7]

There is no set template for this kind of transcription; the students just had to sound it out and do their best to make it read exactly as it was said, grappling with the phonetic transcriptions of speech as precisely as possible while retaining a matter-of-fact tone. Taking seriously the textures of language as it is spoken brings the *Foxfire* books closer to the realms of literary modernism than to the folksy, backward mountain-folk clichés that dominate popular culture.

This approach was matched by the heavily visual layouts; all the photographs

[6] Eliot Wiggington et al., *The Foxfire Book* (New York: Anchor Books, 1972), 20.
[7] Ibid., 21.

were shot and developed by the students themselves and the diagrams were hand-drawn. The images pinpoint the practical information in the text, illustrating two woodgrains meeting in a dovetail joint or the correct hand position for weaving oak splits into a basket. Often people and things are shown from several vantages, creating multidimensional collages. There are also very loving portraits of older people, sometimes smiling and talking, but mostly shown in the midst of work. The result is an image-text tour de force of observational, process-driven writing: this is what happened, this is who does it, this is what each step looks like—this is what you need to know to do it yourself.

One extraordinary sequence, which occupies about a quarter of *The Foxfire Book*, is an in-depth discussion of the kinds of trees located in the region, outlining what each type of wood was traditionally used for and why. It is followed by a richly illustrated section on tools and skills, showing Bill Lamb as he splits a log into boards. One spread of five images describes how a log is cut in half and then into four equal wedges, which are then each split into four more. The effect recalls the procedural performances and conceptual art of the 1960s and '70s, many of which document mundane tasks. This is all groundwork for the feature article, "Building a Log Cabin," synthesizing information the students had gathered from interviews as well as analyses of every log cabin they could find in the region, and again concluding with a point-by-point image-text demonstration. Like everything in the *Foxfire* books, the instructions are clear enough that you could use them to build your own cabin (which people did) without being technically minute or pedantic. Each feature is punctuated with anecdotes and variation, with explanations on how and why alterations occur; the feeling is that these are structures made to be adapted to a particular need and circumstance—try it and find out.

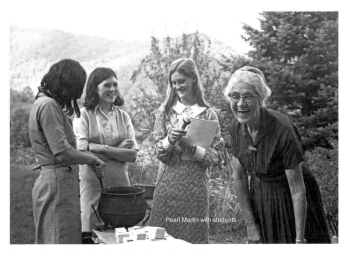

Pearl Martin with students

Spread from *The Foxfire Book*, Book One, 1972

With the success of the first book, the publisher immediately requested a second. *Foxfire 2* came out the following year, bringing together more oral histories, addressing everything from raising sheep to weaving cloth, midwifery, and burial customs. For decades, an ever-changing group of local high school students continued this work, with the first five volumes coming out in the

AFFAIRS OF PLAIN LIVING

1970s, followed by four in the '80s, two in [8] Ibid., 154.
the '90s, and the final numbered volume,
Foxfire 12, published in 2004. Many individuals reappear through-
out the books, creating a beautifully variegated world that both
deepens and expands across the series. Thematic collections have
also been published, drawing from *Foxfire*'s vast archives, including
a cookbook and an anthology devoted to Appalachian women.

Continuously in print for fifty years, *Foxfire* has permeated the
very fabric of American culture across the ideological spectrum, as
likely to appear on the bookshelves of a fundamentalist church as
a radical commune, entering the homes of a New England black-
smith and a Florida farmer, where, respectively, Halvorson and I
encountered it. By that time, the older people photographed and
interviewed in the 1960s and '70s were long dead, and the first
generation of high school students found themselves to be elders.

Today, just as easily as in 1972, you can pick up *The Foxfire
Book* and learn how to make soap out of bacon grease and lye, as
Pearl Martin explained it to her granddaughter and a few of her
friends from school. You can see how Martin wore a nice Sunday
dress because she knew she would be photographed, despite the
work being messy. Because the girls who interviewed Martin had
a tape recorder in addition to cameras, the instructions are in-
terspersed with loving interactions that speak to her relationship
with her granddaughter. Alongside information about soap mak-
ing, you also get to eavesdrop on a scene in which the girls crack
the old lady up by asking if they can put perfume in the soap. She
responds: "Youn's want me t'put perfume in there? I can perfume
it up for your's if you want. But I'll tell you; if for me, I like t'smell
that. It smells like old times. I've washed with homemade soap
s'much—it smells like homemade soap."[8]

And with this tender portrait, readers are empowered to try it
out for ourselves with our family and friends. We can produce that
soap, use it in our homes, give it away, and tell our stories about
it, all in celebration of the humanity of things, of our collective ca-
pacity to remember the dead through living, making, and handing
down. Taken together, these stories are a unique achievement in
the techniques and practices of making a home; *Foxfire* is a mon-
ument to life on Earth.

DAVID HARTT
BRENT LEGGS
VICTORIA MUNRO
CAROLINE O'CONNELL
GRETCHEN SORIN

𝒯HE POWER OF PLACE
Revisiting Historic Sites, Historic Houses, and House Museums

Historic sites, historic houses, and house museums are often distinguished by distinctive architecture, decoration, collections, signage, or even scent. These varied places tend to elicit strong responses from visitors and passersby. Some are drawn in, others repelled, in part because they hold histories and project narratives that can be deeply intimate, subjective, or troubling. They have been witness to real lives and events, and yet the sum of the quotidian experiences of the people who inhabited them nods to something bigger and more complicated. The enduring presence of historic homes and sites in the United States, the fascination with them, and questions about what to do with them serve as the premise for this dialogue among professionals whose work intersects preservation, art, community, and scholarship. This conversation considers the limits of terminology; reimagines thematic, structural, and narrative future(s) for these spaces; and reflects the sense that historic sites, historic houses, and house museums are alive and brimming with narratives yet-to-be unearthed for new audiences. It also captures frustrations and hope for the ways in which public history can be reconceived through material culture.

DAVID HARTT lives and works in Philadelphia. He is an associate professor at the University of Pennsylvania. His art practice explores how historic ideas and ideals persist or transform over time. His work is represented by Corbett vs. Dempsey, Chicago; David Nolan Gallery, New York; and Galerie Thomas Schulte, Berlin.

BRENT LEGGS is the executive director of the African American Cultural Heritage Action Fund and senior vice president of the National Trust for Historic Preservation. Leggs is a Harvard University Loeb Fellow, author of *Preserving African American Historic Places* (2012), and a 2018 recipient of the Robert G. Stanton National Preservation Award.

VICTORIA MUNRO is the executive director of the Alice Austen House, a nationally designated site of LGBTQ history and the only museum in America to represent the work of a solo woman photographer, Alice Austen (1866–1952). Munro is an art and art history educator, a maker, and a curator.

CAROLINE O'CONNELL is the exhibitions curator at the American Philosophical Society. Her work explores the intersections of design, material culture, and public memory. She previously served as first vice president of the Victorian Society New York and is an alumna of the Attingham Summer School, London, England.

GRETCHEN SORIN is director and distinguished service professor at the Cooperstown Graduate Program/SUNY Oneonta. Sorin received a bachelor's degree in American studies from Rutgers University, a master's degree in museum studies from the Cooperstown Graduate Program, and a PhD in American history from the University at Albany. She has worked with more than 250 museums over three decades as an exhibition curator and education, programming, interpretive planning, and strategic planning consultant. Her most recent book is *Driving While Black: African American Travel and the Road to Civil Rights* (2020). She is also cowriter and senior historian with filmmaker Ric Burns on the documentary film *Driving While Black: Race, Space and Mobility* (2020).

UTOPIA

CAROLINE O'CONNELL What is a memorable experience you each have had at a historic site or house?

BRENT LEGGS Beloved in my memory is the home of Madam C. J. Walker, Villa Lewaro, in Irvington, New York. It's on the same street as Jay Gould's Lyndhurst Mansion and three miles from the John D. Rockefeller Estate Kykuit. Walker was a Black woman who became America's first self-made female millionaire and had the gall

to integrate the most expensive zip code in the country. She partnered with the first Black licensed professional architect in the state of New York, Vertner Woodson Tandy, to design this grand Italianate mansion. Walking through the iron gate, the hairs on my arms stood up because I realized the quiet power of historic preservation. It helps keep her remarkable life real.

VICTORIA MUNRO I just came back from a meeting of a branch of the National Trust—the Historic Artists' Homes and Studios. We were hosted at Manitoga, the estate of designer Russel Wright, in Garrison, New York. Homes that are artist-built as complete environments are really inspiring. Manitoga was designed around ideal ways of living, and was influenced by so many different cultures.

GRETCHEN SORIN When my son was sixteen years old, we took a trip with the 1772 Foundation to Charleston, South Carolina, which I recall with almost photographic memory because it was so powerfully upsetting. We walked into an outdoor room at a historic property that was surrounded by hedges with the grass cut to about an inch, and the guide said, "Imagine the ladies with their beautiful dresses playing croquet on this." I had a splitting headache because nobody ever mentioned who cut the lawn. And as we went through the house, the guide kept referring to the "servants," never once mentioning that they were enslaved people. From there, we went to Daufuskie Island to tour broken-down former slave quarters and sharecropper shacks, where there was no furniture and the grasses were so high the guides warned us to be careful of snakes. It was the best experience to be able to see these buildings, even in their unimproved state, and to show my son that this is where his people would

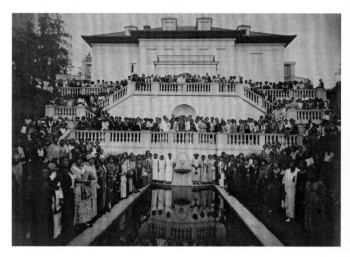

Guests along the terraces and around the pool at Villa Lewaro, Irvington, New York, 1924

have lived. Not to have a fairy tale presented at this elegant historic site that actually tells an inaccurate story.

DAVID HARTT By nature, I find all historic homes pretty creepy. The artificiality of the way a narrative is created and shared is very alienating. That informs my own approach: I try to find a way around the reification of particular narratives, and instead complicate them and move around the blockages that misdirect, misrepresent, or refuse certain ideas of participation.

O'CONNELL Some definitions might be grounding. What constitutes a historic house and what are the implications of that distinction? How do we identify sites that we should consider to be of historic import?

LEGGS The African American Cultural Heritage Action Fund's view is that preserving African American sites is an act of racial justice and should be considered a civil right. Representation matters, and historic African American places deserve care, investment, and stewardship. We have been thinking about how to redefine the term "historic house." When the public hears it, they may think: house museum, velvet ropes, a one-time visit. So, we talk

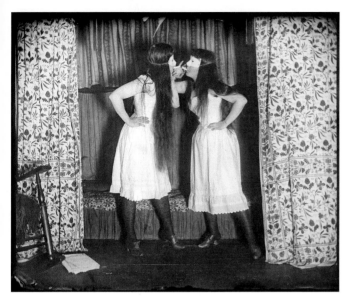

Alice Austen and her friend Trude Eccleston, August 6, 1891

more about "historic sites" instead. Our work is about activating sites that have been witnesses to Black life, humanity, resilience, activism, and achievement, and we view the use of historic landscapes and architecture as a tool for building a national identity that reflects America's full diversity.

SORIN I love that definition, because I have never thought that historic house museums in this country told the history of America. Most of them are about great wealth. They are not about telling the stories of the people who settled or built this country. It is almost like visitors are voyeurs, exploring what it is like to be a super-rich person.

HARTT I agree wholeheartedly. Specifically with this idea of isolating a particular history within all the struggling histories that a space is witness to. When I participated in *Reconstructions: Architecture and Blackness in America* at the Museum of Modern Art in New York, exploring "Black space" was a difficult prompt because it negates the porosity of social life in America. My way around it was through film, because it captures extended moments in time. And through that I could define space as

being contingently Black. The idea of history being singular and located in one space is actually contrary to its essence.

MUNRO I like that you brought up those elements of cinema. The first time I visited the Alice Austen House in Staten Island, I was told to put three dollars in a wicker basket and show myself around. I probably spent less than ten minutes there, and when I left, I didn't know that Alice was a photographer or that she was queer. As a queer artist who utilizes photography myself, that might have been really meaningful. In fact, she lost her wealth and possessions and was evicted from this home, but that story wasn't present at all. As queer and marginalized people get older, maintaining a sense of rights or independence is important. The objects in the house were true to the period, but they didn't even belong to the Austens; the house was groaning under the weight of them. Now, as director, being able to free this house from an object-based interpretation and pivoting to work with a collection of over eight-thousand photographs is a phenomenal way to connect with people. It can be an emotional experience for visitors who have come previously, particularly for the queer community, who understand that her story has been suppressed. Docents and staff had been told never to mention Alice's partner name, Gertrude. We own this unfortunate institutional history because we can learn so much from it.

LEGGS Oftentimes, there is a romanticized version of history presented, a limited interpretation that does not tell a site's full story. As we start to reimagine the usefulness of historic places, for me, it is about creating community. How can we create more equitable and inclusive interpretations that can engage new audiences, whether those be activists, artists, or social justice leaders?

HARTT One of the things I attempt to do with my work is to reconsider the site to represent aspects that aren't contained within the dominant narrative. Sometimes that means stepping outside the historical bounds of the space in terms of what is being preserved, and sometimes it means inviting something in that contaminates the narrative but is necessary to connect to a contemporary audience. It is about not being afraid of stories that may not be central, but that can provide a vantage point that is deeply meaningful to a visitor. I was invited to do a project with Frank Lloyd Wright's only synagogue, Beth Sholom, in Elkins Park, Pennsylvania, and after finding that the building was actually the congregation's second home, it got me thinking about different ideas of community. Their original building is now a Black Baptist Church. My project was in some ways speculative; it explored the capacity of a building to actively host another community and demonstrated a space's capacity to absorb and embrace different possibilities. It is enriching to think about an architectural site as something that goes on living beyond us. Despite our attempts to preserve it in a particular moment, it always has this potential.

SORIN So many historic sites are in neighborhoods that have changed. The Dyckman Farmhouse in Upper Manhattan is a Dutch farmhouse in what is now a Dominican neighborhood that really has no use for an eighteenth-century farmhouse, but they do have a use for a cultural center and for a programming space that can provide music, art, and dance. What are the contemporary uses for these places? This is how museum studies has not served us well. We treat objects better than we treat our audiences and staff. We revere every object as precious and put barriers around it. But we want people to experience these spaces!

HARTT It's funny, but I still have this wonderful appreciation for period rooms—the weirder, the better. They are ripe for respectful interventions by contemporary artists. I would love to do more, because they really do produce a fantastical idea of a particular moment in time.

SORIN Yinka Shonibare created an incredible installation at the Newark Museum of Art in the Victorian-period dining room, complete with people whose feet were up on the tables and oyster shells all over the place. It was sexual, fun, and absolutely hilarious. I think artists can reimagine and actually animate these spaces.

MUNRO It's interesting when artists are invited into historic house museums, because they can be inspired by a collection and by very unconventional spaces, like rooms with original wooden beams, closets, and fireplaces to work around. Sometimes we take two to three years to allow artists the time to create, but the house museum is a really rich place for artists to work. And I think we have an opportunity to create safe spaces for people. We can utilize our unique position as a museum to be welcoming to different groups. The Alice Austen House is a nationally designated site of LGBTQ history. But because we're

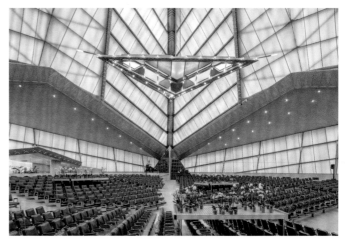

Installation view, The Histories (*Le Mancenillier*), Beth Sholom Synagogue, a Frank Lloyd Wright–designed National Historic Landmark, Philadelphia, Pennsylvania, September 11–December 19, 2019

not a Pride center, we're able to work with students and bring them to the site without outing them, creating this amazing space to celebrate identity.

LEGGS "Identity" is a powerful word. I think about how we can use historic homes and sites to reconstruct national identity. I'm inspired by the structural shifts that happened at James Madison's Montpelier, a site associated with an American president, the Constitution, and also a site of enslavement. Through descendent engagement, archaeology, and a strategic commitment by the organization, they amended their bylaws, secured 50 percent representation at the board of trustee level by descendants, and created a new model for descendant leadership. If historic preservation can play a role in helping to create structural paradigms and shifts in an industry, that could be a model for other professions and industries.

O'CONNELL There is a housing crisis in the United States right now, fueled by a lack of inventory and significant wealth disparities that make homeownership inaccessible, but there is also intense interest in real estate and old homes captured through media representations of "fixer-upper" culture. How do you think this comes to bear on our work?

HARTT Your question deals with the concept of taste, but also with fantasy—the tendency to construct an idea and live in a moment, regardless of whether or not it existed. I made a film installation called *Stray Light* [2011–12] about the Johnson Publishing Company, which was so important in terms of developing a speculative idea of Black taste—imagining something that, quite frankly, didn't exist. The influence that their publications *Ebony* and *Jet*

had in taking Black taste somewhere new is reflected in the interiors developed for their corporate headquarters. When I first visited, it was like nothing I had seen before. It was enthralling, sophisticated, and such a leap, perhaps, from directors John and Eunice Johnson's own past. I think it is important to mention that for all the forces looking to preserve something, there are other forces trying to move things in a new direction. Correct me if I'm wrong, but didn't the test kitchen from the Johnson Publishing Company headquarters go to the Smithsonian's National Museum of African American History and Culture recently?

O'CONNELL Yes! They acquired it in 2023.

LEGGS I have been thinking about the intersection between the cultural reckoning that is currently happening and this cultural renaissance. I'm optimistic that, through culture, media, and various forms of public engagement, we are beginning to build a national ethic for the preservation of historic places, neighborhoods, architecture, and the social fabric of community. But there is a balance between intervening in historic spaces and modernizing them, between retaining historic fabric and architectural integrity to tell a story and preserve an important American identity versus rehabilitating historic places for modern uses. It is beneficial that more folks value historic places and are curious about them; our movement is expanding. We just want to make sure they have the tools to be careful stewards.

O'CONNELL So, what's next? How can historic sites be more relevant to and reflective of this country and its inhabitants, of the communities where these places currently exist, as well as where they may have once stood?

MUNRO We just launched our Queer Ecologies Garden Project. It celebrates the historical site because Alice was the founding member of the Staten Island Garden Club, which was a clever way for her to create safe space for her and her friends to be together without male chaperones. We are planting nonbinary and symbolically significant plants and allowing students to participate in the selection process, creating a pathway for year-round engagement. We're incredibly excited.

SORIN Each of us has identified ways that we are trying to change the paradigm. Mine is to teach people who are going into museum work, and I am happy to say my students are now working with Victoria! I have a reverence for objects, but not all objects, and I think it is very important for us to think first about community and audience before these objects that we are preserving. My program has focused on people who don't go to museums and why. How do we start to engage people, and how do we ask them what their needs are? I'm very inspired by David and thinking about how we can best use artists and people who are bringing these creative perspectives to our institutions.

HARTT You know, I didn't go to an art museum until I was a college student, and I was recently invited to participate in a 2025 exhibition at the Musée d'art contemporain in Montreal, the city where I grew up. That invitation brought up all these feelings about identity and what it means to return to a changed environment. I'm developing a polyphonic heritage story about how all these complicated ideas of identity influenced me. I was born in 1967, a critical moment in the history of the city, when the World's Fair and Olympics were there—the whole city had this new car smell. I would dream of living in one of these new buildings downtown, which is now the Marriott Chateau Champlain hotel—a fantastic modernist tower designed by Roger d'Astous. For the exhibition, we're producing an eye-shaped, precast-concrete window panel from the building, at 4/5 scale, and installing it on my mother's front lawn, memorializing her suburban house through the position of this facade element. It's an attempt to collapse ideas of site, history, and identity to show that they meet in these unpredictable ways.

LEGGS Through the Action Fund, we are increasing the economic and social value of historic Black spaces, reimagining how we talk about the values of historic preservation, even using words like "community assets" and "historic assets" instead of "historic homes" and "historic sites." Another priority is using historic Black spaces to set a new precedent for stewardship planning and modeling. The work is helping all Americans to find home in historic spaces, to create room for culture, belonging, and discussions about American ideals, and to facilitate access to these spaces, to nurture community. If historic places can facilitate connections that bolster racial reconciliation and help social justice values thrive, that, for me, is utopia. That's the future of our movement and work.

DISORIENTING THE ORIENT
Reinvention and Retribution in
Lockwood de Forest's Teak Room

There's a tremendous amount we can learn about people when we walk through their homes. This is perhaps most evident in the living spaces of the super elite and powerful, which frequently project a thorny mix of their authentic and aspirational selves. The homes of the most privileged are fascinating sites of conscious self-fashioning, replete with social and aesthetic complexity. For example, the Andrew and Louise Carnegie Mansion's Family Library—conversationally referred to as the Teak Room—is a modestly sized room designed by the American adventurer, artist, and aesthete Lockwood de Forest in 1902. De Forest began working with Louis Comfort Tiffany in 1879 and, in the same year, traveled to British India for his honeymoon. British artists and designers had already pulled inspiration from Indian design for some time, but this was de Forest's first direct encounter with it, which ultimately revolutionized his design practice. He amassed a number of objects in India to sell in the United States and, in partnership with the Indian philanthropist Mugganbhai Hutheesing, established the Ahmedabad Wood Carving Company in 1881, which employed Indian craftsmen to copy local architectural motifs and transform them into decorative items like folding screens, wall brackets, frames, and furniture. De Forest would go on to decorate and furnish some of the most spectacular American domestic and commercial interiors of the period, all marked with a distinctly Indian flair. Through a multitude of textures, colors, and materials, as well as a dizzying array of patterns, the de Forest "look" is perhaps best summarized in an expression coined by historian John Kasson: "Oriental orgasmic."

SIDDHARTHA V. SHAH is the John Wieland 1958 Director of the Mead Art Museum at Amherst College. His academic and curatorial projects have focused on a range of Indian and South Asian diasporic subjects, including the appropriation of Indian ornament in Victorian design and conflicts and intersections of religion and modern art.

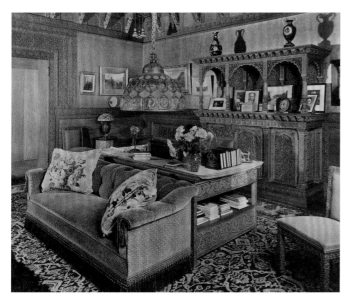

The Carnegie Family Library (Teak Room), 1938; Collection of the Museum of the City of New York

UTOPIA

Indeed, some may find de Forest's Orientalist interiors to be visually explosive and exhausting in equal measure.

The Teak Room is the only expressly designed and commissioned space in the Carnegie Mansion, which makes it a surprising exotic counterpoint to the rest of the building that otherwise conveys the family's Scottish origins. It was designed as a well-appointed and inviting reading room outfitted with an impressive carpet, carved and upholstered furniture, books, framed paintings and photographs, and a Tiffany chandelier. Most of the room's original furnishings and objects are no longer present, yet one might still feel a sense of overwhelm upon examining the extravagant ornamentation and detail on virtually every surface. The wainscoting and doorframe are made of elaborately carved teakwood, used also to create the decorative brackets along the upper perimeter of the room, the beamed ceiling, a sideboard, and grand chimneypiece. The built-in sideboard features a register of scalloped arches pulled so directly from Mughal architecture that it looks as if de Forest has somehow miniaturized an Indian building and transformed it into a piece of furniture. The walls are covered in complex patterns stenciled in gold that evoke the same undulating floral motifs found on the wooden panels and beams throughout the room. The space is lush and extravagant, and transports visitors to a distant place. From one perspective, the room projects the Carnegies' awareness of and appreciation for global design. From another angle, it conveys their capacity to claim and displace the visual language of one location and reanimate it in another environment.

De Forest's design practice celebrated the craft traditions of India and brought the talents and virtuosic skills of native artisans into the private spaces of an elite international audience. But his work also exemplifies a complicated relationship that many Western designers have with Asia as a source of both inspiration and uninvited intervention. Patterns and symbols that may be deeply meaningful in their native vernacular somehow attract manipulation and reconstitution, whether they are lifted from a Hindu temple, the tomb of a Sufi mystic, or the home of a Parsi merchant. The emphasis is thus not on contextual integrity but on inventing something new and more palatable for Western consumers—something more "modern" and perhaps even improved. This fairly common practice homogenizes artistic and cultural distinctions and reduces them to a vague, nebulous fantasy of Asian design. In the Teak Room, for example, functional exterior brackets and window frames are brought indoors as nonfunctional decoration, and elements of Islamic, Hindu, and Jain architecture are reduced in scale and haphazardly collide in a secular space. This

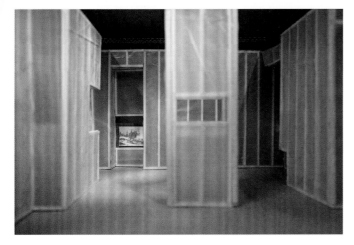

CFGNY, Model, Study for Contrast Form Gestalt, New York, 2023

reduction and homogenization of aesthetic traditions is further complicated when such reinventions are rationalized within an equally jumbled rhetoric of authenticity, preservation, and care.

This complexity—of disparate artistic and cultural traditions converging in a vaguely Indian aesthetic—is precisely what drew the artist collective CFGNY to the Teak Room, which today functions as a flexible exhibition space activated through interventions that either engage with or evade its Orientalist aesthetic. CFGNY is a particularly apt group to reanimate the room, given the New York–based artists' ongoing engagement with the phrase "vaguely Asian" through various mediums including video, performance, painting, sculpture, and architectural installation. Founded in 2016 and composed of four artists—Daniel Chew, Ten Izu, Kirsten Kilponen, and Tin Nguyen—CFGNY's response to de Forest's room employs a practice and methodology that, in rather piercing ways, replicates his own.

Titled Contrast Form Gestalt, a bespoke acronym of CFGNY, the group's intervention in the Teak Room is an exercise in obscuration, making the room look more like a construction zone than a library and giving the appearance of a work still in production. Like de Forest's original commission, the installation is framed by and around wood, but the opulence of carved teak is replaced by the brazen simplicity of two-by-four lumber beams. Plastic sheets are stretched across these wooden frames to form walls that cover the space almost entirely—a conspicuously unadorned and unrefined response to de Forest's densely worked surfaces. Small windows cut into the plastic walls offer visitors their only opportunity to view portions of de Forest's original stencil designs and wooden details, and highlight paintings collectively produced by CFGNY. Each work is a unique composition based on paintings from de Forest's extensive world travels, using his oeuvre as an open archive. His hours of labor and body of work are thus reduced to a sourcebook of impressions; references to specific sites in Egypt, India, Mexico, Greece, and California are intentionally obscured, privileging CFGNY's clever alterations above de Forest's originals. The artists have broken de Forest's paintings into fragments, like puzzle pieces dislocated from their origins, and reassembled and painted them into entirely new visions. CFGNY's relationship to

DISORIENTING THE ORIENT

CFGNY, Drawing, Study for Composite 1, 2023

de Forest's work as both source of inspiration and subject of their manipulation is incisive, ironic, and utterly disorienting. The freedom and power to choose and (re)invent is in their hands alone, and the installation feels like karmic retribution for de Forest's own appropriation of Indian design in the Teak Room.

At the center of CFGNY's project is a humanlike figure composed of disparate objects from Cooper Hewitt's collection, all sourced from places de Forest once visited—India, of course, as well as China, Japan, and Egypt. In this instance, the museum itself serves as the archive from which the artists extract materials and recontextualize them into a figure who occupies the space like a god in its temple. Illuminated within a stark, industrial installation, the form feels miraculous and otherworldly, somehow divine. Like the wooden pillars, scalloped arches, and flower-laden architectural brackets in the Teak Room, the figure's parts have been dislodged from their original sources and transformed into an outsider's unconventional vision. A fourth-century Roman glass vase, Indian jewelry, a Japanese opium pipe, a Chinese snuffbox, and various curiosities comprise this ghostly "body," which can be read as a metaphor for the Western construction of the exotic that subsumes places and peoples as diverse as Japan and India and reduces them to "the Orient."

The artists' intervention is indeed an exercise in obscuration just as it is one of revelation, directing attention from the hypervisible opulence and excess of the "vaguely Asian" Teak Room to all that is hushed and unseen beneath the surface—distinct cultural identities, labor, appropriation, and assimilation. Grounded in the reflexive relationship between Asian and American design, and somewhere between deconstruction and reconstruction, the project unsettles, destabilizes, and lays bare the long, dark shadow of certain forms of cross-cultural exchange. The installation prods visitors to carefully and thoughtfully consider the spaces that surround us, perhaps even in our own homes and rooms. Where have the many parts of our spaces come from? What do they say about our desires, aspirations, and values? Whose lives and stories are embedded within them, and what is it that they may wish to say?

MULTIPLICITY OF HOME

The very notion of home can be painful for some kids and adolescents. The homes we are born into cannot always fulfill all our needs. Intergenerational misunderstanding is inevitable. While this holds true for most teenagers, it is much more intensely felt among queer and trans youth. Parental knowledge imparted across generations rarely furnishes all the tools necessary to assist a child's unfolding life. Many queer children are born outsiders, bound to a longing for the unconditional love and support that home promises. Queer teens often mature into disillusionment, understanding home as a place that was not built for them. These conditions can cause them to grow suspicious of the nuclear family. As they evolve and grow, they realize this disadvantage offers an enormous opportunity—the freedom to reinvent home on their own terms, to reject traditions and morals that exclude them, and to search for new models and approaches to making a home.

MICHAEL BULLOCK is a New York–based writer, editor, and documentary producer. He is the author of *Roman Catholic Jacuzzi* (2012), editor of *Peter Berlin: Artist, Icon, Photosexual* (2019), co-editor of *I Could Not Believe It: The 1979 Teenage Diaries of Sean Delear* (2023), and producer of the MoMA documentary series *Built Ecologies* (2023). He is the associate publisher of *PIN–UP* and a contributing editor to *Apartamento*. His work has been published in Aperture, Frieze, Interview, BUTT, and *New York* magazine, among others.

JOURNEY STREAMS is a writer, artist, and nightlife historian based in Brooklyn, New York.

As friends and collaborators, we began a conversation about our own formative experiences with home, documented here as narrative reflections. Together, we came to the conclusion that home is in the lives we share, the communities we form, and the bodies we inhabit. Home happens when we decide what our homes look like, which values we want to articulate and share, and with whom we want to share them. Home divides, like mitosis, into a plurality. We often exist between worlds—the conventional household we were born into and the queer spaces we create for ourselves. The following two experiences, from creators born just over two decades apart, show us that even though social acceptance, visibility, and consciousness for queer and trans people have improved immensely over the course of a generation, the structures that drive us to reimagine home remain a formative aspect of the LGBTQ experience.

MICHAEL BULLOCK

It is almost impossible to fathom this today, but in 1991, the fifteen-year-old suburban Massachusetts pre-Internet version of myself needed confirmation that I was not the only male in the world who

UTOPIA

was attracted to other men. This fact alone shows us how far American culture has evolved in its embrace of LGBTQ members of society.

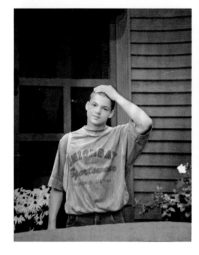

Michael Bullock, First Day of High School, North Attleboro, Massachusetts, September 1991

Hopefully, the gay kids of the pre-Internet '90s were the last to suffer in isolation, truly wondering if their desires were shared by anyone else. Worried I might be a freakish anomaly, I became a detective searching for signs of gay life in my conservative environment, doing so in a way in which I hoped no one would ever suspect that I, myself, might be gay. It was dangerous work. The messages from my peers on the football team, from my priest's sermons, and from the vast majority of pop culture media let me know that my attractions were absolutely not tolerated. This all unfolded at the height of the AIDS crisis in the years before the FDA had approved the cocktail of treatments that made the disease survivable. From afar, I was a witness to the devastation of gay urban life. The news consistently reported on the morbid sickness and untimely deaths, and those that suffered were always to blame. Even so, I considered myself lucky. I had loving parents who were supportive in many ways. They instilled in me the self-worth that made it possible to cope with being born into a homophobic culture. Still, I could read the very Catholic room: having a gay son would break their hearts. So, I remained closeted until I left my parents' home.

The majority of LGBTQ children are raised by guardians who are unlike themselves, a situation that, depending on the family, causes varying degrees of difficulty for both the parents and their gay child. To not be allowed to express a crucial aspect of yourself in your own home has consequences. Sexuality and attraction are vital life forces that inform creativity, dreams, and purpose. For most gay people of my generation, these aspects of self-development happened in isolation, outside the home, and without counsel. This situation filled me with enormous anxiety but also offered the promise of freedom in self-reinvention. In this predicament, I could not rely on the history, style, rituals, and values that are typically shared from one generation to its offspring. A cis-gender straight couple can't totally anticipate the needs of their homosexual child, no matter how understanding they may be. Desire became my North Star.

In my case, in order to cope, I rebranded my situation. I told myself I was part of a secret society, a concept that was occasionally affirmed by coded glances from older strangers. I gained further information from my local college bookstore. Too fearful to browse the gay studies section, I discovered that the art section's

coffee-table books on Robert Mapplethorpe and Andy Warhol more than affirmed my question. Gay people existed, and they could be both beautiful and powerful. This informal research also led me to a conclusion that was both naive and somewhat accurate: being gay was tolerated only in very specific contexts. One was being an artist in New York City.

My innocent need to find my own kind, mixed with my raging teenage hormones, gave me the courage to explore the local mall's bathrooms and nearby highway rest stops, places rumored to be designated for men with same-sex attractions to find each other. In the suburbs, the only queer spaces that were available were the ones we co-opted from public use. Back then, I understood these meeting places only as elements of my new subculture; I couldn't comprehend the greater context that created this phenomenon. Cruising spaces existed on the margins of society because, in that time period, almost every aspect of suburban gay life, even for most adults, had to be lived outside of the home. The situation reaffirmed our public image as outsiders, outlaws, and deviants. I didn't know that camaraderie could exist among a circle of gay people until I saw two men kiss in Madonna's 1991 documentary *Truth or Dare*. It was my first comprehensive vision of another type of home. Decades before the term "chosen family" became a buzzword, Madonna and her backup dancers modeled for the mainstream the possibility of thriving joyfully outside heterosexual norms. It reaffirmed my suspicion that urbanism, creativity, and queer community were linked. For the first time ever, I was able to imagine a future for myself that wasn't depressing, a life that might actually be desirable.

At age twenty-one, at the moment that gay culture was starting to emerge from behind the crushing brutality of the AIDS crisis, I escaped to New York City. For the first time in my life, I found myself in spaces built by and for queer people. I found bars, nightclubs, community centers, galleries, clinics, parks, and beach towns. Here, home and family took on a multitude of new forms, unbound from the expectations, aesthetics, and traditions of my biological family. Together with my partner, I began to build a home that matched our specific needs and ideals. Our apartment offers us security and comfort without the need to parallel all the heterosexual social precedents with which we were raised. Our place showcases the art and artifacts from our circle of friends and celebrates the culture we participate in creating with them. Knowing that this experience was stolen from the generation before me, I never take our home for granted. My peers and I will be the first openly gay generation to live into old age together.

In the summer of 2015, same-sex marriage was legalized on a federal level in the United States. I was sixteen years old, still growing up in Los Angeles, already well acquainted with my own queer consciousness, and I had very accepting parents who embraced me as I was. It was a "normal" childhood, insofar as being queer, weird, and Black were dispositions that maintained some degree of normalcy in popular culture at the time. The liberal bubble had spoiled me; the possibility of marriage appeared to me already uninteresting.

As a proud child of divorce, I had willfully lost hope in the civil union and, perhaps, the idea of enduring love altogether. I had surely lost the coherence of a nuclear household, escaping to clandestine encounters that introduced me to new forms of kinship. I was introduced to queer histories through the friends that I made. This collective past was a reckoning: Sylvia Rivera, Robert Rayford, Ronald Reagan. The political movements that came before me left a residue on the mirror of media that attempted to reflect my experience. I marched in the Pride parade with skepticism. The fact was, my cherry had been popped. I had been radicalized, while queer identity had been sold to the state. I knew this because I saw examples of what life looks like when such social normalcy is not an option. The lives of the generation before mine shimmered in my juvenile eyes, more beautiful for their lack of restraint. They taught me that to live within the renovated confines of civil society meant forfeiting the parts of myself I was only just beginning to love. I was less confronted with the oppressive force of heteronormativity and more fearful of my own assimilation into a new homonormativity emerging all around me. I found some semblance of comfort in the belief that the updated terms of the American Dream did not charter the only future worth striving for.

Besides, I had no time to dream. The restless hours spent with strange bedfellows provided enough to sustain my youthful aspirations. There could be greater comfort awaiting me on the fabled horizon. With the knowledge only offered in pillow talk (and the internet) at my disposal, I resolved to search for my identity through the words of ancestors. I read, I mourned, I

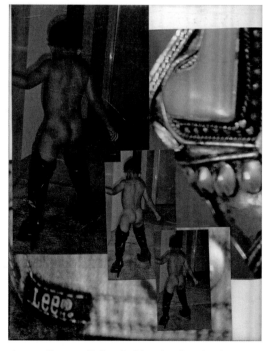

Journey Streams, Collage by Mom, Los Angeles, California, 2002

loved, all in hopes of finding a path that felt more promising than the white picket fence.

The sanctuary that eventually welcomed me cannot be found in books or under bedsheets. It remains hidden behind a tuft of trees, tucked into the jagged edge of a region in the rural Deep South.

It was there—in a home without walls—that I saw what was possible. Across a gorgeous, pastoral patch of land, with barn houses and goats alongside sexual wellness resources and a cubby full of hand-me-down clothes. Up the path sits a cabin, often overflowing with laughter as an impossible dinner is prepared by those brave enough to volunteer in the kitchen. The land is considered home to all who visit but remains the primary residence of a robust community of stewards and healers who sustain it for communal use. It was there that I met the women who changed my life, and there that the idea I might be a woman myself terrified me. But such terror was a comfort, an assurance. I left with a promise to myself: I would not return until I became one of them.

Communal meeting places such as these are fertile with life-changing lessons. I fostered a new intimacy with nature, learning to honor the Earth as I honor my body. The bodies around me coaxed out an appreciation for the beauty of a life outside the new boundaries of queer social citizenship, whether by choice or by circumstance. This intentional community offered a less hierarchal dispersal of resources, pleasure, spiritual knowledge, and tactile skills. The space became possible only out of its necessity, providing tools for the survival of a queer counterculture.

The land nurtures an intimate web of kindred souls, holding space for the type of catharsis not permitted in the modern world. Rural oases like these stand as new frontiers for experimental queer communities, where life can be lived without the pressures of the normative world. In rejecting the conventional understanding of home, of a legible identity, there emerged an actual secret society whose name remains a sacred whisper for a chosen few. In order for spaces such as these to survive, discretion is required. In the advent of queer and trans hypervisibility, our knotted roots remain inconspicuous.

As we continue to reconcile with the true interests that govern the mechanisms of this world, new strategies of homemaking emerge in unconventional forms, unrecognizable to the public eye and therefore protected, more sustainable, or at the very least safer from the totalizing forces that continue to physically—and cognitively—displace us. This home has become a part of me. Even in the abject realities of daily life, I remain comforted by the knowledge that there is always an elsewhere.

UTOPIA

MULTIPLICITY OF HOME

FROM FOUNTAIN TO FOOD COURT

The Charleston Town Center mall in Charleston, West Virginia, was built in 1983 and was, at the time, the largest downtown

RUBA KATRIB is chief curator and director of curatorial affairs at MoMA PS1, New York.

mall east of the Mississippi. It attaches to a modest downtown shopping and entertainment complex that includes a civic center developed in the 1950s, now named the Charleston Coliseum Convention Center, which hosts concerts, ballets, plays, and other cultural events. A couple of blocks away from the mall in the opposite direction is Capitol Street, which can be reached by cutting through a pedestrian path across a small plaza that leads to the middle of the block-long strip of storefronts dating back to the late 1800s.

This complex, with the mall at its center, was the heart of the Charleston I grew up in, neglected at the same time it was being revived by adjacent new development. In the mid- to late-1990s, I spent countless hours strolling and loitering from the civic center to the mall to Capitol Street. Well before the prevalence of cell phones, a parent would drop me off in good faith that I would return at an agreed-upon time. Until then, I would roam freely among these junctions, bumping into friends and gradually gathering a small crew. One of the only walkable areas in Charleston, the dérive persisted there.

The civic center had an exterior mezzanine built into its facade, with a broad concrete staircase. Kids lounged on the stairs, coliseum style, making themselves visible to potential friends. Alternatively, they ducked underneath the stairs to mingle, make out, smoke, skateboard, and sometimes drop acid in the shadows. As an immigrant teen growing up in the rust belt, becoming an "alternative" mall rat was my attempt at finding a way to fit in without fitting in. My parents were concerned.

Crossing the street from the civic center and entering through the big glass doors of the mall, we would be met by the sound of the fountain luring us toward the mall's central atrium. Department stores like JCPenney, Montgomery Ward, and Sears anchored this space alongside the smaller boutiques, the Limited and Wet Seal, which were more exciting for teens. Peppered throughout were shops dedicated to selling CDs and cassette tapes, Claire's for jewelry accessories, and Hot Topic for alternative trends. As grunge flaneurs, we strolled the brightly lit and festive halls under the glares of security guards. Rolling our eyes at Santa Claus

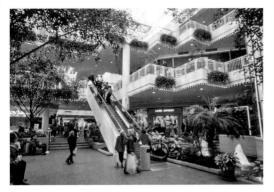
Charleston Town Center Mall, 1980s

seated in his chair and the line of kids waiting for their picture to be taken during the Christmas season, we would meander up a few escalators to the food court. We rarely had much money, so we ordered Long John Silver's "crispies," an off-menu item made from the leftover batter droppings in the fry basket that cost less than a dollar. We eagerly dipped them in ketchup and tartar sauce. If we had more cash, we would buy McDonald's Happy Meals as an ironic gesture.

After ingesting fried food and Cokes, we would walk the rest of the mall and exit on the opposite side, strolling toward Capitol Street and inevitably gathering acquaintances loitering on the benches as we went—some of whom were a little too old to be hanging out with teens. If you squinted, a look down Capitol Street might make you think you were in a major city like New York or Chicago, but if you walked too far the illusion would quickly be lost. The little strip would eventually become home to one of the first, and eventually only, independent bookstores in the city. But when we were there, a modest coffee shop named Common Grounds was the only place to spend any time outside of the few knickknack stores. I don't remember ever buying a coffee there, but I do remember spending countless hours in an attached venue for punk and grunge concerts alongside fellow teens moshing or just intensely nodding their heads to homegrown bands. We would prop open the back doors and smoke in the alleyway, critiquing the bands that were playing and passing out flyers for future shows. The owners attempted to host a rave one night, and we all donned glow-stick jewelry and bright colors, but the music was all wrong. From poetry readings to parties, this was one of the only places in town where independent culture, creativity, and experimentation could be attempted and shared. Outside its doors, threats loomed: locals who might find our dress and manner offensive to the point of violence, disapproving parents, and bored security guards. Inside this modest coffee shop, near the safe familiarity of the mall, we managed to find some form of freedom.

This downtown complex's identity as an essential gathering space quickly waned. At the same time that we were swiping hair clips from Claire's and moshing in Common Grounds, in 1992, a few miles south of downtown and at the base of a mountain ridge off the highway, a stretch was cleared to make way for Southridge—an expansive complex of big-box stores like Walmart and Home Depot. From the flat, walkable valley of downtown, Southridge is a fifteen-minute drive on a highway through the

FROM FOUNTAIN TO FOOD COURT

Appalachian Mountains. An expanse of parking lots and fast-food drive-throughs affirmed that Southridge was accessible only by car. If you wanted to find friends there, you would be wandering on hot exposed pavement through parking lots and a sequence of sprawling stores divided by six lanes of highway. The place was built for pulling in, parking, going into a big-box store, then getting in your car, driving to the next lot, and doing the same thing over again. This could all be finished off by a trip to a drive-through, further reducing the chance for contact with others.

Peak nineties was in many ways the celebration of the mall—exemplified by the cult indie film *Mallrats* (1995)—just as developers and investors worked to bring about its ruin. Strip malls like Southridge accommodated the monolithic shopping experiences of places like Sam's Club and Walmart, who predicted the gradual downfall of the mall, which had been built only one decade before, and along with it, the independent retail stores located in the its vicinity, which, ironically, the mall had once put at risk. Going downtown at all became inconvenient; you had to find and then pay for parking. At Southridge, parking was plentiful and free.

It took some time to see the indications of just how bad things had gotten at the mall. In 2002, Montgomery Ward closed, as did Long John Silver's and McDonald's in 2004. The turn of the millennium put the concept of the mall into peril on a national scale. In 2019, Charleston Town Center was put up for auction after it defaulted on a $100 million loan. It was sold to the sole bidder, Hull Property Group. In 2022, plans were underway to erect a wall that would close off the section of the mall that housed Sears, then demolish that wing and build a freestanding hotel in its place.

Southridge has also faced its share of struggles. Online retail has reduced the relevancy of big-box bargain stores, but there are more factors at play in the area. West Virginia is at the heart of the opioid epidemic, with the highest rate of deaths per capita due to overdoses in the country—52.8 deaths for every 100,000 residents.[1] Many of my old mall-rat friends, acquaintances, and classmates have succumbed. Our juvenile attempts at smoking weed under the civic center steps, at the time seen as antisocial (and criminal) behavior, were replaced by something far more sinister. Perhaps unsurprisingly, West Virginia has one of the highest poverty rates in the country, cultivating the atmosphere of desperation so tied to opioid addiction. Absentee ownership of local industries like coal and timber along with a decentralization of economic engines, such as online retail that operates out of state, has led to increased levels of disenfranchisement and poverty, with deadly results[2] even before the COVID-19

[1] "Drug Overdose Death Rates," National Center for Drug Abuse Statistics, https://drugabusestatistics.org/drug-overdose-deaths
[2] Deaths and injuries are also compounded by lax labor laws. See Jeff Ondocsin, Sarah G. Mars, Mary Howe, and Daniel Ciccarone, "Hostility, Compassion and Role Reversal in West Virginia's Long Opioid Overdose Emergency, *Harm Reduction Journal* 17 (2020), https://harmreductionjournal.biomedcentral.com/articles/10.1186/s12954-020-00416-w.

[3] "Our Epidemic of Loneliness and Isolation: The U.S. Surgeon General's Advisory on the Healing Effects of Social Connection and Community" (2023), https://www.hhs.gov/sites/default/files/surgeon-general-social-connection-advisory.pdf, 4.

pandemic ravaged communities. Online shopping became not only a convenience but a necessity to reduce exposure to the virus, and is now undoubtedly a fact of life.

We are only just beginning to understand the impact of this expanding isolation. The US Surgeon General recently issued an advisory about a loneliness epidemic, claiming that its effects were at play before the pandemic, warning that the "mortality impact of being socially disconnected is similar to that caused by smoking up to fifteen cigarettes a day."[3]

The social and communal spaces of pedestrian shopping centers arguably do more than allow people to purchase goods and services. Jane Jacobs already identified this in 1961 with her now classic book *The Life and Death of Great American Cities*. But the advent of digital technology has accelerated concerns about the erosion of the social fabric as cities increasingly cater to the relentless thrust of capitalism. There are many ironies in the way that the downtown complex I wandered in my teens was designed. The architects, planners, and city officials had clearly imagined people in those spaces, as they included places to sit, rest, and meet throughout. However, when used, politicians, police, business owners, and worried parents became alarmed by alternative cultures using these same spaces in a way that was less focused on shopping and more focused on belonging. The soulless big-box stores, easily surveilled by eyes in the sky and aggressively lit aisles, are a designed response to maximizing efficiency and profitability, stripping away the potential for improvisation and exchange—even criminalizing it—in non-designated areas.

Those few years in the nineties when I was a mall rat seem so wholesome compared to the experiences and access of teenagers today. While the mall was a space meant to facilitate commerce, it was designed to mimic a "center," which permitted forms of community to emerge. There we made friends, got our first jobs, tried new things, and found windows into the world by browsing trends, music, and magazines. Our conflicted parents hoped that the mall was a safe place for us to hang out with some autonomy, but at the same time worried that we might be sucked into the underbelly of teen delinquency. And while that was true for a few (not for most), I can't blame the mall. Instead, its halogen lights, mélange of shops, random run-ins, and bustling crowds turned out to be a balm against the oncoming decline, which was being constructed just outside its walls.

UTOPIA

FROM FOUNTAIN TO FOOD COURT

JOSEPH BECKER
WILLIAM SCOTT

℘RAISE FRISCO
Resurrection by Design

William Scott believes in the transformative power of architecture. Praise Frisco, his wide-ranging urban proposal for the future of San Francisco, centers ideas of rebirth and renewal through new building projects that address issues of housing, community, and care. Scott presents his ideas through paintings and drawings, hand-built models, and, increasingly, digital drawing software. Like many civic-minded citizens, he dares to imagine a safer and more equitable urban fabric. His concerns are rooted in his personal history, having grown up witnessing violence and crime in the Hunters Point neighborhood of San Francisco, and in pervasive issues such as homelessness and a lack of investment in infrastructure. Scott's work serves as a reckoning, reimagining the housing projects he grew up in, the hospital he was treated in as a child, or entire neighborhoods. He sees architecture as a tool that can write the story of the future, but also help rewrite his own story, as if he can be reincarnated into it. In his vision, Praise Frisco also brings people back to life, undoing the pain and trauma of loss and struggle with spaces that are welcoming beacons of prosperity and health.

Scott's utopian proposals merge ideas of faith, referencing gospel exuberance and catering to a moral high ground, as well as fantasy, tapping into the dreams-come-true ethos of Disney. He aims to spread joy and peace, both depicting and manifesting the "wholesome encounters" that are integral to his paintings. This is the poetic and optimistic potential of Scott's idea of home: a world that is peaceful, vibrant, and connected.

JOSEPH BECKER is associate curator of architecture and design at the San Francisco Museum of Modern Art, where his recent exhibitions include *Art of Noise* (2024), *Marshall Brown Projects: Dequindre Civic Academy* (2023), *Barbara Stauffacher Solomon: Strips of Stripes* (2023), and *Tauba Auerbach: S v Z* (2022).

WILLIAM SCOTT is a self-taught artist based in Oakland, California. He works out of the Creative Growth Art Center founded in 1974 to serve adult artists with disabilities. His work is included in the permanent collections of the Museum of Modern Art, New York; the Studio Museum in Harlem, New York; Los Angeles County Museum of Art; Oakland Museum of California; and the San Francisco Museum of Modern Art.

UTOPIA

JOSEPH BECKER William, can you tell me what Praise Frisco is?

WILLIAM SCOTT Praise Frisco is a new city of San Francisco, with balcony high-rises for the good people everywhere. It is Peace Headquarters. San Francisco General Hospital needs to be demolished in 2029 to be rebuilt as brick buildings with the new style of a new look of a new architecture. Praise Frisco is a Gospel City to be rebuilt of a new zoning of a new city with balconies. High-rises in San Francisco with a Disney Gospel Resort. On Van Ness Avenue and on Market Street and including Bayview–Hunters Point. Third Street as Disneywood Oakdale, and Palou Avenue will be demolished. The projects on Oakdale and Palou Avenue in 2029, in five years, will be rebuilt as Pebble Rock Village. A new look by

Hunters Point Shipyard, Cow Palace, and Geneva Avenue in Visitacion Valley. Martin Luther King Towers will be rebuilt in the Visitacion Valley area with twin towers.

BECKER It's a new vision for San Francisco's future?

SCOTT That is a new vision. Because in San Francisco there is too much violence. It's a bad place. We need a Gospel City with high-rise balconies and a Disney Resort. Because Disney is a place to live, like a Gospel Disney Resort. To make people feel good, to bring dozens of people back to life.

BECKER You grew up in Hunters Point, which is where you're designing the Disney Resort. Are you thinking about your own rebirth?

SCOTT Yeah, rebirth. Because there's a lot of killings in San Francisco, and homeless people. We need to bring wholesome encounters to the Earth. We need wholesome encounters of the Skyline Friendly Organization, without aliens, without evils. We need to replace the evils and aliens and

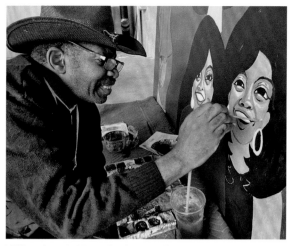
William Scott in his studio, Oakland, California

horrors. Replace scary stuff. That's very important, I'm serious. It's very important.

BECKER And to do that means removing what's existing and starting with something new?

SCOTT Yeah, removing. Starting the wholesome encounters. Replacing the original San Francisco skyscrapers, replacing the old ones from the sixties and seventies, replacing the old original skyscrapers. New ones would have balconies.

BECKER I see that you're looking at Google Maps aerial views of the neighborhoods and buildings that you want to transform.

SCOTT Yes, I do. Yeah. 'Cause that's where you need to read, 'cause this one needs to be demolished, and that one that's demolished, it's demolished, yeah, and this, that's demolished right here.

BECKER Is that what is happening in this painting that you're working on right now?

SCOTT Yeah. Looking at the Pebble Rock Village right here. This is new housing. That's the name of the project, the name of the projects. That's the name of it. It's a nice place to live for church people, Christian people, and gospel people. That's where good people live.

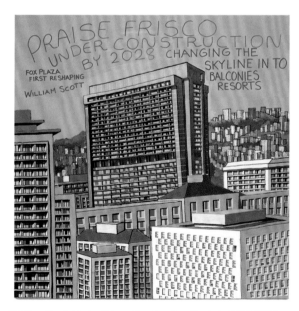
William Scott, Praise Frisco Construction Starts in 2029, 2024

BECKER Okay. And you're suggesting that this is a development that replaces existing architecture? What is your vision bringing that's special with Pebble Rock housing?

SCOTT Because Pebble Rock, it creates good people. Pebble Rock creates a good place for people to live. For church people and Christian people, like different nationality people. The church family and the gospel family and Christians and pastors and co-pastors and bishops and evangelists.

BECKER So, your design builds community as well?

SCOTT Yeah, better building makes good communities.

BECKER Does the architecture do something specific to help make a community?

SCOTT Yes, it does. Because they can create peace on Earth. They create people to create the peace on Earth. It's about the shape, and the air, and the shape. Yeah, because it was too much violence in San Francisco. It needs a new architect. Praise Frisco needs peace. We need Gospel City with the highrise balconies. We need that.

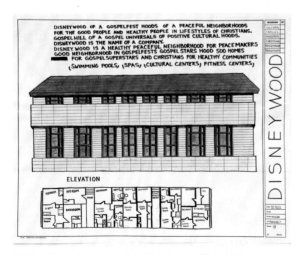

William Scott, Disneywood the New Lennar Church Homes Areas, n.d.

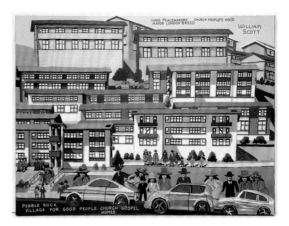

William Scott, Pebble Rock Blue Church Gospel Hoods, 2024

BECKER Right now, you're working in a SketchUp program. Can you tell me what you're designing?

SCOTT I'm doing the San Francisco General Hospital. See the new one? That's the new San Francisco General Hospital. San Francisco General Hospital was an old building when they redesigned it. It needs bringing back to design like this one.

BECKER More arches?

SCOTT Yeah, more arches, yeah.

BECKER More details?

SCOTT More details, yeah. Bring this back to San Francisco General Hospital. 'Cause designs to make a brick buildings of San Francisco General Hospital to make a new way to be for the skin factory and body factory. To bring dead people back to life.

BECKER I want to hear about that, because the hospital experience is a very important force for you, right?

SCOTT That is right. Because San Francisco General Hospital—good people everywhere take good people to take away the sickness. To bring them back, bring back to life lost loved ones of killings and gun violence and hate crimes.

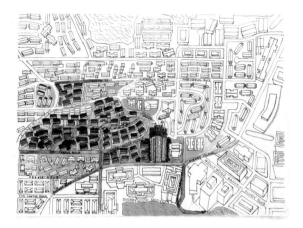

William Scott, Hunters Point Redevelopment as Disneywood Shipyard, n.d.

BECKER That's a very important part of your artwork and your architecture. There's an idea of repair.

SCOTT That is very important, yeah. To be repaired.

BECKER Can you tell me more about how you design what you're doing now? Are you looking at any references in particular?

SCOTT Pulling from my memory, like the reference. See right here? This one needs to be demolished to redesign that into this one.

BECKER Can you tell me why that needs to be demolished and rebuilt?

SCOTT It has been around for a long time. So, it'll make it better. San Francisco General Hospital is where sick people are. There was a burn center there. We need a skin factory to put the skin on, to take the burns off their bodies. Put the new skin on there. A skin factory.

BECKER I see that there's also a relationship between removing scars—something you've painted in your self-portraits and something that happens at the hospital—and the architecture.

SCOTT That's right. How to represent that? Make skin better? Make the body better? To make a new skin better, uh, with no scars, no burns. I am making a new factory at the San Francisco General Hospital. To reshape the building.

BECKER When you paint and draw people, they often have big, beautiful eyes.

SCOTT Yeah, big, beautiful eyes.

BECKER What are they looking at?

SCOTT They're looking at the view from the balconies, the high-rises. They see a new San Francisco with the high-rise balconies. Those are skyline people, church people.

BECKER Can anybody be a church person?

SCOTT Yeah, they can be, they can be a church person. That means it's a community, a better community, to take away the crimes, take away the bad people. And mean people—take away the mean people, take away the mean stuff.

BECKER Stuff like loss and struggle?

SCOTT Yeah, take away all those to hire the good stuff for the peaceful people.

BECKER When I look at this painting—Pebble Rock Blue Church Gospel Hoods—that you're making right here, this is an architecture language of your own, but it feels like it's connected to memory.

SCOTT That's right. Connected to memory. This is a Disneywood right here.

BECKER The green one?

SCOTT Green one, and the yellow one.

UTOPIA

PRAISE FRISCO

BECKER And what about the cream one with the red trim?

SCOTT Red trim? That's housing complexes.

BECKER Are those balconies?

SCOTT Probably escape balconies. That's apartments. That's two-story housing. That's a couple of ideas right there. These are Pebble Rock housing.

BECKER Have you ever lived in housing like this?

SCOTT Yeah. In the Bayview–Hunters Point. The old one. And that's a new shape. That's a new design.

BECKER I love this idea of rebirth. I want to hear more about that. Why is architecture so important for that?

SCOTT Because, high-rise balconies are a resort to, to see people, to see the view with the balconies. So, to get people out of that sun. So, they can relax in the balconies, in the shade. It'd be beautiful in the shade, looking at the view in the shade. It's for good people to gather. Good places for people to gather. Yeah. Homeless people have been around in San Francisco for years. It makes San Francisco worse and it needs a Gospel City with the gospel resort with the high-rise balconies.

BECKER Does Praise Frisco create housing for the homeless?

SCOTT Yes, it does, so it makes it better.

BECKER Is it possible for everybody to have a home?

SCOTT Yeah, for everybody to have a home. Praise Frisco will do it.

BECKER That's a beautiful vision. Is there anything that you want to point out around your desk that you're working on?

SCOTT This is a new housing right here. It will be by Hunters Point Shipyard on Palou and Oakdale Avenue. See, look at all that.

BECKER Is that a community?

SCOTT That is a community. That's a community, church community. See, look at all that. Pebble Rock Village, right here. See that? You want to take a picture of that?

BECKER Sure. Let me take a picture.

SCOTT Go ahead. So you show it to developers and to engineers.

BECKER Okay. Okay. Thank you so much, William.

SCOTT Okay.

HOWEVER, DO YOU WANT ME

HOWEVER, DO YOU NEED ME

An essay on utopia through images in my camera roll

KATHERINE SIMÓNE REYNOLDS's practice investigates emotional dialects and psychogeographies of Blackness within the Black Midwestern landscape, conversations on the "non," and the importance of "anti-excellence." Her work cautiously attempts to physicalize emotions and experiences by constructing works that include photography, film, choreography, sculpture, and an anxious writing practice. Reynolds has exhibited and performed within many spaces and institutions, including the Pulitzer Arts Foundation, the Museum of Modern Art, the Saint Louis Art Museum, and the Black Midwest Initiative Symposium at the University of Minnesota. She was also the 2022 Fellow at the Graham Foundation. Alongside her visual art practice, she has embarked on curatorial projects at the Luminary, SculptureCenter, and exhibitions for Counterpublic 2023, The Stanley Museum of Art, and the Clyfford Still museum opening in winter 2025.

Down the way, there is a car trying to start as you stare up into a deep and hanging blue sky. I like to call this Blue Time. The time where the warming anxiety of the day grates against the velvet of the night as one last protest, making a Midwestern blue that bruises as it lays tenderly on your chest, making it just slightly hard to breathe

in and
out

as the birds fly over for the last time in the day, toward a temporary home that is just as fragile as their bones.

UTOPIA

The car's engine never turns over (gets close) and you submit to the pressure of the blue. You still can't breathe any easier though.

Seeking the pleasure of the pressure comes easy, like you were born into it or of it. I saw a T-shirt once that talked about how we were all made of the same material as stars, and I thought, Stars collapse like we do. Creating a black hole. A black hole was one of my fears growing up, a space of a violent nothing that you could be lost in for eternity, seeing a speck of a smoldering sun as you are yanked into another dimension.

Also, a relenting fear since childhood,

this unknown can tear me from limb from limb as the sweet song of my grandfather's off-key baritone creeps from the back pew of a dying church as he sits with his eyes closed. I can still feel the vibrations from his voice on the nape of my neck, a reminder that I am a sweet child of God and this is why the bees buzz around my syrupy heart.

"If it had not been for the Lord on my

side

Tell me

Where would I be?

somebody tell me

Where would I be?"

And there it was. (A nothing so dense, you could climb into it.) A scene of a beautiful nothing right before you as you flew through the sky. Hanging in the in-between, a bated breath anticipating something, anything that might cut through. What is in a horizon, and what lies just on the other side of graying enveloping clouds that cling to the body like a baptism gown. Dampness in the mouth as you pull the tongue to lick the gusts of wind from outside the plane window, imagining the aftertaste to be one of a dusty plum and metal.

You have a fear of heights and are constantly reminding yourself to look into YouTube videos of how planes actually work, considering you have been taking one almost every other week for six months.
Since the summer of loss and finding and losing again.

In the pale of the graying scene is a comfort, like knowing what someone mouths to you from across a crowded room. Communicating in real time, a somatic connection on a molecular level in a party that is far too loud. They are saying,

"I think it's time to go home. I'm tired."

It's polite to silently acknowledge your want/need to leave, pack away the fusses and sighs, the noisy shuffling, basking in the complaint of not wanting to be somewhere. Who wants to be *that* person? Who wants to be *that* person who fusses and shuffles around noisily basking in the complaint of not wanting to be somewhere? In all honesty, you sometimes do, but this time just leave without hesitation. Grab your bag and walk out into an atmosphere of your own making.

UTOPIA

Just leave.
Like a word unspoken, a breath not taken, a glance not returned, a feeling left behind to wait.

Contents from my bag: rose quartz, hand sanitizer, an unopened
pack of cigarettes, a broken wallet, Lactaid, headphones,
Vaseline, other people's luck/problems, a pen,
a receipt for reimbursement,
condoms, blush, change, and
one earring

There is a recognition problem. I need you to recognize or even authenticate the value of me in order for me to exist.

I am real to me. And I'd rather disappear than participate.

Sipping on the Blackness of her smile, I smile back. Inhabiting a space of a superstitious longing that feels too good to be that way. Wondering if we held our smiles together any longer, one of us may turn into the bad luck we keep hearing about.

I believe that superstitions are prayers,
and my friends and I pray a lot.

My father would say if a black cat crossed your path, and looked at you, then money is headed your way. And you don't keep your bag on the ground, or else you would lose that money just as quickly as the black cat let you *think* you earned it. I wasn't taught or even really told to not keep my bag on the ground, but I picked that up along the way like other things that we just do. I never saw my grandma's purse on the ground, and I love the house she lives in, with the soft brown tiles and the mint-green walls. I feel lucky there, a luck that seems to be fading as she glides around the house in her new wheelchair to catch *Family Feud*. What happens when you can't outrun fate? Stumbling from space to space on a luck you have been told as a Sag rising you innately possess. Out of breath, chalking bad instances up with a karma that has been gunning for you since birth. And you didn't even know it. I didn't even fathom it.

I've had several friends tell me I am lucky, and a reader told me I have a story similar to Snow White or Cinderella. A chart that has a hard life that is all "worth it" in the end. But I didn't leave my shoe at the ball, I took both in my hands and let my blistered feet find their way home through mint and honeysuckle bushes. No one will come searching, as they believe I left my shoe/self behind, because that's how the story goes. No one comes searching for a girl who has chosen the path of *most* resistance. Even though the residue of her foremothers carved that path for her. Almost like a desire path, paved in masochism that hasn't fully concretized yet. I don't know what I am stepping on as I am led home by a familiar wounding as the setting concrete clings to a callus on the bottom of my sole.

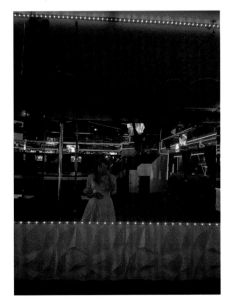

HOWEVER, DO YOU WANT ME / HOWEVER, DO YOU NEED ME

UTOPIA

Ask and you shall
receive

something
of your heart's desire.

I'm an unreliable narrator, and my feelings are dry
like an old bouquet in the corner of the room.

Am I okay to know?

Self-soothing as my wails fall off the bone. Lingering in a waning sweetness that swells and seeps onto a cotton floor. I come in the form of a weeping wound bound by a loosed tourniquet.

No place is utopia. Literally. A mirage of meaning. No place is utopia. To desire means to never have nor had, and to want it so deeply while knowing, once held, you become disgusted by the reality. I just learned the term "limerence," which can be defined as yet another form of daydreaming. So, I made a playlist titled "unrequited"

The Three Phases of Limerence:

Infatuation
Crystallization
Deterioration

Please just tell me one more time how this is the life that is meant for us. For me, and for us. That this is what we have been working and searching for. Finally, a feeling I have felt for so long and yet is still new and craven. In the overwhelming process of it all, you stay and continue to provide some source of weight as I drift away to seek a new feeling. But you stay in that beauty and decay. You stay placed in my head and hands. Intact and motionless, becoming my shadow and my only source of light all at once.

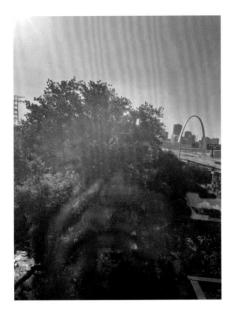

Bessie Smith singing the "St. Louis Blues":

"I hate to see the evening sun

 go

 down

I hate to see the evening sun go down
It makes me think I'm on my last go 'round

Feeling tomorrow like I feel today
Feeling tomorrow like I feel today
I'll pack my grip and make my getaway

St. Louis woman with her diamond rings
Pulls that man around by her apron strings
Wasn't for powder and the store-bought hair
The man I love wouldn't go nowhere, nowhere

HOWEVER, DO YOU WANT ME / HOWEVER, DO YOU NEED ME

I got them St. Louis Blues, just as blue as I can be

He's got a heart like a rock cast in the sea

Or else he wouldn't have gone so far from me"

Crossing over the Mississippi heading back to Chicago, and I pray this bridge can hold us onto the other side.

I travel often, fast and alone. I struggle with packing, still, preparing for the unlikely. But it's important to be prepared, or as prepared as you can be.

You really can feel tomorrow like you feel today. Carrying things over, soaking in the remains and excess from the previous days, months, and years. Never finding this resolution that we claim to achieve. A never-ending aspiration that refuses location.

Black female imagination and dissociation go hand in hand, because in order to imagine/believe you can survive in this world, you have to be out of your body. Just above, or like a reflection from the sun through a window.

Hovering above and looking through to place myself in comfort and just out of reach of misunderstandings. Articulation fails me with a tied tongue and a sore mouth. Memory fails me with a mind made to meander and pause at sensitivities. Intimacy fails me with hands that sometimes shake and sides that ache. Let's pick petals from the old factory and guess if we love each other, or ever did, through the melancholy and bitter-tasting kisses. Every time I leave, my teeth rattle a little more and my knees want to drop the weight. This landscape leaves a dull swelling, like a hickey from a lover. I love the reminder, but love reciprocity more.

And yet still, I allow myself to imagine a world where

*L*IVING ROOM

I have damn near torn myself apart trying to find home inside my body. I travel three hundred days a year. Hotels are my domicile. The circles I have run around the world over the past decade as an opera singer and creator took me far from any stable sense of home, and lord knows I've tried to find it in myriad other ways—some inadequate, some futile, some destructive. I have built and demolished many homes in my time. I have felt them take root and felt them evaporate.

DAVÓNE TINES is a celebrated bass-baritone and creator known for his versatile performances in both classical and contemporary music.

Have you ever imagined what it would be like if the room you were in dematerialized around you? A room: six or so flat planes enclosing a space in which someone or something can exist removed, protected from the environment beyond those walls. But walls do not only frame space, they preserve the ephemeral; they materialize the intangible.

Through harrowing trial and error, I have learned to conjure my primary ideal of home, teleporting myself back to the place that has been a constant in my life: my grandparents' living room. I grew up in that house. A hundred years ago, the house sat on a beautiful horse-country road that would eventually take you from the Virginia countryside to Washington, DC, but not before overwhelming you with rolling hills and glowing vegetation, framed

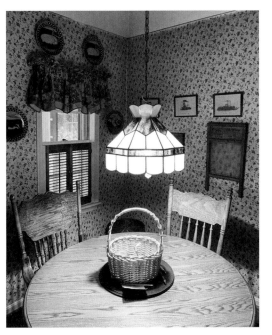

Mayank Chugh, Alma's Kitchen, 2024

in the infinite distance by purple mountains whose majesty came from their weathered repose. I gestated in this house and in this region I now describe as a Ralph Lauren ad built atop a slave burial ground.

The living room, toward the bottom of the list of spaces most commonly inhabited in the sprawling twelve-room house, became my personal sanctuary, laboratory, therapy chamber, and private reckoning place. The absence of regular traffic gave the room a sanctimoniousness that made it feel like a privileged place.

The room exists, in part, in its contents and surroundings: soft cream carpet against ruby silk drapes; clean Virginia sunlight pouring through the branches of a centuries-old oak tree beyond the window;

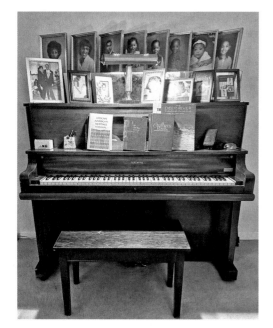

Davóne Tines, Family Piano, 2024

a perfectly off-key piano serving as ruddy plinth for the complete family tree of portraits; a piano bench, an archeological site stacked with the compressed sediment of my musical life; a golden china cabinet with ceramic black angels and keepsakes fought for in the Vietnam War; a grandiose golden mirror I pilfered with high-school friends; a reproduction of the painting The Touch by Aaron and Alan Hicks found in so many Black homes; a portrait an artist friend painted of me while I ran her husband's plein-air painting school; the 150-year-old family Bible; and my great-grandfather's grandfather clock.

The room also exists in memory: a magic box filled with hundreds of my core musical experiences. My origin story. Where did the music begin?

Well, I sang at Providence Baptist Church four minutes down the road since before I could remember. But the more precise question that I am never asked in interviews is: "When was your passion for music born?" As the story goes, one day during a routine Blue Ridge Mountain blizzard, I, in my late single digits, wandered over to the piano out of boredom and struck a single note. As my grandfather puts it: "I saw it happen, and it seemed like that note got stuck in your head and never came out."

I started taking piano lessons from a woman down the street. I would kind of practice with the sheet music I was given, but mainly I would listen a few times and memorize the notes, which peeved my teacher because I was not "learning correctly." In the living room, education was whatever I wanted it to be—lying on the floor listening to Scott Joplin and Mary J. Blige, pacing endless circles repeating a Vivaldi phrase, or quietly chanting German to myself in my grandmother's wingback chair. I spent countless hours a day practicing the violin with a focused fervor of incidental joy born of concentrated, minute, and incremental effort. I was such a nerd about it all. I kept my sheet music on a black Wenger music stand in a bright orange half-inch D-ring binder and took secretarial glee in organizing new pieces into nonglare protective sleeves. I practiced my way into being concertmaster of every school orchestra I was in from sixth grade forward.

The living room is where I would get to intimately know my new violin after I had earned my way up to trading in my old one. Her name was Sofia, and I'd pore over her woodgrain, noting every historic nick and repair, every contour of her back's deeply flamed

maple and ebony-rosewood pegs. I'd luxuriate in the smell of her case's factory-new stiff velvet, whose scent I cannot describe aside from there being an intoxicating element of chemically enhanced cedar. I was in love with how the small golden hygrometer looked against the luscious deep green.

The living room holds the music I have learned there and the music I have shared with other people: one late fall day when I was in high school, I taught my neighbor the entire alto line of Handel's *Messiah* by playing it on violin and singing along with her. I basked in the sunny lilt and drive of Dmitry Kabalevsky's exuberant violin concerto, the last concerto I would learn before laying the violin down for singing.

I meticulously learned the score of the opera that would be my international debut: the Peter Sellars–directed *Only the Sound Remains*, written by godmother Kaija Saariaho. May her memory be a blessing as she rests in peace. She was a steel blade encased in felt as she sat toward the back of the rehearsal hall of the Dutch National Opera, one eye piercing the orchestra and the other fixed on the mirror of her compact while she judiciously applied red Chanel lipstick. I like to imagine that part of her spirit lives in the living room, anchored by the horcrux of my tattered scores stuffed in the piano bench next to Kabalevsky and *The Black Clown*.

I have returned time and again to dig into more scores I was preparing for increasingly "prestigious" (i.e., stressful) contexts; the weight of that pressure was held at bay outside the windows while I swayed barefoot on the creamy carpet.

The living room is where the thorny complexity of the family dinner table went to be baptized in solace and reflection.

The room holds emotions I've processed—throwing myself onto the antique sofa, wallowing in tears after learning, within the span of an hour, that I was rejected from Yale University and that my dog had died.

The room holds the evidence that family can be bliss. At Christmas, it is where we would sit around for hours after opening gifts at midday. It was the only time when that many people would be in the room at once. We would bask in the warm, hazy glow of the moment we fragilely yet determinedly wove together from the strands of nostalgia and good cheer we each silently offered up.

A decade into my career, when I realized that staying in an endless procession of hotels does not a home make and that I was, in practice, homeless, I became aware that I needed to find a psychic home or I would die. (Maybe not die, but I would surely bankrupt my soul by not having a place to replenish it.) I decided that I needed to do what I could to recreate or borrow or teleport that feeling of home. So, I created a two-part ritual:

UTOPIA

LIVING ROOM

ORCHIDS

The living room always has plants in it—
my grandparents' other "grandchildren."
I bring this on the road by way of orchids,
specifically white ones, because of their
beguilingly alien yet elegant form and
ethereal radiance. These days they're available at reasonable prices in many grocery
and convenience stores, so I pick one up
(or three), position it in my hotel room, and
when I am done with my stay, gift it to the
person I am most thankful for on the trip.

INCENSE

Mayank Chugh, Hotel Room Orchid, 2023

The living room also, more recently, has incense, a choice I think
my family tacitly made to honor my late mother, resting in power,
who loved incense. She burned it everywhere all the time. When I
was younger, I hated the scent, which I thought choked the air, but
over time I realized its magical ability to elevate any space into a
spiritual realm. The room now exists in this scent, and my mother's
spirit lingers in the smoke that wafts to connect every single thing.

I know I am not done finding the physical and emotional materials
that will ensure safe passage back to that place, but for now I am
so thankful to have finally found a way to travel from anywhere in
the world, or my mind, to this room that contains the essence of
what grounds me. Its objects, organisms, memories, scents, and
glowing images have become the portals through which I can
actually
go
home.

UTOPIA

REPARATIVE SPACE AS GENERATIVE REFUGE

I had lived in Bronzeville, Chicago, for a year before I started reading about the neighborhood—five years before I would begin advocating in architectural circles for housing as reparations. When I was a child, my family told me that Bronzeville held so much history—that it was designed by famous architects, home to a booming Black middle class, renowned for its jazz and gospel music. It was a place where people journeyed to during the Great Migration and have continued to search for ever since.

ISABEL STRAUSS received a master's degree in architecture from the Harvard Graduate School of Design in Cambridge, Massachusetts, and contracts in the curatorial department at Smithsonian's National Museum of African American History and Culture in Washington, DC. She is from Chicago, Illinois.

Some parts of Bronzeville are peppered with vacant lots, while in other parts there are large stretches of grassy land with no buildings, no people, but they're not exactly empty—music from cars along the boulevard fills the air. Walking the neighborhood on a sun-drenched day recalls Kerry James Marshall's painting set in Bronzeville, 7am Sunday Morning (2003). Leafy, dappled light streams through large trees lining the major boulevards, and breezes drift off Lake Michigan.

I grew up relatively nearby, in an integrated house in an integrated neighborhood with a lot of Richard Nickel prints of both intact buildings and ornamental fragments on the wall. My family considered the photographer, whose images define *The Complete Architecture of Adler and Sullivan* (2010), to be a talented and tragic figure (Nickel was crushed to death during an architectural salvage mission in the Chicago Stock Exchange building in 1972).

Years after I left Chicago, homesick for the city and carsick from Los Angeles traffic, I craved the familiarity of the South Side, craved moseying past Chicago greystones knowing I was going to be late to the function and knowing that my hosts expected me to be. To my surprise and relief in LA, I found that the Art Institute of Chicago's online Nickel archive (1850–2011) captured more areas of the city than I expected, including Bronzeville, with images of buildings I had never seen in person, buildings that had been demolished before I was born. The vacant lots don't appear in the archive, but row houses freshly built or mid-demolition do. Which is why when staring at these photographs I found the relentless pattern in the Adler and Sullivan row house descriptions—"built … demolished … built … demolished … built … demolished"—to

UTOPIA

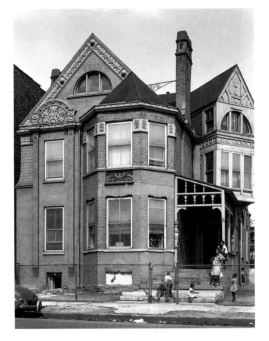

Martin Barbe Residence, 3157 S. Prairie Avenue, Chicago, Illinois, circa 1884–1963; Architects: Adler and Sullivan; Photographed by Richard Nickel before 1963; Richard Nickel Archive, Ryerson and Burnham Art and Architecture Archives, the Art Institute of Chicago

be eerie. And in tiny appendix font, I found haunting passages such as this: "In the late 1950s, the building was acquired by the Chicago Land Clearance Commission for the expansion of the Illinois Institute of Technology and was damaged by a fire before it was demolished."[1]

What I learned from trying to understand this pattern—reading Ta-Nehisi Coates, Arnold R. Hirsch, Nicholas Lemann, and Sarah Whiting, and diving headfirst into the Illinois Institute of Technology archives—was something many Chicagoans already knew because they had lived it: siloed into distinct realms of Chicago history, architectural history, and histories of urban renewal was corroborating evidence that the city, the state, and the federal government engineered the conditions of the "slum" for profit. Forcing African Americans and other "ethnic undesirables" to live under restrictive covenants and then demonizing them for their crowded conditions, these organizations invented and perpetuated the narrative that the slum is created by African Americans rather than by both de facto and de jure systems of segregation.[2] This narrative was used to condemn the land in Bronzeville before turning around and selling it at a bargain price for private gain.

Sharing this with one of my architecture school mentors, Oana Stanescu, I ended my tirade with something like, "Whatever housing I design should take the form of reparations." She looked at me squarely and said something to the effect of, "Go for it, and make sure you understand exactly what that means—and means to you—before you get started."

I ended up proposing that the City of Chicago initiate a homeownership program based on a premise of restorative compensation that would provide grants to descendants of the enslaved peoples and victims of the urban renewal scheme. In other words, reparations in the form of housing. This would give homeownership to those who have a stake in the Black Metropolis,[3] with grant options for individuals with needs outside of housing. I proposed that this initiative be developed by a nonprofit alongside the City of Chicago and use

[1] Richard Nickel et al., *The Complete Architecture of Adler & Sullivan* (United States: Richard Nickel Committee, 2010).
[2] Richard Rothstein introduces definitions for de facto de jure segregation in the introduction to his book *The Color of Law: A Forgotten History of How Our Government Segregated America* (New York: Liveright, 2017), vii–viii.
[3] "The Black Ghetto (also called 'Black Belt') is the spatial manifestation of fixed status, while Black Metropolis (also called 'Bronzeville') is how black people live within that reality.... On one side, then, are the Black Ghetto and the Black Belt. On the other are Black Metropolis, the South Side, and Bronzeville. The nomenclature is a subtle but crucial intervention. Outsiders have a hard time seeing Bronzeville. All they see is the Black Ghetto. Drake and Cayton study both." Mary Pattillo, foreword in St. Clair Drake and Horace R. Catyon, *Metropolis: A Study of Negro Life in a Northern City* (New York: Harcourt, 2015), xvi–xvii.

Isabel Strauss, Plan, 2021. Includes elements from the following: Njideka Akunyili Crosby, Something Split and New (2013) and Thread (2012); Richard Nickel, Louis H. Sullivan's Henry Babson Residence, Riverside, Illinois (ca. 1908–09, demolished 1960); Paul Strauss, Grandma Ida on Martha's Vineyard (n.d.) and Daniel with Bicycle (ca. 1997); Mickalene Thomas, Landscape Majestic (2010).

vacant land from the Large Lot Program for housing, employing a community land trust model. I conceived of this idea before the northern suburb of Evanston rolled out its housing-based reparations project—that is, before it was clear that something like this could actually work. At the time, it seemed like an impossible design problem: as COVID-19 hit in 2020, I oscillated between staring into the infinite depthless planes of architectural modeling software and the endless black squares of Instagram in the wake of George Floyd's murder.

Finally back in Boston but still separated from my family, art was the only thing that soothed my soul in my small rented room. I buried myself under the covers in the early weeks of that summer and looked at artworks by Mark Bradford, Bisa Butler, Jordan Casteel, Nick Cave, Njideka Akunyili Crosby, Ellen Gallagher, Kerry James Marshall, Ebony G. Patterson, Howardena Pindell, Deborah Roberts, Lorna Simpson, and Mickalene Thomas, and I cried. I waited months. Then I put on a mask and flew to Chicago; I isolated until it was safe. And then I asked my mom for help.

I asked, "What was your favorite part about your home growing up in Philly?" She said, "I liked watching my mother garden in the backyard." Sitting cross-legged side by side in her backyard, I kept trying to draw architectural plans, but nothing felt right. In the coming weeks, when my mother would wake me to show a section she had dreamt, sure that the ancestors were sending her drawings in her dreams so she could share them with me, the way her arms stretched outward when she spoke of the possibilities said more to me than the lines on the page.

What I ended up turning in for my degree was a challenge for designers to both imagine and define what form reparations might take. What I ended up not being able to shake was the continuous urge to make another case for reparations, this time in Bronzeville, Chicago. Reparative space, for me, has presented itself as space to dream with the people I love, without feeling threatened and without having to perform—reparative space as generative refuge.

REPARATIVE SPACE AS GENERATIVE REFUGE

SEAN CONNELLY
DOMINIC LEONG

ℋĀLAU KŪKULU HAWAI'I
A Home that Builds Multitudes

He 'ōpū hālau.
"A house-like stomach."
A heart as vast as a house, symbolizing kindness,
grace, and hospitality.
'Ōlelo No'eau No. 869 as translated by Mary Kawena Pukui

What does it mean for a memory or a vision of home to emerge from the most remote landmasses on Earth? From places where humans are not considered separate from nature, but are seen as a part of nature? What does home mean on a volcanic island as opposed to on a continent? Where do we return to in order to investigate the concept of home amid Oceanic cosmologies?

In Pae 'Āina Hawai'i (Hawaiian Islands), a *kauhale*, as defined by scholar, writer, and educator Mary Kawena Pukui, is a group of houses comprising a Hawaiian home, with each house serving a specific facet of domestic life. In the past, such homes would include a men's eating house, women's eating house, sleeping house, cook house, and canoe house. Unlike a Western home, which typically consolidates domestic life into a single enclosure, the kauhale presents a network of enclosed shelters specifically distributed across areas of land and familial settings. In the tropical climate of Hawai'i, the kauhale's spatial organization is particularly idiosyncratic, because it blurs the distinctions between indoors and outdoors and between architecture and nature, inviting the question, Where does a home begin and end?

The epigraph at the beginning of this text is a traditional *'ōlelo no'eau*, or poetic saying, that provides insight regarding the expansive concept of home in Hawai'i from a Native point of view, yielding knowledge about people, places, and behaviors passed down by Kānaka Maoli (Native Hawaiians) over hundreds of years. An *'ōlelo no'eau* such as this provides intergenerational guidance on complex ideas, offering clarity, guidance, reassurance, or cultural connection. Similar to how Pwo voyager and navigator Nainoa Thompson describes how the genius of the Native Hawaiian

SEAN CONNELLY (Ilocano) is an artist from Honolulu, Hawai'i. His practice encompasses architecture, sculpture, installation, film, design, and cartography, frequently integrating experimental methodologies. Founder of After Oceanic Built Environments Lab, Connelly's work emphasizes biocultural, ecological, and spatial knowledge to innovate and improve future well-being using art and design.

DOMINIC LEONG (Kānaka Maoli) is a founding partner at Leong Leong, an internationally recognized architecture practice in New York. The studio works at the intersections of art and living to advance social agendas. He has held invited academic appointments at Columbia University's Graduate School of Architecture, Planning and Preservation; Massachusetts Institute of Technology; Cooper Union; and Yale University.

UTOPIA

navigational star compass lies in its compacting of information together, 'ōlelo no'eau stack numerous interpretations (*makawalu*) and hidden meanings (*kaona*) together. This example in particular uses the words '*ōpū* (stomach) and *hālau* (long house) as dual metaphors for the heart, kindness, grace, and hospitality. The saying could be interpreted as simply describing a hospitality so abundant that guests leave with bellies feeling as big as a house. But with 'ōlelo no'eau, the language embodies a layered unfolding of deeper related meaning.

The '*ōpū* symbolizes a place of innate wisdom, a profound nexus where cognition meets sustenance. While Western pedagogy typically correlates emotions with the heart and thinking with the brain, in the Kānaka worldview, the abdomen is revered as the source of human emotion, instinct, and knowing, referred to as the *na'au* (intestines, bowels, guts; mind, heart, affections). To "follow your na'au (gut-brain)" epitomizes acting with profound perception integrated with your source of being. The *piko* (navel) is the source of connection to one's elders and ancestors through one's umbilical cord. The diaphragm is the source of *hā* (breath of life). The '*ōpū* is the source of nourishment with '*ai* (to eat). Thinking of the home as '*ōpū* evokes the idea of na'au and expands our understanding of home beyond physical shelter. Home thus encapsulates a source of deep connection, reciprocity, and nourishment.

The hālau represents a microcosm of a larger cosmology that transcends its physicality, echoing tradition, oral history, and ancestral wisdom that traverse generations. As mentioned above, *hā* means breath, and *lau* signifies multitude; the hālau is a place of meeting and learning, as for the instruction of hula and the making of a *wa'a* (canoe). Hula is not just a dance, but an environmental science in which performers do not just enact stories of the elements, they become them. The interior of the hālau thus transforms into a space where the elements manifest, blurring concepts of interior and exterior, human and nature. The structural components of the hālau as architecture, and similarly the construction of the wa'a, draw direct parallels with the human body and diagram its relationships. Every notch, every lashed joint in its structure is a metaphor for social relations. As one structural

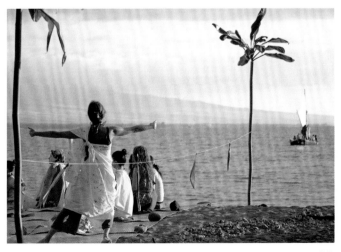

Hula and wa'a practitioners, led by the 'Āina organization HŌ'Ā, conducting the seasonal Wehe Kū ceremony that marks the end of the Makahiki season (the time of Lono) and the moving into Kau (summer). The ceremonies invoke the need to *kū*, to rise, face our challenges, to plant intentions, and *ku mai*, raise them up.

HĀLAU KŪKULU HAWAI'I

element supports another, one individual leans on another—a materialization of social and genealogical relationships.

A century of United States imperialism and militarization in Hawaiʻi has interrupted Kānaka relationships with home, resulting in ecological devastation, racial injustices, and diaspora. "He ʻōpū hālau" counters the idea of home in the Western context of land as a mere asset, a real estate investment, a property. Rather, the Kānaka relationship with land, or ʻĀina, is familial, not transactional. ʻĀina, meaning "that which feeds," is not just a term for land where one resides, but refers to a symbiosis between humans and their environment. This familial relationship with ʻĀina is central to Kānaka cosmology. At the forefront of perpetuating this relationship in Hawaiʻi are on-the-ground community and cultural groups called ʻĀina organizations.

These ʻĀina Hui or ʻĀina Orgs, as they are called, *hui* (unite) together and champion the rejuvenation of home as ʻĀina through the restoration and recovery of Native food systems and cultural sites that include *loko iʻa* (fishponds), *loʻi kalo* (taro fields), *mala* (gardens), and *heiau* (sites of ceremony and observation) previously neglected or damaged by the wrongful US occupation of Hawaiʻi. ʻĀina organizations actively champion Indigenous maintenance practices, construction techniques, Native materials, and cultural protocols. They sustain local communities through food sovereignty initiatives and place-based educational programs that enable intergenerational continuity. They protect against unsustainable land development, desecration of burial and sacred sites, and other ongoing environmental disruptions by commercial tourism and military occupation.

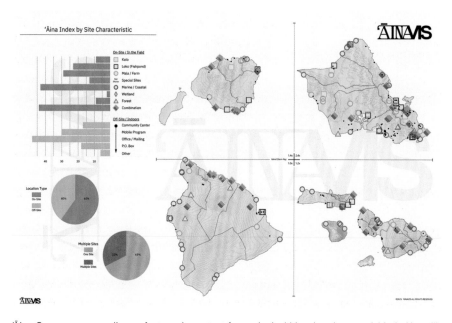

ʻĀina Orgs encompass diverse features important for ecological biocultural stewardship in Hawaiʻi, including taro fields, fishponds, gardens/farms, sacred sites, combinations of ecosystems, marine/coastal areas, wetlands, and forests, each fostering sustainability, cultural heritage, biodiversity, and community engagement.

CONNELLY, LEONG

'Āina Orgs, understood as spaces of cultural and political resurgence, face many challenges to increasing their scale and capacity. The imposed US land-use zoning and building codes inherently prioritize Western methods of design, construction, and maintenance. Native practitioners of built environments, like architects and planners, particularly those engaged with 'Āina-centric projects, frequently encounter marginalization and a lack of support or recognition. This hinders 'Āina Orgs' access to experts in the built environment who are deeply committed to honoring ancestral ties and embodying principles of radical decolonization in their work with the land. Too often, 'Āina Orgs are swayed to accept pro bono services from design firms who contribute to the militarization of the design professions or whose projects contribute to the desecration of Native ecosystems, burial sites, and sacred spaces that Kānaka seek to protect. Such a paradox highlights a critical issue: the need to support 'Āina work beyond token gestures motivated by tax benefits or marketing incentives. True advocacy and allyship require a concerted effort to align the design professions with the values and visions of 'Āina restoration and sovereignty. Through this alignment, 'Āina Orgs can rely on design to hybridize contemporary technologies with traditional knowledge, opening a new channel for Kānaka to reassert cultural identity through innovation while demonstrating the importance of ancient wisdom for a future deeply rooted in the past.

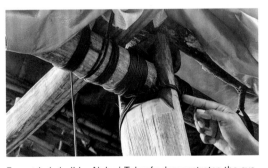

Expert *hale* builder Nalani Tukuafu demonstrates the system of notching and lashing used in the construction of traditional hale structures, which are held together only with lashing. In this image, a traditional hale currently under construction at Kaumaui in Keaukaha, Hilo, is protected from the elements with a tarp before thatching.

One example that architecture can follow is that of the oceanic voyaging canoes, such as the Hōkūle'a, built in 1975, that fused traditional lashing and construction methods of a double-hulled canoe typology with contemporary materials like plywood, fiberglass, and resin to enhance its safety and performance without compromising the integrity of its traditional design. Applying this process to the built environment by embracing Indigenous techniques like canoe lashing adapted for contemporary architectural systems, such as trusses, can reestablish Indigenous perspectives as the foundation of architecture. This would help ensure that buildings and infrastructure honor and sustain the very essence of our island home. 'Āina Orgs can use architecture to demonstrate deep systems of change and commitment to reviving, promoting, and safeguarding Hawai'i as home for Kānaka. By putting the needs of 'Āina and Kānaka at the forefront of design, we can cultivate a sense of home that is more equitable, just,

HĀLAU KŪKULU HAWAI'I

and regenerative, reinstating Native participation in the process of creating home within our built environment.

At stake are both the material conditions of vulnerable communities as well as the cosmological relationships between home and ʻĀina. For Kānaka who are committed to remain in Hawaiʻi or who wish to return home, recovering ʻĀina is an act of resistance, cultural promotion, and ecological regeneration. The saying "he ʻōpū hālau", a house-like stomach, remembers a vision of home as a place of sustenance, a gut-brain, a body, a place of knowledge, an ancestor, a network, a constellation, a place of innovation and excellence. Thus home is not inert or passive; it is an active participant in a dynamic reciprocity that imbues the soil, sea, and sky with reverence, safeguarding ancestral bonds with ʻĀina through generations. Home is a commitment to a way of life that respects a complex web of sustenance specific to its place—we care for ʻĀina, who cares for us—an enduring ceremony of giving more than one takes and leaving a place better than when one arrived there. Hawaiʻi is a place that demonstrates a symbiotic and sacred duty to protect and grow a concept of home that is as vast as ʻĀina.

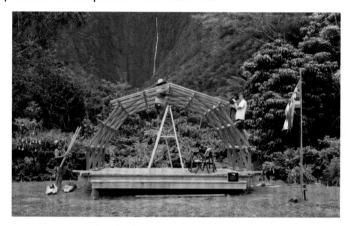

A contemporary hale takes shape in Hāmākua, Hawaiʻi. Designed and built by a *hālau* (school) of architects, cultural bearers, and traditional hale builders organized by After Oceanic Built Environments Lab and Leong Leong (Sean Connelly and Dominic Leong) in collaboration with Jojo Henderson and Nalani Tukuafu, hosted by HŌʻĀ (Lanakila Mangauil and Honi Pahiʻō).

UTOPIA

LORI A. BROWN
KATRINA COLLINS
DALTON JOHNSON
DR. YASHICA ROBINSON
WHITNEY LEIGH WHITE

\mathcal{B}IRTHING IN ALABAMA

Maternal mortality rates in the United States are the highest of any high-income country.[1] And within the US, Alabama has the highest maternal mortality rates for all races,[2] with Black people three times more likely to die from pregnancy complications and two times more likely to die during giving birth than people of any other race.[3] To be pregnant in Alabama is to anticipate giving birth in the most vulnerable and unsafe state in the country.[4] Alabama's long history of poor maternal health outcomes can be traced to scarce prenatal care access, hospital closures across the state compounding rural/urban divisions and producing uneven geographies with no providers, and ongoing systemic racism fostering distrust of the medical profession, which disproportionately affects Black people. Safe home-based midwifery care has remained central for Black women in Alabama given the legacies of slavery and longstanding segregation across the region. Alabama stopped issuing permits to lay midwives in 1977, and it was not until 1980 that nonwhite Alabama hospital birth statistics began to compare to those of the white population.

There are many people steadfastly committed to radically changing the high rates of maternal mortality, including doctors, facility directors, midwives, doulas, grassroot organizers, and attorneys arguing for more just and equitable birthing licensing, regulation practices, and building codes. This conversation brings together advocates on the front lines of this work to identify the challenges of and opportunities for improving maternal health outcomes, especially for Black people, who have experienced the greatest inequities in care.

LORI A. BROWN, FAIA, is an architect and distinguished professor at Syracuse University School of Architecture.

KATRINA COLLINS is a certified nurse midwife. She has worked with Dr. Yashica Robinson for almost three years, providing a full scope of women's health care.

DALTON JOHNSON is owner and administrator of the Alabama's Women

Center for Reproductive Alternatives, Huntsville, one of Alabama's last abortion clinics, and is cofounder of the Alabama Birth Center, also in Huntsville, North Alabama's first freestanding birth center.

DR. YASHICA ROBINSON is an obstetrician gynecologist in Huntsville, Alabama. She has been practicing for over nineteen years, providing abortion, obstetrical, and gynecological care in her two practices, Alabama's

Women Wellness Center and Alabama Birth Center.

WHITNEY LEIGH WHITE is a staff attorney with the American Civil Liberties Union Reproductive Freedom Project, representing Dr. Yashica Robinson and the Alabama Birth Center in current litigation related to expanding access to midwifery care in freestanding birth centers in Alabama.

LORI A. BROWN Given that at-home-birth midwifery practice has a long and successful history serving pregnant people in Alabama, providing care to populations not historically served by the medical establishment, I would like to begin our conversation by asking how you each think about the relationship between birthing and home.

KATRINA COLLINS Back in the day, birth was at home; it was normalized. Women

UTOPIA

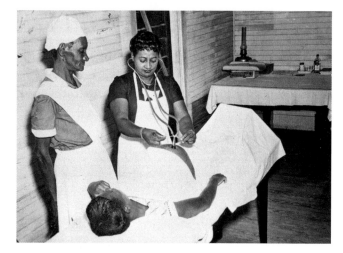

Eugenia Broughton conducting an examination of a pregnant African American woman, photographed by E. S. Powell, ca. 1950–60s

saw their mothers, aunts, and sisters pregnant, giving birth, breastfeeding, and being cared for. Now we have segregated ourselves into our individualized little square boxes that we call homes, and we no longer see or participate in the birthing experience. Moved into the hospital, birthing is a private and individual experience. I have met so many people who fear the birthing process because they have never seen it.

I gave birth to three children in a hospital setting and two at home under the care of certified professional midwives. As a hospital-based midwife, I know that being able to help define "home" for the mother, no matter where she is giving birth, is most important.

DR. YASHICA ROBINSON I think about birthing at home in terms of how bodies work best when they feel most safe. For some, that can be in a hospital; for others, it may be at home; and still for others, it may be in a setting that is between the two. Our goal at Alabama Birth Center (ABC) is to create options for people in our community so that they can choose the environment where they feel most comfortable, where they are safe, where they can be surrounded by people who they feel able to support them during that time that is so special but can also be scary.

BROWN Dr. Robinson, you mention options during a time in Alabama when hospitals have been closing. ABC provides reproductive healthcare services, but also aims to build a culture of care. Could you speak to the network you are building with healthcare workers and local communities to create expanded birthing options?

ROBINSON I completed my training in obstetrical and gynecological care over nineteen years ago. I have learned a lot from others in the birth community and from Katrina, who is a midwife working with us in a hospital setting. I continue to learn from my patients. When we integrate the experiences of all these people, we improve access to and the quality of care in our community. Doulas and midwives have been seen as a luxury in Huntsville, but we integrate their expertise into our practice so that everybody can access it.

To complete certification at ABC, midwives are trained in our community, attending an average of thirty to forty out-of-hospital births. They will be able to work in rural areas, where there are no hospitals providing pregnancy care, especially for low-income people who have difficulty traveling to cities.

BROWN What are the challenges you are facing opening a birthing facility in Alabama?

ROBINSON As a small organization with very big aspirations, we have had difficulty accessing the type of capital needed to open a facility. This involves funding for training a new workforce, including certification for midwives, and the changes needed for the facility itself.

WHITNEY LEIGH WHITE The simplest way to understand the legal challenge is that the Alabama Department of Public Health has

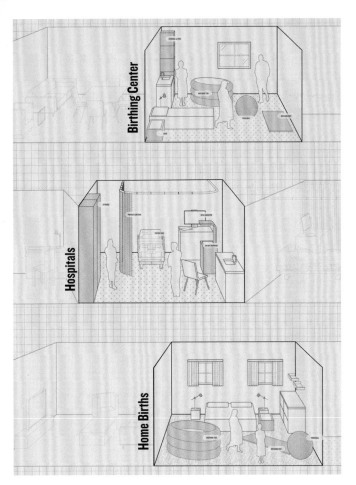

Lori A. Brown, Kelsey Benitez, and Dr. Yashica Robinson, Birthing Spaces in Alabama: Hospitals, Birthing Centers, and the Home, 2024

been taking actions to put barriers in the path of birth centers that want to expand access to much-needed midwifery care in Alabama. In 2023, the department temporarily shut down Oasis Family Birthing Center, the only freestanding birth center operating in Alabama at that time, and more recently passed regulations that would require birth centers to meet hospital licensing requirements, which are not clinically necessary for the care birth centers provide and will be incredibly burdensome, if not impossible, for birth centers to meet. Alabama is facing one of the most severe maternal and infant health crises in the entire country, one that disproportionately harms Black women and birthing folks, and part of that is driven by inadequate access to pregnancy-related care, particularly high-quality prenatal care. More

than one-third of Alabama counties have no hospitals offering labor and delivery services and no practicing obstetricians or certified nurse midwives. Birth centers could expand access to care. In the lawsuit, we are asking the court to order the Department of Public Health to take steps that would allow birth centers to resume or begin operations as soon as possible. In fall 2023, we won an injunction that allows birth centers to open in the state while litigation continues.

BROWN Are hospitals also making it more difficult for birthing centers to open because that would impinge on their revenue?

DALTON JOHNSON The entire medical system has become quite competitive due to the differences between public and private insurance coverage. We are one of ten states that did not take Medicaid expansion. Financially, the margins for healthcare facilities in areas of medicine are running so low. I think it is a misconception that birth centers are going to cut into hospitals' profits. A big hurdle is educating those in the healthcare system to think positively about birth centers, which can be beneficial to them and to the outcomes for pregnant people in Alabama.

ROBINSON Some resistance comes from a lack of education about what midwives, doulas, and birth centers bring. We have faced constant challenges to expanding options for care, running into one roadblock after another. We know that the alternatives we are providing are greatly needed now, and we can produce a midwife a lot faster than an obstetrician.

BROWN When did midwifery become legal in the state of Alabama?

UTOPIA

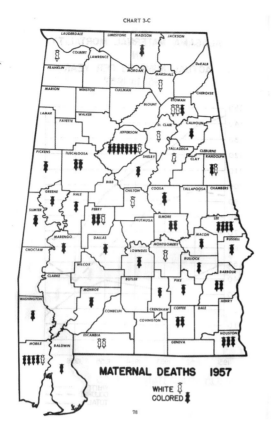

"Maternal Deaths, 1957," Map from the 1957 annual report of the Alabama State Department of Public Heath; Alabama Department of Public Health

KATRINA COLLINS Certified professional midwives won that battle in 2017, with the first licenses in almost fifty years granted in 2019. Regulations require certified nurse midwives to enter into agreements with collaborating physicians in order to practice, which means they are generally limited to practicing in the same locations as their collaborative physician, most often a hospital. Because there are no physicians doing home births in Alabama, neither can we. Certified nurse midwives are becoming certified professional midwives to provide care in a home setting.

BROWN What factors account for the differences in care being provided in a hospital as a certified nurse midwife and care being provided in a birth center or home setting?

COLLINS The difference comes down to the technology. Even though a lot of low-risk

women would only need minimal monitoring of the baby while in labor, hospitals prioritize risk management, so women's activities during labor are restricted, which can degrade their experience. Comfort measures such as hydrotherapy are limited or discouraged in a hospital setting. Despite this, I can still provide good midwifery care that is centered around the birthing person. I am fortunate to work with doctors who have a lot of trust in the birthing process and are willing to give extra time to let things unfold as they will rather than, for example, if there has been no change in a couple of hours, immediately perform a C-section. That allows me to practice midwifery closer to its true ideals, even in the hospital.

BROWN The experience of giving birth is so much more than just delivering a baby. Even if births aren't happening at home, the safety and security of a home environment can be created to let the birthing person's body do what it can naturally do.

JOHNSON I think that really connects back to the healthcare system in the United States being profit driven, whether doctors realize it or not. Why would a doctor labor a patient for three days when they can just perform a C-section and move on to the next patient? I think that is one reason why there are better outcomes in Europe, where they have socialized medicine, where you are not on the clock like we are in the United States.

ROBINSON Midwives really have little choice of how they do things in a hospital. A hospital setting is not so much patient-centered as it is about making sure we are meeting the standard of care for the hospital. For example, a patient was laboring with her doula and was having an unmedicated birth. She was in her zone, and the baby

was getting really close to delivering, but the heart rate had gotten so low that it was no longer being picked up on the external monitor. On the screen you could tell the baby had been off the monitor for about a minute and a half. The nurse said, "Do you want me to get an external monitor on her?" I said, "No, she is fine." This baby was about to be out, and it is normal that the heart tones go down when the head is being compressed so much. But that makes people so nervous. A lot of times the patient gets zoomed to the operating room. I was trying to give the nurse reassurance. We had just seen the baby. There is not something wrong here. Leave her alone for a second. The mother is laboring in the way she wants to. And then, with the next push, she pushed her baby out. When she was done, she looked up and said, "Thank y'all so much for being so patient with me. I could not have done this without you." She was so empowered after she gave birth because she gave birth exactly the way she wanted to.

An empowering birth experience can set the tone for confident parenthood. My patient was a first-time mom. She walks away with that confidence after her birth, returns home and cares for her baby, and feels like, "I got this." As opposed to an experience where every choice a patient has tried to make has been shut down.

WHITE When you talk about the importance of home, it is not just about the physical space, but about whether you feel at home emotionally, that you are being heard, that your values and autonomous choices are being respected and paid attention to. One of the things that is so incredibly important and powerful about the midwifery model of care and the care that birthing centers like ABC want to provide is not only that it is safe and proven for many patients to be better for maternal and infant health outcomes than traditional hospital-based models, but also it is centered around the patient, focused on making sure that patients feel educated and empowered throughout the experience. This is something that everyone should have the right to access when it comes to their own healthcare and something profoundly personal and important, such as deciding whether and under what circumstances to have a child.

COLLINS Cost is another way healthcare choices are limited. The number of times I have had people come for their prenatal care visits and say, "I wanted to birth at home, but I could not afford it in this state." The pregnant population is heavily covered by Medicaid, but Medicaid in Alabama does not reimburse midwifery care in the home setting like a lot of other states do.

BROWN Although the Alabama Attorney General's opinion did not specifically conclude that freestanding birth centers require oversight from the Alabama Department of Public Health, the department has taken the position that birthing centers do require their oversight for licensing and regulation to operate, which has created a variety of cost-prohibitive hurdles that have not necessarily improved safety and quality of care. Given this, what are your aspirations for in the birth facility that you will open?

ROBINSON I want the center to be a resource for the community where everyone is able to access care freely. As Katrina mentioned, much of the pregnancy care in Alabama is heavily dependent on Medicaid, but patients who are blessed to come to our practice would have access to a midwife without having to come up with

an astronomical out-of-pocket expense. Alabama Birth Center has obstetrical providers willing to collaborate with professional certified midwives and nursing midwives. We want to increase the workforce that goes out into the community and make sure that people can access this care regardless of payer status. Our goal is to become an accredited birth center that can contract with insurance, with payers, and work toward improving those payment models for others.

BROWN Regarding state oversight of birthing centers, the tactics are similar to previous restrictions on abortion clinics, making it difficult for clinics to remain open. A few restrictions that come to mind include compelling abortion clinics to become ambulatory surgical center building-code compliant, requiring the clinic not be located within 2,000 feet of a K–8 school, and stating that only physicians can provide procedures.

JOHNSON The state does not want women to have the choice to birth outside of a hospital.

ROBINSON It is hard to think that people do things intentionally to make certain care inaccessible for pregnant people, but when you look at the people who are making those decisions, there is nobody who really knows much about this type of care. There are no midwives that are part of this decision-making process.

COLLINS The Alabama affiliate of the American College of Nurse-Midwives specifically asked to be involved in the decision-making regarding the regulations and were ignored. Midwives need to be in the spaces where policy is being made.

WHITE When you look at the evidence, it is very clear. This care is safe for low-risk patients, and it actually improves many outcomes for low-risk patients as compared to hospital settings. In particular, there is research showing that this model of care is especially promising for narrowing some of the really severe gaps and inequities in healthcare access and outcomes for Black and low-income women. There is clear evidence that states that have higher levels of integration of midwifery-led care in a health system, a supportive legal environment for midwives to practice, higher volumes of midwives practicing, and a strong integration of their care into the wider healthcare system have much better maternal and infant health outcomes. It is very clear: there are steps Alabama could be taking that would lead to direct benefits for patients, and expanding access to birth centers and midwifery care is one of them. Unfortunately, the state's policies are not being informed by that evidence.

[1] "Maternal Mortality and Maternity Care in the United States Compared to 10 Other Developed Countries," Commonwealth Fund, November 18, 2020, https://www.commonwealthfund.org/publications/issue-briefs/2020/nov/maternal-mortality-maternity-care-us-compared-10-countries; Lucy Tu, "Why Maternal Mortality Rates Are Getting Worse Across the U.S.," Scientific American, July 25, 2023, https://www.scientificamerican.com/article/why-maternal-mortality-rates-are-getting-worse-across-the-u-s/.
[2] Katherine Sacks, Lawson Mansell, and Brooke Shearon, "Maternal Mortality among Vulnerable US Communities," Milken Institute, August 2023, https://milkeninstitute.org/report/maternal-mortality-vulnerable-us-communities.
[3] Alander Rocha, "Report: Alabama has Highest Rates of Maternal Mortality among Southern States," Alabama Reflector, August 2, 2023, https://alabamareflector.com/2023/08/02/report-alabama-has-highest-rates-of-maternal-mortality-among-southern-states/.
[4] Sacks, Mansell, and Shearon, "Maternal Mortality among Vulnerable US Communities."

\mathcal{I}S A BIOBANK A HOME?

Home is, of course, not necessarily where our bodies are. We travel, we migrate, we leave or lose places we once considered home. But what does it mean when our genetic material is splintered and partially distributed among various sites? Is a freezer or tank of liquid nitrogen that stores our cells and bodily fluids a home? Or a computer that archives our data? Are we "at home" in these places? Or are we ill at ease? Do we even know which of these sites house and protect our bodily materials? Perhaps most importantly, what would make us feel at home in this physically fractured situation?

DR. HEATHER DEWEY-HAGBORG is an artist and biohacker interested in art as research and technological critique. Her work appears in the collections of the Centre Pompidou, Paris; Victoria and Albert Museum, London; and San Francisco Museum of Modern Art, among others. Her art has been widely discussed in the media, including in the *New York Times*, *Artforum*, and *Wired*.

Many people are unaware that every time you have blood drawn, have a biopsy performed, urinate in a cup, or have your nose or cheeks swabbed, these fluids, cells, and data can have a long afterlife. They can live on in a deep freeze, submerged in vats of liquid nitrogen, or as data, with the potential to be used in scientific research indefinitely. In some cases, they can be bought and sold for profit and turned into commercial products.

Henrietta Lacks was an African American woman whose cervical cancer cells were taken by a doctor at Johns Hopkins Hospital in Baltimore without her permission in 1951. These cells went on to become the world's first successfully immortalized cell line. These cells, called HeLa after her first and last name, are the workhorses of in vitro medical research; every biology laboratory performing tissue culture uses them. HeLa cells were used in developing the polio and COVID-19 vaccines and have been used in studies for AIDS, leukemia, and cancer treatments. For many years, they were the only cell line used for experimentation and have become the default cells for molecular biology because they are so easy to work with. The HeLa cells genome was sequenced in 2013 and is publicly available in scientific databases.

Lacks's story became more widely known following an article by Rebecca Skloot published in the *New York Times* in 2001 and following her 2010 nonfiction publication, *The Immortal Life of Henrietta Lacks*, which was the basis for a film released in 2017. But what most people do not know is that what happened to Lacks is just the first example of what has become an increasingly common practice: making use of the scraps and detritus of medical waste as research material. Our cells and data flow in vast

UTOPIA

networks of both research and commerce, of which we are mostly unaware. Sometimes these networks are tapped for purposes we may strongly disagree with, like military research, or may even be threatened by, like police investigations.

I took these photographs at the Danish National Biobank in Copenhagen as part of my film project *T3511* in 2018. The biobank's freezer contains blood samples taken from every baby born in a hospital setting in Denmark since 1982. It was not easy to gain access to such a facility. I asked several biobanks if I could visit and possibly film; most ignored me completely, while a few were polite enough to decline. The Danish National Biobank was remarkably open to my proposal. When I arrived, I learned that all the blood and various fluids and data they have extracted are linked to extensive medical data for research. I was shocked that such an elaborate and systematic record of the population was permitted. I had a general assumption that Europe was a place that valued and regulated privacy in a more thorough way than in the United States. I had spent a lot of time in Germany, where the laws and customs are quite different. Due to the legacy of the Holocaust, Germans are very careful not to create structures in which impulses toward eugenics could be encouraged.

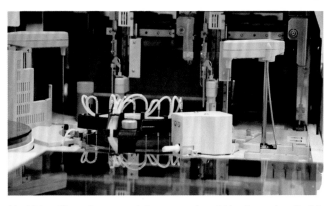

Liquid-handling robot, part of the automation of blood samples, Danish National Biobank, Copenhagen, 2018

For the Danish, there is a strong community orientation—the elevation of the society above the individual (famously described as *samfundssind* during the COVID-19 pandemic)—and there seems to be a great deal of trust in institutions and the government. Denmark has a strong social state and a long history of social democracy. While the country was unique in vigorously protecting its Jewish population under Nazi German occupation, it was also the first country in Europe to introduce forced sterilization laws, in 1929, a part of their history that has not been widely addressed.

My conclusion, therefore, is that since the public generally trusts health services, the biobank had no reason to be secretive. Drawing attention to the accumulation of biological materials and data is not considered a potential public relations problem because it is seen as a national resource. In the words of the director of the biobank, "the entire country is a cohort ... supporting personalized medicine."[1]

DEWEY-HAGBORG

The United States, by contrast, is unsurprisingly disorganized in this regard. We have a patchwork of laws and rules and customs, with much left to the states and local municipalities to navigate. Every child born in a hospital in the US has blood drawn to be analyzed for hereditary diseases and serious medical conditions.

Robot moving newborn-blood cards in the automated freezer, Danish National Biobank, Copenhagen, 2018

The regulation of how these samples can otherwise be used varies by state, but, in general, there is a function creep associated with these types of data storage—they are increasingly accessed for expanding purposes (including by the police) unless explicitly forbidden. For example, police in New Jersey were recently accused of accessing newborn DNA data to investigate a sexual assault cold case, and the family has now brought a lawsuit against the department to challenge this use.[2] The point is not that newborn testing is bad—it is an enormously helpful and successful public health program. Rather, the point is that tremendous caution must be taken with this incredibly personal identifying data.

Informed consent in medicine became widespread in the wake of genocide, eugenics, and the unethical and coercive Nazi medical experimentation of World War II. While the Germans took eugenic policies the furthest, the philosophy and practice were commonplace throughout Europe and the United States.

The Nuremberg Code of 1947 outlined principles for permissible and humane medical experimentation, including explicit voluntary consent and the structuring of experiments to avoid physical and mental suffering. It was not until 1981, however, after the US passed the National Research Act of 1974 in the wake of public outcry against the United States Public Health Service's Untreated Syphilis Study at Tuskegee, Alabama, that these guidelines became law as Title 45, Part 46 of the Code of Federal Regulations, also known as the Common Rule.[3] The Food and Drug Administration further requires "a statement describing the extent, if any, to which confidentiality of records identifying the subject will be maintained."[4]

What has dramatically changed in the last decades is that now, if you consent to medical research, your sample and/or data may be banked and used in

[1] "When an Entire Country Is a Cohort," June 5, 2021, Invest in Denmark, Ministry of Foreign Affairs of Denmark (webinar), 52:34, https://investindk.com/webinar-ondemand/webinar-series-on-personalized-medicine/unique-biobanks-supporting-personalized-medicine.
[2] Crystal Grant, "Police Are Using Newborn Genetic Screening to Search for Suspects, Threatening Privacy and Public Health," American Civil Liberties Union, July 26, 2022, https://www.aclu.org/news/privacy-technology/police-are-using-newborn-genetic-screening.
[3] "Federal Policy for the Protection of Human Subjects," Federal Register, National Archives, January 19, 2017, https://www.federalregister.gov/documents/2017/01/19/2017-01058/federal-policy-for-the-protection-of-human-subjects.
[4] "CFR–Code of Federal Regulations Title 21," US Food and Drug Administration, updated March 22, 2024, https://www.accessdata.fda.gov/scripts/cdrh/cfdocs/cfcfr/cfrsearch.cfm?fr=50.25.

IS A BIOBANK A HOME?

perpetuity by any number of researchers for any number of purposes. Furthermore, DNA data has been shown to be impossible to de-identify. Even when your name is removed, researchers have demonstrated it is possible to use algorithms to make a strong guess about who you are from DNA data alone. In my

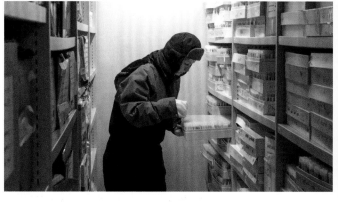

Nonautomated walk-in freezer storing fluids, Danish National Biobank, Copenhagen, 2018

own research, I have found that by using genetic social networks like 23andMe, even an amateur can track someone down from their DNA. This has underpinned a new field in law enforcement: forensic genetic genealogy. With these tools, police traverse family trees in genetic databases, narrowing in on suspects through their relatives' data.

While those working in hospital and medical settings are required to ask patients for consent to use their samples and/or data for medical research, this is often a cursory affair—one more piece of paper to be signed in a stack, complicated by the sense that withholding consent might impact one's treatment. It is rare that doctors or administrators sit with patients to discuss the implications, risks, possible uses, and trajectories of medical data, tissues, or fluids that the patient consents to be used for research. Conversations around data breaches and the potential for one's medical record and biological data to be used against them are not standard, even when undergoing extensive genetic testing for disease. Additionally, medical privacy policies on websites are often referenced indirectly on forms. Few patients will do the extra work of looking up a policy and reading what they are consenting to have their information used for in terms of research or tissue donation.

If one withholds consent, assuming the medical institution follows standard guidelines, there should be a reduced risk of unwanted data sharing. However, withholding consent will not protect from direct attacks on hospital databases (which are increasingly common), and it will not protect "de-identified" data and biological materials. Furthermore, opting out seems to indicate that a person is not "supporting" medical research. This is a false dichotomy. Patients should be confident in supporting research related to their own disease without worrying about their cells and data being passed around between researchers indefinitely for any purpose.

The right to informed consent is governed by the Common Rule, last updated in 2018. While there was a strong movement

at that time to remove the designation of de-identified biological samples or DNA data as free from informed-consent governance, industry voices prevailed, and this part of the regulation was not updated. In other words, medical institutions do not need a patient's consent to do research using their genetic materials as long as their name and contact information are removed.

What might make us comfortable, or feel "at home" in the biobanks and databases we are stored in and shared from? What is clearly missing in this field is trust and the transparency upon which trust can be built. Medical research can benefit us all, but only when it is done with full participant knowledge—with consent and autonomy over personal data. The internet has shown us what happens when we let companies make the rules and govern themselves. Let us not repeat this mistake with biodata. Instead, let us reenvision biobanks as a multiplicity of homes for our cells and data, over which we have control of our presence and participation.

IS A BIOBANK A HOME?

MORE THAN 100 SPECIES IN A HOME

JOYCE HWANG is an architect and educator. For nearly two decades, she has been developing projects that incorporate wildlife habitats into constructed environments. Hwang is a recipient of an Exhibit Columbus University Research Design Fellowship, Architectural League Emerging Voices Award, New York Foundation for the Arts (NYFA) Fellowship, and a MacDowell Fellowship. Her work has been featured by the Museum of Modern Art, New York, and exhibited at Brooklyn Botanic Garden, Matadero Madrid, and other venues. She is an associate professor of architecture at the University at Buffalo SUNY, director of the architecture and research practice Ants of the Prairie, and core organizer for Dark Matter U.

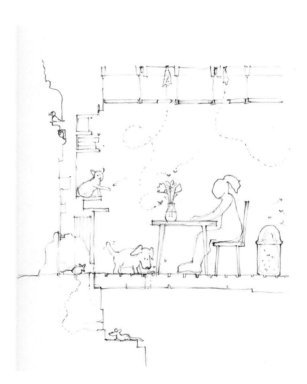

MORE THAN 100 SPECIES IN A HOME

There are more than 100 species present in most US homes.[1] While humans see and acknowledge a range of animals in the home—from beloved pets to so-called pests—these dwellings host a much richer ecosystem of species, beyond what we can typically sense, from carpet beetles to silverfish to book lice.

[1] See Matthew A. Bertone et al., "Arthropods of the Great Indoors: Characterizing Diversity Inside Urban and Suburban Homes," *PeerJ* 4 (2016): 1582.

UTOPIA

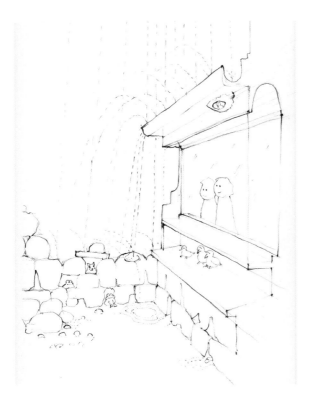
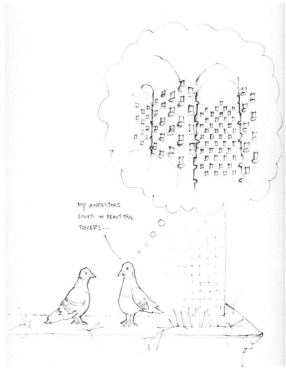

COINCIDENTAL SHELTERS

Put up birdhouses and bird feeders! Build bat houses! Install insect hotels! These are familiar mantras from humans who acknowledge the animals that dwell in urbanized areas. But how often do we acknowledge that the structures we build for ourselves often also serve as shelters and homes for animals? Many species are already synanthropic; in other words, they rely almost entirely on human-built conditions in making their homes.

DWELLINGS FOR SPECIES

The idea of building structures for animals is not new.[2] Civic buildings in the Ottoman Empire incorporated birdhouses into their facades. Towers to house wild pigeons were built in sixteenth-century Iran as tools to collect guano to be used as fertilizer for farmers.[3] In 1911, Dr. Charles Campbell built a thirty-foot tower for bats in San Antonio, Texas, as part of an experiment to combat malaria.

[2] See Pieter de Wilde and Clarice Bleil de Souza, "Interactions between Buildings, Building Stakeholders and Animals: A Scoping Review," *Journal of Cleaner Production* 367, September 20, 2022; Rohan D. Simkin et al., Biodiversity Impacts and Conservation Implications of Urban Land Expansion Projected to 2050," *Proceedings of the National Academy of Sciences* 119, 12 (March 22, 2022).
[3] "Pidgeon Towers of Iran," Atlas Obscura, October 8, 2009, https://www.atlasobscura.com/places/pigeon-towers-iran.

MORE THAN 100 SPECIES IN A HOME

UTOPIA

WELCOMING OUR NEIGHBORS

The planet is experiencing unprecedented biodiversity loss. The Living Planet Index has reported a decline of approximately 69 percent since 2022 in monitored wildlife populations around the world.[4] As humans begin to realize the precarious status of our fellow inhabitants of planet Earth, we can adapt our dwellings to respect our connections with nonhuman neighbors and community members.

[4] R. E. A. Almond et. al., *Living Planet Report 2022: Building a Nature-Positive Society* (WWF, 2022).

CITY AS HOME

If the idea of home can be defined by a sense of belonging, which species actually belong in our cities? We know that cities are hospitable to some and not others. For many species (including fauna and flora), urbanization results in a loss of home and a rupturing of habitat continuity. How might we adapt our built environments to create a sense of truly belonging for our multispecies communities? We must recognize the animals that already live among us as part of our shared world and acknowledge that it is we who are guests when we build our homes among theirs.

UTOPIA

MORE THAN 100 SPECIES IN A HOME

\mathcal{D}ESERT SOVEREIGNTY

The Tohono O'odham Nation has lived in the Sonoran Desert of southeastern Arizona and northwest Mexico, traversing the border between the two countries for thousands of years. Developing a self-sufficient lifestyle closely tied to the land and its resources is core to the O'odham *Himdag*, the ancient life ways of the Tohono O'odham people, to create solutions for the future. With this tradition as a guide, artist, activist, and basket weaver Terrol Dew Johnson and his family have dedicated their lives to developing and disseminating traditional crafts and promoting Native food sovereignty. Johnson's own multifaceted practice represents a form of cultural revitalization in the service of community continuity, health, economic development, and climate action. Johnson and his mother, Betty Pancho, reflect on their family's history of making home with the land and their community.

TERROL DEW JOHNSON was a community leader, nationally recognized advocate for Native communities, and renowned artist. Johnson championed novel approaches to reestablishing cultural traditions, including the Pancho farm; he was focused on teaching O'odham tribal members traditional farming techniques, food preparation, and wild harvesting. His award-winning artwork resides in the permanent collections of multiple national museums.

BETTY PANCHO grew up in the village of Kawulk on the Tohono O'odham Nation, helping her parents tend their nearby farm and gathering the wild foods of the desert. As an adult, she spent forty-seven years working for the tribal government while continuing to harvest and cook traditional foods for the nourishment of her family and the community through her work with Tohono O'odham Community Action (TOCA).

TERROL DEW JOHNSON When I tell the story of my work, I always start with my grandparents, Katherine and Alexander Pancho, because they set me on my path to do the work that I do today for my community and my family. I was very fortunate to have my grandparents in my life. With five kids in my family, my grandparents stepped in to help raise us, and it was with them that we would go into the desert to harvest food. Together we would organize community activities and visit friends. It was through them that I got to know my community and to understand the landscape and the traditional O'odham way of life. My grandfather was a medicine man, a healer, my grandmother was an herbalist, and they were both farmers. They came from the traditional farming village of Kawulk.

BETTY PANCHO In our village, there were at least nine or ten families. My dad's parents farmed the land, and their parents did before that. My mother's family came up from Mexico. It was peaceful and quiet and communal. The kids all played together, and the families all helped each other out. Everyone would get together at harvest time and help one another bring in their crops, going from one farm to another.

JOHNSON Years ago, just about every village on the Nation had farmland where each family would work the land and grow their own food to feed them for the year. We have winter crops and summer crops that correspond to our two desert rainy seasons. We rely on the monsoon rains to supply the water for our fields through flood-based farming. We built canals to

UTOPIA

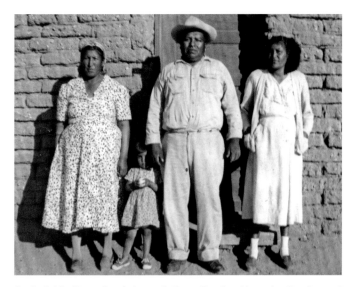

Annie Pablo (Betty Pancho's aunt), Betty Pancho, Alexander Pancho, and Katherine Pancho, early 1950s

divert water from the big desert washes. For most of the year, these washes are dry. But during the rains, the water would flow and cover the fields completely—this is flood-based farming. The canals that supply water to the city of Phoenix today are the remnants of canals like this that the O'odham people built pre-colonization, but the water no longer comes from the desert, it comes from the Colorado River miles and miles away.

The whole family was involved in producing their foods. My mom always told us stories about this. The kids' job was to run around and chase all the animals out of the garden, rabbits, squirrels, things like that. They would also help gather wild foods from the desert. Growing up with my grandparents, I was taught how to recognize the different wild foods in the desert, too, like wild spinach, prickly pears, cholla buds, mesquite beans—all the foods from the desert that Creator had provided for us. The desert was our home, and it provided us with all we needed.

PANCHO I helped a lot at home. I'd milk the cows, feed them, let them out until the evening, and go back later to chase them back into the corral for the night. We didn't

have a store to buy things, so at certain times of the season we ate wild foods. We would go outside and collect 'uṣabï (mesquite sap/gum), wild honey, and other things. Wild spinach and wild carrots we would eat with rabbit. When we would slaughter a cow, it would be shared with the community. Everybody shared when they would go hunting. When I grew up, it would be rabbit, deer, or javelina from the desert. We would get everything we needed from the desert and the farm.

I'd always tell my kids when they wanted shoes, "I never had shoes!" We didn't have shoes during the summer. We'd run around going from shade to shade. During the summer, we would all move outside. We had a summer kitchen, we would sleep outside, shower outside, cook outside. Everyone did, under the shade of our *wa:ato*, our ramada. It was made of mesquite gathered from the desert with saguaro ribs for the roof and ṣegoi (creosote bush) thatching to keep out the rain.

Our house was made of adobe bricks and had a dirt floor. What I remember most is its coolness and the smell of the dirt and creosote when it rained.

JOHNSON In the 1940s and '50s, things began to change. Our men were taken away to fight in wars, and the children were taken away to boarding schools. We were forced to learn other people's ways and prohibited from practicing our own. They wouldn't let the children speak our language, and they taught us industrial trades that had nothing to do with our life back home. It was a relentless program of cultural oppression that severed our connection to the desert and to our traditional way of life. My grandfather was drafted for WWII, and my mother and all her siblings were sent to boarding school. Soon there was no one left to work the fields, and people moved to

bigger towns close to grocery stores with foods sent in from outside the community.

PANCHO In seventh grade, I was shipped off to the Stewart Indian School in Nevada. It was the first time I had been on an airplane, and when I came back, everything had changed. The community had kind of dissolved. There were many things the community would do together, organized by the church, and all that had stopped. Also, some of our desert foods started to disappear. Wild potatoes that we used to pick from the side of the wash during the monsoon—by the time I got back, they were gone.

JOHNSON People stopped picking them, and they stopped growing. Other things, too—wolfberries, wild carrots.

Soon people were dying. I noticed a lot of people in my family were dying from food-related illnesses, especially diabetes and complications from diabetes, and this was happening throughout the entire community. As our healthy traditional foods were replaced by cheap store-bought foods like white flour, lard, processed cheese, and canned foods, people started getting sick. The poverty that set in after the dispossession of our land made things worse. The programs that were established to help people with these issues were also imported. They said, "Eat more broccoli. Eat more cauliflower. Go to the gym and exercise." But we're from the Sonoran Desert, and broccoli, cauliflower, and gyms are very hard to find. It was difficult to see how these programs might be implemented in Native communities like ours. It was then that I got together with friends and started Tohono O'odham Community Action, or TOCA. Our mission was to reestablish our connection to the desert—to our landscape, to our Native foods, and to the culture that

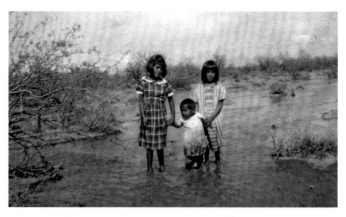

Sisters Thelma, Vivian, Mary, and Betty preparing to thrash beans at the Pancho farm, 1950s

had sustained us for millennia, for the future health and well-being of our people.

Both of my grandparents would eventually die from complications of diabetes, but while they were alive, they were valuable resources and instructors, helping me to teach people how to forage the desert for traditional foods. We started by organizing gathering trips and classes on how to recognize traditional foods, how to process and cook them, reminding people's taste buds of the flavors of the desert after having been numbed for so long by store-bought high-sugar, highly processed foods. With the help of my grandparents and the community, we revitalized my family's farm, which had lain dormant for thirty years. Now we plant corn, beans, squash, peas, melons, and other crops that are native to the Sonoran Desert and adapted to its dry conditions. We distribute the produce in the community and beyond, in stores and farmers markets throughout Arizona. We have a cafe that specializes in Native foods. It draws guest chefs from other Native communities throughout the country and operates a teaching kitchen to popularize the cooking and eating of Native foods. We operate programs in local schools and, most importantly, we involve young people in the entire process of producing our Indigenous foods. We begin with the rituals involved with gathering and planting throughout the year, the ceremonies that

keep us in harmony with the seasons of the land and its plants and animals, engaging elders with young people to help maintain and pass on our ancestral knowledge and food traditions in service of the sustainability of our land and the well-being of the community.

The family farm, now called the Alexander Pancho Memorial Farm, is the literal and symbolic center of the organization that has evolved toward the comprehensive development of Indigenous sovereignty. We look to the O'odham himdag, the ancient life ways of the Tohono O'odham people, to create solutions for our future. From developing and disseminating traditional crafts, games, and storytelling to promoting Native foods, our practice is a form of cultural revitalization in the service of community continuity, health, economic development, and climate action.

Recently we've expanded into the area of spatial justice to address the pervasive spatial inequities that have resulted from the systemic oppression of our people and have historically marginalized my community. Building on ours and others' recent efforts in food sovereignty (the right of communities to determine the quantity and quality of the food they consume), our recent work introduces the concept of housing sovereignty as the right to healthy, affordable, climate-adapted, and culturally

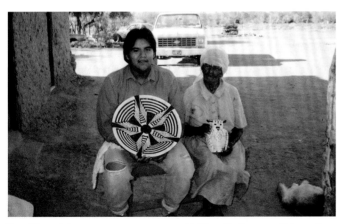

Terrol Dew Johnson as a young weaver with Clara Havier, one of his teachers

appropriate housing. Communities should determine the form and material of the homes they inhabit, along with the supplies of material and labor through which they are created. Too often, federal housing programs on the Nation import generic suburban home designs that are ill-adapted to our desert climate and to the O'odham way of life. They are made with imported materials and built by people from outside the community, short-circuiting the economic benefits that would come from local construction. Emphasizing local materials and traditional methods, this work aims for community empowerment and the establishment of a circular building economy. For my community in the Sonoran Desert, on the front lines of the climate crisis, sustainable housing is a form of climate justice.

PANCHO In the village, everyone built their own homes, but everybody else helped. We used soil from nearby and sand from the wash to make mud bricks. And we harvested mesquite from along the wash for the wa:ato.

JOHNSON We are working to build a home near Pancho Farm that will focus on the revitalization of our traditional way of building and living on the land. It will use traditional materials gathered from the desert and be designed in harmony with the landscape and O'odham cultural practices, where so many things take place outdoors, under the shade of the wa:ato. It will be a gathering place for my family and the community. It will be a place to practice and teach our reconnection to the O'odham himdag, which is now, as it always has been, a source of identity and resilience for the O'odham people and an evolving source of knowledge from which to draw contemporary solutions to the urgent issues of our time.

DESERT SOVEREIGNTY

\mathcal{D}RAW ME THE EARTH WHOLE

There will be unexpected consequences. Taking care of unexpected country will be required—again and always. Reconciliation is not guaranteed; it is proffered, suggested, haltingly pictured. Any reconciliation will depend on descendants of settler worlds letting go of salvation history.... Technocultural people must study how to live in actual places, cultivate practices of care, and risk ongoing face-to-face encounters with unexpected partners.

DONNA HARAWAY, *Speculative Fabulations for Technoculture's Generations*[1]

RANIA GHOSN is founding partner, with El Hadi Jazairy, of DESIGN EARTH and associate professor of architecture and urbanism at the Massachusetts Institute of Technology, Cambridge. Ghosn and Jazairy are authors of *Geostories: Another Architecture for the Environment* (3rd ed. 2022; 2018), *Geographies of Trash* (2015), *The Planet After Geoengineering* (2021), and *Climate Inheritance* (2023).

We live in an epoch that is shaped by climate catastrophes with risks and uncertainties on a planetary scale. On graph after graph, in metric after metric—carbon dioxide in the atmosphere, species extinction, particulate matter in the air—the rate of climate change is referred to as the "great acceleration." A large amount of scientific research and images have sought to communicate the destructive impacts of the climate crisis. And yet, the climate story is difficult both to tell and to hear, both to comprehend and to act on. For scientists, journalists, activists, and designers, the question of how to bring climate matters to public concern is open and urgent. How might the architectural imagination make sense of the Earth at a moment in which the planet is presented in crisis?

Climate, meaning the statistics of weather over a defined time span, does not manifest itself in any single moment, event, or location and can never be directly experienced. In contrast to the immediately experienceable weather event, climate is inherently mediated. The only way it can be apprehended is through systems of data and modeling, including cultural forms—narratives, vocabularies, images, objects, and myths. In other words, climate—as it is imagined and acted upon—needs to be understood culturally. "Climate," writes geographer Mike Hulme, "is weather which has been cultured, interpreted, and acted on by the imagination, through storytelling and material technologies."[2] Approaching climate this way, adds Hulme, demands an "explicitly *geographical* and cultural interrogation of how people

UTOPIA

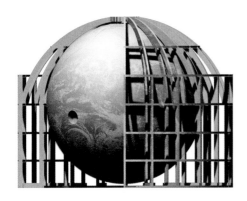

DESIGN EARTH, Blue Marble Circus, 2017

live climatically."[3] After all, "climate," derived from the Greek *klinein* (to lean, rest, recline, bend), was originally a geographical term denoting a position on the Earth defined by latitude (i.e., the specific inclination of the sun on a given place at summer solstice).[4] Retrieving this meaning of climate—geographically situated and differentiated—means considering climate not only from the standpoint of earth sciences as a global statistical average, but also as a situated cultural project of the geographic imagination. Storytelling becomes a method by which to make sense of and relate to a here and now that is otherwise difficult to tell and hear and engenders ways of seeing and knowing the many externalities of our time.

For the collaborative studio practice DESIGN EARTH, storytelling has become a method to act on climate change by the geographic imagination, through geostories. In my book coauthored with El Hadi Jazairy, *Geostories: Another Architecture for the Environment*, we put forth an "architecture with externalities," one that brings into representation—into aesthetics and politics—those things, spaces, and scales otherwise not depicted in the popular imagination of the planet. The series of speculative narratives imagines how technological systems have changed the Earth and considers ways of living *with* externalities—with landfills, abandoned mine pits, decommissioned oil rigs, and space debris. Here, the architectural narrative, as expounded through drawings, narratives, and artifacts, becomes a heuristic device that incorporates externalities to give both figurative shape and cultural meaning to matter and trouble whose repercussions are dispersed across space and time and whose actual costs often remain unaccounted for. These geostories are geographically situated speculations: they always depart from a measured here and a controversial now. Yet, they are not documentary. Nor are they completely fictional. Rather, representation becomes a way to work with uncertainties, frictions, and contradictions, all while magnifying the cultural and geographic climates they engage.

Stories and images matter for the Earth. The present predicament of the climate crisis springs from narratives of modernity—about the world as resource, about nature as external, and about progress as an escape from the gravity of geography. [5] In this worldview, the Earth—from the

[1] Donna Haraway, "Speculative Fabulations for Technoculture's Generations: Taking Care of Unexpected Country," *Australian Humanities Review*, Issue 50, May 2011. https://australianhumanitiesreview.org/2011/05/01/speculative-fabulations-for-technocultures-generations-taking-care-of-unexpected-country/.
[2] Mike Hulme, "Chapter 1: What Is Climate,?" *Weathered: Cultures of Climate* (London: SAGE Publications, 2017).
[3] Ibid., 57.
[4] Eva Horn, "Air as Medium," *Grey Room*, no. 73 (2018): 6–25.
[5] Christophe Bonneuil, "The Geological Turn," in *The Anthropocene and the Global Environmental Crisis: Rethinking Modernity in a New Epoch*, ed. Clive Hamilton, François Gemenne, and Christophe Bonneuil (London: Routledge, 2015), 17.

UTOPIA

DRAW ME THE EARTH WHOLE

[6] Bruno Latour, *Politics of Nature: How to Bring the Sciences into Democracy* (Cambridge, MA: Harvard University Press, 2004), 58.
[7] Ibid.
[8] Bruno Latour, *An Inquiry into Modes of Existence: An Anthropology of the Moderns* (Cambridge, MA: Harvard University Press, 2013), 23.
[9] Bruno Latour, "Agency at the Time of the Anthropocene," *New Literary History*, no. 45 (2014); 3.

atmosphere to the geological superstratum—is a resource predicated on the discounting of negative externalities and their erasure from the cultural imagination. Think of the vast extractive network of fossil fuel extraction, for example. The largest single commodity in international trade, both in value and in weight, oil has inscribed its planetary infrastructural order. Over the past two hundred years, and in particular since the Second World War, the economic promises of carbon modernity have rested on the industry's abstraction and denial of its hidden costs—of land degradation, population decimation, asthma and cancer cases, surface collapse, contamination of subsurface water flows, and the exponential increase in methane and carbon dioxide emissions. In economic discourse, the term "externalities" describes the negative social costs or ill effects of private calculation, notably pollution, public health, and the degradation of shared resources (such as air and water); instead, they are shifted to and ultimately borne by third parties, that is, "other" species, generations or temporalities, people or geographies. Violence, both physical and symbolic, is inherent to the geography of externalities. Acts of destruction—always racialized, classed, and gendered—are validated through stories and images that justify the selective devastation and erasure of "other" worlds and legitimize dispossession through worldviews such as Manifest Destiny, terra nullius, or orientalism.

New stories and images are necessary to participate in an ethical and just response to climate change. The climate crisis began to occupy public consciousness when the unwanted consequences of extractivist actions did not disappear from view. There was "no zone of reality in which we could casually rid ourselves of the consequence of human political, industrial, and economic life."[6] The historical importance of ecological crises, French philosopher Bruno Latour pointed out, "stems from the impossibility of continuing to imagine politics on the one side and, on the other, a nature that would serve politics simultaneously as a standard, a foil, a reserve, a resource, and a public dumping ground."[7] Latour adds: "Why not transform this whole business of recalling modernity into a grand question of design?"[8] His response calls for crafting the "political arts," an experimental method that takes action on climate change by connecting political ecology with aesthetic experience. In this worldview, the role of representation shifts from reinforcing consensus on solutioneering to assembling publics around climate controversies. The reason for which this is needed, Latour states, is that "the Earth has become once again ... an agent of ... our common geostory." He continues, "The

problem becomes for all of us in philosophy, science, or literature, how do we tell such a story."[9]

What would happen if new narratives revolved around things previously relegated as externalities? And which techniques of representation might help make them public? Perhaps speculative narrative and its persistent engagement with technological questions in relation to the planet, including those created by broadening risk scenarios, can open up earthly stories to the urgent troubles of externalities. In her practice of SF, a referent to "science fiction, speculative fabulation, string figures, speculative feminism, science fact," Donna Haraway reminds us that "it matters what matters we use to think other matters with; it matters what stories we tell to tell other stories with.... It matters what stories make worlds, what worlds make stories."[10] In *Staying with the Trouble*, Haraway describes what she has come to call "speculative fabulation" as a "mode of attention, a theory of history, and a practice of worlding" for imagining future presents that disrupt habitual and binary ways of knowing—to open up Earth stories to urgent troubles.

Such narratives dwell within the fundamentally unhomely histories of environmental violence—imbued and perpetuated with colonialism, masculinity, and the heroic domination of nature—"not defeated but not in denial either about the level of destruction that we inherit and hold in our hand," whether we ask for it or not.[11] In a scene from the film *Donna Haraway: Story Telling for Earthly Survival*, a playful exploration of her life and ideas, Haraway picks up a basket made by weavers from a Navajo tribe. As she handles the basket, she explains that she also touches and interacts with the tangled histories of colonial conquest, exploitation, and violence that characterize the United States' past and present.[12] Her existence at that specific moment and place in time—as a white woman of Irish decent in Northern California in the twenty-first century—and her ability to handle, let alone possess that artifact, cannot be disentangled from these histories. We inherit, as she puts it, "the whole thing," whether we want to or not. Which inheritances, which externalities we choose to accept and allow to matter in narratives and representations becomes a political choice. "Storying otherwise," in Haraway's expression, is a characterization of the experiments with different kinds of storytelling, narratives that refuse the promissory narratives of progress to grapple with the destructive forces of settler-colonialism and extractivism—the unfathomable violence of loss and grief and the relentless work of building livable worlds with what remains.

[10] Donna J. Haraway, *Staying with the Trouble: Making Kin in the Chthulucene* (Durham, NC: Duke University Press, 2016), 12.
[11] Lesley Instone and Affrica Taylor, "Thinking About Inheritance Through the Figure of the Anthropocene, from the Antipodes and in the Presence of Others," *Environmental Humanities* 7, no. 1 (2016): 133–50.
[12] Fabrizio Terranova, Donna Haraway: *Story Telling for Earthly Survival* (Brussels: Icarus Films, 2016).

UTOPIA

DRAW ME THE EARTH WHOLE

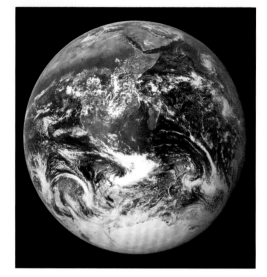

NASA Apollo 17, Earth, 1972

From within the belly of environmental histories, speculative narratives assemble worlds with the matter of externalities by bending the documentary genre—the measured records of environmental documentation and climate communication—with the playfully surreal. Speculative fabulation is done with facts, many of which are stranger than fiction. Fabulation compresses facts—"composts" them, in Haraway's expression—and does so in ways that produce, in the thickness of contradiction, accounts that allow for the exploration of irreverence and humor. Like most stories, fabulations find truth through the imagination; they describe or explicate a here and now that is difficult to tell and hear to come to imagine worlds that are radically different than the ones we inhabit today, or create to echo the artist Robert Smithson, "true fiction that eradicates the false reality."[13]

This trajectory of "earth-writing"—*geo* (earth) and *graphia* (writing or drawing)—brings forth a renewed agency in the ways design culturally grapples with the climate crisis. Designing with externalities might be the apt characterization of this mode of "response-ability" for the worldmaking we participate in—bringing to matter those things, spaces, and lives in the geographic imagination.[14] Approached as such, speculative narratives depict, in the presence of those people and places who have borne the consequences, how technological systems have changed the Earth to conjure *with* those externalities propositions for more inclusive worlds. The resulting Earth-drawing becomes a luring tale for a design agency to be sensitive to and to respond to who counts and what matters.

In this moment of climate crisis, design's ability to respond to the world might hinge on a planetary imaginary that unsettles promissory environmental narratives and images—whether the histories of the Industrial Revolution and frontier settlement as well as future climate engineering. We might want to revisit, for example, one of the most widely circulated images of the Earth. In the Space Age, the iconic Apollo photographs—"The Whole Earth," "Earthrise," and "22727"—became a symbol of Earth as our "precious, fragile home," presumably facilitating a vital environmental movement that animated popular desires to care for it.[15] How might the whole Earth hold

[13] Robert Smithson, *Slideworks* (Verona: Carlo Frua, 1997), 80.

[14] Rania Ghosn and El Hadi Jazairy, *Geostories: Another Architecture for the Environment* (New York: Actar, 2018).

[15] In 1970, the first Earth Day was the largest single-day public protest to date in US history, with an estimated twenty million participants. The corresponding Earth Flag was inspired by the first photographs of the whole Earth taken during NASA's Apollo 10 space mission in 1969. A later version of the Earth Flag used The Blue Marble, a NASA photograph that was taken by the astronauts of Apollo 17.

[16] "Planet Earth by Dawn's Early Light," *Life*, vol. 61, no. 6, August 5, 1966.

its full promise of including everything and everyone without exception, a whole that truly implies that no thing has been omitted, abated, ignored, or taken away?

For another view of the planet, let's consider a photograph from a series taken by the 1966 Earth-orbiting Gemini 10 shuttle. The photograph shows a single trash bag floating in space—a bag that contained the objects that NASA had intended to leave behind before the mission's return to Earth.[16] At over a million feet above the planet's surface, the plastic bag seemed categorically external to concerns on Earth, as if it could safely disappear forever. Yet the material afterlives of space debris continue to haunt the Earth with an ever-increasing number of decommissioned satellites, extraterrestrial resource-mining missions, and other space debris. Today, scientists in space agencies consider that this space junk poses a threat not only to other space-based projects but also to people and property on Earth.

How might a planetary imagination, rather than seeking to forever keep that bag at bay, stage it within the portrait of the Earth? Using the language of science fiction, DESIGN EARTH engages the lives of technological objects, such as the management of space junk. In the "Neck of the Moon" project, you encounter Laika, a new satellite planet—named for the stray dog launched into low orbit by the USSR in 1957—made entirely of compacted space junk that orbits the Earth. Equipped with a giant robotic tug that approaches and compresses large pieces of debris at high altitudes, the compacted mass grows steadily and continuously, becoming a kind of second moon. In the "Cosmorama" project, the "Pacific Cemetery" triptych visualizes how decommissioned satellites and other space debris are brought back from orbit at Point Nemo, a spacecraft cemetery known formally as the South Pacific Ocean Uninhabited Area, where it is terraformed to house refugees displaced from their nearby islands by the impacts of climate change. In response to the many "I can't breathe" calls, the Respirator Goddess blows a breath of life into the planet.

To the question then of what the work of designers might be, one answer is that we need to make externalities matter, to arouse a different sensibility of the critical climate troubles, so to begin to design and inhabit the Earth with care and responsibility.

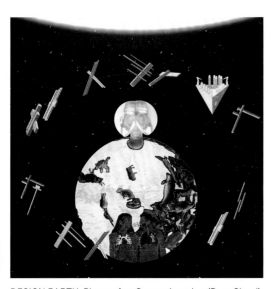

DESIGN EARTH, Planet after Geoengineering (Dust Cloud), 2021

DRAW ME THE EARTH WHOLE

AFTERWORD
Michelle D. Commander

Spoken of fondly by elders of my grandmother's generation, Kingville, South Carolina, is now a ghost. A once promising railroad town and the former post-slavery home of my maternal kin, Kingville had been embraced by African Americans in the lower portion of Richland County; but because of various financial and environmental realities, the town had ceased to exist by the time I was born. Growing up in the shadows of the region's slave plantations and the memories held and sustained by these brutal yet beautiful landscapes, *home* for me was marked by family, culture, tradition, and the various physical places where my loved ones and I lived and grew, laughed and wept, felt safe and unsafe, were vulnerable and strong.

Looking back, I see that this up-bringing and family history of displacement no doubt had a bearing on my scholarly career, which in sum has been a continuous engagement with and exploration of notions of home. It began with inquiries about the phenomenon of African American travelers and expatriates and a wide range of artists, all of whom were seeking out utopic ancestral African homelands to fulfill their desires for belonging and spaces to just be as they struggled with various societal pressures and real, perceived, and anticipated injustices in the United States. And, in a recent short memoir, I focused the microscope on myself, so

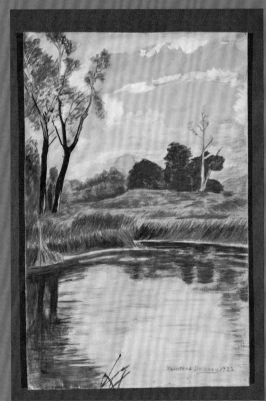

Beauford Delaney, Untitled (Knoxville Landscape), 1922; Private Collection, Knoxville

to speak, forcing a kind of reckoning with all that I have felt as I endeavored to establish myself in cities and towns across the United States and even as I asked research questions of

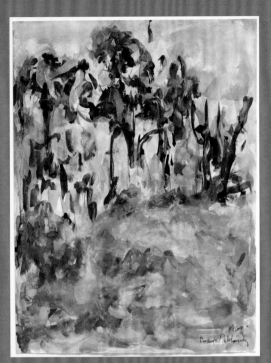

Beauford Delaney, Knoxville, 1969; Knoxville Museum of Art, 2014 purchase with funds provided by the Rachael Patterson Young Art Acquisition Reserve

others—questions that I was grappling with personally, if silently.

During the 2010s, I made a home in Knoxville, Tennessee, an Appalachian city with a complex history. Local lore celebrated that great African American painter Beauford Delaney, who had been born and raised there a century before. Delaney left Knoxville after riots rocked the city during the Red Summer in 1919, eventually expatriating to Europe. Curious about how Delaney had experienced the city in the acute racial turbulence of the twentieth century, I began exploring his work and archives. I came away with a broad understanding of individual relations to home, space, and placemaking via Delaney's paintings of real and imagined Knoxville landscapes, created over five decades. Each work indicates a major shift in how he viewed, remembered, and understood his hometown, as he had experienced both the security of family-as-home and the memory of unrest outside his own front door.

The gradual abstraction of the Knoxville landscape paintings over time indicates psychic acuity rather than a deterioration in the artist's perspective. The paintings quite literally illustrate that notions of home can be shaped by internal and external forces. They show how increasing amounts of time and distance away from or even inside one's home may render it less recognizable to the eye and the mind. My life in Knoxville,

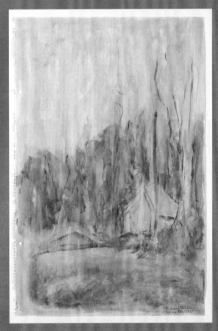

Beauford Delaney, Untitled (Knoxville Landscape), 1969; Knoxville Museum of Art, 2014 purchase with funds provided by the Rachael Patterson Young Art Acquisition Reserve

too, was lived in abstraction, and my view of it remains abstract in the years since the unmaking of my home there. The hauntings of the city's past, its paired charming embraces and expected and unexpected refusals, and the comfort bestowed by even marginal signs of progress felt like a microcosm of Black life across the United States and solidified for me that home is not only a place, but also a feeling to which one may return, or from which one may flee, and that one can perpetually make anew.

The creative practices of the artists and designers in these pages and those represented in Smithsonian collections are instructive, as they enable us to develop fuller and more dynamic American narratives in our exhibition spaces and programs. Indeed, through abstraction, speculative renderings, and re-narrativizations of home and nation, the artistic desire to move beyond the surface and into the depths leads us to critical (re-)discoveries as we reckon with the past and present and move with surety and hopefulness into the future.

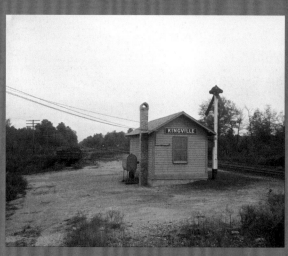

Richard Taylor, Kingville Depot in Lower Richland County, 1958; the State Media Company (Columbia, South Carolina); Richland Library, Columbia, South Carolina

MICHELLE D. COMMANDER is Deputy Director of the National Museum of African American History and Culture. She is the author of *Afro-Atlantic Flight: Speculative Returns and the Black Fantastic* and *Avidly Reads: Passages*. Commander is also the editor of the anthology *Unsung: Unheralded Narratives of American Slavery & Abolition* and the catalog *Reckoning: Protest. Defiance. Resilience.*

ACKNOWLEDGMENTS

The editors of *Making Home: Belonging, Memory and Utopia in the 21st Century* are indebted to the Smithsonian Design Triennial's designers, artists, and community, whose open hearts and minds served as the inspiration for this book. They include After Oceanic Built Environments Lab and Leong Leong; Artists in Residence in Everglades (AIRIE); La Vaughn Belle; Black Artists + Designers Guild; Lori A. Brown, Trish Cafferky, and Dr. Yashica Robinson; CFGNY; Mona Chalabi and SITU Research; Nicole Crowder and Hadiya Williams; Designing Justice + Designing Spaces; Heather Dewey-Hagborg; East Jordan Middle/High School; Sofía Gallisá Muriente, Natalia Lassalle-Morillo, and Carlos J. Soto; Curry J. Hackett, Wayside Studio; Hugh Hayden, Davóne Tines, and Zack Winokur; Hord Coplan Macht; Terrol Dew Johnson and Aranda\Lasch; Liam Lee and Tommy Mishima; Lenape Center with Joe Baker; Joiri Minaya; Robert Earl Paige; *PIN-UP*; Ronald Rael; William Scott; Amie Siegel; and Renée Stout.

This expansive effort would not have been possible without the faith and leadership of Cooper Hewitt's director, Maria Nicanor, whose enthusiasm and encouragement helped us create a new museum experience for *Making Home—Smithsonian Design Triennial*. John Davis and Rukmini Neuhold-Ravikumar kept the vision alive during their respective terms as acting director, and we're grateful to have the support of new Deputy Director Elissa Black in bringing *Making Home* to the public.

We are grateful to Kevin Young, director of the Smithsonian's National Museum of African American History and Culture (NMAAHC), and to Deputy Director Michelle D. Commander for dedicating staff and resources to the realization of this collaboration. At NMAAHC, we also thank William Pretzer, Paul Gardullo, Adele Hixon-Day, Miriam Grotte-Jacobs, Deirdre Cross, and the late Debra McDowell for their efforts to support this institutional collaboration. From the start, we hoped this project would embody a "One Smithsonian" ethos, and we leaned on many colleagues within the Smithsonian Institution for their feedback and guidance. We thank Secretary Lonnie G. Bunch III for supporting this collaborative ethos. Special thanks to Under Secretary of Museums and Culture Kevin Gover and Senior Program Officer for Art Joanne Flores for shepherding our work. We would also like to acknowledge the generosity of Betty Belanus, Michelle Anne Delaney, Kālewa Correa, Taína Caragol, Diana Baird N'Diaye, Cristina Diaz-Carrera, Megan Machnik, Samir Meghelli, Jason Morris, Sabrina Motley, Kate Lemay, Danielle Lote, David Penney, Margaret Salazar-Porzio, Rachel Seidman, and Christopher W. Williams.

Stephen Velásquez and colleagues at the National Museum of American History, Joshua Bell and colleagues at the National Museum of Natural History and the National Anthropological Archives, Rachelle Graves and Nancy Herbolsheimer at the Office of Government Relations, and White House Curator Donna Hayashi Smith with the White House and First Lady's staff provided invaluable support to realize ambitious installations.

Acting Curatorial Director Matilda McQuaid served as a sounding board and sage throughout this process. We also wish to recognize our curatorial colleagues Susan Brown, Caitlin Condell, Emily Orr, Andrea Lipps, Cindy Trope, Jamie Kwan, Kimberly Randall, Crystal Ferrer, Mackenzie Jones, Casey Monroe, and especially Cynthia Smith, whose insight was invaluable.

Publishing eighty perspectives on the complexity of home is a challenging process. This volume would not be complete without the wisdom, guidance, and responsiveness of Pamela Horn, Cooper Hewitt's Director of Cross-Platform Content. Many facets of *Making Home* were supported by Matthew Kennedy and Xhosa Fray-Chinn of Cross-Platform Content, along with Shamus Adams, Mary Fe Alves da Silva, Isabel Kok, Michelle Belot, Kang-Ting Peng, Nolan Hill, and Julia Ha in Digital and Emerging Media. Our wise and careful copyeditors Nirmala Nataraj, Kara Pickman, and Joanie Eppinga strengthened and unified text, and we received continual encouragement from our editor at MIT Press, Victoria Hindley. Our book designer Sunny Park of Park-Langer translated the depth of our research and the perspectives of the contributors into engaging visuals appealing to broad audiences. Thank you to Sarah Hromack-Chan and Linked By Air for their work developing and publishing the multidimensional digital exhibition platform for this project.

Cooper Hewitt, Smithsonian Design Library is a treasured resource for scholars and design lovers. Thank you to librarians Jennifer Cohlman Bracchi, Michelle Jackson-Beckett, and Nilda Lopez for providing a quiet place for this book to be developed.

Making Home's total museum takeover of new commissions meant that Cooper Hewitt's exhibitions team, conservators, registrar, and art handlers worked overtime to problem-solve and remain agile. We are indebted to Cooper Hewitt's outstanding exhibitions team, led by Director of Exhibitions Yvonne Gómez Durand, with Molly Engelman and Dillon Goldschlag. We are indebted to Carl Baggaley, Andrew Behm, Jennifer Dennis, Isabella Di Blassio, Jonathan Hayes, Charley Summers, Michael Sypulski, and Zachary Ziemann for their careful craftsmanship and installation. Registrars Wendy Rogers, Winona Packer, Antonia Moser, Kim Hawkins, Simon Goldsmith, Lauren Robinson, Janice Hussain, and Larry Silver always found a way to make things work. The skills and creativity of conservators Sarah Barack, Kira Eng-Wilmot, Perry Choe, Jessica Walthew, Jody Hanson, Marilu Hartnett, Matthew Schwede, and Martha Singer were invaluable. A similar debt is owed to our art handlers, Peter Baryshnikov, Ted Kersten, Joel Bacon, Carolyn Morris, and Robert Paasch, for the safe installation of this unusual exhibition.

Architects Johnston Marklee approached this project with an eye to the past, present, and future, creating synergy across a complex historic site hosting many voices. It was our great pleasure to work with their team, especially Sharon Johnston, Mark Lee, Nicholas Hofstede, Andrew Fu, and Olivia Malone. Design studio Office Ben Ganz infused humor and color through a bold identity and signage. Ben Ganz, Pablo Genoux, Laura Foxgrover, Nicholas Phillips, Kristin Hrycko, and Mayatu Peabody were keen collaborators across all museum departments.

Cooper Hewitt's expert communications and marketing team—Ashley Tickle, Laurie Bohlk, Sara Cohen, Olivia Manno, and Ann Sunwoo—thoughtfully brought new audiences to reflect on *Making Home*. Our Learning Audience and Engagement team, directed by Kim Robledo-Diga, developed workshops and programs that allowed for multigenerational opportunities for engagement. We thank educators Vassiliki Giannopoulos, Louisa Hartigan, Alexandra H. Hodkowski, Alexa Griffith Winton, Alexa Cummins, Kirsten McNally, Nadya Kim, and Hannah Riley, along with accessibility manager Kirsten Sweeney. Our Visitor Experience colleagues Kathleen Kane, Mauricio Portillo, Katherine Miller, Mya Bailey,

Olivia Bambara, Ellie Botoman, Emily Brillon, Kendra Caldwell, Robyn Carter, Nancy Lee Cesario, Daniella Gonzalez, Anamika Misra, Rachael Patterson, Miguel Santiago, Kristie Siegel, Suzy Swygert, and Johnny Tran supported these ambitious installations, creating a welcoming environment for visitors, artists, and designers.

Emily Raddant and Paul Beasley found personal and fun ways to source a collection of objects that represent the ethos of the Triennial—all available in Cooper Hewitt's SHOP.

Cooper Hewitt's Advancement team—Veronica Bainbridge, Abbey Hunter, Sheila Egan, Ruth Epstein, Madeline Warner, Amanda Cook, Kelly Millán, and Merit Myers—worked tirelessly to find support for this project and enliven it with events. Paula Zamora and Caeli Tracey pushed the limits of our contractual capacity to accommodate the unique nature of the endeavor. Special thanks to Nykia Omphroy, who is the glue that holds Cooper Hewitt together.

We thank David McClelland, Anthony Rubert, Angel Tellado, Alvaro Imbrett, David Samuel, Kenny Chan, Angela Diaz, Philip Diaz, Yareli Ortega, and Sean Thompson for keeping the museum operating smoothly.

The most profound gratitude goes to Curatorial Assistants Sophia Gebara, Caroline O'Connell, Julie Pastor, and Isabel Strauss (NMAAHC) for their indefatigable partnership and labor in realizing *Making Home*. Their collaboration has carried this effort, supported by Fellows Elisabeth Garman, Nhadya Lawes, Sunena Maju, Ivana Maldonado, Lourdes Miller, Sara Valbuena, Bethany Vickery, Elizabeth Watkins, and Gabriel Ziaukas (NMAAHC), who brought fresh thinking and detailed organization to this layered and fluid endeavor.

Many colleagues and friends contributed key moments of inspiration, invaluable introductions, and insightful guidance. We are grateful for conversations with Cathy Byrd, Martina Dodd, Brittany Drakeford, Kimberly Driggins, Angela Dupont, Michelle Millar Fisher, Reese Fayde, Rachel Ginsberg, Lauren Bostic Hill, Healoha Johnston, Nena Perry-Brown, Carlos Martín, Suchi Reddy, Thaisa Way, and John Zeisel.

Alexandra Cunningham Cameron expresses deepest thanks to Edward and Helen Hintz for providing a strong foundation for her work at Cooper Hewitt, which gave her the courage to explore and innovate. Felix Burrichter, Carson Chan, Adam Charlap Hyman, Rafael de Cardenas, Majandra Delfino, Deana Haggag, Kim Hastreiter, Tom Healy, Fred Hochberg, Patricia Engel, Ruba Katrib, Cynthia Leung, and Ian Volner all found the time in their busy lives to sit with her and talk Triennial. Her heart goes out to Seth, Hadrian, and Joseph-Sligh Cameron, as well as her parents, for their love and good humor.

Christina L. De León wishes to express her gratitude to Jonathan Carrasquillo, Juliana Fagua Arias, Lawrence Fowler, Justin Irwin, Marisa Lerer, and Yao-Fen You for their unwavering encouragement and support throughout this multiyear project. She extends deep thanks to Eduardo Díaz, Diana Bossa Bastidas, and colleagues at the National Museum of the American Latino for believing in the importance of elevating Latino design. Finally, she offers deep appreciation to her mother, Magali Laguna, whose endless patience and willingness to listen provided a constant source of strength and laughter.

Michelle Joan Wilkinson thanks the National Museum of African American History and Culture for its commitment to and support of *Making Home*. Colleagues across NMAAHC provided valuable feedback on the project, especially Deputy Director Michelle Commander, Ariana Curtis, Mary Elliott, Tuliza Fleming, and Paul Gardullo. Michelle also extends thanks to Lanisa Kitchiner, Krista Thompson, Jerry Philogene, Rocio Aranda-Alvarado, and Mabel O. Wilson for their thoughtful insights and encouragement. To Pearlene Wilkinson, her mother, and to Priscilla Renta, she offers sincere gratitude for their time, listening, and love.

—Alexandra Cunningham Cameron, Christina L. De León, and Michelle Joan Wilkinson

PHOTOGRAPHY CREDITS

9: © Sheila Pree Bright. [BELONGING] 18-19: © Frank Blazquez; 20: © Brian Adams; 21: Architect of the Capitol; 22: NASA images created by Jesse Allen, using Landsat data provided by the United States Geological Survey; 25: Courtesy of Elia López; 31, 33: Carlos Martín; 37-47: © Brian Adams; 48-50: Photo by Renée Stout; 52-53: Designing Justice + Designing Spaces; 56-57, 59: Courtesy of Mona Chalabi; 61: [No credit]; 62: US Marine Corps, photo by Sgt. Jose Angeles; 63: Photo by Jared Suba; 66: From the collection of the Milwaukee Public Museum, #44474; 67: National Portrait Gallery, Smithsonian Institution, NPG.93.372; 68: Courtesy of the Luther Bean Museum, Adams State University, Gift of Gwendolyn Hill, 1975.10.1o; 71-81: © Frank Blazquez; 82, 83: Photo by Patrick Downer; 84: Photo by Angela Barrera; 86: © Leeroy New; 88: Photo by Allan Punzalan Isaac; 89: Courtesy of Joiri Minaya; 91: Photo by Matt Flynn © Smithsonian Institution; 92: Courtesy of Joiri Minaya; 95-96: Image by Sofía Gallisá Muriente and Natalia Lassalle-Morillo; 97: Image by Sofía Gallisá Muriente; 99: Photo by Liam Lee; 100: Photo by Wilson Santiago; 102: © Valerie Aboulker 2023; 103: Photo by Catherine McKinley; 104: Courtesy of Catherine McKinley; 105: © Valerie Aboulker 2023; 108-10: Roxane Gay. [MEMORY] 112-13: © Sheila Pree Bright; 114-15: Courtesy of Michelle Joan Wilkinson; 116: Intelligent Mischief; 121, 123: © 2022 by Patrick Cline; 127-35: © Curry J. Hackett; 136, 137, 139: Courtesy of Joe Baker; 140: Bernard Castillo; 141: I Do Art Agency courtesy of meter space; 142: Tamia Williams; 143-44, 146: Courtesy of Sarah Lopez; 148-51: Courtesy of AIRIE; 153-61: © Sheila Pree Bright; 163: © Emanuel Hahn; 164: © Reddymade; 165-66: Photo by John Zeisel; 171-72: Hord Coplan Macht; 175: © Kerry James Marshall, courtesy of the artist and Jack Shainman Gallery, New York; 178: Courtesy of Black Artists + Designers Guild (BADG); 179: Courtesy of Shaw Contract Hospitality; 180, 181: Photo by Sandra Jackson-Dumont; 182: Photo by Carl Dumont; 184: Courtesy of Robert Paige; 185: Photo by Alexandra Cunningham Cameron © Smithsonian Institution; 188 (top): © Hadiya Williams; 188 (bottom): Photo courtesy of North Carolina Museum of History; 191: Farm Security Administration/Office of War Information photography collection (Library of Congress); 193-94: Carehaus. [UTOPIA] 196-97: © Leah DeVun; 198: Photo by Matt Flynn © Smithsonian Institution; 199 (left): Courtesy of the Johnson Family; 199 (right): © Shumon Basar; 200: © Leah DeVun; 203-15: © Leah DeVun; 216: Artwork © Josephine Halvorson, courtesy of Sikkema Jenkins & Co., New York; 217, 220-21: Courtesy of the Foxfire Fund © Penguin Random House; 224: Madam Walker Family Archives/A'Lelia Bundles; 225: Alice Austen, courtesy of the Alice Austen House; 226: Photo by Michael Vahrenwald, courtesy of the artist, Corbett vs. Dempsey, David Nolan Gallery, Galerie Thomas Schulte; 229: Collection of the Museum of the City of New York; 231-32: Image Courtesy CFGNY; 234: Courtesy of the Bullock family; 236: Image courtesy of Journey Streams; 239: Gazette-Mail file photo; 241-43: Courtesy of Creative Growth; 247-48, 250-51, 253: © Katherine Simóne Reynolds; 255: Mayank Chugh; 256: Davóne Tines; 258: Mayank Chugh; 260: Richard Nickel Archive, Ryerson and Burnham Art and Architecture Archives, the Art Institute of Chicago; 261: Courtesy of Nathan Keay; 263: Image courtesy Lanakila Mangauil; 264: Map courtesy 'ĀINAVIS; 265: Image courtesy Hui Ho'oleimauluō; 266: Stills by film collective kekahi wahi (Sancia Miala Shiba Nash and Drew Kahu'āina Broderick), 2024; 268: National Library of Medicine, History of Medicine Collection, Archives, 1946-76, Box 2; 269: Drawing by Kelsey Benitez, 2024; 270: Alabama Department of Public Health; 274-76: Heather Dewey-Hagborg and Toshiaki Ozawa; 278-81: © Joyce Hwang; 283-85: Courtesy of the Johnson Family; 287: DESIGN EARTH; 290: Harrison Schmitt or Ron Evans of Apollo 17 crew for the National Aeronautics and Space Administration (NASA); 291: DESIGN EARTH; 292: © The Estate of Beauford Delaney, by permission of Derek L. Spratley, Court Appointed Administrator, photo by Bruce Cole; 293 (top & bottom): © The Estate of Beauford Delaney, by permission of Derek L. Spratley, Court Appointed Administrator, photo by the Knoxville Museum of Art; 294: © The State Media Company. All rights reserved. Richland Library, Columbia, SC.

COOPER HEWITT

Published in conjunction with the exhibition *Making Home—Smithsonian Design Triennial* organized by Cooper Hewitt, Smithsonian Design Museum, New York, November 2, 2024–August 10, 2025.

Published by Cooper Hewitt, Smithsonian Design Museum
2 East 91st Street
New York, NY 10128
USA
cooperhewitt.org

Distributed by The MIT Press
Massachusetts Institute of Technology
Cambridge, Massachusetts 02142
mitpress.mit.edu

ISBN 978-0-262-54979-0
Library of Congress Control Number:
2023949074

Director of Cross-Platform Content
Pamela Horn

Cross-Platform Content Publishing Associate
Matthew Kennedy

Book Design
Sunny Park of Park-Langer

Typefaces
Caslon Ionic, Lace, Octave, and Scribiti

2020 2021 2022 2023 2024 / 10 9 8 7 6 5 4 3 2 1
Printed and bound in Italy

Cover photograph: Brian Adams, Quinhagak, Alaska, for I am Inuit, 2015; © Brian Adams
Front flap photograph: Frank Blazquez, The Gutierrez-Padilla Living Room, 2018; © Frank Blazquez
Back flap photograph: Leah DeVun, Theory of Light, 2020; © Leah DeVun

"Resume" from *STONES: POEMS* by Kevin Young, copyright © 2021 by Kevin Young. Used by permission of Alfred A. Knopf, an imprint of the Knopf Doubleday Publishing Group, a division of Penguin Random House LLC. All rights reserved.

"Intentional, Home" by Roxane Gay © 2024 by Roxane Gay. Used with permission.

"The Hard Work of Forgetting: The Black Family Home and the Two Sides of American Memory," by Bryan Mason and Jeanine Hays, reprinted with permission from *AphroChic: Celebrating the Legacy of the Black Family Home*. Published by Clarkson Potter, an imprint of Penguin Random House.

Smithsonian Design Museum